FEMALE BUDDHAS

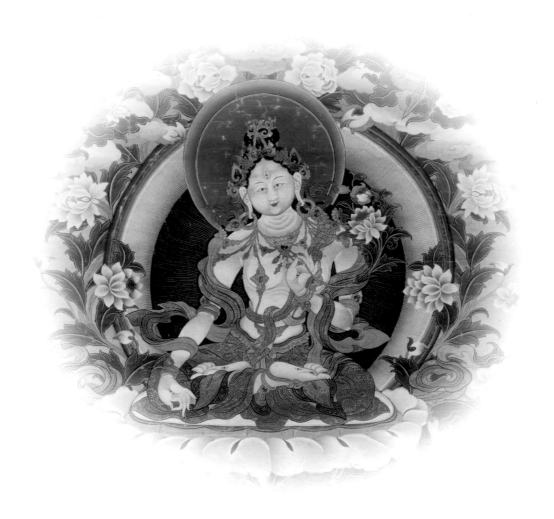

FEMALE BUDDHAS

Women of Enlightenment
in Tibetan Mystical Art

GLENN H. MULLIN

with Jeff J. Watt

Art from the Collection of the
Shelley & Donald Rubin Foundation

Photographs of Tibet by Marcia Keegan

CLEAR LIGHT PUBLISHERS

Santa Fe, New Mexico

Clear Light Publishers
823 Don Diego
Santa Fe, New Mexico 87505
www.clearlightbooks.com

First Edition
10 9 8 7 6 5 4 3 2 1

Library of Congress Cataloging-in-Publication Data
Mullin, Glenn H.
 Female Buddhas : women of enlightenment in Tibetan mystical
art / by Glenn H. Mullin ; illustrated with masterpieces from the
Shelley and Donald Rubin collections.
 p. cm.
 Includes bibliographical references and index.
 ISBN 1-57416-067-2 -- ISBN 1-57416-068-0 (pbk.)
 1. Art, Tibetan. 2. Buddhist goddesses in art. 3. Art, Tantric
--Buddhist--China--Tibet. 4. Buddhist art and symbolism--China
--Tibet. 5. Buddhism--Doctrines--China--Tibet. 6. Rubin,
Shelley--Art collections. 7. Rubin, Donald--Art collections.
8. Art--Private collections--New York (State) I. Title.
N8193.3.T3M848 2002
700'.48294363'09515--dc21

 2002012577

Endsheet tangka paintings: Centerpiece—Healing Tara, detail from tangka on page 69;
Background—watermark from tangka on page 103.
Cover design by Tamara McElhannon, Marcia Keegan & Carol O'Shea.
Interior design and typography by Carol O'Shea.

TABLE OF CONTENTS

List of Illustrations V
Preface X
Foreword XI

Part One: An Overview of the Tradition

1. In Praise of the Feminine 15
2. Male & Female Buddhas 17
3. Buddha Shakyamuni 19
4. The Buddhist Legacy in India 21
5. The Sutra Way 23
6. The Doctrine of the Three Kayas 27
7. Tantra, Mantra & Mandala 31
8. The Tantra Way 35
9. Three Jewels, Three Roots & Three Types of Female Buddhas 39
10. Tibetan Mystical Art as Pictorial Language 43
11. The Story of Tibetan Mystical Art 47
12. Concluding Reflections 50

Part Two: Treasures from the Rubin Collection

13. Arya Tara 54
14. Healing Trinity 98
15. Female Buddhas with an Agenda 111
16. The Yum in Yab Yum 129
17. The Vajra Dakinis 148
18. Female Buddhas & Their Mandalas 164
19. Female Dharma Protectors 178
20. Great Female Lineage Masters 202

Part Three: Epilogue

A Dakini Song from the Seventh Dalai Lama 219

Bibliography 224
Female Buddhas on the Web (www.himalayanart.org) 225
Index 227

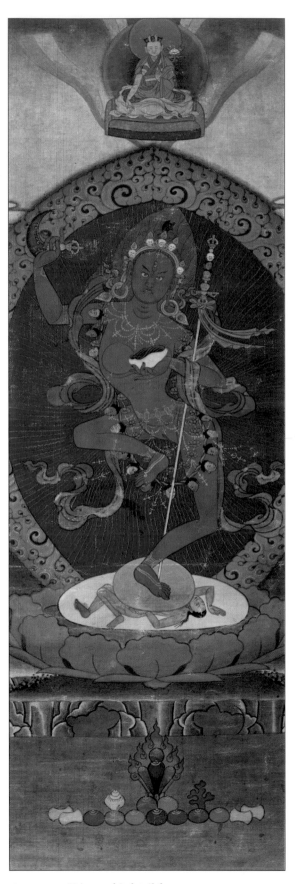

Vajravarahi, detail from page 153.

LIST OF ILLUSTRATIONS

Photographs

Tibetan prayer flags on the bridge on the Kyichu River, Lhasa XII

Female pilgrim offering devotions at a mountain of murals near Lhasa 14

The Potala from the roof of the Jokhang Temple 16

Tibetan yogini in the meditation caves on Iron Mountain, Lhasa 18

Buddha Shakyamuni carved into stone face of mountain, Kyichu Valley 20

Tibetan woman on pilgrimage in the Jokhang Temple in Lhasa 22

Buddha in the Jokhang Temple, Lhasa 23

The Wheel of Life on a temple doorway 25

Buddha emanating rainbows at Ramochey Temple 26

A stupa at Ganden Monastery 28

Statues of King Songtsen Gampo with his Nepali and Chinese Buddhist wives 29

Sand painting at the Norbulinka, the Dalai Lama's summer residence 30

The Dalai Lama begins the dismantling of a Kalachakra Mandala 33

Temple mandala fresco of the Wheel of Time, the Potala, Lhasa 34

Tara statues in Dolma Lhakang Temple, Tibet 39

Artist painting a temple fresco behind the head of a large Buddha statue 42

Female shaman in Lhasa with sacred symbols of swastika, moon and sun embroidered on the back of her dress 44

A Tibetan nun in Lhasa gives us a history lesson 46

Anni Sangku Nunnery in Lhasa 50

Three generations of women on pilgrimage at the Potala 52

Tangkas

Arya Tara; Tib., Pakma Dolma; Transcended Liberator 60

The Twenty-One Taras: The Atisha Lineage (detail, 63) 65

The Twenty-One Taras: A Sakya Interpretation 67

White Tara, from the Atisha Lineage of Twenty-One Taras 69

Yellow Tara, from the Atisha Lineage of Twenty-One Taras 71

Red Tara, from the Atisha Lineage of Twenty-One Taras 73

Dark Colored Tara, from the Atisha Lineage of Twenty-One Taras 75

The Eight Taras Who Protect from the Eight Dangers 81

The Centerpiece for the Taras Who Protect from the Eight Dangers (detail, 54) 83

Tara Who Protects from the Danger of Lions 85

Tara Who Protects from the Danger of Elephants 87

Tara Who Protects from the Danger of Fire 89

Tara Who Protects from the Danger of Thieves 91

Tara Who Protects from the Danger of Imprisonment 93

Tara Who Protects from the Danger of Drowning (detail, 79) 95

Tara Who Protects from the Danger of Ghosts 97

Chintachakra Tara; Tib., *Dolkar Yizhin Khorlo; White Tara, the Wish-Fulfilling Wheel* (details, cover, frontispiece, 98) 103

Amitayus; Tib., *Gyalwa Tsepakmey; Amitayus, Buddha of Boundless Life* 105

Ushnisha Vijaya; Tib., *Tsuktor Namgyalma; The Victorious Ushnisha Female Buddha* (detail, 107) 109

Ushnisha Sita Tapatra; Tib., *Tsuktor Karmo; White Ushnisha Parasol* (detail, 112) 113

Parnashavari; Tib., *Loma Gyunma; The Leaf-Clad Lady* (detail, 115) 117

Marichi; Tib., *Ozer Chenma; She with the Rays of the Sun* (details, 111, 120) 119

Kurukulle; Tib., *Rigchema; She of the Action Family* (detail, 121) 123

Simhamukha; Tib., *Sengdongma; The Lion-Faced Dakini* 125

Sherab Chamma, She of Loving Wisdom (detail, 126) 127

Samantabhadra and Samantabhadri; Tib., *Kuntu Zangpo and Kuntu Zangmo;*

 All-Good Male, All-Good Female (detail, 128) 133

Guhyasamaja and Sparshavajri; Tib., *Sangwai Dupa; The Secret Gathering* 135

Vajrabhairava and Vajra Vetali; Tib., *Dorjey Jigjey Yab Yum; The Diamond Terror Male/Female.* 137

Kalachakra and Visvamata; Tib., *Dukhor Yab Yum; The Time Wheel, Male/Female.* 139

Chakrasamvara and Vajravarahi, Tib., *Khorlo Demchok Yab Yum; The Wheel of*

 Supreme Bliss Male/Female 141

Hevajra and Nairatmya; Tib., *Kyedor Yab Yum; The Ultimate Diamond Male/Female* (detail, 129) 143

Vajrakila and Triptachakra; Tib., *Dorje Purpa Yab Yum; The Vajra Dagger Male/Female.* 145

Walchen Gekho and Lokbar Tsamey 147

Vajravarahi; Tib., *Dorjey Pakmo; The Diamond Sow* (detail, VI) 153

Vajrayogini; Tib., *Dorjey Naljorma; Diamond Yogini* (detail, 148) 155

Vajra Nairatmya; Tib., *Dorjey Dakmeyma; The Selfless Diamond* 157

Sita Yogini; Tib., *Naljorma Karmo; The White Yogini* 159

Krisna Krodha Dakini; Tib., *Khadroma Troma Nakmo; Black Fierce Dakini* 161

Samaya Tara Yogini; Tib., *Damtsig Dolma Naljorma; The Sworn Liberator Yogini* 163

Heruka Chakrasamvara Mandala; Tib., *Khorlo Demchok Khyilkhor; Mandala of the Wheel of Supreme Bliss* 167

Vajravarahi Panja-devi Mandala; Tib., *Dorjey Pakmo Lha-nga Kyilkhor;*

 The Five Deity Mandala of the Diamond Sow 169

Vajrayogini (Naro Khechari) Mandala; Tib., *Dorjey Naljorma Kyilkhor; Diamond Yogini* 171

Baishajvaguru Mandala; Tib., *Sanggyey Menla Kyilkhor; Mandala of the Master Healer*

 (symbolized by Prajna Paramita) 173

Arya Tara Anuttaratantra Mandala; Tib., *Jetsun Dolma Lamey Khyilkhor; Highest Form of the Tara Mandala* 175

Rakta Yamari Mandala; Tib., *Shinjey Shemar Yab Yum Kyilkhor*

 The Mandala of the Red Enemy of Death, with Consort 177

Palden Lhamo Magzor Gyalmo, Glorious Divine Queen of Wrathful Rituals 183

Magzor Gyalmo with Tseringma Chey Nga, The Queen of Wrathful Rituals
 with the Five Longevity Sisters (detail, 178) 185

Dorjey Rabtenma, Superbly Constant Diamond 187

Shri Chitipati; Tib., Pal Durdak Yab Yum; The Lord and Lady of the Charnel Grounds 189

Ekajati; Tib., Ralchikma; The One Hairbraid Lady 191

Rakta Ganapati; Tib., Tsokdak Marpo; The Red Wrathful Lord and his Five Dakinis 193

Khadroma Tsomo Chechang Marmo, The Red-Tongued Dakini Queen 195

Sinpoi Tsomo Jigjey Marmo, The Red Bhairava Spirit Queen 197

Lhamo Dorjey Yudonma, Divine Turquoise Lamp 199

Lhamo Tashi Tseringma, Divine Auspicious Longevity 201

Avalokiteshvara; Tib., Chenrezig; The Gently Gazing Bodhisattva 205

The Niguma Lineage of Heruka Chakrasamvara (details, 151, 206, 220) 207

Saraha and His Female Guru 209

Ghantapada and Consort (detail, 202) 211

Dombi Heruka and Consort 213

Padma Sambhava (detail, 214) 215

Machik Labdon (detail, 218) 217

Other Items

Carved book cover 56

Arya Tara, statue 59

Ushnisha Vijaya Stupa from Nepal, statue 110

Simhamukha, statue 124

Mandala of Vajrayogini (Naropa Lineage) 164

Instructions on how to use the Web to learn more about items in the Rubin Collections 225

PREFACE
Glenn H. Mullin

When Professor Lloyd Nick, Director of Oglethorpe University Museum of Art in Atlanta, invited me to put together a Tibetan exhibition from the many treasures in the Shelley and Donald Rubin Collection and to write the accompanying text, I was both honored and delighted. The masterpieces in the Rubin Collection (from their Foundation, Cultural Trust and personal collection) represent one of the greatest repositories of Tibetan art in the world today. The chosen theme—*The Female Buddhas: Women of Enlightenment in Tibetan Mystical Art*—is especially exciting for me, because nothing of substance has been done on this subject, and it is a field in which Tibetan art is especially rich.

A few technical notes regarding the spelling in this volume are needed. I have presented Tibetan words and names as they are pronounced—for example, *Machik Labdon* rather than *Ma-gcig-lab-sgron,* and *Palden Tashi* rather than *dPal-ldan-brka-shis.* Formal Tibetan spellings are visual impossibilities to the eye of the casual reader, the large number of silent consonants making for a complete mystery. Tibetan scholars can easily find their way to the formal spellings from the phonetic system, and the formal spelling serves no purpose for the casual reader.

I have followed a similar policy with Sanskrit and left out the diacritics. Again, diacritics may be useful in specialist literature intended solely for academics, but they remain a mystery and eyesore to the uninitiated reader. They are, simply stated, as un-American as writing a Russian name with half the letters backwards, or running a bunch of slashes through the vowels in the fairy tales of Hans Christian Andersen.

Please note that the sound of the Tibetan *a* is always soft, as in "water." It is closer to the the *o* in "song" than to the *a* in "sang." The word for a Tibetan painting, *tangka,* is thus pronounced more like "tongka."

Speaking of tangka/tongka/thanka, those familiar with the Tibetan language know that there are two letters *t* in Tibetan, as in Sanskrit. Most Western writers chose to write the first as *t* and the second as "*th.*" Some readers might therefore have seen "tangka" written as "thangka" in other books on Tibetan art. Unfortunately the *th* always makes for a mispronunciation with all but the most seasoned reader. "Thangka" usually comes out like "thank-a" rather than "tong-ka."

Working with Jeff Watt and Lisa Schubert at the Rubin Museum in New York has been a great pleasure for me. The former is perhaps the greatest living expert on Tibetan iconography, and the latter a most talented and inspired artist. I would also like to thank Carol O'Shea, who designed the book, and Marcia Keegan, who contributed the photographs to Part One. Finally, I would like to thank my sixteen-year-old son, Atisha Mullin, who proofread the entire manuscript for me during his summer vacation. He offered many valuable suggestions on how to liven up the language of the reading and make a potentially technical and esoteric subject more accessible to a general audience.

FOREWORD

Lloyd Nick

Director, Ogelthorpe University Museum of Art, Atlanta, Georgia

The Many Faces of Buddha at the Ogelthorpe University Museum of Art (OUMA), Atlanta, was the first Asian and Buddhist exhibition in the Southeast. The year was 1985, and I felt the intellectual and spiritual climate was ripe for the sixty images representing each of the major Buddhist cultures. The exhibition was an enormous success—thousands viewed it, attended the lecture series and walked away with insightful ideas.

For the 1996 Olympics, OUMA initiated and brought to Atlanta the historically important *The Mystical Arts of Tibet Featuring the Personal Sacred Objects of the Dalai Lama,* which is still traveling across North America on its educational journey of inspiration. That exhibition appropriately embodied the image of oneness and the transcendence of differences through beauty. A large, detailed sand mandala of Yamantaka contributed to the quality of the exhibit and became a magnet for our community and our international guests. The curator of the exhibition and author of the catalogue was the internationally renowed Tibetologist Glenn H. Mullin.

Last fall, OUMA was offered the opportunity to exhibit Tibetan art from one of the world's largest private collections. Donald Rubin, an alumnus of Oglethorpe University, with his wife, Shelley, has been collecting Himalayan art for the past 25 years. Over a brainstorming lunch, Glenn and I developed the idea of an exhibition representing the range and power of the female form as expressed in Tibetan Buddhist art. We hoped this exhibition would make a major contribution towards the study of the Buddhist art of Tibet.

This book, written by Glenn H. Mullin with Rubin Museum of Art iconographer Jeff Watt acting as consultant, has been published to coincide with the exhibition of the same title, *The Female Buddha: Women of Enlightenment in Tibetan Mysticism,* at OUMA from the Rubin collection.

Shelley and Donald Rubin are the founders of a new museum in New York city, scheduled to open in 2004. The concept for a musuem grew out of Donald Rubin's early efforts to make Himalayan art accessible to as wide an audience as possible through building a virtual musueum, www.himalayanart.org. Known as the Himalayan Art Project, the website, host to private and public collections of art from the world over, offers the most comprehensive resource on the Web for studying Himalayan art. The Rubin Museum of Art will house a permanent collection and curate exhibitions exploring and contrasting Himalayan art with art from other cultures and traditions.

I am grateful for the generosity of Shelley and Donald Rubin in making this exhibition possible. I am especially grateful for the dedication of Glenn Mullin—for his expertise, enthusiasm, and anecdotes. My deep appreciation also goes to Jeff Watt for his valuable assistance and research and to Marcia Keagan, who generously contributed her photographs to part 1 of this publication and thus provided the timeless setting for the tangkas. This book would not have been possible without the wholehearted support of publisher Harmon Houghton of Clear Light Publishers.

I do believe that we influence everything we touch, and I know that spirituality and art provide the only place in which we can experience our interconnectedness regardless of our differences and circumstances. The Western challenge of Socrates's "awakening to the supreme importance of attending to the soul" is expressed beautifully through the Eastern tangkas. The outer world softens in their presence and art. Goethe's "the sister of religion" works its magic.

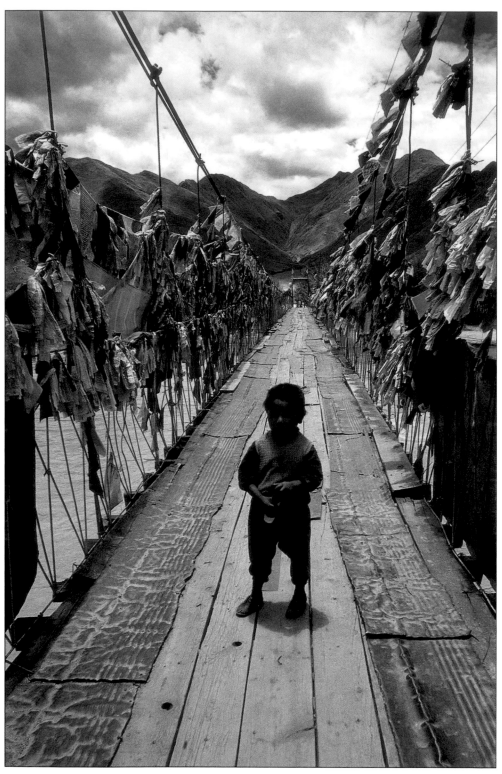

Tibetan prayer flags on the bridge on the Kyichu River, Lhasa.

Part One

AN OVERVIEW OF THE TRADITION

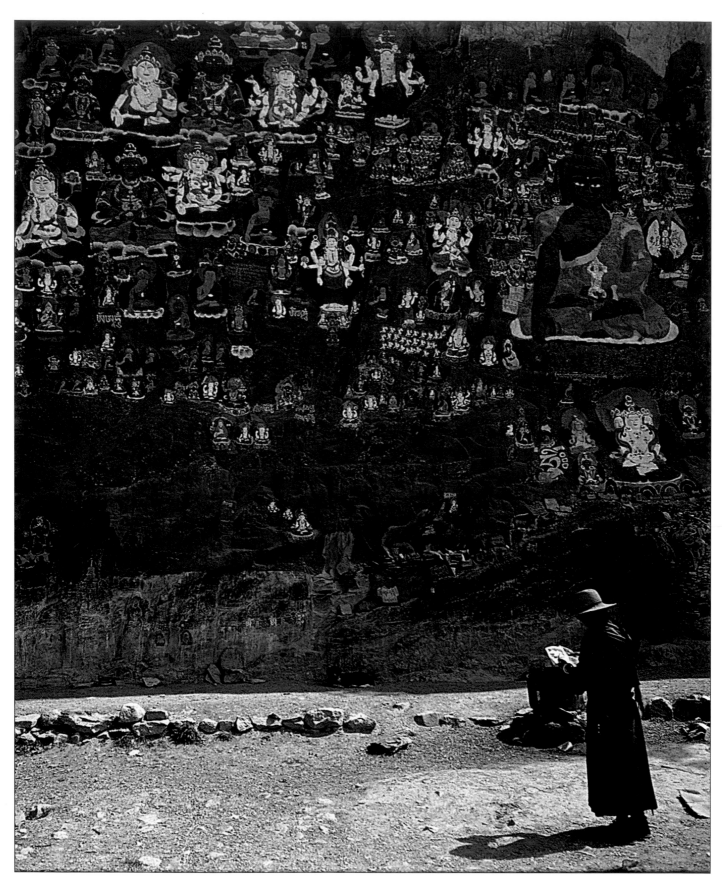

Female pilgrim offering devotions at a mountain of murals near Lhasa.

In Praise of the Feminine

One of the most popular verse eulogies composed by the First Dalai Lama (1391–1475) is his *Lek Trima*, a mystical song dedicated to Arya Tara, Tibet's favorite female buddha.[1] Known by heart to almost all Tibetans, in old Tibet it was chanted in a deep bass melody at the great gathering of 20,000 monks and nuns during each day of Lhasa's annual Great Prayer Festival. In it the First Dalai Lama writes,

> *Glorious Arya Tara, who embodies the insight,*
> > *kindness*
> *And strength of all buddhas, and uplifts those in*
> > *need;*
> *The female buddha of enlightenment energy*
> > *miraculously born*
> *From the force of the Buddha of Compassion:*
> > *Homage.*
>
> *Upon a pure lotus and moon symbolizing knowledge*
> > *and the void*
> *Sits emerald-green Tara, vibrant with*
> > *life power.*
> *Her right leg out-stretched and left*
> > *withdrawn*
> *Symbolize energy and wisdom conjoined.*
>
> *Her rounded breasts a treasury of*
> > *transcendent bliss,*
> *Her moon-like face smiling brightly,*
> *Her wide, compassionate eyes gazing serenely:*
> *Homage to beautiful Tara of the*
> > *Rosewood Forest....*
>
> *Though dwelling in stillness you are moved by*
> > *compassion*
> *And on arms of compassion carry*
> > *to stillness*
> *The beings struggling in this ocean*
> > *of misery.*
> *To you gone to the end of compassion I bow down....*

Any visitor to a Tibetan temple will be impressed by the large number of female images that appear in wall frescos and tangka paintings, as well as in various sculptured forms.

This strong role of the feminine in Tibetan sacred art is common to the chapels of monasteries and nunneries alike, as well as in communal meditation hermitages. The feature stands in sharp contrast to the predominance of male images seen in the temples of most other Buddhist countries. When it comes to female buddhas in their mystical art, the Tibetans seem rich beyond compare.

The two-hour drive from the Gongkhar airport in Central Tibet to the sacred city of Lhasa demonstrates the point. The first temple one comes across on the way stands near the road at roughly the halfway point of the journey. Known to Tibetans as the Dolma Lhakhang, or "Sacred Tara Chapel," it is dedicated to Arya Tara, most ubiquitous of all the female buddhas. Built in the mid-eleventh century under the inspiration of the Indian master Atisha, it has stood here for the past ten centuries as a statement in stone to Tibet's devotion to Arya Tara. Although a somewhat small temple, it is considered to be one of the most sacred power sites in the country, containing several dozen images of Tara in various mediums, including clay statues, bronzes, and exquisite paintings.

A monastery stands at the top of the valley behind the Dolma Lhakhang, perhaps a mile away and readily visible from the road. This is the famed Rato Gompa, a meditation hermitage again strongly linked to Arya Tara. Yogis and yoginis have come here for generations to meditate in the many caves and huts on the hills above it. Again in Rato one beholds numerous images of Tara and the other female buddhas, the most famous of these being a small bronze of Tara said to have been brought to Tibet by Atisha himself when he first came to Tibet in 1042.

The proliferation of female buddha images continues throughout the sacred city of Lhasa. The Potala Palace, home of the Dalai Lamas, is a prime example. Numerous chapels are dedicated to various female buddhas, including Tara, Vajrayogini, Prajna Paramita, and Ushnisha Vijaya. Similarly the Norbu Lingka, the Dalai Lama's summer residence, has

1. I included a translation of this hymn to Arya Tara in *Selected Works of the Dalai Lama I: Bridging the Sutras and Tantras* (Snow Lion Publishers, Ithaca, N.Y., 1982). Of interest to lovers of international music, the hymn is included in a CD collection of chants by the monks of Drepung Loseling, *Sacred Tibetan Chants from the Great Prayer Festival* (Music and Arts Program of America, Berkeley, Calif., 1995).

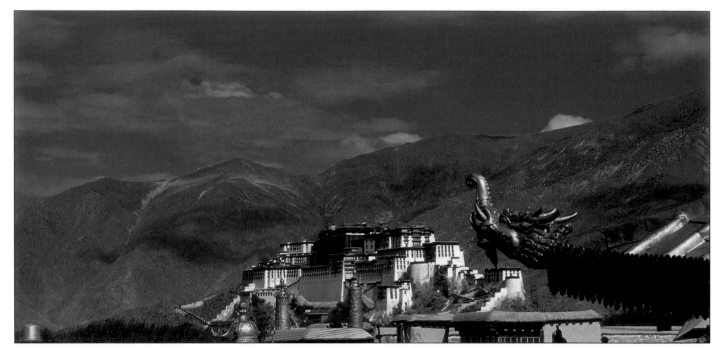

The Potala from the roof of the Jokhang Temple.

several chapels dedicated to feminine images, the most famous being the White Tara Chapel built by the Seventh Dalai Lama in the mid-eighteenth century.[2]

The same proliferation holds true for the Jokhang, Tibet's oldest and most sacred temple. Established at the heart of Old Lhasa in the mid-seventh century, the Jokhang is comprised of dozens of small chapels, each dedicated to a particular spiritual theme or energy. Here one beholds several hundred female buddha figures.

Who are all these beings? What do they represent? And why do the Tibetan Buddhists hold them in such high regard?

This book attempts to answer some of these questions. It does *not*, however, aspire to serve as an encyclopedia of the many female buddhas found in the Tibetan pantheon. Tibetan art studies are still at too pioneering a stage to allow for such an undertaking.

Instead, we have limited our ambitions to the most popular female buddhas, to those known to educated Tibetan Buddhists in all schools and sects, and commonly found throughout the vast regions of Central Asia where Tibetan Buddhism abounds, from East Russia and Mongolia on the north to the small kingdoms of Himalayan India on the south; and from Western China on the east to Ladakh, Lahoul, Spitti and Kinnaur on the west.

2. White Tara meditation and mantra practice is used for lifespan extension and healing. The First Dalai Lama relied heavily on the tradition throughout his life, and all subsequent Dalai Lamas followed his example. The Seventh was always of delicate health, and as a consequence life in the rather cool and damp Potala sometimes did not agree with him. He built the Kalzang Potrang, as this Tara chapel is known, as a place for his summer retreats, and would often give public teachings and audiences on the grounds around it. Of note, in his next life as the Eighth Dalai Lama he constructed the Norbu Lingka on the grounds adjoining the Kalzang Potrang, which from then on became the Summer Residence of all future Dalai Lamas. The Great Thirteenth gave many of his great public discourses in the gardens of the Norbu Lingka. All three of these Dalai Lama residences—the Potala, Norbu Lingka and Kalzang Potrang—still stand in Lhasa, and are open to pilgrims and visitors.

Male & Female Buddhas

Some years ago the Dalai Lama gave a public talk in a New England university. At the end of his discourse he opened the floor to questions.[1]

A young lady stood up and asked, "What is the position of women in Tibetan Buddhism? And what is the Buddhist view of how gender relates to enlightenment?"

The Dalai Lama thought for a moment and then replied, "In general, it can be said that Buddhism considers men and women to be equal in their enlightenment potential and capacity."

He then thought further on the matter and added, "In particular, however, there are two levels of the Buddhist teachings. One of these is called the Sutra Way, and is based on Buddha's open or public teachings. The other is called the Tantra Way, and is based on Buddha's secret or restricted teachings. Perhaps I should qualify what I said above by adding that in the Sutra Way men are credited with having something of a superior position, whereas in the Tantra Way women are credited with having the advantage."

Later in this chapter we will look at what the Dalai Lama meant by these two Buddhist "ways," and why the status of males and females is said to be opposite to one another in the two, with males dominating in the former and females in the latter.

Perhaps then we will appreciate why the female buddhas, who are the focus of this book, are mainly connected to what the Dalai Lama refers to here as "the Tantra Way." Hopefully we will also then appreciate why they have been such a source of inspiration to the artists and mystics of Central Asia for so many centuries.

To understand the female buddhas, however, we must first know what is meant by the word "buddha." The Sanskrit term simply means "awake," and carries the sense of "awakened from the sleep of un-knowing," Tibetans translated it as *sang-gyey*.[2] They then gave the epistemology of *sang* as meaning purified or liberated, in the sense of purified of and freed from the emotional and cognitive distortions; and *gyey* as meaning accomplished or expanded, in the sense of completely accomplished in all realizations, and with the mind expanded to encompass the two levels of reality: the appearing, conventional nature of things and the ultimate, infinite nature that lies beyond appearances. In other words, a buddha is someone who has achieved complete spiritual perfection or enlightenment, both from the side of what is to be transcended—the emotional and cognitive distortions—and what is to be realized—the two levels of reality.

Thus "buddha" is a title acquired by anyone who achieves enlightenment. In that millions of beings have achieved enlightenment over the eons, we can say that there are millions, perhaps even billions or trillions, of buddhas in the universe. Buddhists believe that all of us will one day achieve enlightenment and, like a drop of water flowing into the ocean, will at that time merge with the infinity mind of all who have previously achieved that same sublime state.

Peoples of all races and both genders have achieved enlightenment. The former fact is demonstrated in Tantric Buddhist art by the presence of the "five races of buddhas" in mandala paintings: white, yellow, red, green and blue. These, in the Indo-Tibetan way of thinking, are the five principal races of humanity. Here the "green" refers to the olive/brown peoples, and "blue" refers to the brown/black race. Of course, as those educated in Buddhist tantric lore will know, these five symbolize much more than race; each is also associated with a particular element, psychophysical aggregate (Skt. *skandha*), wisdom energy, and so forth. In tantric mandalas these five are given specific placements within the directions of the mandala.[3]

Similarly, the female potential for enlightenment is made clear in Tibetan Buddhist art by the large number of female buddha images found in the temples and hermitages. Again, these appear in the five primary racial colors, indicating that women of all races have an equal potential for enlightenment.

It should be noted here, however, that the gender issue has only limited significance in the enlightenment sphere. A person has a gender identity up to the moment of enlightenment, but only partially so thereafter. We will see more on this issue in chapter 6, which discusses the doctrine of the Three *Kayas*.

1. I quote this from notes I took on the occasion. It was, I believe, 1985, and the location was Smith College, Northampton, Mass.
2. Tib. *Sangs-rgyas*.
3. Some Buddhist scholars may take exception to my interpretation of the Tibetan term *rig* (spelled *rigs*) as referring to race. However, in my humble opinion, this is one of the many implications of the word.

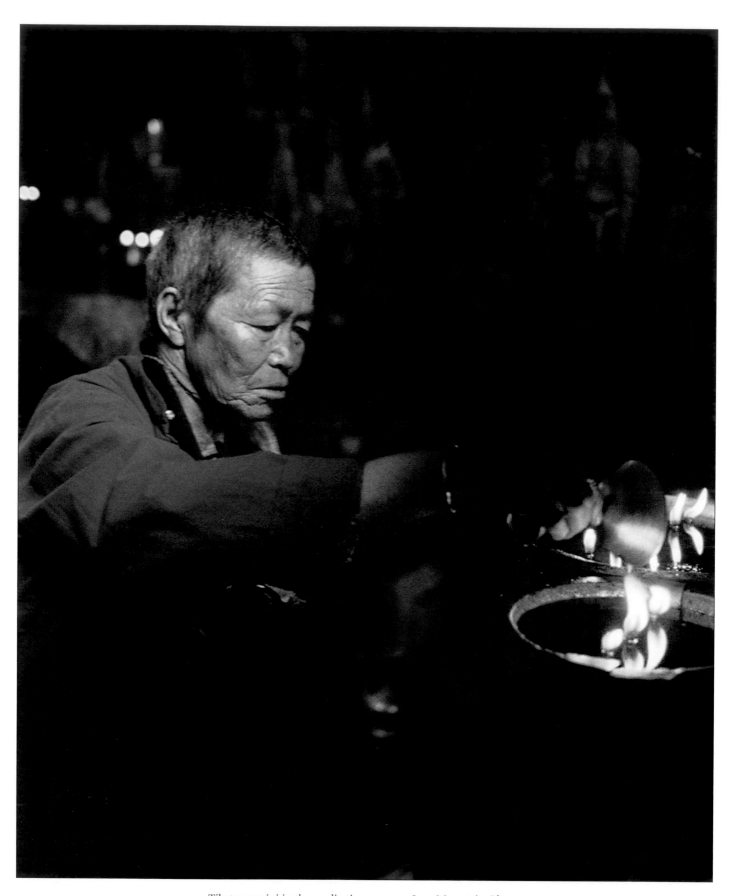

Tibetan yogini in the meditation caves on Iron Mountain, Lhasa.

Buddha Shakyamuni

Although the word "Buddhism" in general refers to any tradition that teaches a path to full awakening or enlightenment, we should remember that there are "the buddhas" and then there is "the Buddha." Hence in a more particular and historical sense, Buddhism today refers to the enlightenment tradition descending from Buddha Shakyamuni, who was born some 2,500 years ago just inside the modern-day border of Nepal and India. His father was the patriarch of the Shakya clan, a prominent family in the Bihar region of modern-day central north India.[1]

This child was named Siddhartha at birth, but as a young man he took the ordination of a monk and was renamed Gautama. He studied meditation with a number of masters, practiced diligently, and finally achieved enlightenment. In this way he acquired the title of "buddha."

Buddha's peers referred to him as Shakyamuni, or "The Sage of the Shakya Clan," because of his parentage. This eventually developed into the epithet "Buddha Shakyamuni," or "The Awakened Sage of the Shakya Clan." This latter appellation is in fact but a small part of a more flowery yet somewhat standard name as seen in the scriptures, "Bhagawan Tathagata Arhat Samyaksambuddha Jina Shakyamuni," or "Transcended-Accomplished/Gone-to-Thusness/Destroyer of-Inner-Foes/Completely-Perfectly-Awakened/All-Victorious/Shakya Sage." Most writers in the West generally prefer the simplicity of "The Buddha."

The First Dalai Lama (1391–1475) composed a poetic eulogy of the Buddha's life, entitled *Crushing the Forces of Darkness*.[2] In it he writes,

> *First the noble Shakyamuni gave birth to*
> *the precious bodhimind,*[3]
> *The aspiration to enlightenment based on*
> *universal love and compassion,*
> *And then for three ages trained under*
> *myriads of buddhas.*

> *Gradually he crossed the paths and stages*
> *And gained enlightenment in this*
> *age of conflict.*
> *O Buddha, lord of men, I sing this praise to*
> *you....*

> *Thus through love he conquered darkness*
> *And through meditation gained higher vision.*
> *Homage to him who at the break of dawn*
> *Won peerless enlightenment with the vajra*
> *samadhi.*

> *Without an army or weapons he defeated*
> *the enemy Delusion,*
> *And with no material agent cleanses*
> *himself of karmic stains.*
> *Unasked, he accepted personal*
> *responsibility for the world,*
> *And manifested as an unprecedented*
> *universal teacher.*

Although the First Dalai Lama here uses extravagant words, it is important to appreciate the fact that Buddha Shakyamuni is not seen as being more enlightened than any of the other beings that achieve buddhahood. All who achieve enlightenment gain the state of *ro chikpa*,[4] or "one-tasteness." His uniqueness is really only his work of systemizing and transmitting the enlightenment technology in this particular era in such a way as to establish a world tradition prophesied to endure for five thousand years. The First Dalai Lama indicates this uniqueness with the passage "manifested as an unprecedented universal teacher."

In fact he is said to be the fourth of one thousand such universal teachers who will manifest in the *bhadrakalpa*, or auspicious eon, and whose enlightenment legacy will similarly endure for a considerable length of time.

1. Buddha's birthplace, Lumbhini, is located just six miles inside the Nepali border. Its exact location was lost to history after the Muslim destruction of the twelfth to fourteenth centuries, but rediscovered by British archaeologists in the late nineteenth century. It has now been considerably rebuilt, with Buddhist countries from around the world contributing to the effort.

2. The First Dalai Lama bases his epic poem on the account of Buddha's life given in the *Lalitavistara Sutra*, a popular Mahayana scripture.

3. Here he uses the Tibetan word *jang-sem* (Tib. Byang-sems), which in Sanskrit is *bodhichitta*. Bodhichitta literally means "mind of enlightenment," but does not refer to the actual enlightenment experience. Rather, it is the aspiration to highest enlightenment, based on universal love and compassion, together with the resolve to live and practice accordingly. Western translators have tried various English equivalents for it; I personally prefer the simplicity of "bodhimind."

4. Tib. *Ro-gcig-pa.*

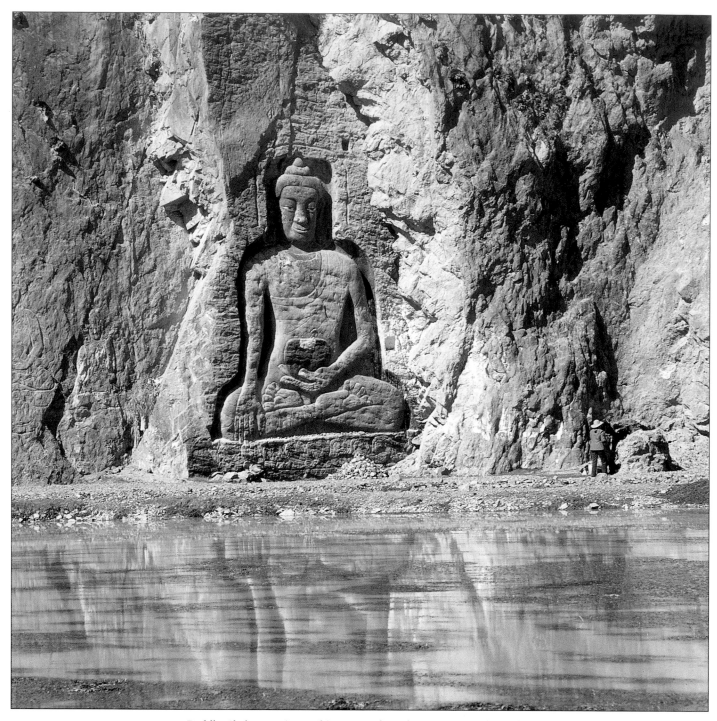

Buddha Shakyamuni carved into stone face of mountain, Kyichu Valley.

In brief, then, Buddhism in general can be defined as a legacy coming from any buddha and leading to buddhahood/enlightenment. Buddhism today, however, is the collected methodology for generating the enlightenment experience as systemized by Shakyamuni 2,500 years ago, and as passed down over the generations through the various lineages of living Buddhist masters. This is true for all the various forms of Buddhism that we see today in countries as diverse as Tibet, China, Japan, Korea, Vietnam and Thailand.

Buddha and this lineage of masters in the line of transmission are popular subjects in Buddhist art throughout Asia. We will see some of the important female lineage masters later in chapters 9 and 20.

The Buddhist Legacy in India

The enlightenment technology of which Buddha Shakyamuni's legacy is comprised can be spoken of in various ways. As the Dalai Lama put it (chapter 2), "In particular, however, there are two levels of the Buddhist teachings. One of these is called the Sutra Way, and is based on Buddha's open or public teachings. The other is called the Tantra Way, and is based on Buddha's secret or restricted teachings." This twofold classification of Buddha's various transmissions was made in India during the Classical Period, i.e., somewhere between the first and fourth centuries A.D.

Buddha taught for some forty-five years after his enlightenment. He traveled widely, and his audience was diverse, ranging from highly educated urbanites to illiterate villagers, from kings and queens to farmers and street-sellers, from young people to the very aged, and from highly developed yogis and meditators to simple beginners.

One reason that he was so successful as a teacher was that he always tailored his words to suit his audience. As a result, his various teachings exhibit a quality that accords with the character of the specific listeners.

In addition, nothing of what he said was written down during his lifetime. Instead, various individuals were entrusted with memorizing the gist of each discourse. A conference of the senior monkhood was convened shortly after his passing, and an attempt was made to systemize his teachings. Still, at this time only the monastic code was transcribed, and everything else still preserved by oral tradition.

Two more conferences would be held over the generations to follow, with further transcriptions being produced at each. However, by this time Buddhism had spread like wildfire over much of the Indian subcontinent, moving as far north as modern-day Afghanistan and the Silk Route nation of Khotan; and also moving south all the way to India's southern tip and beyond, to the island nation of Sri Lanka.

Tibetans believe that this hesitancy on the part of the Buddha and his immediate followers to commit the enlightenment teachings to paper, and instead to preserve them as oral tradition, was a purposeful strategy gauged to maintain the maximum fluidity and living power of the enlightenment experience. It only became necessary to write things down when the darkness of the changing times threatened the very survival of the legacy. An oral tradition becomes lost to history when its holder dies or is killed prematurely, without first passing on his or her lineages.

This intended fluidity, and the according rejection of an "enlightenment dogma," is perhaps best demonstrated by a verse that the Buddha himself said shortly before his death.[1]

Do not accept any of my words on faith,
Believing them just because I said them.
Be like an analyst buying gold, who cuts, burns
And critically examines his product for authenticity.
Only accept what passes the test
And proves useful and beneficial in your life.

This simple statement empowered future generations of Buddhist teachers to accept and reject at will anything said by Buddha himself as well as by his early disciples. If something that was said by Buddha or the early masters did not pass the test of personal analysis, one could simply discard it as being limited in application to particular times, people or situations, and therefore as only contextually valid.

This introduced the concept of what the Tibetans call *ngedon* and *drangdon*, or "certain in significance" and "only metaphorically significant." The former is used in reference to any teaching that is accepted as directly true or valid, whereas the latter refers to those teachings that are only valid in particular situations or contexts.

As a result, several dozen Buddhist schools emerged in early India, each emphasizing different aspects of the enlightenment legacy. As the Second Dalai Lama (1475–1542) put it in *A Raft to Cross the Ocean of Buddhist Tenets*,[2] they all

1. This verse appears in many different Tibetan scriptures. The most popular is the *Tsom* (Tib. *Tshhoms*), or *Collected Verses*. This is a text that was created in ancient India by drawing all of the most popular passages of Buddha's practical teachings and rewriting them in verse. In Tibet it became widespread during the eleventh to fourteenth centuries, when it was required reading in the Kadam School. Because the Kadampas influenced all other schools of Tibetan Buddhism directly or indirectly, this eventually brought it to a wider audience in Central Asia. It is one of the most oft quoted scriptures in Tibetan literature.

2. I included a translation of this work in my study of the life and time of the Second Dalai Lama, *Selected Works of the Dalai Lama II: The Tantric Yogas of Sister Niguma* (Snow Lion Publications, Ithaca, N.Y, 1982).

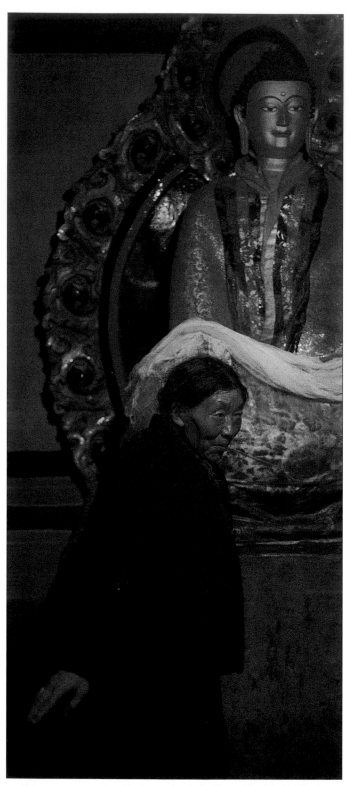

Tibetan woman on pilgrimage in the Jokhang Temple in Lhasa.

had their own take "on what constitutes *ngedon* and *drang-don*, or direct and metaphoric teachings. This in turn gave great play on how to establish the three quintessential spheres of interest in the quest for enlightenment: *tawa*, or philosophical attitudes; *chopa*, or action/social integration; and *gompa*, or meditational application."

Eventually all of these movements were spoken of as belonging to one of two categories: the Sutra Way and the Tantra Way. As we will see in the next two chapters, the quintessential approaches of these two "ways" differ considerably.

Although some Indian masters chose one as opposed to the other of these two, most chose to integrate both within their own continuum of practice. When this was the case, the Sutra Way was seen as a preliminary to and preparation for the Tantra Way.

In the early days of Buddhism in Tibet, the Tibetans seem to have held a stronger interest in the latter and a near-disregard for the former. By the mid-eleventh century, however, the Indian model of the one being used as a preparation for the other began to take deeper hold, and by the fourteenth century had become the *modus operandi* for all schools of Tibetan Buddhism.

As we will see in the next two chapters, the art associated with these two ways also differed considerably.

The Sutra Way

Buddha in the Jokhang Temple, Lhasa.

In general a Sutra refers to a text that transcribes a particular teaching of the Buddha. As said earlier, none of these was written down during Buddha's lifetime, and indeed most were maintained solely as oral transmissions for several centuries. A Tantra is also a text transcribing a particular teaching of the Buddha. The difference between the two is that the former generally is based on a discourse given openly, whereas the latter is based on an esoteric and private transmission. Several hundred Sutras, and as many or more Tantras, exist in the Tibetan canon, or *Kangyur*, all translated from the original Sanskrit.

Sometimes the Sutra transmissions are divided into three categories, known as the *Tripitaka*, or "Three Baskets," in accordance with the three essential trainings of the spiritual path: the *Vinaya Pitaka*, which has self-discipline as its focus; the *Sutra Pitaka*, which mainly addresses meditation; and the *Abhidharma Pitaka*, which addresses the subject of wisdom and the philosophy of enlightenment. These three trainings are the principal means whereby the practitioner works toward the goal of nirvana, which is freedom from karma and delusion.

Another way in which the Sutras are divided is into the two *Yanas*, or "Vehicles": the *Hinayana*, or "Compact

Vehicle," and the *Mahayana*, or "Universal Vehicle." When this is done, the former is regarded as a preliminary to the latter in terms of training.[1]

The essence of the Hinayana involves the three higher trainings listed above: self-discipline, meditation and wisdom. These three topics are the main focus of the so-called Hinayana Sutras. Once the practitioner has developed stability in these three areas, he or she goes on to the Mahayana trainings.

The basis of the Mahayana is something called the *bodhichitta*[2] in Sanskrit, a term that literally translates as "enlightenment mind." This refers to the consciousness of universal love and compassion that aims at the achievement of enlightenment as the foremost means of benefiting the world. A practitioner of the bodhichitta is termed a bodhisattva, or "enlightenment hero." All bodhisattvas eventually progress along the enlightenment path and become buddhas. From that time onward they are referred to as a buddha in terms of their realizations and accomplishments; however, they also retain the title of bodhisattva, in reference to their continued committment to manifest in the world in ways that uplift and bring benefit to living beings.

The Mahayana Sutras detail the exploits of numerous male bodhisattvas, including Avalokiteshvara, the Bodhisattva of Compassion; Manjushri, the Bodhisattva of Wisdom; and Vajrapani, the Bodhisattva of Power, and so forth. They also detail the exploits of numerous female bodhisattvas, Tara perhaps being the principal of these.

The bodhisattvas, or "enlightenment heroes," have numerous characteristics similar to those of our archangels in the West. Like the archangels, they manifest for hundreds of thousands of years over human history in order to uplift civilization in general as well as to help and save individual human beings in particular.

The Mahayana Sutras also mention and outline the teachings of numerous buddhas in addition to Shakyamuni, showing them a respect equal to that shown Shakyamuni himself. This feature stands in sharp contrast to the Hinayana Sutras, where the historical Buddha Shakyamuni is always held above all others, and the term "bodhisattva" is largely reserved for Buddha Shakyamuni in his previous lives, or *Jatakas*, prior to his enlightenment.

Both of these Sutra approaches are based on Buddha's first teaching, which laid out the doctrine of the four noble truths or spiritual axioms: suffering, its causes, liberation, and the path. In other words, this is the doctrine of cause and effect in the experience of suffering and happiness: the truth that living beings are prone to suffering; the truth that suffering is rooted in causes and conditions that can be transcended and uprooted; the truth that the transcendence of these causes and conditions produces liberation; and the truth that the path to that transcendence can be accomplished through application to the appropriate spiritual methods.

Thus the Sutra Way, in both Hinayana and Mahayana traditions, views the human spiritual situation as being somewhat linear, in the sense that both suffering and happiness come from their according causes. We increase our suffering by foolishly cultivating the according causes, and we increase joy and liberation when we wisely cultivate their causes.

The main difference between the Hinayana and Mahayana traditions is that the former is mainly presented in accord with the conventional view of life and history, whereas the latter takes a far more exotic approach. A casual reading of Sutras from the two traditions makes this very clear.

In terms of the art associated with these two Sutra traditions, the former mostly inspired painters and sculptors to glorify the life (including the previous lives or *Jatakas*) of Buddha Shakyamuni, the accomplishments and adventures of his immediate disciples, and finally the great deeds of later lineage masters. This is also true with the Mahayana tradition, although here numerous other Mahayana buddhas and bodhisattvas were added to the field of popular subjects. In art associated with the Mahayana Sutra tradition, however, the emphasis is on capturing and communicating the spiritual quality that the specific buddha or bodhisattva is said to embody, such as love, compassion, wisdom, healing power, and so forth.

Both of these Sutra traditions also inspired artists to create instructional pieces as aids to teaching and meditation. An example here is the "Wheel of Life," in which the six realms of the world are depicted as being held between the jaws of the Lord of Death. The idea is that we reincarnate between these six realms—hells, ghost realms, animal worlds, human world, lower god heavens, and higher god heavens—until we learn the lessons of life and achieve nirvana or liberation.

In fact most Buddhist art is intended as a spiritual aid, in the sense that a painting or statue of a particular buddha or bodhisattva is thought to bring an atmosphere of serenity and transcendence into the household, and to serve as a support of mindfulness. That is to say, the image will remind those who see it of the spiritual values and practices associated with the

1. Several modern Western scholars, inspired by little more than bland political correctness, are pushing for a ban on the usage of the term "Hinayana," on the grounds that it could be construed as having sectarian undertones. Hinayana could perhaps be translated as "Inferior Vehicle," and Mahayana as "Superior Vehicle." However, the word "Hinayana" appears frequently in the shastras of Classical Buddhist India as well as in the writings of almost all great Tibetan texts (in its translated form of *tegmen* [Tib. *Theg-dmad*]). It seems dishonest simply to drop or ignore it due to a modern phobia. Instead, it can simply be given a slightly more user-friendly translation, such as I have done here, and which is closer to the spirit of how the term is used in most instances in Sanskrit and Tibetan.

2. I discussed the significance of this term in a footnote in chapter 2.

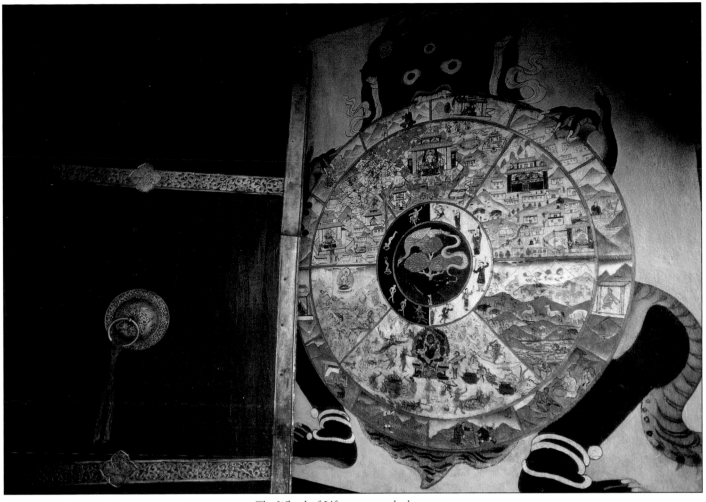

The Wheel of Life on a temple doorway.

enlightenment tradition, such as love, compassion, patience, wisdom, meditation, non-violence, honesty, integrity, and so forth. The mere sight of the image will inspire the person's mind to turn from worldly thoughts and distracting activities to these more meaningful spheres of engagement.

Buddhists also credit spiritual artwork with having the ability to both embody and transmit spiritual energies. After a sacred piece is completed it is consecrated by means of ritual and meditation. This process calls spiritual energies into the image, much like nectar is poured into a vase. The image becomes what Tibetans call a *ten*,[3] or "receptacle," in the sense that it is now a vessel holding transformative spiritual energies.

The piece can then perform paranormal tasks, from directly speaking to those who meditate before it to performing miracles such as healing.

For this reason Tibetans regard the commercial bartering of any consecrated image as being a heavy negative karma, a transgression of the spiritual code that leads to rebirth in the lowest of the eighteen hell realms. A piece will always be made by an artist on commission, rather than made and then placed in the market for sale. It will only be consecrated after the person who requested it has paid the commission and brought it home.

If for any reason the piece ever needs to be restored or repaired, a ritual of deconsecration will first be performed, and the spiritual energies that were called into it will, as stated in the traditional texts, be sent back to their natural abodes. Only then will the traditional artist begin the restoration or repair work on it.

3. Tib. *rTen.*

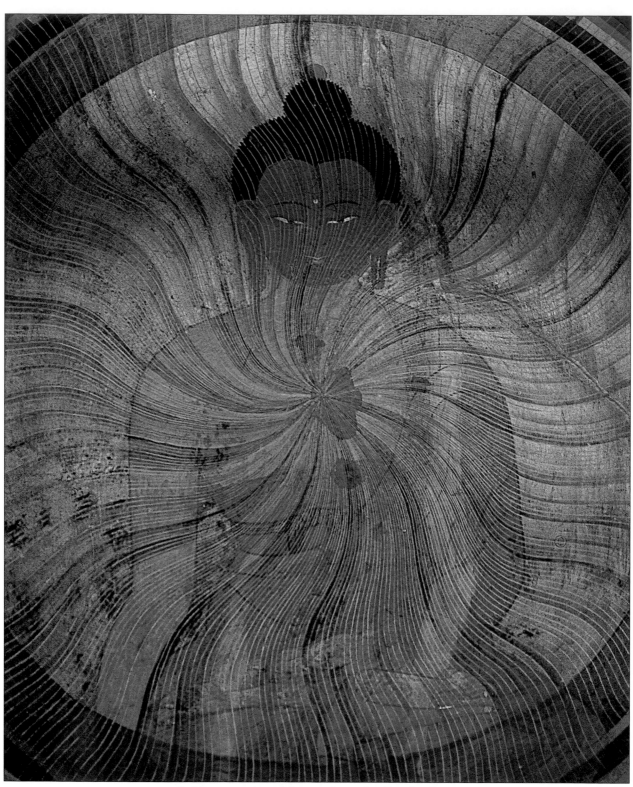

Buddha emanating rainbows at Ramochey Temple, Lhasa.

The Doctrine of the Three Kayas

A doctrine central to both the Mahayana Sutras and the Tantras, and which is not presented in the Hinayana Sutras, is that of the three kayas: *Dharmakaya, Samboghakaya,* and *Nirmanakaya*. This important idea discusses the mystery of what happens to a person's *santana*, or "stream of being," after he or she attains enlightenment. This aspect of the Buddha's teachings also accounts for the vast numbers of buddhas and bodhisattvas encountered in the literature, art and iconography of the Tantric and Mahayana Sutra traditions.

Here the term "Dharmakaya" literally means "Reality Body," "Samboghakaya" literally means "Body of Complete Enjoyment," and "Nirmanakaya" means "Emanation Body." These three are sometimes made into two by combining the second and third into the *Rupakaya*, or "Form Body." When this is done, the first of the three, or Dharmakaya, is sometimes termed *Arupakaya*, or "Formless Body." They can be made into four by speaking of the Dharmakaya as having two aspects, addressing it from both its radiance (*sel*) and infinity (*tong*) aspects.

The concept is that mind and matter remain as separate, albeit cooperative, entities until enlightenment is achieved. At the moment of enlightenment, however, they become of one nature. At that time the stream of the person's being utterly dissolves into the Dharmakaya, or formless sphere of infinity, becoming "of one indistinguishable taste" with all beings who have ever achieved enlightenment.

The metaphor is of a drop of water flowing into the ocean. The individual being dissolves into the universal Dharmakaya like a drop of water into the ocean. Just as the drop of water then becomes indistinguishable from the rest of the ocean's water, the individual here becomes indistinguishable from the ocean of universal buddha mind. Perhaps Christians would call this sphere of pan-cosmic consciousness the Godhead.

However, the being that is resting in the Dharmakaya can only be perceived by other fully enlightened beings. Not even tenth-level saints (Skt. *arya*), let alone ordinary mortals, have direct access to the Dharmakaya.

For this reason the Dharmakaya aspect eventually comes around to an awareness of the vow taken long ago to achieve enlightenment in order to be of maximum benefit to living beings. The impetus of the universal love and compassion of the bodhichitta aspiration comes into play.

Because there are two kinds of living beings—those who have attained the arya status of the ten levels of sainthood and those who have not—and because the degree of the powers of perception in these two is dramatically different, the enlightened being therefore sends out two levels of "emanations," known in Tibetan as *tulpa*.[1] These two are the Samboghakaya and Nirmanakaya aspects. The Samboghakaya emanations reveal themselves to the living beings on the arya states and inspire them to evolve toward complete enlightenment; the Nirmanakaya emanations reveal themselves to the ordinary living beings, to inspire and guide them.

These two types of emanations cannot really be called "reincarnations" in the ordinary sense of the word, even though some of them might go through the motions of entering a womb, taking birth, and so forth. Nothing done by them is created by the normal powers of contaminated karma and delusion. Instead, they are driven solely by the forces of universal love and compassion.

There is no limit to the number of emanations on these two levels that an enlightened being can simultaneously send out from the Dharmakaya. The field is really only established by the readiness of those to be trained. For this reason the fourth-century Indian master Asanga wrote in his transcription of Maitreya's *An Ornament of Clear Comprehension*,[2]

> *The rains fall equally on all,*
> *But only the fertile seeds will sprout.*

In other words, an infinite number of enlightenment emanations hover everywhere, awaiting the moment when we are sufficiently ripe to receive their inspiration and guidance. There are no hesitation, prejudices or ulterior motives from their side. However, they are only able to get through to us when we are spiritually ready for them, just like warm rains can cause only fertile seeds to sprout. From our side, the challenge is to sensitize ourselves to their presence.

1. Tib. *sPrul-pa.*
2. Skt. *Abhisamaya-alamkara.*

The Thirteenth Dalai Lama (1875–1933) put it like this in a verse work of instruction to a disciple,[3]

> *Like the sun, the compassion of the enlight-*
> *ened beings*
> *Shines equally on all living creatures;*
> *But those who are spiritually ripe*
> *Are able to reap the greater benefit from it.*
> *The difference lies on the side of the*
> *trainees;*
> *The buddhas themselves do not*
> *discriminate.*
> *Therefore cultivate the methods that ripen*
> *the spirit.*

And elsewhere in a prayer he writes,

> *I send forth the pure aspiration*
> *That the state of the four perfect kayas*
> *May quickly be fully achieved,*
> *And that I may then fulfill my vow to be*
> *Of continual and ultimate benefit to*
> *the world.*

Because the Dharmakaya aspect is formless, it is not appropriate to speak of it in terms of gender. Dharmakaya is a unisexual or perhaps para-sexual state of being. However, both Samboghakaya and Nirmanakaya emanations can be gender-specific.

The Dharmakaya is infinite, and therefore cannot be reduced to artistic form. Hence it can only be hinted at by means of symbols. The symbol for it most commonly used in Buddhist art is the *stupa*, or "buddha burial mound." Eight of these were constructed in ancient India to house the relics from the cremation pyre of Buddha Shakyamuni. These burial mounds were made of brick and clay, and were often as large as a two- or three-story house.

Over the last ten or twelve centuries, however, it has become more popular to make them out of bronze or gold, roughly a hand span in size, so that the piece is small enough to sit on a household altar as a symbol of enlightenment's Dharmakaya, or Reality Body.

Because the Dharmakaya is formless, any painting or sculpture of a buddha or enlightened bodhisattva will generally approach the subject from the point of view of the Samboghakaya or Nirmanakaya aspects. There are a few exceptions, such as the images of Samantabhadra and Samantabhadri in union, but the tendency is to use abstrac-

A stupa at Ganden Monastery.

tions for the Dharmakaya. For example, as mentioned above, both the Sutra and Tantra art forms often use a stupa to represent Dharmakaya. Also, the circle at the center of the mandala in Tantra art has this same meaning.

The Samboghakaya emanations usually are shown as having the thirty-two major and eighty minor physical signs of perfection, such as the characteristic shape of wide eyes, long ears and so forth that we see on so many Asian art pieces. Moreover, depictions of Samboghakaya images in Tibetan art usually show the subject wearing the five-pointed crown symbolizing the five wisdoms.

There are three types of Nirmanakaya emanations, although only two are commonly seen in Tibetan art. The first of these is called "Supreme Nirmanakaya Emanations," and has the 112 marks and signs of perfection generally associated with the Samboghakaya. In terms of Buddhist doctrine, only people with great merit collected over many lifetimes have eyes sufficiently pure to perceive an actual Supreme Nirmanakaya. Were a Supreme Nirmanakaya to appear before a person of lesser merit, that person would

3. I included this poem in my study of the life and works of the Great Thirteenth, entitled *Path of the Bodhisattva Warrior* (Snow Lion Publications, Ithaca, N.Y. 1988).

only see a beggar, a crazy person, a dog, or some such thing. The glory of the emanation would remain invisible to that person of low merit.

Thus it is only the lowest level of the Emanated Body of an enlightened being that ordinary people can perceive. This Emanated Body appears, warts and all, in accordance with the karmic predispositions of those to be trained.

This doctrine of the Three Kayas became prominent in Buddhist India from the third century onward. The Tibetans seized upon it and carried it to a new level.

In brief, they linked it to the high Tantric yogas of the death simulation process, and developed it to the art and science of conscious rebirth. This eventually manifested as their tradition of *tulku*,[4] or "officially recognized reincarnation." The tradition seems to have emerged in the twelfth century or so and expanded from there.

There were approximately 3,000 of these officially recognized reincarnate lamas in Tibet when the Chinese Communists invaded in the 1950s. The Dalai Lama was the most famous of these, but was no more a Nirmanakaya or Tulku than any of the others. He was just special among equals, for historical reasons. The most famous of the female incarnations was probably the Dorjey Pakmo incarnation.[5]

In fact the word "tulku" is a direct translation of the Sanskrit term "Nirmanakaya." The idea is that the dying lama applies the Tantric yogas to the clear light of death, the bardo visions that follow death, and finally the rebirth process, and links these three occasions successively to the Three Kayas. Consequently the lama's reincarnation would ideally be a Nirmanakaya emanation.

Another interesting feature of the Three Kayas doctrine that developed in Tibet concerns *tulpa*, or Emanation, as contrasted to *Tulku*,[6] or "Emanated Body." Because the Dharmakaya can send forth an unlimited number of Samboghakaya and Nirmanakaya emanations, it became common to speak of various high lamas and other historically important persons as being "emanations" of a particular buddha or bodhisattva.

For example, the Nepali and Chinese princesses who married King Songtsen Gampo in the mid-seventh century,

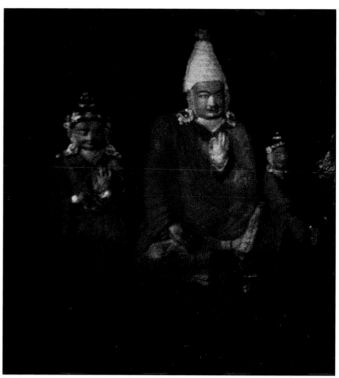

Statues of King Songtsen Gampo with his Nepali and Chinese Buddhist wives in meditation cave on Iron Mountain, Lhasa.

and who inspired him to adopt Buddhism as Tibet's national religion, are usually spoken of as being emanations of the female buddha Tara. Under their inspiration King Songtsen Gampo built 108 great Buddhist temples and hermitages across the country, and set up a national sponsorship program for Tibetans to go to India to study and translate the great Buddhist classics into Tibetan. In fact, Tibetan culture as we know it today owes its greatest debt to what Songtsen Gampo accomplished under the tutelage of these two female buddha emanations.

In the same vein, the Dalai Lamas are thought to be emanations of Avalokiteshvara, the Sakya Lamas emanations of Manjushri, and the Sharmar Tulkus emanations of Amitabha Buddha. Several dozen of the reincarnate lamas of Tibet are connected to various buddhas and bodhisattvas in this way.

4. Tib. *sPrul-ku.*
5. In Tibet this extraordinary female incarnate lama was ranked in status immediately after the Dalai, Panchen and Sakya Lamas. Thus of Tibet's 3,000 reincarnates, she stood fourth in place of importance, and as a consequence at any official gathering would be seated on a throne of a higher level than any of the other 2,995 tulkus. For those who have traveled in Tibet, her traditional monastery is located just behind the Turquoise Lake, as seen on the drive from Lhasa to Gyantsey.
6. Tib. *sPrul-pa* and *sPrul-sku.*

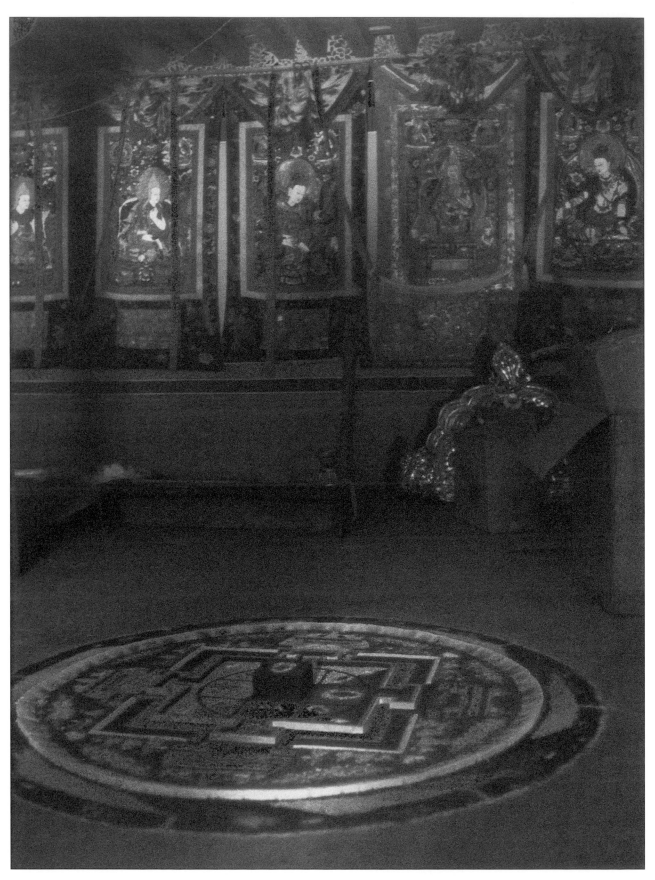

Sand painting at the Norbulinka, the Dalai Lama's summer residence, Lhasa.

Tantra, Mantra & Mandala

The doctrine of the Three Kayas opened the door for an endless stream of buddhas, both male and female. The Dharmakaya is a mystical sphere of buddha mind that can be achieved by anyone; once it is achieved it becomes a fountainhead from which an infinite number of emanations can flow. Countless Samboghakaya and Nirmanakaya forms can be sent forth, each in accord with the needs of those to be trained.

This doctrine found its full flowering in Tantric Buddhism. Here the Dharmakaya emanates on Samboghakaya and Nirmanakaya levels as male and female Tantric deities, complete with their mandalas, mantras, and so forth, each as an embodiment of a complete yogic path to enlightenment.

Thus we encounter countless buddha forms in the Tantric Vehicle, each emanated in order to serve as meditational objects for initiates. Many of these emanations are male, others are female, and still others are male-female-in-union.

The Sutra Way, as discussed in chapter 5, is also known in Tibetan literature as *gyu gyi lam*,[1] or "the path of causes." This is because in the Sutra approach one looks at one's shortcomings and inner weaknesses, and works on the methods for systematically eradicating them; and one looks at one's lack of enlightenment and engages in the spiritual practices that cause the enlightenment experience to arise. In brief, one sees oneself as a sick person afflicted with the inner illness of the three emotional and cognitive distortions or poisons—anger, attachment, and ignorance of the true nature of the self—and regards the spiritual practices such as meditation and so forth as being the medicines for systematically curing the disease.

The Tantra Way takes a radically different approach. Rather than accept the conventional appearance of both one's own imperfections and those of the world, one instead sidesteps the conventional altogether and replaces it with the practice of *lhayi naljor*,[2] or "deity yoga," with the word "deity" meaning "buddha." In brief, one cultivates the vision of oneself as a deity/buddha, others as Tantric deities/buddhas, and the world as sacred mandala.

There is no place here for the four noble truths that are the very foundation of the Sutra Way: suffering, its causes, liberation, and the path to liberation. This is because there is no room in the Tantric vision for even the word "suffering," and no need for a path to liberation. One instead borrows liberation directly from the enlightenment experience.

For this reason the Tantra Way is sometimes called *trebu gi lam*,[3] or "The Path of the Result" (in sharp contrast to the Sutra appellation "The Path of Causes"). Here, rather than think of oneself as needing to generate the causes of enlightenment within oneself, one identifies immediately with resultant buddhahood.

In other words, on the Tantric path one adopts an attitude and lifestyle that borrow the essence of enlightenment, and proceeds accordingly. Deity yoga is the application used in order to make this approach successful. One tells oneself, "I am a buddha, you are a buddha, the world is playful theater, and all activity is enlightened exchange."

All Buddhist Tantric systems have their own *Mulatantra*, or *Root Tantric Texts*. Most of these open with a presentation of how, where, when and why the specific system was taught. Often the text will say something like "taught by Buddha Shakyamuni, when he visited the Thirty-Third Heaven, at the request of… in his emanation as….," and so forth. Alternatively, the speaker may be another buddha in a far more ancient era, such as the eternal buddhas Samantabhadra or Vajradhara.

Some Tantric systems have even more extraordinary myths surrounding their origins. The *Kalachakra Tantra*, for example, a system into which the Dalai Lama has given initiation over a dozen times in the West, is said to have been taught by Buddha Shakyamuni in South India, while he simultaneously taught the *Perfection of Wisdom Sutra*[4] in North India. This ability of enlightened beings to multitask is not considered to be at all beyond the bounds of reason.

The esoteric nature of the origin of the Buddhist Tantras does not seem to bother Asian practitioners. Regardless of where, when, how and by whom the Tantras were spoken, they are all considered to be equally authoritative teachings of Buddha Shakyamuni. Perhaps he spoke them himself, perhaps another master or emanation did so on his command, or perhaps he just assimilated and signed off on them. Whatever the case may be, Tibetans believe that

1. Tib. *rGyu-gi-lam.*
2. Tib. *hLai-rnal-'byor.*
3. Tib. *'Bras-bu-gi-lam.*
4. Skt. *Prajna Paramita-sutra.*

every Tantric text included in the Buddhist Canon fully communicates the enlightenment spirit and was fully endorsed by Shakyamuni himself.

The word "Tantra" literally means "stream" or "thread." Although different Tantras present slightly different epistemologies, a common threefold approach is taken from the perspectives of basis, path, and result. When this is done, "basis" refers to the primordial thread or stream of reality that is present in both mind and matter at every moment of existence. That is to say, the thread of perfect being is always present. "Path" refers to the method for attuning to that primordial thread or stream of reality; and "result" refers to the complete integration or fulfillment (Skt. *yugganada*) that is the utter harmony of the radiance of the mind (*selwa*) and the presence of the experiences that arise within the mind (*nangwa*). Put in terms of Highest Yoga Tantra, yugganada is the complete and unobstructed flow of awareness of the dance of bliss (*dewa*) and infinity (*tongpa*).[5]

The Tantra Way is sometimes termed the *Guhya-mantra-yana* in Sanskrit, or "Vehicle of Secret Mantras." When this is done, the word "Mantra" has the same referent as "Tantra," although it is given a different epistemology, with *man* meaning "mind" and *tra* meaning "to protect." The idea is that the Tantric method is comprised of a yogic technology (*tra*) for protecting the mind (*man*) from the distorting influences of ordinary appearances. This allows the practitioner to rest within the natural perfection of uncontrived being in every situation, rather than get twisted into knots with the conventional appearances of things.

In a more simple sense, as anyone familiar with Indian-based traditions will know, a mantra is also a formula of syllables or words that is recited as part of a particular meditation technique. Every Tantric deity has his or her own mantras, and the practitioner recites and meditates upon these at length as a means of establishing a link with the primordial stream of inner being (i.e., tantra). Each Tantric system has a series of strict retreats associated with it, in which hundreds of thousands or even millions of the various mantras are recited. In the Tantric retreat of the female buddha Arya Tara, for example, it is most common to recite 400,000 of the main mantra.

Each Tantric system also has its own mandala. These hold many features in common with one another, but each of them also has its own unique qualities, symbolizing the uniqueness of the tradition as a yogic system.

In general all Tantric mandalas are twofold: supported, which refers to the mandala deity (or deities, when the mandala is more complex) and supporting, i.e., the cosmogram or residence that supports the deities. The former is the real nature of living beings, which refers to self and others, whereas the latter is the real nature of the environment or outer world in which self and others live.

Tibetans translated the word "mandala" as *kyilkhor*, with the epistemology of *kyil* meaning "essence" and *khor* meaning "to extract." The sense of the equation is that meditation upon a supported and supporting Tantric mandala is a technique for extracting the essence of life/wisdom/enlightenment. In other words, one extracts the essence of being by transforming the ordinary vision of self, living beings, and outer world into the pure vision of supported and supporting mandalas.

In mandala practice, the living beings and external world are seen respectively as enlightened Tantric deities and blissful rainbow-like environment. The technique is expressed by the Seventh Dalai Lama in a verse,[6]

> *Wherever you go, see yourself as a buddha,*
> *With an illusory body manifest yet empty,*
> *Abiding in an inconceivable mansion of*
> * wisdom.*
> *Take sounds as vajra song and thoughts as*
> * pure joy.*

Probably in ancient times each Tantric system was taken as a complete practice tradition in and of itself. By the sixth or seventh centuries A.D., however, efforts were underway to gather, compare and structure all the different Buddhist Tantric systems into a unified whole. In the end it became popular to speak of four classes of tantras: *Kriya, Charya, Yoga* and *Maha-anuttara-yoga*, or "Purification," "Action," Union," and "Great Highest Union." This fourfold system of categorization was adopted by the Tibetans, at least in the new schools such as Sakya, Kargyu, Kadam, Ralug, Zhalu, and Geluk.

There are several dozen different Tantric systems within each of these four classes of tantras. Each has its own root and secondary texts, as well as its own mandala or mandalas. Each is symbolized by its own principal deity, which has its own mantras and associated meditation techniques. In addition, each has its own "lineage of gurus in the line of transmission," through which the tradition was handed from generation to generation down to the present day. Finally, each also has its series of Tantric initiations and empowerment ceremonies, through which the novice enters into the

5. Tib. *bDe-ba* and *sTong-pa*.
6. This is one of the poems by the Seventh Dalai Lama from my study of his life and works, entitled *Meditations to Transform the Mind* (Snow Lion Publications, Ithaca, N.Y., 1999).

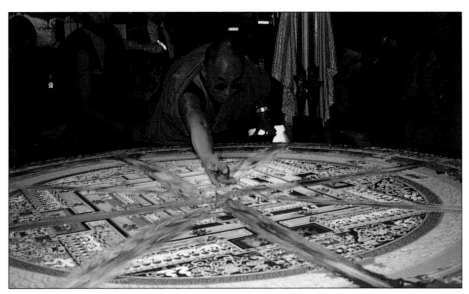

The Dalai Lama begins the dismantling of a Kalachakra Mandala.

mandala and is authorized to meditate upon himself or herself as the deity.

Many of these Tantric systems have a female buddha as their principal mandala deity. A male initiate will meditate upon himself in this female form, just as will a female initiate. Conversely, a female initiate receiving empowerment into a mandala with a male buddha as the central figure will visualize herself as male while doing that particular practice.

Most Tantric practitioners have initiations into numerous Tantric systems, with both male and female mandala deities as the principals. The Tantric initiate therefore does gender-transfer meditations of this nature several times daily.

There are also, as we will see in Part Two of this book, an entire series of *Yab Yum Nyamjor*[7] mandala deities, or "Male Female in Sexual Union." In these systems the initiate sees himself or herself as being simultaneously male and female, with mouths touching in a kiss and sexual organs in union.

7. Tib. *Yab-yum, snyams-'byor.*

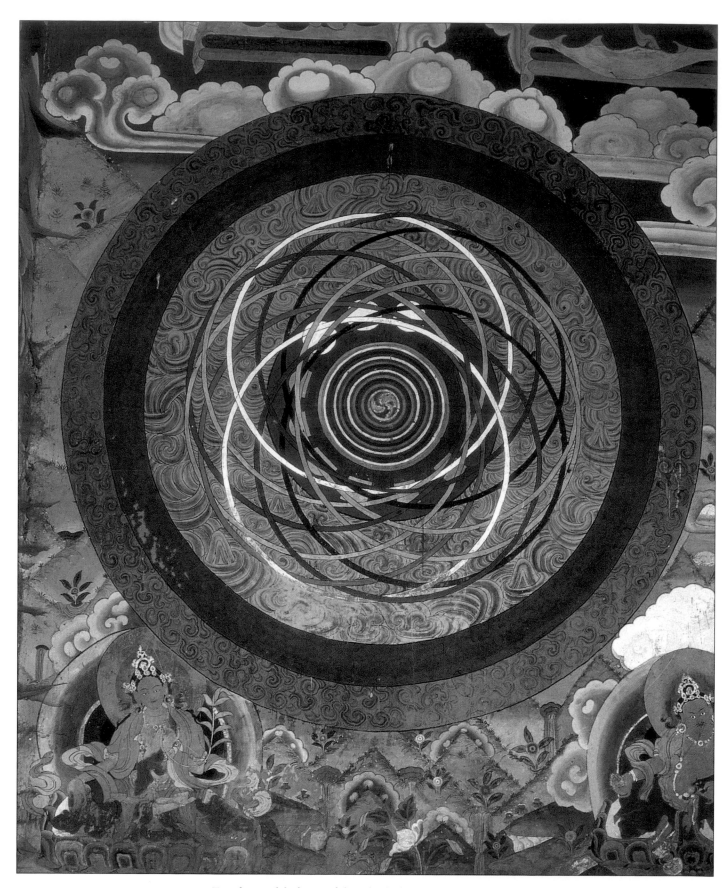

Temple mandala fresco of the Wheel of Time, the Potala, Lhasa.

The Trantra Way

As was pointed out in the previous chapter, Tantric meditation is also sometimes called *lhayi naljor*, or "deity yoga," with the word "deity" being synonomous with "buddha." The Thirteenth Dalai Lama (1875–1933) put it this way in his *A Guide to the Buddhist Tantras*:[1] "The Tantra Way is a special method for protecting the mind from the subtle instincts of the three appearances, in which one meditates in the mode of the resultant stage. This means that in the Tantric Way one conceives of oneself and all others as sharing in the four pure qualities of a fully accomplished buddha: perfect form; perfect communication; perfect awareness; and perfect activity."

He goes on to say, "There is no difference between the esoteric Tantra Way and the exoteric Way of the Mahayana Sutras in terms of the buddhahood that is attained, the bodhisattva attitude that is used as the basic motivating factor, nor the nature of the view of emptiness that is experienced. In these respects the terms superior and inferior do not apply. Nevertheless the Tantra Way is superior in four ways."

In brief, the Great Thirteenth is saying that both the Mahayana Sutra Way and the Tantric Way have three essential qualities in common with one another: the basic motivation of the universal love and compassion that characterizes the bodhichitta aspiration; the view of emptiness or infinity, which is the ultimate nature of all phenomena; and the state of buddhahood that is eventually attained. The two Ways are the same in these three respects.

He then mentions four ways in which the Tantra Way is superior: (1) its wisdom technique is more powerful, i.e., its method of generating the experience of emptiness or infinity is superior; (2) its method is more far-reaching, which refers (at least in part) to the deity yoga practice of seeing oneself and others as possessing the four qualities of a buddha as listed above; (3) it is faster and easier, in the sense that the Sutra Way requires many lifetimes for the accomplishment of full buddhahood, whereas in the Tantra Way buddhahood is easily attained in a single lifetime; and (4) it appeals to those of sharpest karmic maturity. In other words, the Tantra Way is deeper, more vast, easier, and smarter.

Most Tantric practices begin with the recitation of the two following verses:

Until enlightenment I turn for inspiration
To the Buddhas, Dharma and Sangha.
By the positive energy of my practicing the
 six perfections,
May buddhahood be attained for the bene-
 fit of all.

May all beings have happiness and the
 causes of happiness;
May all be free from suffering and the
 causes of suffering;
May all never be parted from the joy that is
 without sorrow;
And may all abide in the equanimity that is
 free from the prejudices
Of attachment and repulsion for beings
 near and far.

The appearance of these two verses at the beginning of Tantric practice texts (Skt. *sadhana*) clearly demonstrates the fact that the Tantra Way shares the bodhisattva attitude of universal love and compassion with the Way of the Mahayana Sutras. The verses are, of course, in the Sutra sentiment and are superfluous to actual Tantric practice. They are only included in Tantric practice as a preliminary.

Moreover, these verses are usually followed by a pronouncement. "In order quickly to attain full enlightenment and thus be of greatest benefit to other living beings, I now enter into the practice of this Tantric method." Here again we see a statement of the bodhisattva resolve.

These preliminary verses are usually followed by a Sanskrit mantra: *om svabhava shuddha sarva dharmah svabhava shuddhoh ham.* This is known as the "Emptiness Mantra," because its words suggest the infinity/emptiness nature of all that exists: "Om, all phenomena have utter purity (of infinity/emptiness) as their quintessential nature."

The meditator recites the mantra and then visualizes that the external world dissolves into light. This light dissolves into the living beings. Next the living beings dissolve into light, which dissolves into oneself. One's body, from head down and

1. I included a translation of this work in my study of the life and times of the Great Thirteenth, entitled *Path of the Bodhisattva Warrior* (Snow Lion Publications, Ithaca, N.Y., 1988).

feet up, now dissolves into light, and into one's heart center. This then also dissolves into light, until there is only an infinite radiance, with no center and no periphery.

This process is symbolic of how distinctions of self and other, inner and outer, etc., are mere ascriptions. There is no "self" separate from the world, and no "world" separate from the self. All things are interdependent, with no real nature to set them apart.

The Seventh Dalai Lama put it this way in a verse,[2]

> *All things in samsara and nirvana*
> *Are mere projections of one's own mind.*
> *That mind too is beyond birth and death,*
> *Abiding in the ultimate nature of being.*
> *Eh-ma-ho! How wondrous!*

In other words, this mantra points out the Thirteenth Dalai Lama's claim that there is no difference in the emptiness/infinity that is the object of the view in the Mahayana Sutra and Tantra Ways. However, it also points to his claim that the Tantric method of meditating on emptiness is superior. Rather than passively observing the radiant mind and its experiences, as is done in many of the emptiness techniques, and also rather than approach it by means of the Madhyamaka process of inquiry, one simply dives into the luminosity of infinity/emptiness being. On higher stages of the practice, of course, this "luminosity" takes on an entirely new dimension.

All Tantric meditation manuals (Skt. *sadhana*) begin with this meditation on the infinity/emptiness nature of the self, and this is an important key to success in the Tantric process. Here we take the ordinary sense of self, which is prone to unhappiness, suffering and imperfection, and replace it with a sense of our natural perfection. This is only possible because of the infinity/emptiness nature of the self. The self lacks any static, independent existence, and has no inherent nature; it is completely empty of these qualities. We limit our life because of our identification with a small, limited self. How much better to drop the small self altogether, and instead identify with our enlightenment aspect! The nature of the self is only limited by our own attitudes in this respect.

For this reason the first stage of Tantric practice is often called *dak-kyey*,[3] or "self-identification." The meaning is really "re-identifying the self." We drop the ordinary sense of

self, others, and world, and replace these with the Tantric vision of perfection. The Tantric vision of these three entities is in fact closer to their final natures than are our smaller, mundane senses of them.

As mentioned above, at the beginning of the self-identification process one dissolves into infinite radiance/emptiness. In Tantric terminology this is called "the ultimate deity." In other words, it is from this fountainhead of infinite light that the deity yoga and the self-identification process proceed. One then goes on through the steps of re-identification in accordance with the particular Tantric system being practiced. Eventually the supporting mandala emerges from the radiance/emptiness, and within it the supported Tantric deity or deities. In this way one re-emerges in the form of a buddha dwelling in a rainbow-like blissful environment.

As we saw in the previous chapter, there are four classes of tantras, and each class has various individual Tantric systems within it. Each of these Tantric systems is represented by a Tantric deity and also by its own mandala. In fact, each of the individual systems is a complete recipe for enlightenment, a complete Way in and of itself.

All these Buddhist Tantric systems hold a number of features in common with one another. They all also have *rimpa nyigi-naljor*,[4] or "two stages of yogic application." The first stage of all of them mostly concerns itself with establishing two inner qualities, known in Tibetan as *lhayi nga-gyal*, and *sel-nang*.[5] These translate respectively as "divine pride" and "vision of radiance." The practitioner of any Tantric system has to make these two qualities firm within himself or herself. The first, as explained above, refers to training oneself in the habit of always seeing oneself as a buddha, in the aspect of the principal deity of the mandala into which one has received initiation; the latter refers to training oneself in the habit of always seeing other people and things as being radiant manifestations of the primordial, playful wisdom of the mandala of enlightenment energy.

The Second Dalai Lama explains it as follows,[6]

> *One must learn to relinquish the habit of*
> *grasping*
> *At the mundane way in which people and*
> *things are perceived,*
> *And to place all that appears within the*
> *vision*

2. This is another of the verses from my study of the Seventh's life and times, *Meditations to Transform the Mind* (Snow Lion Publications, Ithaca, N.Y., 1999).

3. Tib. *bDak-skyes*.

4. Tib. *rim-pa-gnyis-gyi-rnal-'byor*.

5. Tib. *hLa-I-nga-rgyal* and *sSal-snang*.

6. This verse comes from one of the poems in my study of the Second's life and teachings, *Mystical Verses of a Mad Dalai Lama* (Quest Books, Theosophical Publishing House, Wheaton, Ill., 1994).

Of supported and supporting mandalas.
This is the essence of the generation stage
yogas.

As for the second stage of Tantric practice, the various systems here provide their own individual techniques. In the so-called Lower Tantras (i.e., the first three classes of Tantras: Kriya, Charya and Yoga), the first stage of application is called "the stage of symbols" and the second is called "the stage beyond symbols." This first stage mostly involves the cultivation of meditative powers that are then engaged in the two practices mentioned above, "divine pride" and "vision of radiance." The second stage mostly deals with turning the powers of highly attuned concentration, now infused with a constant spiritual joy, to observation of the various levels of the radiant mind.

With the fourth class of Tantras, the first stage[7] is called "the stage of creative imagination" and the second[8] called "the completion stage." Here the first stage utilizes the practices of divine pride and the vision of radiance, in conjunction with highly attuned meditative concentration, for blending the three essential moments—sleeping, dreaming and waking—to eliminate the ordinary appearance of the three occasions of death, in-between, and rebirth. Spiritual powers such as clairvoyance, supramundane physical abilities, and so forth, are here generated as side effects. The basis of the meditation process is, of course, the supported and supporting mandalas, with the practice of mantra recitation, as described in the previous chapter.

The second stage mostly involves yogic application involving the bodily energy centers (*chakras*), energy pathways (*nadi*), and drops (*bindhu*)in order to arouse paranormal out-of-body experiences that allow access to the most subtle and primordial mind states, the most primitive of which is simply known as "the clear light consciousness."

The Second Dalai Lama describes this in verse,[9]

Next one stimulates the vajra body
And directs the energies flowing in the side
channels
Into dhuti, mystic channel at the center,
Thus gaining sight of the clear light nature
of the mind,
And giving rise to wisdom born together
with bliss.
Cherish meditation on these completion
stage yogas.

In terms of Tantric systems associated with female buddha forms, these energy/bliss/radiance yogas are mostly linked to the traditions listed in Part Two of this book in the two chapters entitled "The Yum in Yab Yum" and "The Vajra Dakinis."

It may be prudent here to mention a misunderstanding about Tantra that is prevalent in the West. Tantra in Western literature often seems to refer almost exclusively to sexual practices of a somewhat indulgent nature. This is probably because early Western writings on Tantra were produced during the age of Victorian puritanism, and the Victorians took an illicit titillation in looking at erotic aspects of Asian and African cultures. Moreover, the Victorians heard of the Tantric sexual practices from Indian aristocrats during the zenith of the British Raj days, and the Indian aristocrats, who often had dozens of wives, often drew from the Tantric tradition in order to keep up their extensive conjugal duties.

It is true that the Buddhist Tantric tradition does offer elaborate instruction in spiritual love-making. In Tantric Buddhism this is termed *karmamudra*, or "the seal of destiny." The sexual partner is a person with whom one shares great destiny; the "seal" refers to the fact that, through the act of sexual intercourse with the destiny partner or partners, one arouses a state of consciousness characterized by bliss, radiance and non-duality. These qualities of consciousness arise during the sex act and come to an intense presence at the moment of orgasm. The practitioner engages certain Tantric techniques in order to sustain orgasm, thus augmenting the experience of these three aspects of consciousness. This unique state of consciousness is then in turn utilized for the higher Tantric activities.

As said earlier by the Thirteenth Dalai Lama, one of the four superior features of the Tantra over the Sutra Way is that the former has a richer array of methods. This includes practices for every experience in life, from sex yoga, sleep and dream yogas, eating yoga, going to the toilet yoga, death yoga, and so forth. There is even a killing yoga, so that policemen and soldiers can practice meditation while performing the duties involved in their vocations.

Sexual yoga is in a sense more important than the others listed above, simply because the orgasmic consciousness is more useful to the Tantric process than, say, eating consciousness or toilet consciousness. The three qualities of consciousness that arise with intensity during the sexual encounter—bliss, radiance and non-duality—are life's metaphors for the enlightenment experience. These three have been brought to eternal perfection in buddhahood, whereas in sexual orgasm they are experienced momentarily.

7. Tib. *sKyes-rim.*
8. Tib. *rDzogs-rim.*
9. See note 6 on previous page.

Put another way, it is during the moments of sexual orgasm that the ordinary human consciousness most closely parallels the enlightenment consciousness of a buddha, because the three mental qualities of bliss, radiance and non-duality are most powerful at that time, and these three are always there in enlightenment.

The Sutras only tell us what *not* to do with our sexuality, and not what *to do*. For example, they tell us not to have sex more than five times a day, not to force or deceive others into having sex with us, not to have sex with anyone under the age of puberty, not to have sex on new or full moon days, and so forth. In other words, the Sutras only outline the "don't aspect" of sexual behavior, and not the "do aspect." The Tantric tradition, on the other hand, clearly outlines techniques for Tantric love-making, in which the Tantric consciousness is made ever stronger through the course of sexual engagement.

Let's come back for a moment to the statement by the present Dalai Lama quoted in chapter 2, in which he said: "In the Sutra Way men are credited with having something of a superior position, whereas in the Tantra Way women are credited with having the advantage."

It may be useful to contrast the linear approach of the Sutra Way, as described in the previous chapter, with the non-linear use of positive thinking and creative imagination as outlined here in the Tantra Way.

It is possible that men have something of an advantage in the Sutra approach, and women an advantage in the Tantra approach, because of the difference in the texture of the aesthetic sensitivities of the two genders, and how these aesthetic sensitivities are able to adapt to the linear and non-linear situations of the two Ways.

And, as Charles de Gaulle once put it, "Vive la différence."

Three Jewels, Three Roots &
Three Types of Female Buddhas

Tara statues in Dolma Lhakhang Temple, Tibet.

As stated by the Thirteenth Dalai Lama (and quoted in the previous chapter), the Tantra Way is superior to that of the Sutras in four ways, one of which is speed and efficacy. The traditional Indian and Tibetan scriptures state that it takes many lifetimes to achieve enlightenment through the Sutra Way, whereas enlightenment is easily achieved in one short lifetime through the Tantric path. For this reason Tibetan texts often refer to the Sutra methods as being *sem minpai ngondro*,[1] or "preliminaries to ripen the mind." In other words, the would-be Tantric practitioner first engages in the Sutra trainings for a few years in order to prepare his or her mind for the Tantric methods.

Given the fact that Tibetans regard the Tantric path to be the means available to them for achieving enlightenment in one lifetime, it is not surprising that most of the female buddhas celebrated in Tibet's mystical art are associated with the Tantric legacy.

Spiritually speaking, a Buddhist by definition is someone who takes refuge in the Buddhas, the Dharma and the Sangha. That is to say, a Buddhist looks to three sources for

his or her spiritual inspiration and guidance: the enlightened masters of the past, present and future; their teachings on the means of accomplishing enlightenment oneself; and the community of practitioners who are highly accomplished and evolved in the enlightenment methodology. This is the Sutra approach. These three Refuge Objects are known in Tibetan as *Konchok Sum*,[2] or "Three Precious Jewels." The Sutra practitioner should invoke mindfulness of and meditate on these Three Jewels three times during the day and three times during the night. The Tantric practitioner recites a verse invoking these Three Jewels prior to engaging in a Tantric meditation session, to indicate that maturity in the Sutra trainings is a necessary preliminary to Tantric practice.

In the Tantra Way, however, these three are replaced by the *Tsawa Sum*,[3] or "Three Roots": the *Tsa-gyu Lama*,[4] or Root and Lineage Masters; the *Yidam*, or Mandala Meditational Deities; and the *Chokyong Khadro Khadroma*,[5] or "Dharmapalas, Dakas and Dakinis." The Tibetans tend to

1. Tib. *Sems-smin-pai-sngon-'gro.*
2. Tib. *dKon-mchog-gsum.*
3. Tib. *rTsa-ba-gsum.*
4. Tib. *rTsa-rgyud-bla-ma.*
5. Tib. *Chos-skyongs-mkha-sgro-mkha-sgro-ma.*

mix both Sutra and Tantra in their practices, but when the two are separated and made into distinct entities, the Three Jewels are the basis of the Sutra Way, and the Three Roots are the basis of the Tantra Way. A Sutra practitioner is defined as someone who looks to the Three Jewels for inspiration and guidance, whereas a Tantric practitioner is defined as someone who looks to the Three Roots.

All the various female buddhas that appear in Tibetan literature and art can be subsumed into the above threefold Tantric doctrine of the Three Roots.

The first of these is the "root and lineage masters." Here "lineage" implies "of the past," and "root" implies "of the present." In other words, these are the great masters in the lineage, both those dead and those living today. It is through these masters that the tradition comes down to us.

If we go all the way back to Buddha Shakyamuni, then we can say that there are thousands of female figures in this category. In this book we have highlighted a half dozen or so who are especially important in Tibetan Buddhism and who are known to all educated Central Asians.

Some of these are from ancient India and lived somewhere between the eighth and eleventh centuries A.D. Included in these are Bikkshuni Lakshmi and the yogini Niguna. Others are from Tibet, such as the eighth-century mystic Yeshey Tsogyal and the yogini Machik Labdon (1055–1153). All of these figures, and their lineages, are widely celebrated in Tibetan art. We look at some of this art in chapter 20. Being actual human teachers, they are representatives of the buddhas and thus here serve the role of the Buddha Refuge. However, as gurus they are all three in one: their minds are Buddha Refuge; their teachings are Dharma Refuge; and their physical aspect is Sangha Refuge.

The second category of female buddhas is comprised of the *Yidam*,[6] or Meditation Deities. The first six chapters of Part Two are dedicated to these Yidams. These are the mandala deities from the four classes of Tantras that are used as objects of meditation and self-identification, as described in the previous two chapters. These female buddhas not only embody the enlightenment experience, but also are vehicles for transporting the practitioner to the very same enlightenment state that they themselves symbolize. Because we realize our enlightenment by meditating on these mandala deities and performing the associated yogas, they represent the Dharma Refuge and serve the role that ordinary Dharma practice does in the Sutra Way. Buddha forms in this category are the subjects of chapters 13 through 18.

Third, we have the so-called Dharmapalas, or Dharma Protectors, the "Guardians of Truth," together with the Dakas and Dakinis. These are very popular subjects in Tibetan art, and depictions of them can be seen in most Tibetan temples.

The first in this category, the Dharmapalas, are perhaps the most popular objects of devotion for ordinary Tibetans, being regarded somewhat along the lines of personal guardian angels. Many families have their own traditional clan Dharmapala, in many cases associated with the family lineage all the way back to King Songtsen Gampo or King Trisong Deutsen in the seventh and eighth centuries, when Buddhism became Tibet's national religion. All family members have over the generations relied on that one particular Dharmapala since that time. Although there are hundreds of Dharmapalas in the Tibetan pantheon, some are more widely propitiated than others. We include a number of the female ones in chapter 20.

In fact these Dharmapala are of two types: *Jigten Chokyong*,[7] or "Worldly Dharmapalas," and *Jigten Leydeypai Chokyong*,[8] or "Dharmapalas Beyond-the-World." The latter, or Dharmapalas Beyond-the-World, are considered buddha forms. That is to say, they are emanations sent forth from the Dharmakaya and in reality are expressions of the enlightenment energy of a buddha. Their main driving force is a vow taken long ago to help and protect those dedicated to the enlightenment path. Some of these are male, and others female. Probably Palden Lhamo is the most important of them all, in her variant expressions as the twenty-one forms of Palden Lhamo.

The Worldly Dharmapalas cannot really be included in the category of buddha forms and therefore do not fit neatly into this book, *The Female Buddhas*. They are worldly deities, usually incorporated from either pre-Buddhist India or Tibet, who became subdued by Buddhist ritual and sworn to uphold Dharma and help those practicing the path. We nonetheless have incorporated several of them in chapter 20; the oaths that they swore in the presence of the enlightenment masters do give them some qualification to act on behalf of the buddhas.

The Dharmapalas serve the role of Sangha for the Tantric practitioner. Just as advanced Sangha practitioners serve as a reinforcing spiritual community for a Sutra practitioner, supporting, uplifting and inspiring him or her, the Dharmapalas support, uplift and inspire the Tantric practitioner.

The Dakas and Dakinis are the other two listed above as belonging to this third "Root." The Tibetans translated them

6. Tib. *Yid-dam.*
7. Tib. *rJig-rten-gi-chos-skyongs.*
8. Tib. *rJig-rten-las-'das-pai-chos-skyongs.*

as *khadro* and *khadroma*, or "space traveler" and 'space travelleress," because according to myth they have the ability to fly through space.

It should be noted that some dakas and dakinis are regarded as full-fledged buddhas and serve in the capacity of Yidams, or meditational deities. These are the Vajra Dakas and Vajra Dakinis, and we have dedicated chapter 17 to the latter.

However, when the dakas and dakinis are mentioned in connection with the third of the Three Roots, as is being done here, the terms do not refer to buddha forms or mandala deities, but to a class of male and female deity that is invoked and propitiated by the Tantric practitioner for various purposes, much in the same way that the Dharmapalas are invoked and propitiated for assistance. However, the dakas and dakinis are not oath-bound in the manner of a Dharmapala, but rather share an inherent harmony of purpose with the Tantric practitioner.

The terms "daka" and "dakini' can have another and more erotic meaning, in which they are used to refer to the sexual partners taken by Tantric practitioners as part of the practice of sexual yoga. The sexual partner of a female practitioner is referred to as a daka, and the sexual partner of a male practitioner is termed a dakini. The Tantric scriptures speak of various types of "daka and dakini as lover," establishing different categories by such means as size and shape of the sexual organs.

A popular threefold categorization speaks from the perspective of defining the beings that qualify for the position of Tantric sexual partner. Here the three types are called mantra-born, place-born, and innately born. The first refers to a sexual partner who is highly trained in Tantric meditation and whose qualification is born from Tantric knowledge generated through systematic practice. In other words, it is a person who is highly accomplished in Tantric training. The second refers to someone qualified by their place of birth; i.e., he or she was born in one of the twenty-four power places on the planet, and as a consequence has a special sexual sensitivity due to the blessings of that place. Third, the innately born daka or dakini is someone who was born with a sexual sensitivity linked to awareness of the deeper levels of consciousness, and in particular to the primordial levels of consciousness characterized by bliss, radiance and non-dual awareness. In other words, this is a naturally born daka or dakini.

Daka and dakini, used in the above manner to refer to the yogic sexual partner, become the Tantric equivalent of the Sangha for a Sutra practitioner. In the Sutra Way the advanced Sangha meditators provide inspiration, support and guidance. The dakas and dakinis as sexual yoga partners play much the same role and fulfill much the same function in the Tantra Way, providing inspiration, support and guidance, albeit in a totally different style and with a completely different mood.

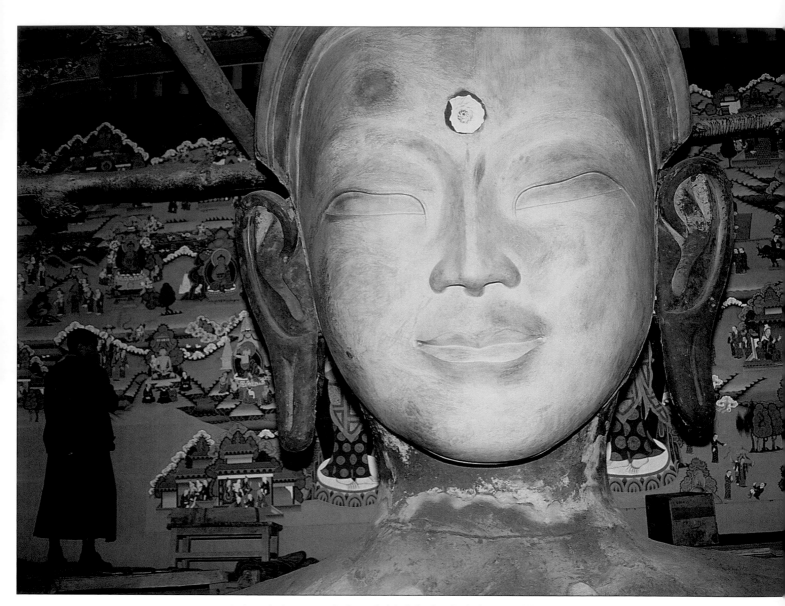
Artist painting a temple fresco behind the head of a large Buddha statue.

Tibetan Mystical Art as Pictorial Language

All mystical traditions love symbols. Not only is the simplest of symbols worth more than a thousand words, it transmits experience on dimensions that words cannot even touch. The Buddhist Tantric tradition took this basic principle to its limit, and through its Tantric art developed a complete language for communicating spiritual meaning. Volumes could be written on the symbolism found in even a small Tantric painting. Mystical code is omnipresent and drips from every brushstroke.

Any Tibetan trained in the tradition will, on viewing a piece of Tantric art, gain more from the subliminal messages embedded in this code than he or she will from knowing reams of linear information such as lineage, art history, and so forth. This secret code will transport the viewer out of the world of human ordinariness and place him or her in the timeless zone where heaven and earth come into harmony, where the sportive play of the Tantric vision drops down to our ordinariness and transports us to that higher realm where bliss, radiance and non-dual awareness are the dominant features. The vision is always one of beauty, harmony, strength and perfection. This is the case even when the Tantric image is a wrathful mandala deity; the deity is so ugly that it passes back into the sphere of the beautiful, so out of harmony in the ordinary sense that an altogether higher sense of harmony is established.

A ubiquitous symbol in Tantric art is the lotus flower. In ordinary (Sutra) Buddhism the flower has two symbolic uses.

In the first of these it represents the wisdom of infinity/emptiness. Once at a public gathering when the Buddha was asked to teach, he responded by simply holding up a flower and remaining silent. The flower became the teaching.

When we look at a flower it seems as though there is really a truly existent flower, some actual "flowerness" that is present, that exists from its own side. In reality, however, there was a seed borrowed from another flower; this seed drank water that came in on clouds from the most distant ocean; it soaked in sunlight and starlight from distant bodies in the sky; it breathed air carried by the winds from the four corners of the earth; and it ate nutrients from the soil, deposited from the decayed corpses of our own ancestors from a million years ago and from dust blown in from the Sahara Desert. In fact, traces of the entire universe had come into that little flower. We do not look at the flower and think "sunlight," or "dust from the most remote desert," or "my great-great-grandfather," or "water from the China Sea." We simply think "flower." Yet when we look in the flower all we find are the traces of infinity. The flower itself dissolves into mere names and labels. Any trained Tibetan looking at a flower in a painting is reminded of this first symbolic message.

Secondly the lotus flower is used to represent compassion linked to the wisdom of emptiness. The fourth century Indian master Asanga wrote in (Maitreya's) *The Peerless Stream*,[1] "A lotus grows in mud but is not stained by it. Similarly, the bodhisattva lives in the world but is not stained by worldly corruptions." Compassion inspires engagement, while wisdom maintains spiritual freedom. The idea is that a bodhisattva enters the ordinary world in order to help uplift living beings. However, like a lotus in a muddy pool, he/she remains free from ordinary worldly corruptions, such as attachment for seemingly beautiful things, repulsion for seemingly ugly things, anger at seemingly evil people, and so forth. The power of his or her wisdom allows for the vision of the infinity/emptiness in all of the things that so easily twist, scar and corrupt the spirit of the person lacking this wisdom.

Both of these meanings are rooted in the Sutra view. The Tantric tradition bumps things up a notch. Here the lotus symbolizes the female sexual organ, the object of the greatest bliss and pleasure in the universe. This is true for both males and females; the female organ gives great bliss to its owner, but also to the man with whom that owner shares it. "Lotus" is the most common name used for the female sexual organ in Tantric scriptures.

As was said in an earlier chapter, the ecstasy of the sexual encounter is regarded as the most excellent Tantric occasion. In fact a similar peak consciousness is experienced to some degree on any of five occasions: the high end of a sneeze; the pinnacle of a yawn; the moment of falling into sleep; the moment of sexual orgasm; and the clear light flash at the time of death, when consciousness slips out of the body into the hereafter. All five of these occasions are characterized to some extent by the three qualities of bliss, radiance and non-dual

1. Skt. *Uttaratantra-shastra*.

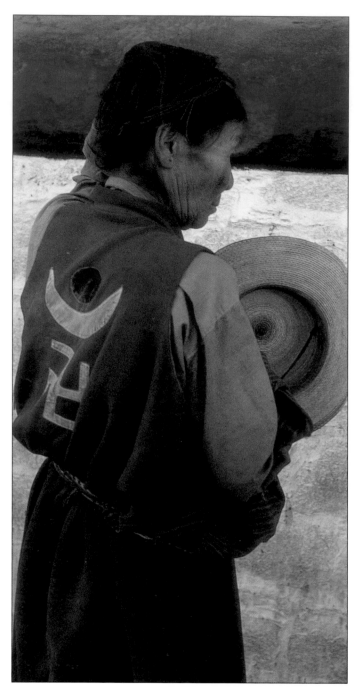

Female shaman in Lhasa with sacred symbols of swastika, moon and sun embroidered on the back of her dress..

awareness, and therefore are thresholds from which we can step into the enlightenment experience.[2] The sexual experience is the most dramatic and also most accessible of the five through yoga. Like the lotus opening in bloom, the Tantric practitioner opens in bloom toward the opportune experience of bliss, radiance and non-dual awareness during Tantric sex.[3]

Usually a sun and moon are depicted in the sky above the main image. In the Sutra Way the sun represents the female quality of the wisdom/energy of infinity/emptiness, whereas the moon represents the male quality of method, compassion, and linear thinking. In the Tantra Way the sun represents ovum, all we have inherited from our female ancestors (as represented in the body by the 72,000 female drops of genetic code), and the radiance aspect of mind. The moon represents sperm, all we have inherited from our male ancestors (as represented in the body by the 72,000 male drops of genetic code), and the blissful energy aspect of mind.

The Tantric deities usually stand on a seat comprised of three "cushions": a lotus at the bottom; a sun disk above this; and a moon disk on top. These have the symbolisms of lotus, sun and moon as described above. To transform into the Tantric deity being visualized, we must stand on the firm ground of bliss, radiance and non-dual awareness (i.e., the lotus), the freedom afforded by infinity/emptiness awareness, as well as with our 72,000 female drops activated and in harmony (i.e., the sun); and the warm yet refreshingly cool light of universal caring, as well as with our 72,000 male drops activated and in harmony (i.e., the moon).

In the same way, every attribute of the Tantric mandala deities meditated upon in the re-identification process calls out with a symbolic language. Every aspect of bodily position, every ornament worn, everything held up in hands or trampled underfoot, and all in the surrounding retinue communicate secret meaning to those with eyes able to read the code. A sword in hand represents the ability to cut off ordinary appearances and penetrate to hidden truth; the skull cup filled with blood, that is held by so many of the dakinis, represents the omnipresent potential of transcendental bliss within our impermanent human lives, if only we would drink from the cup; the curved knife cuts off the head

2. These five occasions, and the technology for accessing them, are a principal theme of the Guhyasamaja tantra.
3. The importance of these three consciousness attributes during sexual orgasm, and the yogas for inducing and then utilizing them in mahamudra meditation, is discussed at length in the eleventh-century Indian master Naropa's *Treatise on the Initiations*.

of ego-grasping; being seated with legs folded represents complete immersion in meditation; one leg folded and one outstretched represents remaining in meditation while being active in the world; and so forth.

Nowhere is this secret language of the Tantric arts more prominent than in the hand postures of the buddha figures. Known in Sanskrit as *mudra*, or "seal," the hands communicate secret seals of experience. Just like a letter bearing the seal of a powerful king gives us freedom to venture anywhere without fear, these mudras are like letters bearing seals from the enlightenment realm, seals that grant us free travel through entire dimensions of consciousness. The position of every finger receives commentary in Tantric literature.

Just as form and content are vehicles of the secret language of Tantric art, so color too plays an extremely important role. White is water, purity, and the source of all form; for all life emerges from water, all things are purified in water, and all form is perceived as paintings on the white canvas of the primordial mind. Yellow is earth, the support of all that lives, and the power of increase; while red is fire, the power of transformation, and so forth. Color communicates mood and meaning, just as does shape.

Color therapy is widely used in Tantric meditation. For example, a common healing practice associated with the tradition of the healing buddha White Tara (see chapter 14) involves mantra recitation while bathing the inner elements of the body in visualized streams of colored lights and nectars: first white, then yellow, then red, and so forth. This color therapy is thought to rejuvenate the inner chemistry of the body, heal any lurking causes of future disease, and in general make the body a happier and healthier vehicle for the support of the mind and the life-force.

The casual viewer can perhaps appreciate Tibetan art simply for its beauty, amazing skill in execution, transcendental vision, richness in creative imagination, and sheer power of presence. This is fair enough, and many Asian art enthusiasts will stop there. However, one should also appreciate that a book could be written on the symbolic meaning and secret language of almost every detail in any given painting.

I say "almost" here. We shouldn't take the point too far. Sometimes, as Freud put it, "A cigar is just a cigar."

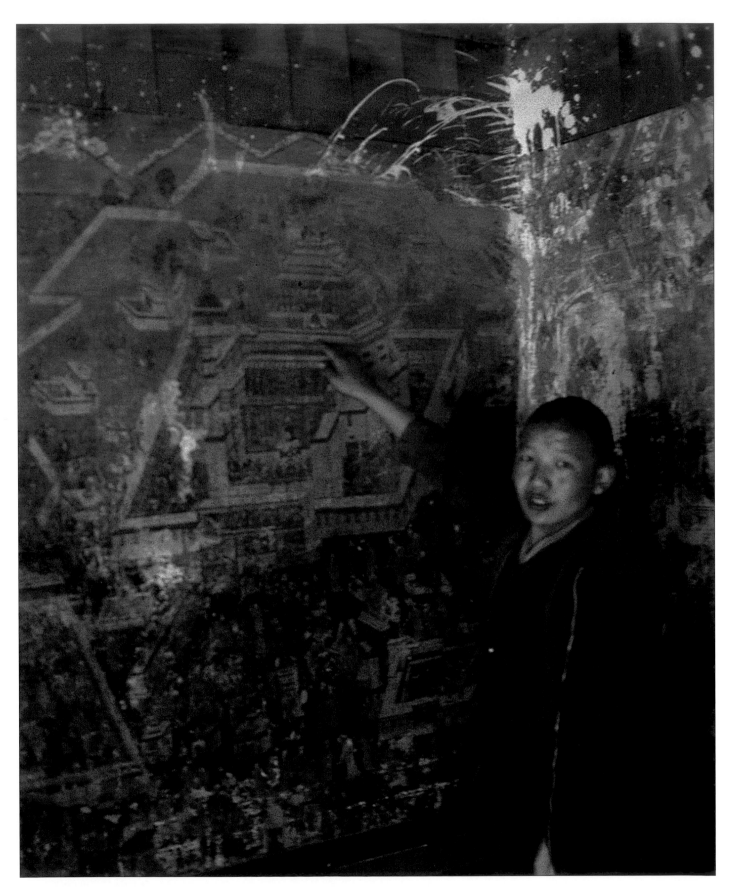

A Tibetan nun in Lhasa gives us a history lesson.

The Story of Tibetan Mystical Art

In ancient times Tibet's culture was probably rooted in the pan-Asian shamanic traditions common to much of Central Asia. Our own North American natives carried some forms of this culture with them when they first migrated here from the Tibeto-Mongol hinterlands some fifteen to twenty-five thousand years ago. Many religious symbols common to the two traditions, such as the swastika and the sand painting, stand in support of this theory. Elements from this prehistoric legacy can still be seen in Tibetan art and life.

In more recent times Tibet complemented her shamanic basis with traditions gleaned from her powerful neighbors. Standing at the heart of Asia, she was surrounded by super-civilizations on all sides. The ancient Persian Empire lay to her west, and perhaps as early as 4,000 B.C. Tibet began to absorb lineages from Persia that eventually evolved into the tradition known as "Bon." By the time of Christ, Bon had swept across the highlands of Central Asia and was the dominent spiritual culture in most Tibetan kingdoms.

Secondly, China lay to Tibet's east, and perhaps as early as 2,000 B.C. the Tibetans began to absorb numerous traditions from her, mainly brought back as part of the spoils of war, as well as through intermarriages arranged as peace initiatives between warring tribes.

Thirdly, India lay to her south and eventually was to become her closest friend, ally and cultural resource. In all probability the first king of the Yarlung Dynasty was a refugee from India. Nyatri Tsenpo by name, he lived in the fourth century B.C. or so. It was his descendents some thirty-three generations later who united the tribes of Central Asia and first established the nation that we now think of as Tibet.

Finally, the Silk Route skirted Tibet's borders to the north, running between China and Persia, and from there headed westward towards Egypt. Many great city-states had sprung up across this route on Tibet's northern borderland, where caravans traveling east and west would stop to rest, rejuvenate, and resupply themselves for the long journey ahead. The Tibetans undoubtedly traded with and through these city-states, and on occasion even conquered several of them.

Tibet began to absorb influences from all of these sources long before the Buddha appeared in India. However, Buddhism began traveling across the Silk Route as early as the third century B.C. with the cultural exchange work of the great Indian King Ashoka, and as a consequence the Buddhist tradition began making inroads into Central Asia from that early date. It became the national religion of Tibet in the mid-seventh century A.D. under King Songtsen Gampo, and from that time onward Tibet became a *de facto* Indian cultural satellite.

As was mentioned earlier, it was King Songtsen Gampo's two foreign wives, the first from Nepal and the second from China, who inspired him to embrace Buddhism and then to make it the national religion of his newly formed empire. He sponsored the creation of a grand temple in Lhasa for each of them—the Jokhang for the Nepali queen and the Ramochey for the Chinese. In addition, he ordered the construction of Buddhist temples and monuments at the 108 principal power places of his empire.

All of this building activity required a fleet of artists, craftsmen and builders. Most of these were imported from Nepal and China, as well as from other nearby Buddhist kingdoms such as Khotan to the north and Kashmir to the west. The Tibetans worked, apprenticed and learned under them.

Tibet's artistic tradition as it exists today has its strongest roots in King Songtsen Gampo's period. Two of his descendents—King Trisong Deutsen a century later and King Tri Ralpachen a few generations after that—also dedicated vast resources to building Buddhism in Tibet, and therefore during their eras the Buddhist arts developed and expanded dramatically. Tibetans speak of this as "The Golden Age of the Three Great Dharma Kings." They also think of these three kings as being previous lives of the soul destined to become the Dalai Lama incarnations, and Songtsen Gampo's two foreign wives as having been incarnations of the female buddha Tara. All lineages of Tibetan Buddhism rooted in this era of Tibetan history are known as the Nyingma Rinlug,[1] or "Old School."

The second great phase of Tibet's adventure in the Buddhist arts came with the renaissance of the eleventh

1. Probably Goe Lotsawa's *The Blue Annals* (Tib. *'Deb-ther-sngon-po*), translated by the Russian scholar George Roerich and published in India in 1949–1953 (Royal Asiatic Society of Bengal), is still the best source in English for information on the development of Tibetan Buddhism.

century and the development of monasticism as a national passion that followed thereafter. Although prior to this time the Tibetans had built a few Buddhist monasteries, these had always remained small affairs, with the monks being chosen from aristocratic families almost in the form of a tax. They really served more as national mascots than as upholders of Dharma in the classic sense.

During the early days of Buddhism in Tibet, the model used was more like that of the earlier Bon tradition, in which knowledge was held by and passed through family lineages. Buddhist knowledge was now passed down within individual family traditions, with retreat hermitages built in the mountains above the family home. Anyone who wanted to study Buddhism would have to approach the family elder and request to be accepted as a trainee. Being accepted had something of the significance of adoption or joining the clan.

The renaissance of the eleventh century brought dramatic change, in Tibetan social life as well as in the arts. It began in Western Tibet with the great translator Rinchen Zangpo and spread from there. Perhaps the most important figure in this movement after Rinchen Zangpo was the Bengali master Atisha Dipamkara Shrijnana, who was brought to Tibet at Rinchen Zangpo's promptings. Readers may remember him from chapter 1, as the builder of the jewel-like Tara Temple just below Rato Monastery near Lhasa. Most of Atisha's immediate disciples became monks or nuns, and established monastic communities and hermitages across the land. His chief disciple, Lama Drom Donpa, was a lay person, but nonetheless established Rateng Monastery as the principal seat of Atisha's lineages. The tradition descending from Atisha and Lama Drom became known as the Kadam, or "Oral Instruction Lineage." Lama Drom, by the way, is another historical figure thought to be a previous incarnation of the Dalai Lamas.[2]

Simultaneously with all of this activity in Western and Central Tibet, Marpa the Translator began his own mini-renaissance out of Lodak in the south, and although neither he nor any of his principal disciples were monastics, Marpa's chief disciple was Milarepa, and Milarepa decided to enthrone the monk Gampopa as his heir to the Marpa lineages. Gampopa established a monastery at Dvakpo to house these lineages, and thus was born the Kargyu Rinlug, or "Oral Transmission School." Gampopa's four most important disciples were all monks and established their own monasteries. One of them, Pakmo Drupa, had eight main disciples, again all monks, who in turn established monasteries to house their lineages. In this way the Four Older and Eight Younger Kargyu Schools were born.

Meanwhile in Tsang, Southwestern Tibet, the chief of the Khon clan decided that it was time to seek out the new Tantras from India. Until this time the Khon family had followed the Nyingma tradition. At this time Khon Konchog Gyalpo was sent to study with the great Drogmi Lotsawa, and on his return home built the Gorum Zimchi Karpo Temple at Sakya. This eventually developed into the Sakya Monastery, named after the hill on which it stood. The Sakya School spread from there and soon became one of the dominant forces in Tibetan life. Perhaps one of the reasons for its great success was that it combined the family-lineage tradition of the Bon and Nyingma Schools with the monastic enthusiasm of this renaissance period. The heads of the Sakya School were always lay people, with the position passing by hereditary right rather than spiritual accomplishment. In almost all other features the Sakya movement was predominantly monastic in style. This has remained the case until the present day, and Sakya monasteries are more common in Central Asia than Sakya lay centers.

The birth of these three schools in the eleventh century —Kadam, Kargyu and Sakya—and the amazing zeal for monasticism that they produced, resulted in an explosion of building activity. Monasteries, temples and meditation hermitages sprang up everywhere. Once again artists, craftsmen and builders became the most sought-after professionals in the Tibetan world, and Tibetan art took a quantum leap forward. As during the golden era of the Three Dharma kings of old, many of these professionals were imported from India, Nepal, Kashmir and China; but by now Tibet had produced many of its own masters in the Buddhist arts, and they began to play an ever-increasing role in all artistic activity.

Probably the next great historical period affecting the development of Tibetan art is that of the thirteenth century. Two things happened simultaneously at that time. The first was the destruction of Buddhist India at the hands of the invading Muslim hordes from Afghanistan and Persia. The second great change, which occurred half a century later, was the rise of Mongolia as a superpower in the east and the fall of just about everyone else as a result. The Mongolians considered themselves to be spiritual brothers of the Tibetans, and soon after taking over China they began a massive program to import Tibetan Buddhism into the Chinese mainland. This is the so-called Chinese Yuan Dynasty, when the Chinese emperor and all ruling families throughout China were Mongolian. Marco Polo was the first Western traveler to make known in the West the reality of China under Mongol rule. While in China he met the great

2. Atisha's work in Tibet is treated in detail in *Atisha*, by A. Battacharya and Lama Chinpa, Calcutta, 1967.

Chogyal Pakpa, the lama of the Sakya school who became the guru to the emperor Kublai Khan.

Hundreds and perhaps even thousands of Tibetan monasteries and temples were built under Mongolian patronage throughout China and Mongolia at this time. Here the Mongolians imported Tibetan artists and builders to oversee the work, with the Chinese working under Tibetan supervision. No doubt this all had a profound effect on the development of Chinese art; conversely, and of greater interest to our study here, Chinese artistic traditions also profoundly impacted Tibetan art. Most Tibetan artists and builders returned home after their contracts were fulfilled. However, their exposure to the wider field of Chinese art, as well as to the many artistic treasures that had been gathered by the Mongols on their campaigns from Korea to Europe, no doubt had a transformative impact on their work. Not only did they experience whole new worlds of technique and materials, they learned the "p" word: perspective. It was perspective that transformed European art during the early days of the European Renaissance, and it was perspective that now transformed Tibetan art.

Historians of Tibetan art sometimes term this the Sakya Period, because during these years Tibet was ruled by the Sakya lamas of Tsang. It began when the Chinese emperor Kublai Khan took Chogyal Pakpa (mentioned above) as his guru. However, the artists used in this program came from all regions of Tibet and all schools of Tibetan Buddhism. As a result, the backflow from the experience had a national impact. Perspective now became a ubiquitous element with all but the most provincial of Tibetan artists.

Of course Tibetan art has undergone many more phases of development and evolution since then. There was what Prof. Robert Thurman likes to call "The Ganden Movement" that developed between the fourteenth and seventeenth century after the advent of Lama Tsongkhapa and the First Dalai Lama, and the wave of building activity that followed in their wake. The Old Mentri, New Mentri and Karma Gadri schools of art are all by-products of this phase of Tibet's history. Thurman sees these developments as the Tibetan vision of life on earth, as an extension of the Ganden Paradise of Maitreya Buddha. Certainly there are merits in his arguments, just as there are merits in these schools of Tibetan art.[3]

Other art scholars like to emphasize the period of great patronage of the arts that ensued after the Fifth Dalai Lama became head of Tibet in 1642, when he in Lhasa and his guru, the First Panchen Lama Lobzang Chokyi Gyaltsen, in Tsang (listed as the Fourth Panchen by the Chinese) transformed art from a mere passion into a national obsession, perhaps somewhat similar to the art mania that swept Europe and America during the first half of the twentieth century. Again, much could be said on the contributions that the Fifth Dalai Lama, known as the Great Fifth, and the First Panchen Lama made during the mid-seventeenth century.

In particular, the Great Fifth strongly promoted the tulku tradition of reincarnate lamas, together with its *labrang* infrastructure. Under the Great Fifth's leadership Tibet became a federation of several hundred quasi-independent kingdoms, each of which had its own king, chieftain or otherwise designated hereditary head. The Great Fifth promoted the idea of having a local tulku or reincarnate lama serve as multigenerational spiritual leader to balance and complement the influences and activities of the secular rulers. Their labrangs, or "residence-throughout-reincarnations," became like treasuries, archives and museums rolled into one, all of which were used to sustain the spiritual and cultural stability of their individual regions through the ups and downs of the passing generations.

These labrangs became primary patrons of the arts in their individual regions. Today, the statement that a particular painting is "labrang quality" means that it was made for a reincarnate lama's private residence in some bygone age. The implication is that it was painted by the best artists of the day, using nothing but the best of materials.

It also implies that the artist knew his creation would be his ticket to art immortality. His painting would end up in the reincarnate lama's labrang, and as a result all subsequent reincarnations of that same lama would continue to cherish and show the piece in accordance with tradition. The artist's name would be entered in the *Labrang Karcha*, or "Official Labrang Record." In this way the artist and his creation would continue to benefit the peoples of his homeland for centuries to come.

Certainly from the time of the Great Fifth Dalai Lama until today the reincarnate lamas have continued to be the greatest patrons of the arts in Tibet. Many of them study art in their childhood and practice painting as a meditation aid throughout their lives. Few of them can dedicate the time or energy required to become truly great artists, for in their youth the majority of their time is spent in spiritual study and in gathering the various lineages of transmission; in their adulthood most of their time must be given to meditation, teaching, and delivering lineage transmission. Nonetheless almost all reincarnate lamas pride themselves on their knowledge and patronage of the mystical art tradition.

The present Dalai Lama is no exception. Many of the greatest Tibetan artists in the refugee communities of India

3. He discusses this in his contribution to *Worlds of Transformation* (Tibet House, New York, 1999).

Anni Sangku Nunnery in Lhasa. In the early fifteenth century, six female disciples of Llama Tsonkapa made a retreat
in a cave here, achieved enlightenment and later established it as a female practice site.

today receive commissions from him. However, whereas in Tibet these would have been placed in one of the spiritual hermitages associated with him and remained there for centuries, the Dalai Lama as a refugee in exile takes them with him on his world travels and finds good homes for them around the globe, usually donating them to meditation or interfaith centers, or other such institutes where he feels the beauty, power, and sublime spirituality of Tibetan art will be appreciated.

Concluding Reflections

The late great Indologist and Asian scholar Prof. A. L. Basham once wrote,

> One of the unexpected results of the Chinese occupation of Tibet was the emigration of thousands of Tibetan lamas, who joined His Holiness the Dalai Lama in voluntary exile. Bringing with them copies of their scriptures and the rich traditions of their own brand of Buddhism, they quickly adapted themselves to new environments and found many students in both America and Europe. The spread of the knowledge of Tibetan religion in the West within a few decades is in some ways comparable to the spread of Greek and classical culture in Europe after the capture of Constantinople by the Turks and the diaspora of Byzantine scholars. It is as though a new dimension has been added to the stock of world civilization. Where once Tibetan Buddhism was studied outside of Tibet only by a few specialists, it is now taught widely in American and European universities, and is being studied at various levels all over the world.[1]

Although Prof. Basham here was speaking of Tibetan spiritual culture, his words are equally true of Tibetan art. Very little was known of it in the West prior to the mass exodus of the Tibetan refugees in 1959 and 1960.

Tibet had led a charmed life for much of the fifteen hundred years before this event. Although it did suffer occasionally from internal and external conflicts, it was spared many of the great catastrophes that befell other nations. No doubt the high mountains that guarded it on every side helped, as did the Buddhist distaste for violence and the so-called glories of war.

It was only in the 1950s, with the Chinese Communist invasion of Tibet, and then the great destruction that characterized the Chinese Cultural Revolution of the 1960s and '70s, that Tibet fell prey to the cultural genocide that had afflicted so much of the rest of the world in recent centuries. The Cultural Revolution led to the destruction of much of the art, literature and architecture throughout China itself.

This destruction was even more pervasive in Tibet, now under Chinese occupation. All but a dozen of her monasteries, temples and hermitages—homes to most of Tibet's art treasures and libraries—were razed to the ground. The few that were not destroyed were converted into army barracks or storage warehouses. Most of the artworks and books in these institutions were destroyed: statues were melted down for the metals in them; sculptures were cut up and used as building stones; books and paintings were put to the torch or used for recycling materials.

Some of the artwork escaped destruction. The Tibetans themselves hid what they could, tucking it in caves, or burying it under the earth. They also smuggled what they could into the large exiled community now living in India and Nepal.

Anything with a Chinese connection had some hope of being saved by the Chinese themselves. Statues or paintings that had been commissioned by any of the great Chinese Buddhist aristocratic families in centuries past, or that were somehow connected with the Chinese emperors, had the greatest hope of survival. Much of this was thrown on trucks bound for China, where it went into warehouses for indefinite storage, in case sometime in the distant future it would prove useful.

Fortunately Tibetan culture continued to exist uninterrupted in several small Himalayan kingdoms, including Bhutan, Sikkim, and parts of Nepal, as well as in several regions of the Indian Himalayas, such as Ladakh, Spitti and Lahoul. The Tibetans who had come into exile now teamed up with these diverse ethnic groups, all of whom practiced Tibetan Buddhism and used the Tibetan script as their written language, and together they formulated a plan for the preservation of Tibetan culture, with the Dalai Lama as the symbolic head of the movement. The work has been quite successful, and the Tibetan efforts to preserve their ancient traditions in exile have been quite successful. Moreover, the wave of liberalization that swept China in the 1980s also brought great benefits inside Tibet itself, and the Tibetans were allowed to rebuild many of their institutions, including most of the great monasteries and temples. It would seem that, at least at the present moment, Tibet's traditional culture is no longer in any immediate danger of extinction.

1. Prof. Basham, whose masterpiece, *The Wonder That Was India* (Hawthorn Books, New York, 1963), stands as one of the greatest literary presentations of Indian culture to be written in the West, penned these dramatic statements shortly before he passed away in a foreword he wrote to a book of mine, *Selected Works of the Dalai Lama II: The Tantric Yogas of Sister Niguma* (Snow Lion Publications, Ithaca, N.Y., 1982).

The real problem concerns Tibet's antiquities. By the mid-1960s many of these started showing up on international art markets. The Tibetan refugees in India and Nepal, many of whom now faced extreme poverty and even starvation, had begun to sell off the best of what they had been able to carry out with them. And from the Chinese side, officials had begun to smuggle out what had been locked away in warehouses for storage. Most of this was ending up in the hands of casual buyers with no knowledge of what they now possessed or of how to care for it. The great art treasures that had escaped destruction at the hands of the Cultural Revolution back in Tibet were now facing destruction at the hands of innocent yet poorly informed souvenir collectors, interior decorators, and antiquity peddlers around the world.

A good portion of this artwork also found its way into museums, both private and public, and this stands a better chance of survival. The Rubin Museum of Art in New York City has developed one of the strongest such collections in America.

The present book, *Female Buddhas: Women of Enlightenment in Tibetan Mystical Art*, was first conceived as an exhibition drawn from the Rubin Museum of Art, to be shown in the Oglethorpe University Museum of Art in Atlanta. I was delighted to be invited by Prof. Lloyd Nick, OUMA's visionary director, to design and curate the exhibition, and honored to be asked to write an accompanying reader. Working with Jeff Watt, the curator of the Rubin Museum and one of the world's foremost authorities on Tibetan art, has been an especially wonderful privilege.

Neither the book nor the exhibition on which it is based are intended to serve as complete presentations of the vast role of the feminine in Tibetan culture. Rather, they are both but glimpses into the rich, exotic and compelling expressions of the feminine in Tibetan mystical art.

Three generations of women on pilgrimage at the Potala.

Part Two

TREASURES FROM THE RUBIN COLLECTION

Arya Tara

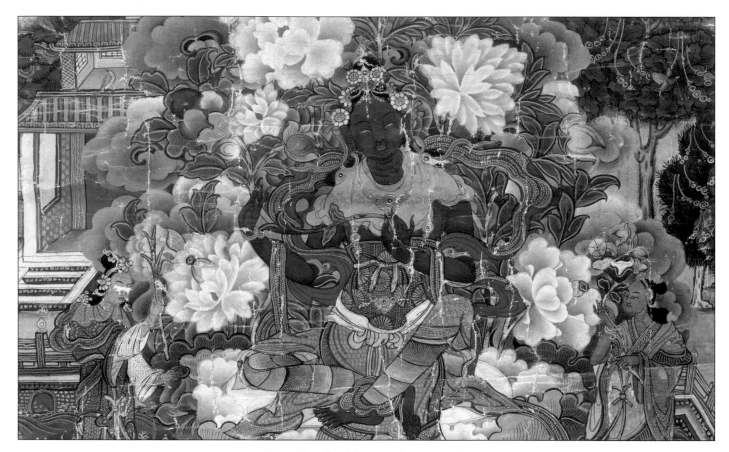

Green Tara, detail from tangka on page 83.

Arya Tara is perhaps the most popular female buddha in Tibet, and images of her can be found in almost every monastery and temple throughout Central Asia. No doubt one of the reasons for her widespread popularity in this regard is her mythological connection with Arya Avalokiteshvara, the Bodhisattva of Compassion and patron protector of Tibet.

Several books on Arya Tara are available in English,[1] and people can refer to them for a more in-depth treatment of the role of Arya Tara in Tibetan Buddhism. Here we present a thumbnail sketch for the general reader and art enthusiast.

1. The first in-depth study of Arya Tara and her role in Tibetan Buddhist culture was Steven Beyer's excellent anthropological analysis, *The Cult of Tara: Magic and Ritual in Tibet* (University of California Press, Berkeley, Calif., 1973). Beyer studied the Tara tradition from the perspective of the various types of rituals of invocation practiced by the Drukpa Kargyu monastery at Tashi Jong, Himachal Pradesh, India. Another important study is Martin Wilson's *In Praise of Tara: Songs to the Savioress* (Wisdom Publications, Boston, 1986). Wilson surveys the mainstream Indian and Tibetan literature pertaining to Arya Tara, including a summary of the contents of the thirty-five chapters of the *Root Tantra*, and contrasts Buddhist attitudes toward Tara to Western attitudes on the Mother Goddess. Mention could also be made of *The First Dalai Lama: Meditations on Arya Tara* (Tibet House, New Delhi, 1981, translated by Glenn H. Mullin). This latter work contains six different texts on Tara practice written by the First Dalai Lama. These were later included in *Selected Works of the Dalai Lama I: Bridging the Sutras and Tantras* (Snow Lion Publications, Ithaca, N.Y., 1982).

ARYA TARA, MOTHER OF ALL BUDDHAS

A number of popular epithets are associated with Arya Tara. One of these is *Gyalwai Yum*,[2] or "Mother of the Victorious Ones," an expression often translated as "Mother of All Buddhas." *Gyalwa* here is the Tibetan equivalent of the Sanskrit term *Jina*, which is synonymous with "Buddha." A buddha can be called a *jina*, or "victorious one," because he or she is victorious over (i.e., freed from) the emotional and cognitive distortions, and has gained realization of (i.e., victory over) the two levels of truth. "Victorious One" is also a name given to a buddha from the perspective of the four maras or devils; a buddha has gained victory over all four.[3]

The epithet "Mother of the Buddhas" is, in fact, commonly used for two female buddhas, Arya Tara and Prajna Paramita, whose name means "Perfection of Wisdom." These two—Arya Tara and Prajna Paramita—earn their designations as Mother of the Buddhas in different ways.

Westerners are probably more familiar with Prajna Paramita than they are with Arya Tara. The former symbolizes the wisdom that is the topic of the *Prajna Paramita Sutras*,[4] or "Perfection of Wisdom Discourses." Most of these were translated into English during the first half of the twentieth century by Edward Conze and others, and information on Prajna Paramita became widely known at that time. Moreover, Prajna Paramita is a popular subject of iconography in China, Korea and Japan. The West came into intimate contact with all three of these countries during and immediately following World War II, leading to a wave of scholarly studies of their art and culture.

Although Tibetans are aware of Prajna Paramita and also use the expression "Mother of the Buddhas" for her, she is not a popular object of meditational practice with them. This is partially because she is mainly thought of as being merely a symbol of the wisdom taught in the Prajna Paramita Discourses of the Sutra tradition, rather than as a Tantric meditation deity.[5] Thus she primarily belongs to the exoteric Sutra Way, and not the esoteric Tantra Way. Preference for the Tantric tradition rules all things Tibetan.

Prajna Paramita is the "Mother of all the Buddhas" in the sense that all beings who achieve buddhahood do so by means of arousing the transcendental wisdom. There are many types of wisdom; the Sanskrit term for the transcendental wisdom that arouses the experience of enlightenment is *prajna paramita*. Nothing other than this wisdom can deliver enlightenment. Just as mothers are the ones who give birth to all the children on earth, this wisdom gives birth to all who achieve enlightenment. Prajna Paramita as a female buddha is an embodiment of or symbol for that wisdom.

The Prajna Paramita Sutra in 8,000 Lines states,[6]

> *O Shriputra, just as mothers gives birth to all children,*
> *The transcendent wisdom gives birth to all enlightened beings.*

The expression "Mother of the Buddhas" is also used for Arya Tara because Tara is the embodiment of or symbol for buddha karma, or *sang-gyey kyi trinley*.[7] When spoken of from the perspective of buddha karma, Arya Tara is referred to as *Trinleyma*, or "Karma Lady." Transcendental wisdom may be the direct force that arouses the enlightenment experience, but buddha karma is the force fostering the conditions that make the birth of this wisdom possible.

The doctrine of buddha karma is an extension of the doctrine of the Three Kayas. As discussed in chapter 6, the Dharmakaya is the formless state of wisdom attained by all who achieve enlightenment. Moreover, it is from the formless Dharmakaya that the buddhas send out their Samboghakaya and Nirmanakaya emanations to benefit the world. All of these emanations are "buddha karma."

Thus we can see that when the word "karma" is used in the context of buddha activity it does not have the same sense as it does when used in reference to the ordinary, compulsive karma of cyclic patterns that is created by ordinary, unenlightened beings. Rather, it is karma in the sense of post-enlightenment work, to the buddha work of bringing benefit, higher evolution and enlightenment to all living beings. For this reason we often see it alternatively translated as "buddha energy," "buddha activity," and "enlightenment activity."

2. Tib. *rGyal-bai-yum*. Another epithet for Tara is *Dezhin Shekpai Yum* (Tib. *De-bzhin-gshegs-pai-yum*), or "Mother of the Tathagatas." The term *tathagata* means "those gone to suchness," and, like *jina*, refers to the buddhas. "Mother of the Tathagatas" is the name used in the *Tara Root Tantra*.

3. Four maras: *klesha*, or delusion; *skandhas*, or psychophysical aggregates; *yama*, or death; and *devaputra*, or son of the gods.

4. There are forty-two different Prajna Paramita Sutras, all translated from the Sanskrit originals, in the Tibetan canon.

5. Prajnaparamita also appears as a female buddha in several Tantric mandalas. However, these particular mandalas are not commonly practiced by the Tibetans. Rather, they tend to know her in the context of her role as embodiment of the *Prajna Paramita Sutras*.

6. Tibetan literature often refers to this text simply as *Gyal Yum*, or "The Mother of the Buddhas."

7. Tib. *Sangs-rgyas-gyi-'phrin-las*.

Carved wooden book cover. Thirteenth century. The female buddha Prajna Paramita sits on the left, with the five transcendent buddhas to her left. In all probability the cover was used with a copy of one of the three larger versions of the *Prajna Paramita Sutra*, which are 100,000 lines 25,000 lines, or 8,000 lines. Tibetans generally keep a copy of the last of these as a blessing, and once a year invite a group of monks or nuns to come to their home to chant it aloud.

The fourth-century Indian master Asanga describes buddha karma as follows,[8]

> *The all-pervading Dharmakaya needs make*
> * no effort;*
> *Yet from it there emanates forth*
> *The various aspects of buddha karma*
> *To bring benefit to the living beings.*

And also,

> *The sun effortlessly releases its radiance,*
> *Causing lotuses to bloom and seeds to*
> * sprout.*
> *Similarly buddha karma shines from the*
> * sphere of buddha mind,*
> *Causing lotus-like living beings to evolve*
> * and to grow.*

The idea is that the Dharmakaya of the buddhas is omnipresent and all-pervasive. In the above metaphor, Dharmakaya is being compared to the sun, and buddha karma to the sun's rays. This Dharmakaya emanates a steady flow of enlightenment energy that is similarly omnipresent and all-pervasive. Arya Tara is an embodiment of or symbol for that omnipresent, all-pervasive buddha energy.

The text on the previous page by Asanga explains that buddha karma inspires the birth of all goodness that exists in the world, from the most simple to the most sophisticated. Buddha karma inspires a person to give a crumb of food to an ant, to save a worm caught in the heat of the sidewalk, to love a pet and to speak kindly to one another. It also inspires a person to embark on the enlightenment path and engage in the practices leading to enlightenment. Then in the end it leads the practitioner to the very threshold of the wisdom that arouses the final and highest enlightenment experience. In other words, it is by means of connecting with this force that the living beings create the good karma for their own growth and evolution, and it is this connection that eventually induces the enlightenment experience.

While Prajna Paramita is called Mother of all Buddhas because she symbolizes the transcendental wisdom that gives birth to the enlightenment experience within all who attain buddhahood, in contrast, Arya Tara is called the Mother of all Buddhas because she represents the enlightenment energy that causes living beings to evolve and to grow toward enlightenment. Whereas Prajna Paramita is mainly thought of in connection with the Sutra Way, Arya Tara is primarily used for Tantric practice.

Most people engaging in meditation on Arya Tara will do so by using a self-generation text in which he or she first dissolves into infinity/emptiness (as described in chapter 7), and then goes through the process of re-emerging from the radiance of infinity with the reconstructed ego-identification of actually being Arya Tara. The mantric process of linking up to the sphere of buddha karma and drawing it into one's own life is then performed from within the sphere of self-identification as Arya Tara.

It could also be said that both Arya Tara and Prajna Paramita are mothers to one another, or that they are but one female buddha appearing in two different forms. Tara attained her own enlightenment by relying on the transcendental wisdom symbolized by Prajna Paramita; and Prajna Paramita attained her enlightenment by relying on the buddha karma symbolized by Arya Tara. In fact, Prajna Paramita Devi is one

8. This verse is from his *Uttara-tantra-shastra*.

of the names attributed to Arya Tara, as listed in the ancient Indian text *In Praise of the 108 Names of Arya Tara.*[9]

Some Western scholars, writing on Tibetan Buddhism, have likened Tara as Mother of all Buddhas to the Roman Catholic tradition of Mary Mother of God. However, the similarities are superficial. Mary is referred to as Mother of God because she physically gave birth to Christ, whom Christians think of as being a god. She is "blessed among women" because "blessed is the fruit of her womb." Her title as "Mother of God" comes to her as a by-product of her human motherhood and the child that this produced in the human realm.

Tara, on the other hand, did not physically give birth to a child who came to be regarded as a divinity. Rather, the Tibetan relationship with Arya Tara is meditative in nature, with the focus on the process of ego re-identification. One drops the ordinary sense of self and replaces it with a sense of "I am Arya Tara." This meditation technique is then followed by mantra recitation, in which one connects with the universal river of buddha karma and directs it at fulfilling particular functions within one's life.

As with most Tantric practices, correct mantra recitation and meditation on Arya Tara creates two effects: conventional and ultimate. Conventionally one connects with buddha karma and uses it to draw health, happiness, abundance and success into one's life. Ultimately one uses the connection with buddha karma as a force propelling one toward enlightenment. Arya Tara is spoken of as Mother of all Buddhas in these two respects, in that the former supports the latter. She represents the universal, all-pervasive buddha karma or energy that brings conventional conditions suitable to spiritual practice and consequently supportive of the ultimate purpose, which is buddhahood.

In this sense she is the mother of one's personal enlightenment. Moreover, all beings who have ever attained enlightenment in the past, are attaining it now, or will attain it in the future, have done, are doing and will do so by attuning to and riding upon the force of this universal wave of energy known as buddha karma.

Color is an important factor in the language of Tibetan mystical art. Arya Tara as Mother of the Buddhas and symbol of buddha karma is usually depicted as green in color, because green is thought of as the color of the energy (Skt. *prana*) that is the source of all matter. It is also the subtle wind element (Skt. *vayu*) that is the quintessential force supporting consciousness on its journey from life to life. Arya Tara is thus shown as being green in color because buddha karma is transmitted by means of this subtle energy or "wind."

The Tibetan Romance with Arya Tara

The Tibetans' fascination with Arya Tara is rooted in their love for myth and the manner in which myth is so profoundly interwoven with their own sense of their history.

One aspect of the Tara myth is related in the first verse of the famous *In Praise of the Twenty-One Taras,*[10] a short text that is extracted from chapter 3 of *The Tara Root Tantra.*[11] The First Dalai Lama speaks of it as follows in his commentary to the Tibetan translation of the former work. He begins by quoting the verse of the Indian text, and then proceeds to elucidate the meaning.[12]

> *Hail Tara swift and fearless,*
> *Whose eyes flash like lightning;*
> *She born from a lotus in an ocean of tears*
> *Of Avalokiteshvara, Lord of the Three*
> *Worlds.*

He comments, "It is said that once the Bodhisattva of Compassion became dismayed on seeing that, even though he had striven with all his might to free the sentient beings from samsara, the number of sentient beings suffering in samsara was not significantly decreasing. He burst into tears, and from the pool that formed from the waters flowing forth from his lotus eyes there sprang forth a lotus. Arya Tara suddenly appeared from the lotus, her exquisite face embodying the delicacy of a million lotus blossoms."

The First Dalai Lama continues, "Thus the compassion of all buddhas emanated as a fountain of buddha karma. This took the form of Arya Tara, the female buddha of enlightenment energy. She turned to the Bodhisattva of Compassion and said, 'O noble one, I offer myself in the service of freeing the countless sentient beings from cyclic existence. Shed no more tears. We shall work together to turn the battle against

9. Tib. *hLa-mo-sgrol-mai-mtshan-brgya-rtsa-brgyad-pa.*

10. Tib. *sGrol-ma-nyer-gcig-gi-bstod-pa.*

11. Tibetans know this text by many names. The First Dalai Lama refers to it in his commentary as *In Praise of Tara, Mother of All Tathagatas* (Tib. *sGrol-ma-de-bzhin-gshegs-pai-yumla-bstod-pa*).

12. This is quoted from *Selected Works of the Dalai Lama I: Bridging the Sutras and Tantras* by Glenn H. Mullin (Snow Lion Publications, Ithaca, N.Y., 1983).

samsara.' Then a net of light shone forth from her two eyes and scanned the three realms of the world."

This simple myth, related unostentatiously by the First Dalai Lama, holds a number of levels of meanings for Tibetans. In terms of spiritual allegory, Avalokiteshvara is the symbol of compassion. He works hard to alleviate the suffering of the world, but seems to make little headway. Tara represents enlightened work. Only when compassion gives rise to enlightened activity is the battle against suffering turned. Compassion is the necessary first impulse, but for it to bring joy it must be united to effective action.

On the level of historical myth, Tibetans believe that they have a special relationship with both Avalokiteshvara and Tara that goes back to primordial times. Long before humans appeared on earth, Avalokiteshvara was a monkey living in the Yarlung Valley of Tibet, and Tara was an abominable snowlady living in rock crevices nearby. Time passed, and the two became friends. Eventually they fell in love and mated, giving birth to the first six humans. This ancient Tibetan legend predates Darwin's theory of human descent from primates by several thousand years.

Since that time Avalokiteshvara and Tara have worked together to elevate the Tibetans and lead them to the enlightenment path, showing up in some form or another at virtually every crossroads in Tibetan history. This special relationship revealed itself dramatically in the mid-seventh century, when King Songtsen Gampo united all of Tibet under his rule, married one Buddhist princess from Nepal and another from China, and under their guidance made Buddhism the official spiritual tradition of the country. Tibetans speak of this king as having been an emanation of Avalokiteshvara, and the two Buddhist princesses as having been two emanations of Arya Tara.

Again, it was Avalokiteshvara and Arya Tara who inspired the great renaissance of the eleventh century. The illustrious Indian master Atisha, whose work launched the renaissance, only agreed to come to Tibet after a stone statue of Arya Tara

at the great temple in Bodh Gaya spoke to him. At that time Tara told him that the trip to Tibet would shorten his lifespan, but would be of immeasurable benefit to the enlightenment tradition. Atisha therefore journeyed to Tibet, where he taught for thirteen years before passing away. His greatest disciple was Lama Drom Tonpa, a master regarded as being an emanation of Avalokiteshvara. Lama Drom organized Atisha's teachings and spread them, until they became cornerstones of all schools of Tibetan Buddhism.

Some three hundred years later Avalokiteshvara incarnated again, this time as the Buddhist monk who was destined to become known to history as the First Dalai Lama. From his youth the First Dalai Lama made meditation on Arya Tara his most important daily meditation commitment, and in his adulthood spread the practice far and wide. At one point he contracted a serious illness that no doctor could cure, and people feared that he would pass away. He entered a strict retreat to engage in the healing yogas associated with White Tara. The retreat was successful, and premature death was avoided. He went on to become the greatest lama of his generation, and his success set the stage for all the greatness that future Dalai Lamas achieved. All Dalai Lamas since then have been incarnations of Avalokiteshvara, and all have maintained a special spiritual link with Arya Tara through meditation and mantra.

Tibetans interpret these and hundreds of other similar events in their history in the light of the myth of Avalokiteshvara and Arya Tara. They believe that the two have worked hand-in-hand over the millennia to uplift, protect and enlighten the Tibetans, and will continue to do so in the future. For this reason, Avalokiteshvara is their favorite male buddha, and Tara their favorite female one.

Of course they do not think of these two buddhas as being limited in the scope of their work to Tibet and the Tibetans. They merely think of themselves as having an especially strong karmic link with the two, and thus as being more attuned to receiving their blessings.

POPULAR FORMS OF TARA IN TIBETAN MYSTICAL ART

Because Tara represents buddha karma or enlightenment energy/activity, and because these phenomena are limitless in forms of expression, there is no limit to the number or aspects of Arya Tara that can appear in the world.

This said, Tibetans have evolved a preference for three different spiritual practices of meditation and mantra related to Tara. This preference is strongly reflected in Tibetan art, and we have included masterpiece examples of all three in this book. These include Green Tara, the Twenty-One Taras, and the Eight Taras Who Protect from the Eight Dangers.

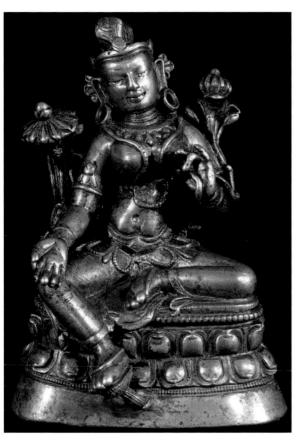

Arya Tara, fifteenth century, 5 inches, bronze.

Green Tara is the principal form of Arya Tara, and the form most commonly seen in artistic representation. Every Tibetan is familiar with the basic mantra and prayer of Green Tara and does some practice on the new, half and full moon days of the month.

The twenty-one Taras are also very important. Most Tibetan monasteries perform a special ritual based on these twenty-one forms of Tara at least once a month, usually on the half or full moon day. The artistic and spiritual tradition is based on the Sanskrit text of twenty-one verses in praise of Tara, with one Tara representing each verse. In this book we present six masterpiece paintings, two of which depict all twenty-one as a group, and the others depicting the four main forms of the twenty-one.

Finally we have the Eight Taras Who Protect from the Eight Dangers. In this book we present paintings of individual Taras, each of which depicts one of these eight important functions of Tara. The tradition of "Eight Taras as Protectors from the Eight Dangers" is based on chapter 8 of *The Root Tantra*.

In addition to these three primary forms, mention should be made of Chintachakra Tara, the White Tara with seven eyes. This is the form of Tara commonly used for healing by means of meditation, as practiced and popularized by the First Dalai Lama. It is also the form most often given as public initiation by means of *tsewang*, or "life-enhancement empowerment." We include a masterpiece of White Tara in chapter 14, "The Healing Trinity."

Finally, there are numerous versions of an Eight-Armed Tara, which are connected with Highest Yoga Tantra rather than the Kriya systems of the Taras discussed above. In fact, there is even a Highest Yoga Tantra version of the Twenty One Taras, in which all twenty-one have eight arms. We have included one of these Highest Yoga Tantra Taras in chapter 17, "The Vajra Dakinis."

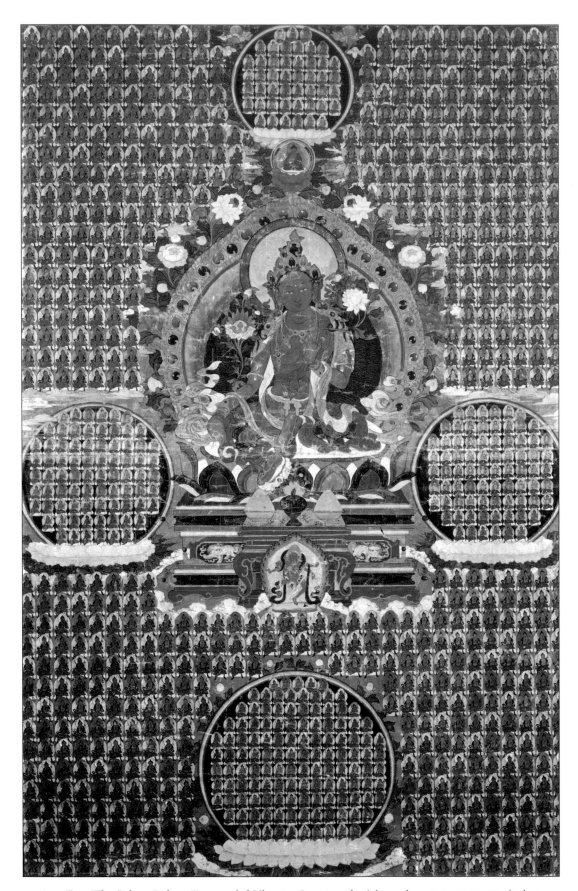

Arya Tara; Tib., *Pakma Dolma; Transcended Liberator*. Seventeenth-eighteenth century, 60.5 x 38.5 inches.

Arya Tara

TAM Om svabhava shuddha sarva dharmah svabhava shuddhoh ham.

All becomes emptiness. From emptiness appears the syllable *PAM*, which becomes a lotus marked by *AH*. *AH* transforms into a radiantly white moon disk covering the stamen of the lotus. Above this is the syllable *TAM*, in essence the ultimate nature of my own mind. This transforms into a utpala flower marked by *TAM*... and from this I emerge as glorious Arya Tara.

Thus writes the First Dalai Lama in one of his brief meditation manuals focusing on Arya Tara. The meditator begins by dissolving the world into infinity/emptiness, as elucidated in chapter 8, and then emerges from that radiant sphere with the vision of himself or herself in the form of the female buddha Arya Tara. He or she then proceeds with all the various phases of the self-identification process of Arya Tara, together with the mantra recitation for accomplishing specific purposes.

In another of his meditation manuals focusing on Arya Tara, the First Dalai Lama elucidates eight different ways in which the mantra can be used: (1) increasing life energy; (2) increasing creative energy; (3) increasing wisdom; (4) increasing personal renown; (5) eliminating diseases; (6) eliminating hindrances; (7) pacifying distractions and the wandering mind; and (8) dispelling the occurrence of bad dreams.

In our painting Arya Tara is depicted as the central image of the tangka. She is peaceful in appearance, and her bodily color is emerald green. One thousand and eight small Taras sit in various arrangements around her. These symbolize the thousands of ways in which the buddha activity embodied by Tara manifests in the world in order to benefit living beings. Her throne is upheld by eight lions (only two of which are visible), to indicate that she is supported by the eight great enlightenment qualities, such as fearlessness and so forth.

Tara's right hand is in the mudra called "supreme generosity," for it indicates how meditation and mantra practice bestow both the ultimate siddhi of enlightenment/mahamudra, and the conventional siddhis of health, prosperity, clairvoyance, and so forth.

Her left hand is in the mudra called "bestowing refuge," indicating how her meditation and mantra practice bring complete protection of Buddha (i.e., enlightenment), Dharma (i.e., knowledge) and Sangha (i.e., harmony with the world); or, in Tantric terms, how she performs the threefold function of Teacher, Yidam, and Dharma Protector. Both hands hold the stem of a utpala flower, representing how Tara practice empowers the practitioner to carry the beauty and purity of the Tantric tradition into all ordinary situations.

Her right leg is extended in the "hero/heroine posture," indicating that the Tara practitioner does not shy away from but rather is fully active in worldly activities. Her left leg is folded under her in the "posture of meditation," indicating that, although the Tara practitioner is active in the world, his or her mind always remains at rest in meditative equipoise. As the First Dalai Lama put it,

> Though dwelling in stillness you are moved
> by compassion
> And on arms of compassion carry to
> stillness
> The beings struggling in this ocean of
> misery.

Buddha Amitabha is seated above the central figure, for Tara belongs to the Padma family symbolized by him (of the three "families of Tantras" in the Kriya class). The semi-wrathful female buddha Kurukulle dances below her. We will see more on her later, in chapter 15 of this part, "Female Buddhas with an Agenda."

As with most of the Kriya Tantra mandala buddhas, Tara is almost always depicted as being youthful in appearance, as though sixteen years of age. This is because enlightenment bestows a mental vigor and joy, as well as a physical stamina, similar to that of a mature teenager.

THE TWENTY-ONE TARAS

The First Dalai Lama wrote a commentary to the small text on which the practice of the Twenty-One Taras is based. In it he states, "The famous twenty-one verses to Arya Tara are found in the third of the thirty-five chapters of the scripture entitled *In Praise of Tara, Mother of All Tathagatas*. Although this work is said to belong to the Kriya class of tantras, it is also said that the twenty-one verses can be explained in connection with Highest Yoga Tantra."

In other words, the Tibetan text which is used in conjunction with the meditations and rituals connected with the Twenty-One Taras was translated from Sanskrit, and is of Indian origins. In particular, it is found in chapter 3 of *The Tara Root Tantra*, which contains thirty-five chapters.

The practice of the Twenty-One Taras is popular in all schools of Tibetan Buddhism. Numerous artistic and iconographic traditions are connected with it, based on the meditational experiences and visions of the great masters of the past. Here we present two of the most widespread of these, both of which are based in the lineage brought to Tibet by the eleventh-century Indian master Atisha Dipamkara Shrijnana.

The text referred to above by the First Dalai Lama is known as "The Praise of the Twenty-One Taras." This usually is the first liturgy committed to memory by any young monk or nun joining a monastery. In Tibet most children destined for monastic life would be enrolled somewhere between the ages of five and ten. They would memorize this Tara text even before learning how to read and write. It is also memorized in grade one of almost all Tibetan secular schools. As a result, almost all Tibetans know it by heart. Ask the next one you meet to recite it for you, and most likely he or she can do so without hesitation.

Most Tibetan monasteries and nunneries perform one or more monthly practices based on the Twenty-One Taras, usually on the morning of the half moon, full moon or empty sky days (i.e., the day before new moon). The most common format of the practice is known as *Dolma Mandal Zhichok*, or "A Tara Ritual in Four Mandala Cycles." Here the practitioner generates the vision of himself or herself as Arya Tara and also invokes a visualization of the Tara mandala in front. He or she then performs four cycles of meditation, each of which contains a symbolic offering of the universe and seven recitations of the twenty-one verses to Tara, followed by a mantra recitation. Usually the ten-syllable Tara mantra is recited 300 times each of the first three cycles, and then 400 with the fourth and final cycle. In this way during the course of the ritual the practitioner makes four universal mandala offerings, recites the twenty-one praises twenty-eight times, and collects 1,000 mantra recitations. The merit is then in general dedicated to the benefit of all living beings, and in particular is dedicated to the specific purposes for which the rite was commissioned.

Many Tibetan families invite monks or nuns to come to their house once a month to perform this rite. It is not uncommon for wealthier families to commission *Dolma Boom*, or *The 100,000 Taras*, on occasions requiring special blessings. On these occasions the text to the Twenty-One Taras is recited 100,000 times during the ritual. Large monasteries having two or three thousand monks can perform this rite in a day; smaller monasteries will take many days, and perhaps even weeks, to complete it. The principal nunnery in Dharamsala, residence of the Dalai Lama in India, does the *Dolma Boom* practice several times a year.

Many Tibetans have this ritual performed for general health, success and protection when they move into a new house, launch a new business venture, or give birth to a child. The idea is that the ritual brings buddha karma blessings on a mundane, worldly level, but, more importantly, causes everything related to the occasion to be of maximum spiritual benefit and draws maximum enlightenment energy to everything and everyone involved. For example, a business venture can produce negative karma because of greed, abuse of power and resources, and so forth; alternatively, when it is done in the spirit of service to the world, and with the prayer that whoever is involved receives blessings of happiness, growth and enlightenment, it is a source of good karma. The *Dolma Boom* encourages the latter situation.

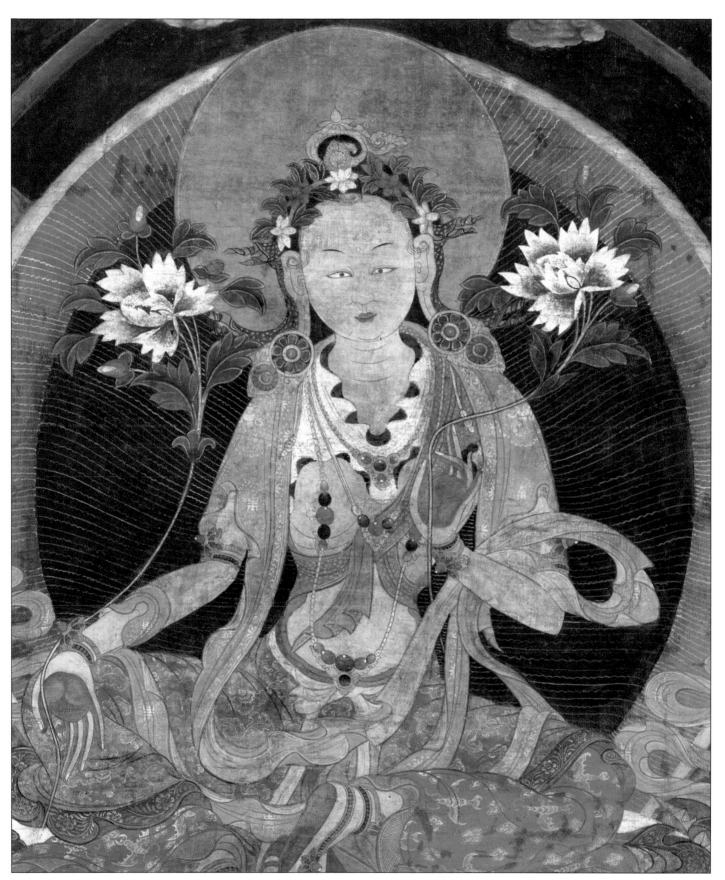

Detail from tangka on page 65.

The Twenty-One Taras: The Atisha Lineage

Here a golden Tara is shown in the center, in the form and aspect of the standard Green Tara. That is to say, she has the same postures as does Green Tara, shows the same hand mudras, holds utpala flowers in her two hands, and so forth. The spiritual symbolism of Green Tara was explained in the description of the previous tangka, and what was said there applies here.

The reason for her golden color is indicated by the set of three bodhisattvas shown immediately above her: Manjushri (center, yellow), Avalokiteshvara (Manjushri's right, white), and Vajrapani (Manjushri's left, blue). These three bodhisattvas respectively symbolize wisdom, compassion, and power, and are known in Tibetan as *Rigsum Gonpo*, or "The Three Great Protectors." The fact that the central Tara is golden in color indicates that she represents the power of increase. In other words, here we see Tara meditation as an embodiment of the force that increases wisdom, compassion and spiritual power. These three forces increase and grow within us when we meditate on the Tara mandala.

The Twenty-One Taras are arranged above, below and to the sides of her. They are all similar in form to the central figure, with a few essential differences.

First, only the left hand holds a utpala flower. The right holds a vase filled with wisdom ambrosia. The meaning is that anyone who practices the meditations and rituals associated with the Twenty-One Taras will drink deeply of the nectars of buddha karma that herald all spiritual success on both worldly (e.g., health, prosperity, family success,) and other-worldly (i.e., personal enlightenment) levels.

A second iconographic characteristic of the Twenty-One Taras is that they are shown in four groups of five colors: white, yellow, red, dark blue, and smoky green. This makes twenty. The twenty-first Tara, shown at the center below, is red, indicating that the power of increase symbolized by the central figure is augmented by the twenty-first Tara, an extra red, the color of power.

The meaning of the five colors of the Twenty-One Taras is pointed out in a verse by the First Dalai Lama,

> Homage to Arya Tara, she gone to the end
> of buddha karma;
> Her miraculous activities of peace, increase,
> power and wrath
> Like tides of the ocean are never at rest,
> But spontaneously flow in an unbroken
> stream.

As said earlier, Arya Tara represents buddha karma or enlightenment activity. In Tantric practice we see ourselves and others as mandala buddha forms, and all activity as playful enlightenment theater powered by buddha karma. We show our love and compassion to one another in four ways, as an expression of buddha karma.

These four expressions of buddha karma are symbolized by the colors of the Twenty-One Taras. There is the white radiance of the buddha karma that invokes peace/harmony; the yellow radiance of buddha karma that invokes increase/prosperity; the red radiance of buddha karma that invokes power/subduing; and the dark blue radiance of buddha karma that invokes wrath/violence. As Tantric practitioners we play with and express all four. In addition, all four can be combined as one, becoming a smoky green Tara.

There is nothing in the painting to indicate the sect of the practitioner who commissioned it. In that the Atisha lineage from India spread to all three great new schools of Tibetan Buddhism, as well as to many minor ones, the history of the tangka could be linked to any of these.

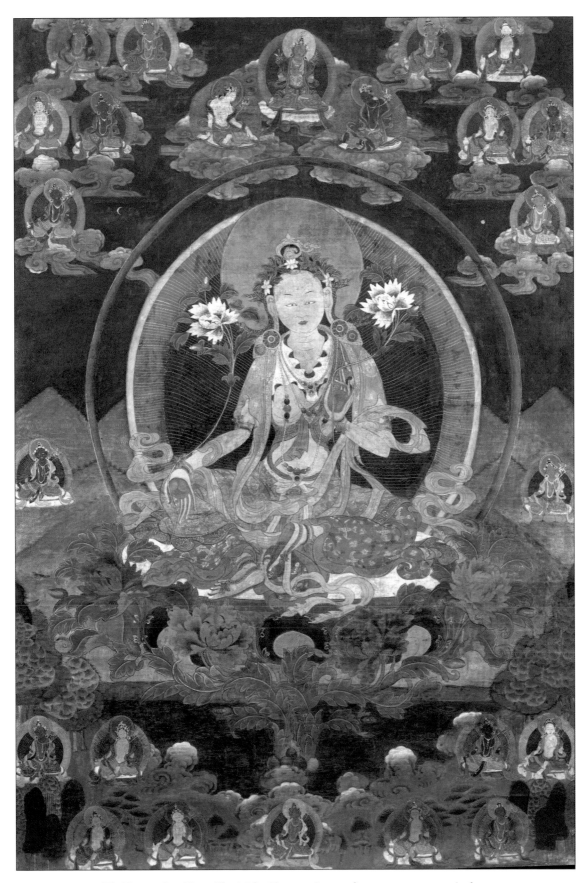

The Twenty-One Taras: The Atisha Lineage, nineteenth century, 50.5 x 35.2 inches.

The Twenty-One Taras: A Sakya Interpretation

Here we have a very different artistic interpretation of the Twenty-One Taras. Both the Tara at the center and the Twenty-One Taras surrounding her are painted in gold. The twenty-one are set in the central figure's halo, to indicate that they are all emanations of the one source. In fact the twenty-one would have their normal colors; the gold is given by the person commissioning the painting, as an offering to Tara. It is not unusual for Tibetan artists to be requested to coat all the figures in a painting with pure gold, as a source of merit born from making offerings to the buddhas.

This tangka clearly belonged to a lama of the Sakya School, as indicated by the lineage masters depicted in the palace behind the central Tara. The lama in the palace to the viewer's right (to Buddha's left) is one of the early Sakya lamas. The Indian mahasiddha on Buddha's right is Virupa, source of the main Sakya lineages.

The other figures in the tangka are all important meditational deities in the Sakya School, the most significant being the male-female-in union forms of Yamantaka and Hevajra. We will see more on them in chapter 16 of this section, "The Yum in Yab Yum." The female buddha Kurukulle dances above Tara's right shoulder, and the mystical Lion-Headed Dakini dances above Tara's left shoulder. The dark blue figures above these two dakinis are important Dharma protectors in the Sakya tradition.

Offering goddesses dance below Tara and the cluster of Twenty-One Taras. These represent the transformation of the five sense objects, as well as the other attributes of worldly existence, into objects used only as expressions of buddha karma, i.e., into things used for enlightenment and the universal good.

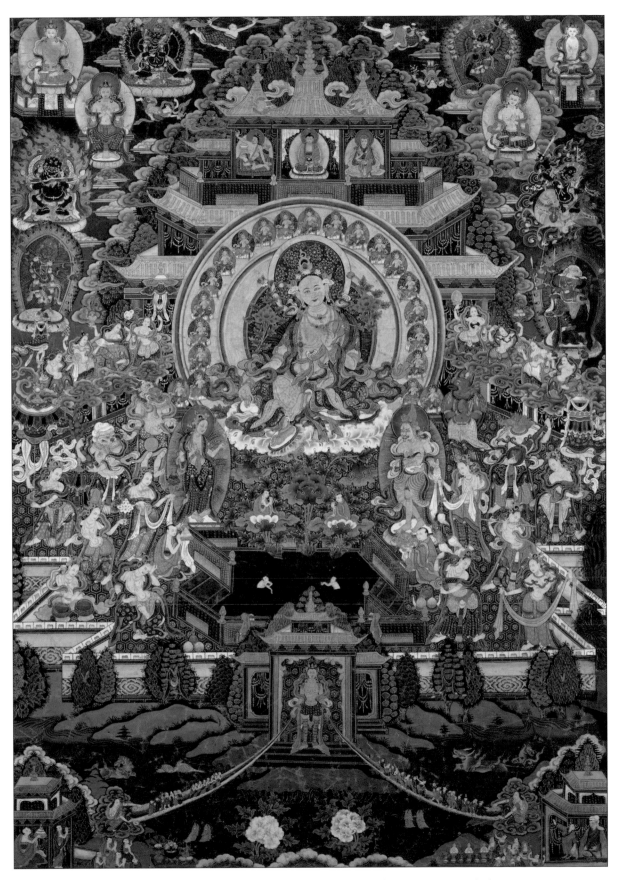

The Twenty-One Taras: A Sakya Interpretation, nineteenth century, 21 x 12.5 inches.

FOUR TARAS FROM THE ATISHA LINEAGE

We most often encounter the Twenty-One Taras as a set in a single painting. However, monasteries, nunneries and lama residences that maintained a strong tradition of the *Dolma Mandal Zhichok,* or "A Tara Ritual in Four Mandala Cycles," and the *Dolma Boom,* or *The 100,000 Taras,* would sometimes commission paintings of all twenty-one as individual pieces. Here we present four from a set inspired by the Atisha lineage of the transmission. All four reveal an intense beauty and subtlety of technique that is characteristic of the best in Tibetan art.

In accordance with tradition, the set is created with four Taras in each of the five color groups: a white Tara, for the buddha karma of peace/harmony; a yellow Tara, for the buddha karma of increase/prosperity; a red Tara, for the buddha karma of power/subduing; a blue Tara, for the buddha karma of wrath/violence; and a smoky (brownish) green for combination of the four karmas. In the set, each of these colors is presented in four different hues, to indicate the intensity of the particular karma and a movement from the basic buddha karma toward the next karma in the line of four.

Moreover, with each of the twenty-one paintings in the set, the central figure of Tara is surrounded by mandala deities, lineage masters, dakinis and Dharma protectors. The complete set acts as a map to all the Tantric practices that were central to the monastery to which the set belonged. Several tangkas in the set have Gelukpa lamas in the upper corners, indicating that they once belonged to a Gelukpa monastery, nunnery or lama residence. In fact these lama figures are various incarnations of the Panchen Lama, so the set would have come from a monastery affiliated with Tashi Lhunpo. The Yidam mandala deities, as well as the Dharma Protectors, also indicate that the set belonged to a Gelukpa institution or individual.

White Tara, from the Atisha Lineage of Twenty-One Taras

White in color, this White Tara has a peaceful and smiling countenance to indicate the buddha karma of peace/harmony. She sits with her right leg slightly extended and left withdrawn, indicating action transformed through meditation, and is surrounded by a lush green landscape. A small green female figure sits in front of her, offering her rolls of precious fabrics in a variety of colors.

At the top center is the healing buddha Amitayus, his hands in the posture of meditation. Green Tara sits to the left, and Healing Tara to the right. Three Dharma Protectors stand below, guarding the safety, prosperity and spiritual success of those who practice the Tara meditations.

The words "tenth to the left" are written in gold in her halo. The set of twenty-one would have been hung along a single wall in a line, with one in the center and ten to either side. This piece would stand tenth in placement to central Tara's left (the viewer's right).

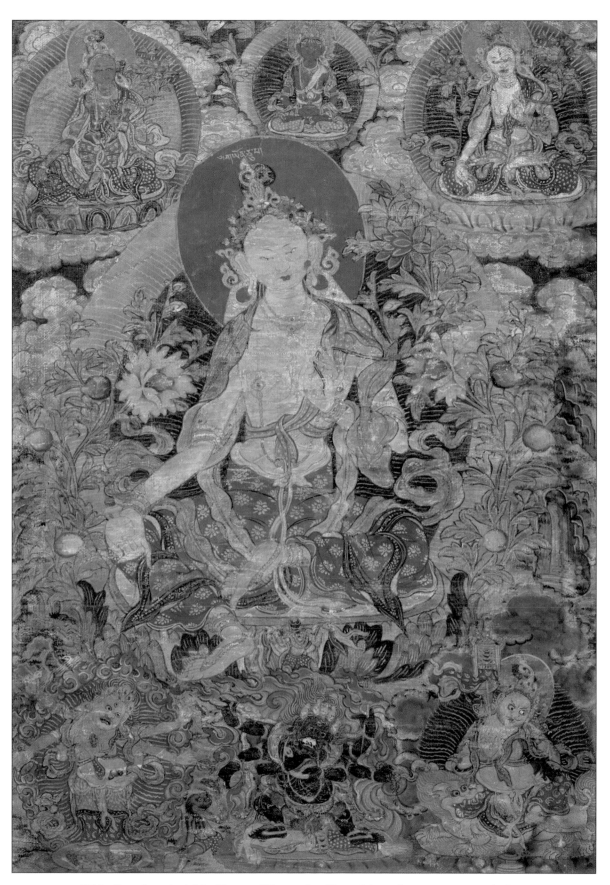

White Tara, from the Atisha Lineage of Twenty-One Taras, eighteenth century, 19 x 11.5 inches.

Yellow Tara, from the Atisha Lineage of Twenty-One Taras

Here the central Tara is yellow tinged with orange. A red female figure stands below and in front of her, offering foodstuffs on a plate of gold. Below her is a small dark man with his hands tied behind his back. Presumably he symbolizes how Tara practice brings freedom from bondage, slavery and imprisonment.

At the top left is the primordial buddha Vajradhara, dark blue in color, holding a vajra and bell, seated in sexual union with his consort, signifying the state of enlightenment attained by those who practice the Tara Tantra well. At the right sits the eleventh-century Indian master Atisha Dipamkara Shrijnana, the source of this lineage of the Twenty-One Taras.

Two Dharma Protectors stand below, guarding those who practice the enlightenment path.

The words "ninth to the left" are written in gold in her halo. This piece would stand ninth in placement to Central Tara's left (the viewer's right).

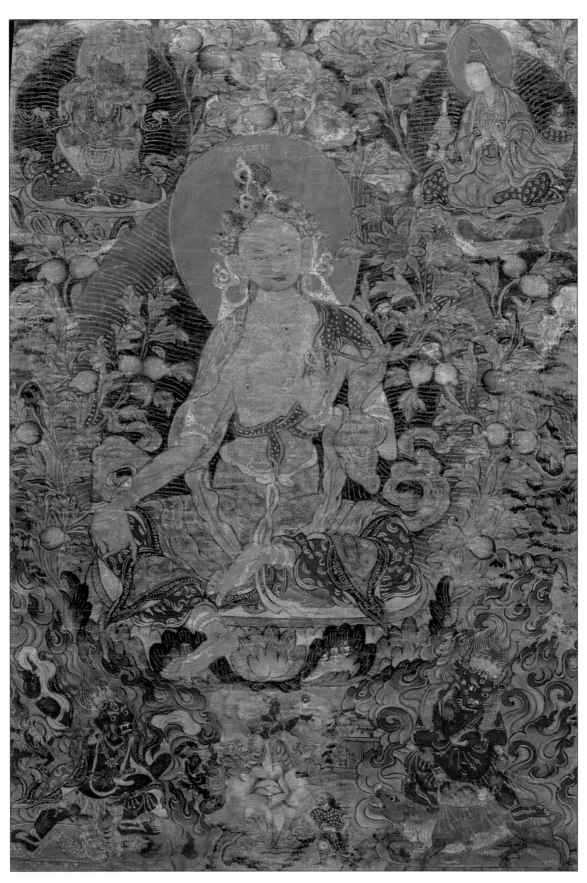

Yellow Tara, from the Atisha Lineage of Twenty-One Taras, eighteenth century, 17 x 11.5 inches.

Red Tara, from the Atisha Lineage of Twenty-One Taras

Here Tara appears in a slightly fierce form, and with three eyes. The third is the eye of fierce wisdom, which searches for what needs to be tamed in order for goodness and enlightenment to be accomplished.

Manjushri, the bodhisattva embodying the wisdom of infinity/emptiness, sits at the top of the painting. He holds a sword of wisdom, and a lotus supporting the Perfection of Wisdom Sutra. To his left is his wrathful emanation Vajrabhairava, "The Diamond Terror," also known as Yamantaka, "The Destroyer of Death." He stands in sexual union with the dakini Vajra Vetali, "The Resurrected Diamond." The symbolism is that Wrathful Tara works through the wisdom of infinity/emptiness in order to destroy the forces of death and resurrect those who have fallen to darkness.

A Gelukpa lama sits to Manjushri's right, his right hand in the mudra of teaching and left in the meditation mudra. The rainbow streaming from his heart to Manjushri and Yamantaka indicates that he was considered to be an emanation or incarnation of Manjushri. Several Gelukpa reincarnate lamas are considered to be Manjushri incarnations, with the Ling Tulkus being the most important in modern times. Perhaps this figure represents one of his early incarnations.

Two Dharma Protectors stand at the bottom of the painting. Both are in the "worldly protector" class, indicating that they are of Tibetan rather than Indian origin.

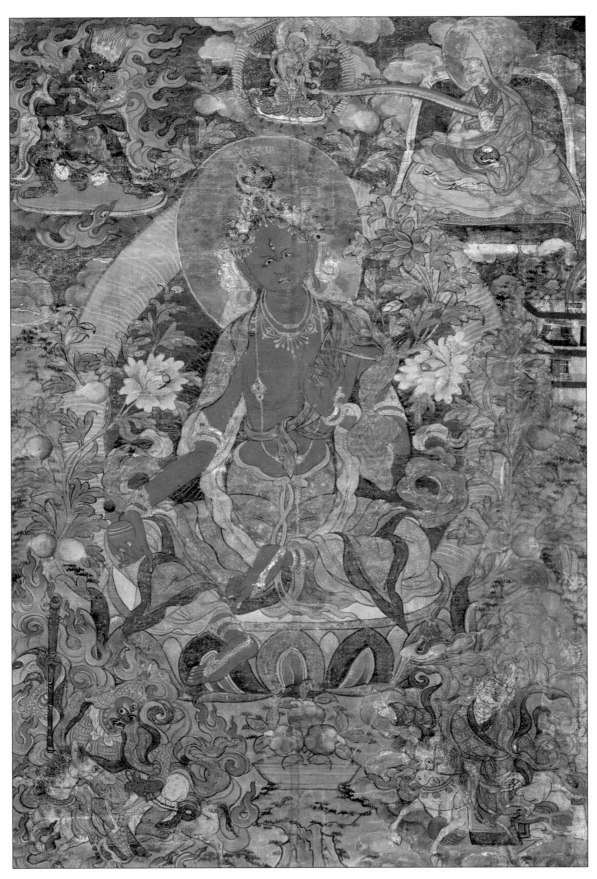

Red Tara, from the Atisha Lineage of Twenty-One Taras, eighteenth century, 19 x 11.5 inches.

Dark-Colored Tara, from the Atisha Lineage of Twenty-One Taras

Red-black Tara exhibits a slightly stern gaze, and shows bared fangs in a threatening manner. In front of her is a blue lapis lazuli bowl containing wishing jewels and a gold Dharma Wheel. This auspicious offering symbolizes how Tara practice fulfills all wishes and leads to the complete realization of Dharma, or enlightenment.

At the top left is the wrathful mandala Rakta Yamari, red in color with one face and two hands, in sexual union with a consort. At the right Lama Yunten Dorjey Pal, a disciple of the thirteenth-century-master Buton Rinchen Drup and pre-incarnation of the Panchen Lamas, is engaged in a wrathful exorcism ritual, holding a Tantric dagger with a black cloth tied to it as his exorcism tool. The face of the demon he is exorcizing appears in smoke and flames to his left.

Of the three monks seated at the bottom left, two are from either the Zhalu or Geluk schools, as indicated by their yellow hats. The other perhaps is Bodong Chokley Namgyal of the Jonang School, from whom the First Dalai Lama received his Tara lineages.

The Dharma Protector Mahakala stands off to the side below, holding a sandalwood staff in the right hand and a skullcup in the left, surrounded by orange fire of pristine wisdom awareness.

The words "fourth to the right" are written in gold in Tara's halo, indicating that the painting would stand fourth on the right of the central Tara (the viewer's left).

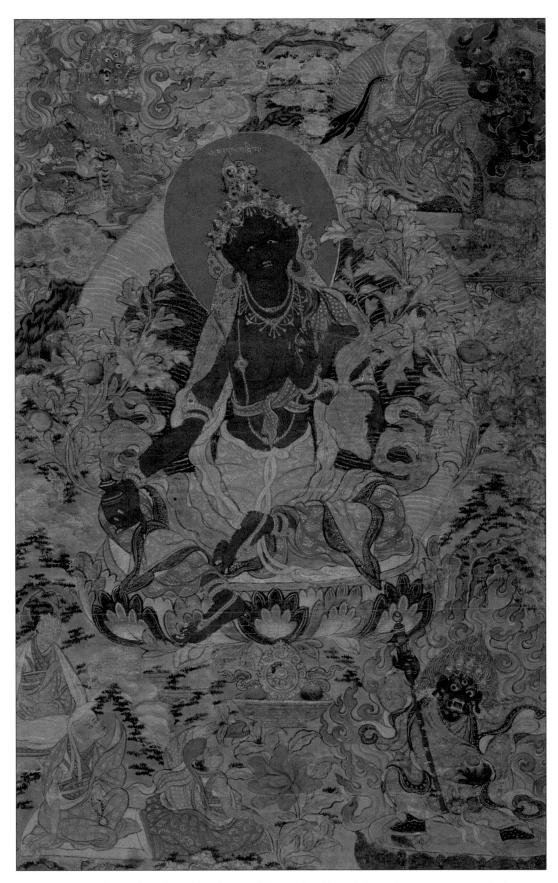

Dark-Colored Tara, from the Atisha Lineage of Twenty-One Taras, eighteenth century, 23 x 16.7 inches.

THE TWENTY-ONE VERSES IN PRAISE OF TARA

In his commentary to "The Praise of the Twenty-One Taras," the First Dalai Lama quotes the Sanskrit text from which the verses are extracted and from which the Tibetan translation was made. He refers to these verses as a *dharani*, which is more or less equivalent to a mantra. Thus the recitation of the text has less to do with the actual meaning of the words than with the blessings that the tradition of the recitation carries. The Tibetan verses are four lines in length, with each line having eight meters and the emphasis being on the first, third, fifth and seventh participles. The verses are usually chanted in a fast, slightly sing-song monotone, somewhat like a drum beat moving between four different drums, with each being hit twice in each line.

He comments on the meaning of the name Tara: "Tara means free, or liberated. The name indicates the state beyond the ocean of suffering. Being a female term, it also refers to the state wherein all sentient beings are held with an equal love, where attachment and aversion have been overcome. Tara symbolizes the love for all sentient beings that resembles the love that a mother holds for all her children, being without discrimination and being equally strong for all."

He then gives the verses, with a commentary on their meaning, and also gives the epithet of Tara with which each verse is associated. The verses and epithets are as follows. Space does not permit the commentary.

1. *Hail Tara swift and fearless,*
 Whose eyes flash like lightning;
 She born from a lotus in an ocean of tears
 Of Avalokiteshvara, Lord of the Three Worlds.
 (This verse refers to the form of Tara known as "Tara the Heroine.")

2. *Hail she whose face is made*
 Of one hundred full autumn moons
 And blazes with the dazzling light
 Of a thousand constellations.
 (This verse is "Tara of White Luster.")

3. *Hail she with hands adorned by lotus flowers,*
 Golden blue Tara, embodiment
 of the perfections:
 Generosity, joyous effort, pacifying discipline,
 Patience, meditation and wisdom of the ultimate.
 (This is "Tara of Golden Hue.")

4. *Hail she who crowns the heads of all buddhas,*
 Whose action is victorious without limit.
 Attained to every perfection,
 The bodhisattvas themselves rely upon you.
 (This is "Victorious Ushnisha Tara.")

5. *Hail she who, uttering tuttare and hum,*
 Tramples to dust under her feet
 The seven worlds of desire, form and space
 And has power to invoke all forces.
 (This is "Tara Who Resonates the Mantra Hum.")

6. *Hail Tara, an object of worship*
 To all the worldly gods that exist.
 Even the spirits, vetali, gandharas and yakshas
 Sing praises at her feet.
 (This verse refers to "Totally Victorious Tara.")

7. *Hail she who, uttering hrad and phat,*
 Thoroughly destroys external threats.
 Her right leg drawn in and left extended,
 She blazes amidst darting flames.
 (This verse is to "Tara Who Destroys Negativity.")

8. *Hail to Ture, who vanquishes*
 The great terrors and the mightiest devils.
 With a wrathful twist of her lotus face,
 She clears all foes without exception.
 (This is "Tara Who Heralds Supreme Power.")

9. *Hail she exquisitely adorned*
 By the hand mudra Three Jewels at her heart.
 Her glorious wheel fills all directions
 With an overwhelming burst of light.
 (This is "Tara of the Rosewood Forest.")

10. *Hail she brilliant with joy,*
 Her radiant crown the source of a garland of light.
 Smiling and laughing she utters tuttare
 And overpowers devils and gods of the world.
 (This is "Tara Who Dispels Sorrow.")

11. *Hail she with power to invoke*
 All the armies of Dharma Protectors.
 With face fiercely wrinkled and a vibrant hum
 She brings freedom from every poverty.
 (This is "Tara Who Invokes.")

12. *Hail she crowned by a crescent moon,*
 Her head ornament dazzlingly bright.
 From her hair-knot Buddha Amitabha
 Constantly beams forth streams of light.
(This verse is to "Tara of Auspicious Brilliance.")

13. *Hail she who dwells within a garland*
 Of flames like the eon ending in fire.
 Her right leg stretched and left withdrawn,
 Joy of her followers and scourge of their foes.
(This is "Tara Who Bestows Maturity.")

14. *Hail she whose feet pound*
 And palms of hands press upon the earth.
 With a wrathful glance and the sound hum
 She subdues all in the seven dimensions.
(This is "Tara with Vibrant Lines of Wrath.")

15. *Hail the blissful virtuous, peaceful one,*
 She who acts from within nirvana's serenity.
 With the pure sounds svaha and also om
 She annihilates even the greatest evils.
(This verse is in reference to "Tara of Virtuous and Creative Serenity.")

16. *Hail she whose followers are joyous,*
 Who utterly destroys the forms of enemies.
 The knowledge letter hum and the ten-syllable mantra
 Arranged on her heart's wheel bestow liberation.
(The ten-syllable mantra refers to the root mantra: *om tare tuttare ture svaha.* The knowledge letter hum indicates the wrathful mantra: *Om nama tare name hara hum hara svaha.* By the power of these two mantras one destroys the two enemies of liberation: (a) grasping at a false self within; and (b) clinging to permanent, substantial existence in the external world. This is "Tara, Destroyer of Grasping.")

17. *Hail Ture, she with pounding feet*
 Whose essence is the seed letter hum;
 Who causes the mountains Meru, Mandhara
 and Vindhya
 And all the three worlds to tremble and quake.
(This is "Tara Who Produces Bliss.")

18. *I prostrate to she who holds in her hand*
 A moon resembling a celestial lake.
 Saying ture twice and also the sound phat
 She dispels poisons entirely and forever.
(This is "Totally Victorious Tara.")

19. *Hail to she upon whom even*
 The kings of gods and divinities rely.
 Her armor mantras radiating joy to all,
 She soothes conflicts and nightmares as well.
(This is "Tara Who Consumes Sorrow.")

20. *Hail she whose two eyes*
 Like the sun and moon are brilliant.
 Saying hara twice and also tuttare
 She calms and quells the most fearful disease.
(This is "Tara, Source of Siddhi.")

21. *Hail she whose three natures*
 Are made perfect with serene strength
 Able to eliminate demons, zombies and ghosts.
 O Ture, most exalted of the supreme.
(This is "Tara Who Brings Complete Perfection.")

The First Dalai Lama then points out that the dharani concludes with verses that elucidate four themes: the attitude of the practitioner; the time for practice; the beneficial effects of the practice; and the number of recitations to be performed, together with a summary of the beneficial effects that are produced.

> *Those who joyfully recite this dharani*
> *With a clear and appreciative mind,*
> *Mindful of the practice, at dusk and dawn,*
> *Achieve freedom from every fear.*
> *All their negative karma is pacified,*
> *And the lower realms are destroyed for them.*
>
> *Seven million buddhas will manifest*
> *And bestow empowering initiations;*
> *Yet they will gain even further greatness,*
> *For they shall attain final buddhahood itself.*
>
> *The strong poisons opposing that*
> *attainment,*
> *Together with the stable and moving poisons,*
> *And any harmful element eaten or*
> *imbibed—*
> *All are eliminated by recollecting Arya Tara.*
>
> *The host of painful sufferings*
> *Caused by ghosts, diseases or poisons*
> *Are totally eliminated,*
> *Even for other sentient beings.*

If one recites this Tara dharani
Two, three, or seven times,
Those wanting a child will obtain one,
Those wanting wealth will gain it,
All prayers will be fulfilled,
And all hindrances destroyed.

The First Dalai Lama here explains, "The basis for recitation of the dharani of the twenty-one Taras is the renowned 'Tara Ritual in Four Mandala Cycles'." Readers may remember our discussion of this ritual at the beginning of the section on the Twenty-one Taras in this chapter.

He goes on to explain the numbers "two, three, or seven times" from the second line of the above verse. Here the word "two" means that those wishing a child should perform the Tara Ritual in Four Mandala Cycles twice; "three" means that those wanting prosperity should perform the rite three times; and "seven" means that all prayers shall be answered for those who perform it seven times."

He then relates how in another tradition the numbers given here are used as the basis of a one-day intensive practice. "Two," he states, refers to two prerequisite qualifications of the practitioner: he or she should be of sharp intellect and should possess the stability provided by appreciative faith. "Three" refers to the number of recitations to be done during both the dawn and the dusk sittings, which, together with one recitation during the day, means "seven" daily recitations of the dharani.

He points out that there is also a tradition of using the twenty-one verses and related mantras as the basis for a twenty-one-day intensive. Here, he states, "two, three and seven" are interpreted as follows: If someone possessing the two qualities recites the dharani seven times each day as described above in three sessions for three times seven days—that is, for three weeks—all wishes will be fulfilled and one will become a treasury of fearlessness. Interferences to attainment will become impotent and all hindrances will be abandoned by means of their direct opponents.

Finally he comments on a practice tradition from the renowned Zhalu lama Buton Rinchen Drup, who gave a procedure for a seven-day intensive. According to his tradition, "two" refers to day and night, and "three" means that three sessions are to be performed during each of these two periods. The three daily sessions are to be performed just after sunrise, at noon and just before sunset; the three nightly sessions at dusk, midnight and early dawn. Thus practicing six sessions a day for seven days, the dharani is read forty-two times. He quotes Buton as saying, "Were one to pursue the practice of the dharani recitation in a continuous stream in this way for a week, all of the beneficial effects described above will be produced."

Of note, the First Dalai Lama here lists twenty-one different epithets of Arya Tara and links one to each of the twenty-one verses of the dharani. There is also a tradition of 108 epithets of Tara, and no doubt an artistic tradition does exist with them. However, whereas the twenty-one listed by the First Dalai Lama became very popular with the Tibetans and other Central Asians, the tradition of 108 Taras seems to have received very little notice from them.

THE EIGHT TARAS WHO PROTECT FROM THE EIGHT DANGERS

Another interesting artistic tradition connected to Arya Tara is that of "The Eight Taras Who Protect from the Eight Dangers." As with the practice of the Twenty-One Taras, the source of the tradition is *The Tara Root Tantra*. In particular, chapter 11 of *The Root Tantra* contains a short text that is regarded as the basis of the tradition. It also is termed a "dharani" and is recited somewhat in the same manner as a mantra.

The text, like that of the Twenty-One Taras, is included in the large anthology known in Tibetan as the *Zung Du*, or *Collected Dharanis*, a version of which is owned by most Tibetan monks, nuns and shamans. Usually it is referred to as *The Dharani of Tara Who Protects from the Eight Dangers*. Although extracted from chapter 11 of *The Tara Root Tantra*, it is also sometimes seen as *The Sutra of the Taras Who Protect from the Eight Dangers*. Perhaps the reason for the discrepancy is that the language of the first eighteen verses of the text seem more like the Sutra linguistic than that of the Tantric tradition.

Tibetans frequently commission monks, nuns or shamans to chant aloud the *Zung Du*, or *Collected Dharanis*, on their behalf. The anthology is large, and the reading takes four professional ritualists a full day to complete. This is about the only occasion one hears *The Dharani of the Taras Who Protect from the Eight Dangers* being chanted. Unlike the text of the Twenty-One Taras, which everyone knows by heart, very few Tibetans memorize *The Dharani of the Taras Who Protect from the Eight Dangers*. Most Tibetans are more familiar with the reference to the eight in the First Dalai Lama's *Lek Trima*, a text we have already quoted with some frequency.

Tibetans are also very familiar with the eight as an artistic tradition, for paintings on the subject are frequently encountered in Tara chapels of larger monasteries. Artist renditions of the Taras who protect from the eight dangers are especially popular in Gelukpa monasteries, due to the First Dalai Lama's *Lek Trima*.

Sometimes the theme is presented in a single painting, with Arya Tara seated at the center and eight other Taras arranged around her. The "danger" from which each of these eight Taras establishes protection is usually also depicted.

Alternatively, the eight themes are occasionally treated individually, with one tangka being dedicated to each. We include both traditions here.

Detail from tangka on page 95.

The Eight Taras Who Protect from the Eight Dangers

The centerpiece of our tangka is green Arya Tara, seated serenely amidst scenes of worldly strife. Her body is green, symbolizing enlightenment activity, although here she is painted in gold as an offering. The eight Taras who protect from the eight dangers are similarly covered in gold. Buddha Amitabha sits at the top center of the painting, his hands in the mudra of meditation.

The eight Taras are arranged around her as follows:

(1) To her right we see two small figures of monks offering petitions to be saved from the danger of water.

(2) The Tara who protects from the danger lions sits to Amitabha's left.

(3) The Tara who protects from the danger of fire sits on a thick rain cloud below that, her right hand holding a vase from which she pours forth abundant water.

(4) The Tara who protects from the danger and fear of snakes sits in the lower left corner, where she protects a laywoman;

(5) At the top right, Tara protects a layman from the danger and fear of a rampaging elephant.

(6) Below that, she protects a lone traveler from the danger and fear of two marauding thieves on horseback.

(7) Below that, she protects a fervent petitioner from the danger and fear of imprisonment from unjust rulers.

(8) At the bottom center, a Tara sits beside a cluster of wishing jewels and precious objects, and protects a lay couple from the attack of a red demon.

Nothing in the tangka indicates the school or sect to which the patron belonged. However, the attire of the couple depicted in the house in the lower right hand corner suggests that it is from northeast Tibet. They are shown as happy, healthy and prosperous, natural qualities of life for those who meditate upon the Eight Taras.

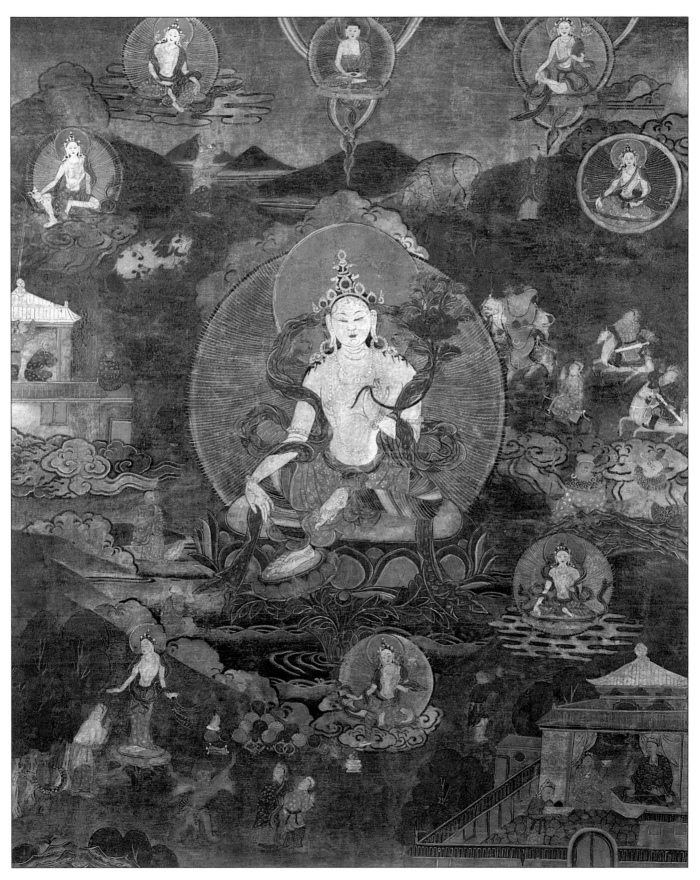

The Eight Taras Who Protect from the Eight Dangers, eighteenth century, 25.5 x 17.2 inches.

The Centerpiece for the Taras Who Protect from the Eight Dangers

Sets of paintings in Tibetan art are often designed with the idea that they will be hung in a row on a single wall. When this is the case, an extra painting is created to act as a centerpiece, usually with the main image staring straight ahead. The main figure in each of the tangkas to be hung to the right and left of the centerpiece will be set in profile, as though looking in toward the center of the group. Thus all the central figures on the right are looking left, and all the ones on the left are looking to the right. This is the situation with our set of eight Taras protecting from the eight dangers. In fact there are nine of them, with one serving as the centerpiece.

Here the central Tara looks straight ahead at us. The four to either side have established complete protection from the eight dangers, so the scenes around her are ones of peace and tranquility. This differs considerably from the backgrounds of the other tangkas in the set, where we see people being attacked by thieves, wild animals, and so forth, with only those ones who remember to invoke Tara being saved.

A couple sits happily in the upper storey of their large house and gazes out over the beauty of the world in which they live. Precious jewels, rolls of cloth, and bags of goodies sit on a shelf at the back, symbolizing their worldly success and prosperity. In the lower room we see another person, perhaps a son, again with jewels, rolls of cloth and so forth off to the side. Another family member strolls on the bridge and enjoys the moment with the swans, ducks and geese depicted in the stream that has been channeled under their house.

As in all the paintings in this set, the artist reveals his/her love for architecture and landscape engineering. The house and its relationship to the land around it reveal an exquisite attention to detail. It is built above a stream, with a sunken lotus pond off to the right, the waters around the house moving between four different levels to provide beautiful sounds and also a cooling effect. The overall scene is one of beauty and harmony, with waterfowl playing under the bridge, and the sun, moon, clouds, water, trees and flowers all in balance. Tara's divine palace is similarly beautiful, with gardens having ponds, streams, and so forth.

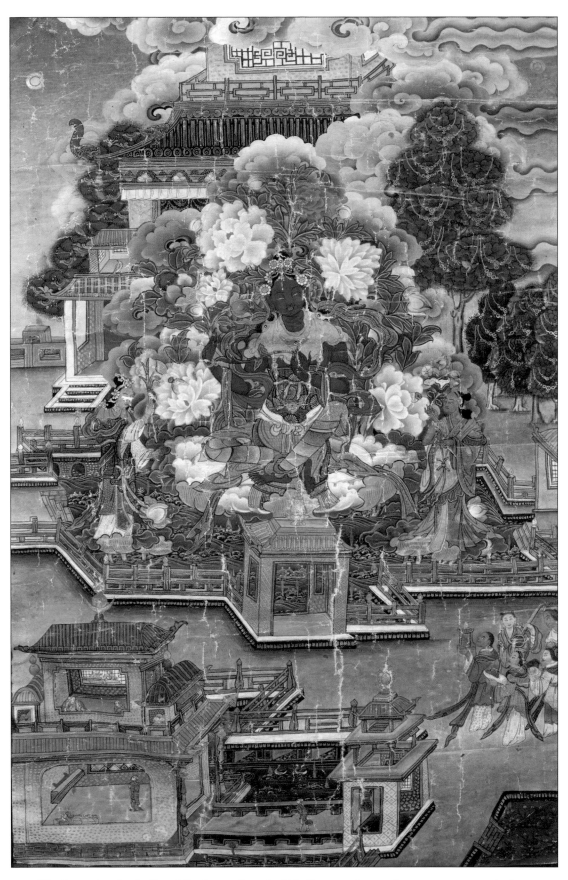

The Centerpiece for the Taras Who Protect from the Eight Dangers, nineteenth century, 52.5 x 31.2 inches.

Tara Who Protects from the Danger of Lions

The First Dalai Lama wrote in his hymn to Tara entitled *Lek Trima*,

> *Protect us from the terrifying lion of pride,*
> *Which dwells on the mountain of wrongly*
> * held views,*
> *An inflated mentality holding itself as*
> * superior*
> *And wielding a claw to belittle the world.*

The first of the eight dangers is attack from lions. This is a metaphor for lion-like pride which, as the First Dalai Lama puts it, "dwells on the mountain of wrongly held views." In other words, pride is a distorted state of consciousness based on an erroneous understanding of reality. It is "an inflated mentality holding itself as superior," and it strikes with "a claw to belittle the world."

Tara sits facing to the right, meaning that the painting would be hung to the left of the centerpiece. Below and to the right, a snow lion attacks a traveler. However, an emana-tion of Tara, perhaps in the form of Parnashavari, "The Leaf-Clad Female Buddha," pulls the traveler to safety and pushes back the lion with a wave of her hand.

Two deer grazing calmly in the lower foreground are a sign of the peace and harmony established by Tara meditation. One represents universal love and the other the wisdom of infinity/emptiness. Lotus flowers bloom in the lake on the lower right, symbolizing the purity and beauty inspired by Tara practice.

Buddhist history is rich in anecdotes of mystics who tamed wild animals through the power of their wisdom, love and meditation. For example, when the eighth century Indian monk Shantideva was kicked out of the monastery for doing nothing but eating, sleeping and going to the toilet, he levitated off into the distance and disappeared. Impressed by the feat, everyone felt shamed and wanted to find him and bring him back. However, when they eventually spotted him he was meditating in a jungle cave, with two lions snoozing beside him, their heads in his lap.

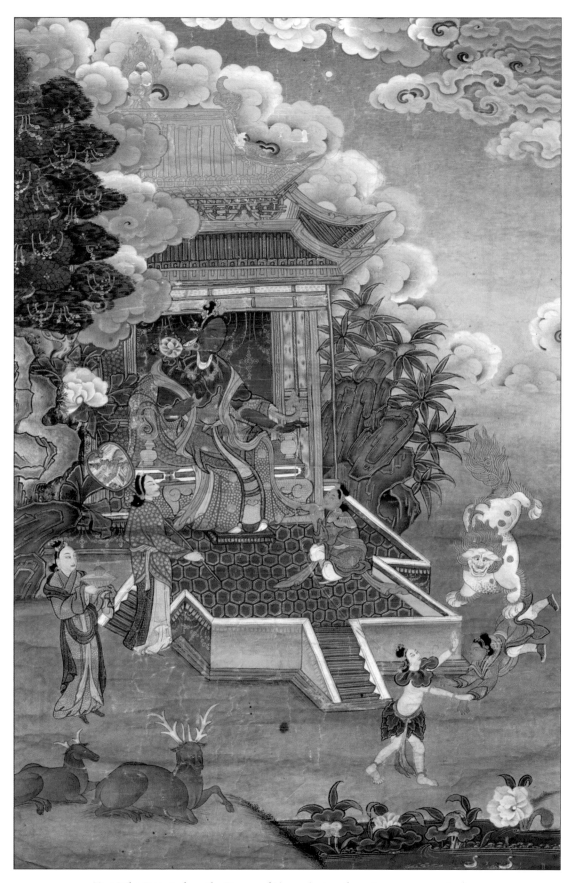

Tara Who Protects from the Danger of Lions, nineteenth century, 52.5 x 31.2 inches.

Tara Who Protects from the Danger of Elephants

The First Dalai Lama wrote,

> *Protect us from the terrifying elephant*
> *ignorance, that,*
> *Untamed by the sharp hooks of mindful*
> *alertness*
> *And confused by the wine of sensual*
> *indulgence,*
> *Leads us down the wrong paths toward*
> *sharp fangs of pain.*

The drunken elephant is a metaphor for ignorance in its two forms of mis-knowledge and unknowing. When the mind is untamed by the hook of meditative awareness and instead is driven wild by the alcohol of indulgence and addiction, one enters wrong paths and comes to suffering.

In the painting we see a scene of a lady with a basket strapped to her back. It seems to contain foliage, suggesting that she had gone to the forest to collect medicinal herbs, or perhaps wild greens. A wild elephant attacks her; however, she recites a Tara mantra, and the animal is immediately subdued and the danger averted.

In the same way, meditation on Arya Tara subdues the elephant of ignorance within the mind by revealing the true nature of reality, and consequently protects from the danger of the result of ignorance, which is suffering.

A number of details in this tangka contribute to the transporting effect that it has upon the viewer: the carpet on the deck leading to Tara's seat; the trees that stand so stately behind and to the side; the flowers in bloom; the swirls in the boulder; and of course the clouds, which convey entire worlds of mood.

Anecdotes showing the ability of spiritual power to overcome an angry elephant go back to the time of the Buddha and beyond. For example, someone once tried to kill the Buddha with an elephant. He knew that the Buddha would be walking through a narrow road at a particular time, and he lay in wait. When the time drew near he gave the elephant a barrel of alcohol to get it drunk. He then prodded it with an iron hook until it was enraged, and released it toward the Buddha. The elephant raced along the road in a fit of drunken rage, destroying all in its path. When the Buddha beheld it charging at him, he looked deeply into its eyes and said a mantra. The elephant immediately sank to the earth peacefully and fell into a deep sleep.

Because the Tara in the painting is facing to the viewer's left, it would be hung to the right of the centerpiece tangka.

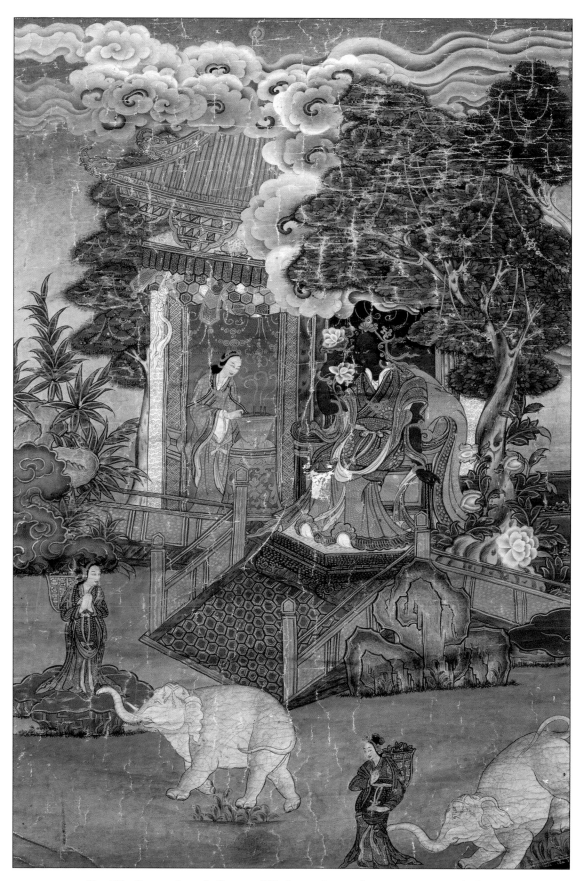

Tara Who Protects from the Danger of Elephants, nineteenth century, 52.5 x 31.2 inches.

Tara Who Protects from the Danger of Fire

The First Dalai Lama wrote,

> *Protect us from the terrifying fires of anger*
> *That, roused by the winds of deluded*
> * thought,*
> *Billow forth swirling smoke-clouds of wrong*
> * actions*
> *Razing the slow-grown forests of worth.*

Anger is like a terrible fire. As with all the distorted emotions, it is based in wrong understanding of reality. It becomes ignited by the winds of negative thinking and releases billowing clouds of negative activity that destroy the forest of our happiness, which took so much time and effort to grow.

In the lower right of the tangka we see a house being consumed by flames. Tara seems to be holding up a conch shell; presumably it is filled with water that will be used to extinguish the fire. In any event, the husband and wife call to Tara and manage to escape an unpleasant death.

In the sky above we see a bird of paradise flying in, a branch of the legendary healing tree laden with medicinal berries in its mouth. An attendant holds up a delicate parasol.

The artist here again shows us his interests in landscape architecture. In the foreground to the right we see a spout coming out of the earth, with water flowing from its mouth into a manmade pool. It overflows and continues into a larger pool below, where it contributes to the view from the house window.

Tara sits in a simple meditation hut, an auspicious bamboo tree off to its left. The roof of her hut reveals a pink seat, presumably for her to sit and enjoy sunrises and sunsets. She is facing to the viewer's right, so the tangka would be hung to the left of the centerpiece.

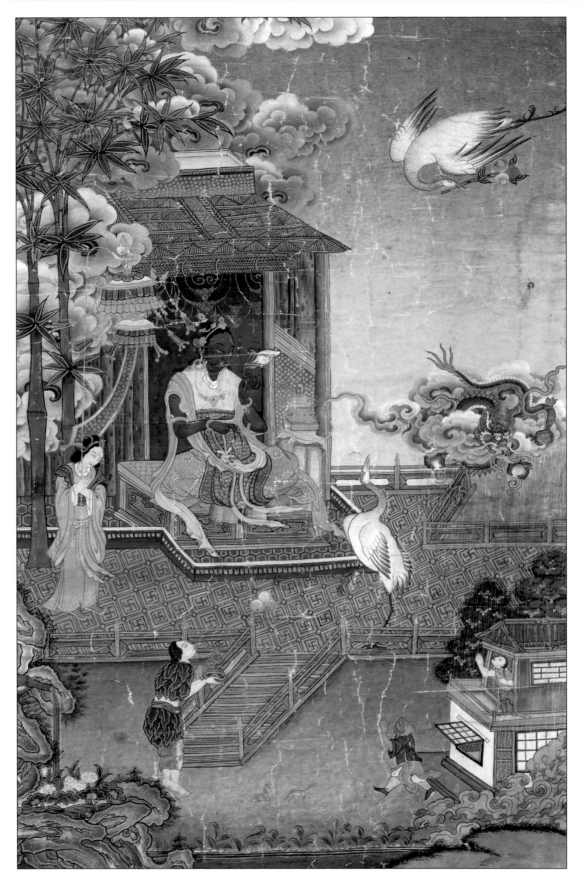

Tara Who Protects from the Danger of Fire, nineteenth century, 52.5 x 31.2 inches.

Tara Who Protects from the Danger of Thieves

The First Dalai Lama wrote,

> Protect us from the dreaded thief
> preconception,
> That creates the wilderness of inferior codes,
> The barren wastes of eternalism and
> nihilism,
> Destroying towns and sanctuaries of virtue
> and joy.

The scene at the bottom center of the painting depicts a group of travelers under attack from thieves. Their horses and elephants, laden with their cargo, stand off to the left. One of the travelers has been killed and impaled on a tree stump; another has suffered a knife wound to the throat; and a third lies on the ground in agony.

Fortunately one of them remembers to offer a prayer of supplication to Tara, who immediately sends two heroes to the rescue of the group. These heroes can be seen racing down the steps of Tara's abode and charging in the direction of the disaster, one with bow and arrow at the ready and the other with sword raised and ready to strike.

Once more the artist's attention to architectural detail is in evidence. Tara's divine palace has a most exquisitely tiled walkway in front of it, with a view of sea and mountains off to the side. The trees standing beside it offer both natural beauty and eco-friendly air conditioning, providing cool shade in the summer and protection from the cold winds of winter.

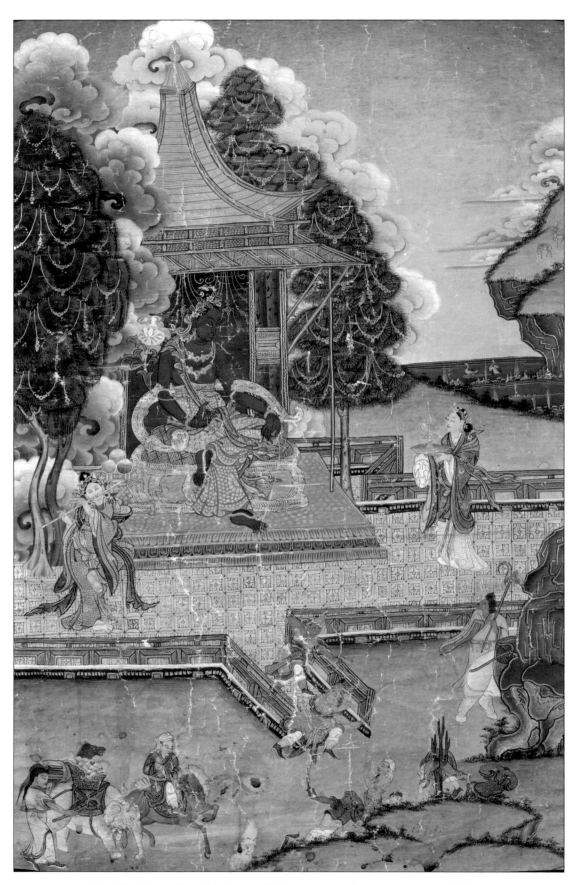

Tara Who Protects from the Danger of Thieves, nineteenth century, 52.5 x 31.2 inches.

Tara Who Protects from the Danger of Imprisonment

The First Dalai Lama wrote,

> Protect us from the terrifying shackles of
> miserliness
> That lock us in attachment difficult to
> spring
> And binds all living beings helplessly
> To the unbearable prison of cyclic existence.

In the lower left corner a man languishes in prison, naked, cold and in shackles. Outside, a businessman, perhaps a relative attempting to buy the prisoner's freedom, looks on with a forlorn expression. In the palace above, the wealthy person enjoys life as usual with his family and friends.

Buddhism has always taken a cynical attitude toward the human justice system. The first of the six perfections of an aspiring bodhisattva is the practice of generosity. One of the three forms of the bodhisattva generosity is the giving of sanctuary to those pursued by the government or the law. The poor and downtrodden languish in prisons, while the rich eat cake and drink wine. This has always been the case in human society, and certainly is so today every bit as much as in the distant past.

However, salvation for our naked and shackled prisoner is at hand. Above we see a lady, presumably his wife, offering supplications to Tara. A rainbow phoenix swoops down from Tara's mystical abode and gazes upon him with sympathy, heralding the advent of his freedom.

Here Tara is facing to the viewer's left, so the painting would be hung to the right of the centerpiece.

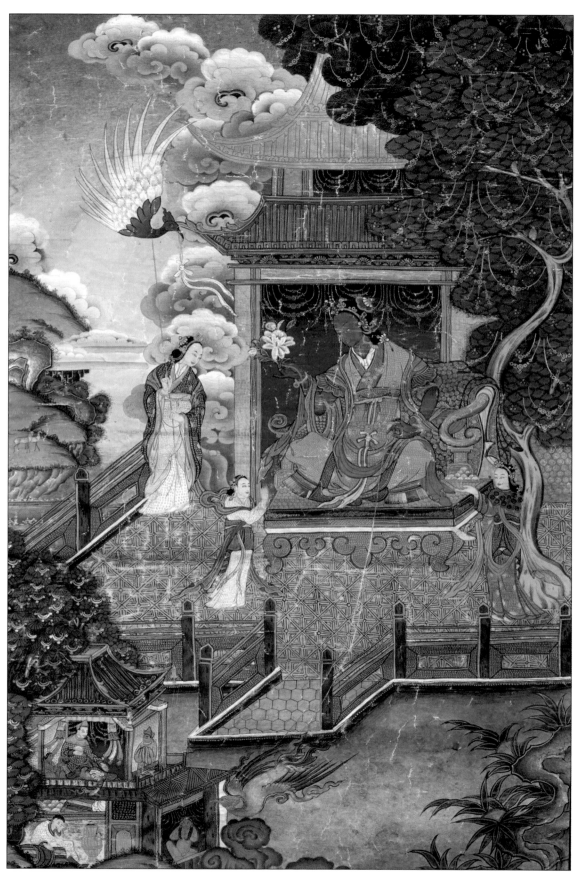

Tara Who Protects from the Danger of Imprisonment, nineteenth century, 52.5 x 31.2 inches.

Tara Who Protects from the Danger of Drowning

The First Dalai Lama wrote,

> *Protect us from the terrifying waters of
> desire
> That carry us relentlessly in the current of
> samsara,
> Where, conditioned by the propelling winds
> of our karma,
> We are tossed in the waves of birth, sickness,
> aging and death.*

The water scene depicts two boats. One on the left is under attack from a sea monster. Its three passengers offer reverent supplications to Tara and escape unharmed. The boat on the right has stopped at the gateway to Tara's palace, and the three passengers are engaged in offering devotions at Tara's feet. In that the three passengers in each of the two boats are dressed in the same attire and have much the same look about them, we can presume that these are "before" and "after" takes on the situation.

The artist again shows us his architectural wizardry. The upper floor of Tara's residence has an exquisite sunroom and deck. Trees stand on all sides of it, their branches adorned with jewels and songbirds, and providing shade and fragrance.

Tara is depicted as facing to the viewer's right, so the painting would be hung to the left of the centerpiece.

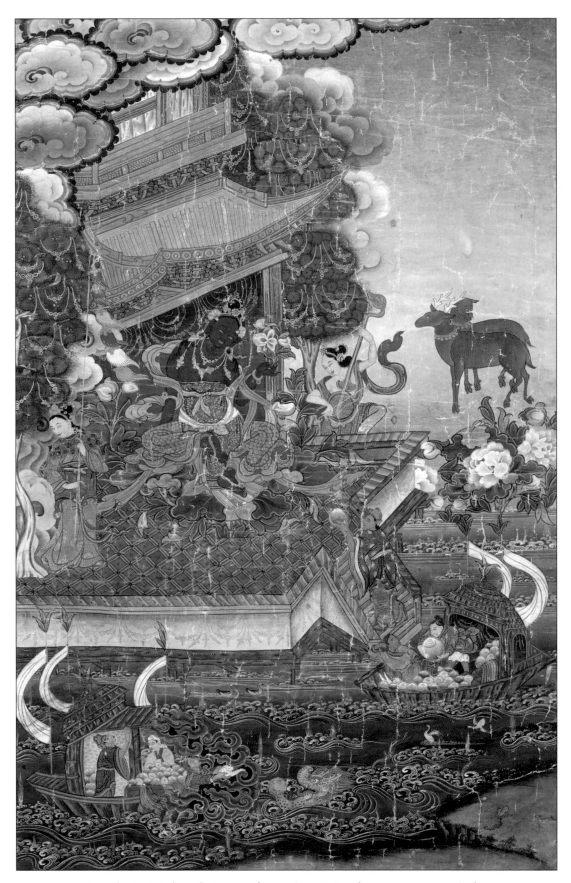

Tara Who Protects from the Danger of Drowning, nineteenth century, 52.5 x 31.2 inches.

Tara Who Protects from the Danger of Ghosts

The First Dalai Lama wrote,

> Protect us from the terrifying ghost
> hesitation,
> That malignant spirit which in unknowing
> roams,
> Attacking those with interest in ultimate
> aims
> And obstructing the path to freedom and
> joy.

The painting is identified by the scene in the lower left, where a monk is being bothered by two malignant spirits. Off to the right, a malignant spirit makes offerings to the monk. Again, this is a "before" and "after" take on the situation. Tara practice not only eliminates the disturbances of malignant spirits and ghosts, it brings them to the enlightenment path, where they serve as protectors of meditators.

The First Dalai Lama gives the inner meaning: the ghost of doubt and hesitation. Hesitation is one of the fifty-one secondary mindsets, and is likened to trying to sew with a needle having a point on both ends and no eye for the thread. The person afflicted with constant doubt and hesitation cannot sew the fabric of his or her destiny, and is rendered impotent with paralysis in all important life situations. This is like the monk in the painting, whose attentions seem to be alternating between the two ghosts. The solution is to rely upon Tara meditation, which creates a link to buddha activity and dispels hesitation and indecisiveness.

The artist gives us another treat from his architectural genius. Tara's residence is encircled by a fence with two layers of bamboo pipes as its railings. Water is fed through these pipes and spills out into a pool to her right. She thus constantly hears the delightful sounds of running water, while simultaneously her house is air-conditioned by the water's cooling presence.

Here Tara is again facing to the viewer's left, so the painting would be hung to the right of the centerpiece.

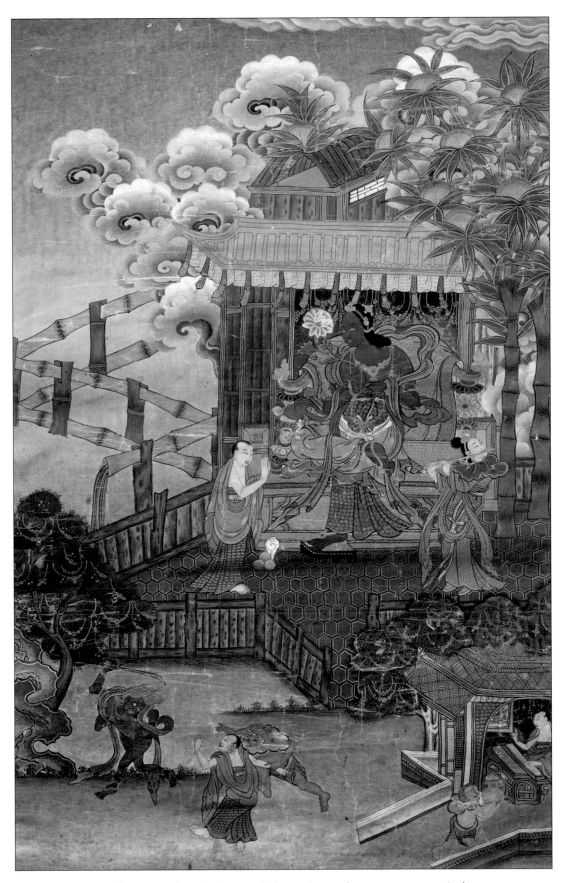

Tara Who Protects from the Danger of Ghosts, nineteenth century, 52.5 x 31.2 inches.

The Healing Trinty

Three healing buddhas, detail from tangka on page 103.

Tibetans like to place many of their buddhas and bodhisattvas in sets of three. It is a natural extension of the Buddhist love for trinities, such as the Three Kayas (i.e., Dharmakaya, Samboghakaya and Nirmanakaya), the Three Jewels (Buddha, Dharma and Sangha), the Three Roots (Lama, Yidam and Daka/Dakini), the three quintessential spiritual powers (compassion, wisdom and power), the three doors of karma (body, speech and mind), the three times (past, present and future), the three essential moments (waking, sleeping and dreaming) and so forth.

One of the most commonly seen trinities is that of the three healing buddhas: White Tara; Amitayus; and Ushnisha Vijaya. The first and third of these are female, and although the second is male, its most popular lineages of practice in Tibet come from an eleventh-century female mystic from Nepal. Sometimes one sees the three together in one painting and sometimes as separate paintings hung together as a set.

The first two of these Tantric systems are best known by ordinary Tibetans because of the tradition of *tsewang*, or "life-enhancement initiation ceremony." The tsewang is one of the most common public empowerment ceremonies given by high lamas of all schools of Tibetan Buddhism on their travels. Any traveling lama would expect to be asked to give a *tsewang* in many of the towns and villages on the circuit. Lay Tibetans love the tsewang because it is presented as a guided meditation, with the lama explaining each step clearly, and the crowd joining in with the visualizations and mantra recitations. They also love the tsewang because blessed substances to eat and drink are passed out at various phases of the ceremony. Generally these periods are marked by extraordinary pushing and shoving, because everyone wants to be first in line to receive these substances. This contributes to the excitement of the affair. There are also plenty of "repeat after me" verses during the ceremony, adding to the sense of participation.

The meditational and devotional practices associated with these three Tantric buddha forms became especially popular in the mid-eleventh century with the Sarma or "New Schools" that formed during this time: the Kadam, Kargyu and Sakya. They did exist in Tibet before this time with the Nyingma, or Old Schools, but only one of the three Tantric systems, that of Amitayus, achieved any serious degree of interest. Moreover, the Amitayus lineage of practice in the Old Schools was not that of the female mystic from Nepal, but a male lineage of transmission from India. In more modern times the Nyingma have mostly relied on *Terma,* or "Revealed Treasure Transmissions," from the visions of lamas from the fourteenth century and later in all their versions of these three traditions.

Both the First Panchen Lama and the Fifth Dalai Lama, wrote extensively on all three of these Tantric traditions in the mid-seventeenth century, launching a renewed interest in them that has continued to the present era. In recent decades the present Dalai Lama, the present Sakya Trizin Lama, and the great Tai Situpa of the Karma Kargyu have all given frequent initiations into them, thus continuing the legacy.

These later lamas are all refugees living in India. It is interesting to note that the Healing Trinity also played an important role back in Tibet with the lamas who chose to remain and stand up to the Chinese at home rather than work for Tibetan rights from abroad.

Readers familiar with modern Tibetan history will know of the great destruction that befell Central Asia as a result of the barbaric Communist onslaughts. Many will also know of the liberalization that swept China in the 1980s and resulted in the release of most political prisoners, including many high Tibetan lamas. Almost all of these had languished in Chinese prisons for twenty years or more.

Among them was the previous Panchen Lama, Tibet's second highest lama. After his release from prison the Panchen was reinstated in a position of authority in Tibet, and immediately set about on a mission to resurrect Tibet's ancient traditions. He understood the link between art and cultural identity and knew that the Tibetans could only regain their spiritual vitality if they could first reclaim their artistic heritage. Therefore, one of his first projects was the mass printing of a set of good quality tangka replicas. Included in his first set was a reproduction of an exquisite Healing Trinity painting.

At the time, all things Tibetan had been banned for more than twenty years. Much had been destroyed by the Red Guard during the oppressive days of the Chinese Cultural Revolution, when most of Tibet's intellectuals, artists, doctors and social leaders were either liquidated or imprisoned. During those dark years the Tibetans were not allowed to possess any of their own cultural artifacts. Children in kindergarten and re-education schools were pressured into reporting their own parents, grandparents and family friends for possessing any Tibetan book, painting or other item of cultural significance. The only legal visual art was a photo of Chairman Mao, and this should be displayed on the wall where the altar had previously been kept. The only legal literature was Mao's *Little Red Book* and other such Communist propaganda.

Tibet at the time was at the lowest and darkest point in its long and venerable history, with almost all of her monasteries, temples, meditation hermitages, libraries and art repositories reduced to rubble or ashes, and every household stripped of anything of any cultural or spiritual significance. One can only imagine the excitement that swept the land when the Tibetans learned of the Panchen Lama's designs for cultural revival.

Tibetans believe in signs and omens. For them, ink on paper is not just ink on paper. A crow calling from a particular direction at a particular time of the day is *not* just a crow calling from a particular direction at a particular time. These things are statements on the bigger picture of life's unfoldment, in tune with and therefore reflective of everything else happening and about to happen. The shape of clouds, what flowers bloom where and when, the coming and going of birds in one's garden: all of these are signs.

The first bird of spring heralds the end of winter's gray and chilly sleep, and prophecies the rebirth of a world of color, with spring greens bursting from every corner and flowers of every hue filling the world with joy. Similarly, the sudden appearance in the marketplace of the full-color reproduction of the Healing Trinity was just such a sign to the Tibetans. It provided them with their first glimmer of hope that perhaps the long winter of their oppression had passed, and the spring of their cultural rebirth was at hand. Everyone rushed out to acquire a copy of the Healing Trinity reproduction, and made it the centerpiece of their new and now legal household altar.

Tibet has come a long way since that first effort at cultural revival. Several hundred monasteries and temples have now been rebuilt, publishing programs revived, and art schools opened. As anyone familiar with recent Tibetan history knows, there is still a very long way to go, but the Panchen Lama's efforts at cultural and spiritual revival have had amazing effects.

There have been many setbacks, of course, because life under a Communist totalitarian system is not easy. High

prices have been paid, perhaps the highest by the Panchen Lama himself. When he suddenly and unexpectedly passed away on January 28, 1989, the Beijing government announced his death to be the result of a heart attack. Some Tibetans believe otherwise. He had walked a fine and very dangerous line from the very moment of his release from prison in 1979. On the one hand he pushed in every way possible for the human and legal rights to which Tibetans were supposedly entitled under the Chinese constitution, but of which they had been completely deprived since the first day of China's takeover of Tibet in the 1950s. In addition, the Panchen worked tirelessly to revive Tibet's cultural and spiritual traditions from the destruction they had suffered at the hands of the Red Guard during the years of the Cultural Revolution.

On the other hand, his position in Chinese-occupied Tibet was controlled by the Chinese government, and he had to satisfy Beijing's demands to at least some minimal degree in order to survive as a spokesperson and lobbyist for the Tibetans.

The civil unrest and public demonstrations that erupted in Tibet in 1987 and 1988 as a result of (and in support of) the Dalai Lama's addresses to the US Congress and the European Parliament in those years led to massive retaliations on the part of the Beijing government, with hundreds of arrests and many deaths.

This all put the Panchen Lama in a most precarious position. In mid-January the Beijing authorities ordered him to make a public speech condemning the Tibetan activists at home and the Dalai Lama abroad, and to publicly declare his support for the Chinese government. Instead, he left the pre-written government speech on his table, and spoke to the Tibetans directly.

His message was similar to that of Mahatma Gandhi to the British Raj after the Amritsar massacre. He stated that things had come to such a position with the Chinese that no matter what they were to do to compensate they could never make up for the damage that had been done. He requested the Tibetans to work with peaceful means for their rights, and to strive to preserve the Tibetan identity.

The Tibetans do not, however, see his death as the end of his work. The spiritual and cultural revival that he initiated in the early 1980s, as signaled by that first printing of the Healing Trinity reproduction, is still in full swing. The hundreds of projects that he launched during the decade in which he shone so brightly, from publishing great Tibetan literary classics, re-building monasteries and nunneries, opening schools for training young Tibetans in the traditional arts, and re-establishing many of Tibet's major cultural institutions, all continue as statements of his vision.

Moreover, copies of his reproduction of the Healing Trinity are on proud and prominent display wherever one goes in Tibet today, in large temples and humble households alike, quietly radiating their healing energies over the work that he initiated and for which he died.

Chintachakra Tara

Om svabhava shuddha sarva dharmah svabhava shuddhoh ham. All becomes emptiness. From emptiness appears the syllable *PAM*, which becomes.…and from this I emerge as glorious White Tara, seated with legs crossed in meditation in the vajra posture.…At my heart is a white wisdom wheel having eight spokes that in nature is wisdom itself. The wheel has five circles of mantras: one on the hub; one on the spokes; and three on the outer rim. My name stands at the center of the hub, between the mantras *om* and *hum*.

Tantric Buddhism regards the mind as being the first and most powerful agent in the wellness process. In general, a positive mind contributes to our health, happiness and success in life. In particular, the state of our mind dramatically impacts the pace and success of the healing process when we are recuperating from an illness. All three of the Tantric systems included in the Healing Trinity tap into this dynamic and set forth meditation methods that prevent illness, strengthen the immune system, and facilitate recovery.

Here we see the complete Healing Trinity. White Tara, the principal image of the painting, is depicted with Amitayus in the upper left corner (above Tara's right shoulder) and Ushnisha Vijaya in the upper right (above Tara's right shoulder). Usually Amitayus is shown as being seated in the crossed-leg posture of meditation; here, rather uniquely, he is standing. This is a special Amitayus lineage beginning with the eighth-century Indian master Padma Sambhava. The transmission was picked up three centuries later by the early Sakya lamas, who designed it as a week long healing retreat known as the *Tsepagmey Shakdunma*, or "Amitayus/Boundless Life in Seven Days."

White Tara is probably the most popular personal meditation practice of the three in the Healing Trinity. Her yogas are in fact extracted from the Amitayus Tantra, so carry a double blessing. Moreover, she has the added charisma of the Tara legacy, and this goes a long way with Tibetans. Finally, the fact that the First Dalai Lama personally relied on the system for healing whenever he became ill brought it to a lasting national prominence.

In the brief exerpt from the White Tara sadhana quoted above we see that in the standard practice one first visualizes oneself as being White Tara, and then focuses upon a visualization of a white eight-spoked wheel at the center of the heart chakra. The later process of mantra recitation and color/light therapy works its magic from this wheel. This is the reason that this form of Tara is known as *Chintachakra Tara*, or "The Wish-Fulfilling Wheel Tara." Meditation on this wheel in conjunction with mantra recitation and the according visualizations easily fulfills all wishes.

In his commentary to the White Tara healing meditations, the First Dalai Lama quotes his teacher Lama Chenngawa as saying, "Anyone who holds the initiation (of White Tara) and knows how to correctly practice the mantra becomes almost invincible.…Even if the most definite signs of death have occurred, such as having received many ostensibly fatal wounds, he or she will easily and fully recover."

Tibetan manuals on the White Tara healing meditations vary in length. The First, Second, Fifth and Seventh Dalai Lamas all wrote on the practice. The Seventh's manual is perhaps the most interesting, because it combines elements from the writings of his three predecessors. The First's commentary remains the most important, however, because it is the one that established the popularity of the lineage.

In addition to writing a meditation manual, the First Dalai Lama also wrote a poem to White Tara that achieved widespread popularity for its beauty. In it he states,

> *Hail the youthful one with full breasts,*
> *One face and two arms. Sitting in the vajra*
> * position,*
> *She regally displays both grace and calm*
> *And exudes the great transcendental bliss.*
>
> *Hail the ultimately generous one whose*
> * right hand,*
> *In the mudra of supreme generosity, easily*
> * releases*
> *Boundless karmas of peace, increase, power*
> * and wrath,*
> *As well as the eight siddhis, and even*
> * supreme buddhahood.*
> *Hail the refuge of the world, whose eyes*
> *In hands and feet gaze at the doors of*
> * freedom,*
> *Who leads all manacled sentient creatures*
> *Towards the isle of blissful liberation.*

As stated in the first verse above, White Tara is shown with her two breasts fully revealed. The upper shawl covers only the

shoulders. The female breasts symbolize spiritual nourishment, the power of growth and transformation, healing energy (a mother's milk being the safest food for a newborn infant), and pure medicinal essence. In our painting here, however, the left hand obscures the view of the left breast, while a golden ornament discreetly covers the nipple of the right breast. We can presume from these details that someone living in a monastery originally commissioned our tangka. The artist decided to create an understated sexuality in his presentation, so as not to distract the monks with erect nipples.

The second verse mentions the four Tantric activities: peace, increase, power and wrath. We discussed these earlier in the treatment of the Twenty-One Taras. They are mentioned here because the White Tara healing meditation and mantra recitation involve radiating light successively in each of the colors of these four buddha karmas: white, yellow, red and blue, followed by green for all four karma together, and brown to stabilize the lot. These lights fill the body, healing and rejuvenating it, and then form a tent of light (i.e., a halo) a hand span in radius around the body. These processes are shown in the tangka by the rainbow-like ring at the edge of White Tara's halo.

The third verse mentions the four eyes in White Tara's hands and feet. These, with the three of her face, are the seven eyes through which she sees all the pain, anguish and illness of the seven worlds and consequently is able to heal them. The seven are the hells, the ghost realms, the animal world, the human realm, the lower gods (similar to the titans in Greek culture), the kama heavens (i.e., the sense world heavens, like the Christian and Muslim paradises), and the rupa and arupa heavens (like the Hindu and other meditationally created realms). White Tara sees all in these seven realms with her seven eyes, and heals the beings therein from all their sufferings and limitations. The "doors of liberation" mentioned in the verse refer to the ways whereby transcendence of everything in these seven realms is attained.

At the bottom center is Green Tara, with yellow Marichi and blue Ekajati flanking her. This is another popular Buddhist trinity and is mentioned by the First Dalai Lama in his famous hymn to Green Tara, the *Lek Trima*.

> *Homage to Marichi, the devi at your right*
> * side, Her peaceful face emanating lights*
> * the color of the sun;*
> *And homage to the devi at your left,*
> * Ekajati, who is*
> *Wrathful, lustful, radiant and the color of*
> * the sky.*

This trinity is a female version of the Rigsum Gonpo, or "Three Essential Protectors": compassion, wisdom and power. Here Tara stands in for Avalokiteshvara and compassion; Marichi is substituted for Manjushri and wisdom; and Ekajati is the substitute for Vajrapani and power. Placed at the bottom of the tangka, they serve the function of Dharma Protectors, in the sense that our compassion, wisdom and power are our best protectors of truth.

Chintachakra Tara; Tib., *Dolkar Yizhin Khorlo; White Tara, the Wish-Fulfilling Wheel.* Nineteenth century, 26 x 17.5 inches.

Amitayus

Om svabhava shuddha sarva dharmah svabhava shuddhoh ham. All becomes emptiness. From emptiness appears the syllable *PAM*, which becomes....and from this a red *HRIH*. From this I emerge as transcended and accomplished Amitayus, embodiment of immortal life and wisdom.

Amitayus is a male buddha symbolizing a very important Tantric system for healing through meditation and ritual. One reason he is included here is that he is a central member of the Healing Trinity. Another reason is that the most popular lineage of his practice in all schools of Tibetan Buddhism comes from the eleventh-century female mystic Siddharani, known to Tibetans as Drubpai Gyalmo, or "Queen of the Siddhas."

Siddharani came from the region of what today is Katmandu, Nepal. At the time Katmandu was an Indian cultural satellite and one of the great Buddhist kingdoms of the subcontinent. The Katmandu Valley had originally become Buddhist in the third century B.C. during the time of the great Indian emperor Ashoka, and in fact the modern-day stupa at Katmandu's eastern gate is said to stand on the foundations of a stupa erected by one of Emperor Ashoka's own daughters.

Many of Tibet's Tantric lineages, and also its artistic traditions, have links to Nepal; the Tibetans commissioned Nepali artists and builders from the earliest days. Mention of them is made in connection with the seventh-century King Songtsen Gampo and his creation of 108 temples around the country. The First Dalai Lama imported a number of Nepali masters when he built Tashi Lhunpo Monastery at Shigatsey in the mid-fifteenth century, as did the Second Dalai Lama when he constructed Chokhor Gyal Monastery below the Lhamo Latso Oracle Lake half a century later.

The Amitayus Tantric system came to Tibet through several dozen different lineages over the centuries, and all schools of Tibetan Buddhism hold their own exclusive transmissions. For example, the Nyingmapas have lineages from Padma Sambhava and others; the Sakyapas have their transmissions from the Mahasiddha Jetari, the Gelukpas have a lineage from Atisha, and so forth.

These were brought to Tibet by Rechungpa, one of the two disciples of the eleventh-century yogi Milarepa. Thus her tradition first came into Tibetan Buddhism via the Kargyu School, but from there quickly spread to everyone.

Tibetans love Siddharani for the magic and mystery surrounding her life. Her story involves four of Tibet's beloved characters of the eleventh century: Marpa Lotsawa, his chief disciple Milarepa, Marpa's son Dharma Dodey, and Milarepa's disciple Rechungpa. These are all men, but the lives of them all were connected with a solitary woman, Siddharani.

According to the story, Marpa had foreseen obstacles to the life of his son and heir, Dharma Dodey, and requested him to stay in the house for some days. Dharma Dodey, however, was young and impetuous, and wished to compete in a local horseracing event, and therefore left against his father's wishes. During the race he fell from his horse and suffered a lethal blow to the head. Now, from amongst the important doctrines that Marpa had received from Naropa, one had to do with the yoga of forceful mind consciousness at the time of death. Marpa now used this, and forcefully placed his son's soul in the body of a nearby pigeon. The pigeon flew to India, where it alighted on the body of a young man who had just died. To everyone's surprise the boy instantly revived. His character was greatly changed, for his body was now occupied by Dharma Dodey. This young man now showed signs of great spiritual ability and became known as Mahasiddha Tipupa, "The Pigeon Master."

Some years later Rechungpa was preparing for a visit to India. He had already gone there several times in order to gather lineages and translate Tantric texts. Milarepa told him the story of Tipupa and informed him that this mahasiddha had received the lineages of a female mystic by the name of Siddharani. He requested Rechungpa to search out Tipupa, request the Siddharni lineages, and bring them back to Tibet for him.

Rechungpa traveled to India, met and trained with Tipupa, and eventually mastered the Siddharani lineages. Finally, he brought them back to Tibet and gave them to Milarepa. Thus in this particular lineage of transmission the disciple (Rechungpa) appears in the list of lineage masters as the guru to his own guru, Tibet's beloved mystical poet Milarepa.

Although all schools of Tibetan Buddhism later absorbed the Siddharani lineage of the Amitayus healing yogas, her lineages in their completeness are only preserved in the *Rechung Nyen Gyu*, or "Rechungpa Oral Transmissions." Siddharani lives on through them.

For the past five or six centuries, traveling lamas of all schools of Tibetan Buddhism have been more likely to publicly give the Siddharani *tsewang*, or "life-enhancement empowerment," than an Amitayus tsewang from one of their

Amitayus; Tib., *Gyalwa Tsepakmey; Amitayus, Buddha of Boundless Life.* Eighteenth century, 27 x 19 inches.

exclusive transmissions, because of its multi-denominational status. Everyone will come when they give the Siddharani lineage, whereas only members of their own sect will come if they give an Amitayus tsewang from a transmission that is exclusive to their personal school. They generally only give the initiations exclusive to their own lineages at smaller and more restricted gatherings.

The Siddharani transmission is in fact a composite of nineteen lineages from this great yogini, all of which are based on her personal visionary experiences. Of these, the most popular is the lineage known as *Tse-ta Zung-trel*, or "Amitayus-Hayagriva Combined." In other words, it combines elements from the Kriya Tantra tradition of the Amitayus mandala with the Highest Yoga Tantra tradition of the Hayagriva mandala.

The First Dalai Lama wrote a lengthy commentary to this yogic legacy, and the Second, Third, Fifth and Seventh Dalai Lamas all wrote shorter ones. Commentaries to the tradition can be found in the writings of major lamas of all schools.

The First Dalai Lama states that the system has four means of healing: (a) the tsewang, or "life-enhancement empowerment ceremony," which is performed for the healing of others; (b) the eight generation stage; (c) the eight completion stage yogas; and (d) the Amitayus method of *chulen*, or "extracting nutritional essence."

The first of these is usually performed by a high lama or healer on the behalf of a sick person, although in recent centuries, has been used more at large public gatherings for collective healing and life-enhancement. The second is comprised of a set of eight phases of visualization that work with light and color therapy, wherein one visualized drawing in eight different types of life and healing energies and powers. The third involves eight levels of chakra work. Finally, "extracting nutritional essence" involves giving up eating ordinary food altogether and instead living on "nutritional essence."

In chapter 20, with the Tibetan mystic Machik Labdon, we will see a method of doing this yoga by means of making nutritional pills from flowers, known as *metok chulen*, or

"extracting flower nutritional essence." The Second Dalai Lama wrote a commentary on the method. In addition, the First Dalai Lama wrote a commentary on how to live by extracting quintessential nutrient from starlight.

In contrast, the Amitayus system descending from the yogini Siddharani utilizes "stone nutritional essence," or *dogyi chulen*, as opposed to the flower essence pills used in the Machik Labdon tradition or the starlight recommended by the First Dalai Lama.

Here, one puts a small stone in a glass of water, together with a few special tinctures, and then performs meditation and mantra over it, visualizing that it becomes an enormous ocean of ambrosial nectar containing every essential nutrient. At mealtime one drinks the transformed glass of water, which is now made rich by means of the Tantric meditation. In this way one replaces the consumption of ordinary food and drink with the extraordinary techniques of "extracting stone nutritional essence."

Many Tibetans do this unique form of fasting for a set period of time, such as seven or twenty-one days, as a method for healing and rejuvenation. However, if one achieves the siddhi of "extracting nutritional essence," one can forego ordinary food and drinks forever, and live on water/stone essence for the rest of one's life. Those who achieve this ability are said to become immortal.

However, in Tantric Buddhism immortality does not mean that one lives forever. Instead, one lives with perfect health and vigor until one has benefited all the trainees with whom one has a teacher-trainee relationship. One then consciously withdraws one's psycho-physical aggregates and dissolves into the clear light Dharmakaya, remaining there until one's presence and services are once more needed in the ordinary world. At that time one emanates forth from the Dharmakaya and reappears as needed.

This is what is meant in the Amitayus transmission from the female mystic Siddharani by the commonly seen expression *tsedang yeshey gyi ngodrup*, or "the attainment of immortal life and wisdom."

Ushnisha Vijaya

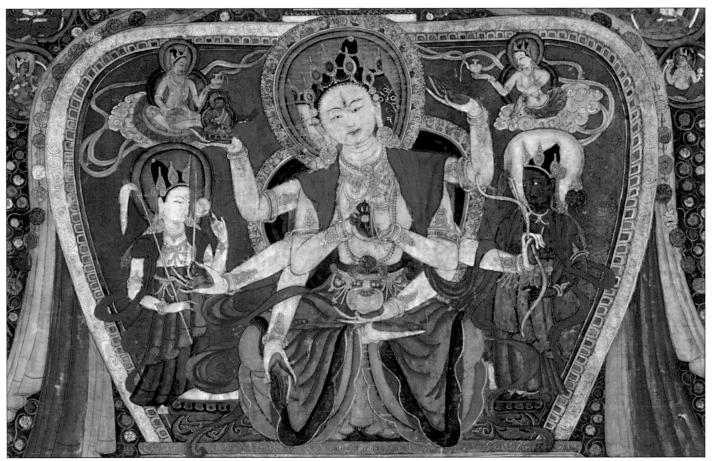

Ushnisha Vijaya, detail from tangka on page 109.

Om svabhava shuddha sarva dharmah svabhava shuddhoh ham. All becomes emptiness. From emptiness appears the syllable *PAM*, which becomes....and from a white syllable *BHRUM*....From that appears a glorious stupa made of the light of precious jewels. Inside of that is an eight-petalled lotus with a moon disk, the syllable *BHRUM* standing above it. This becomes a crossed vajra with *BHRUM* at its navel. Lights emanate from this, accomplish the two purposes, and withdraw. *BHRUM* completely transforms, and from it I emerge as Ushnisha Vajra, body white in color, having three heads and eight arms....

Our painting of Ushnisha Vijaya, over five hundred years old, depicts her in accordance with the tradition of the nine-deity mandala. This lineage comes from the Indian mahasiddha Jetari through the early Sakya lamas, and from them spreads to all schools of Tibetan Buddhism.

Unlike most mandalas, which show the central mandala deities in a square structure within a circle, Ushnisha Vijaya is shown seated inside of a stupa. She is flanked by two bodhisattvas—Avalokiteshvara, white in color, who sits to her right; and Vajrapani, blue in color, who sits to her left. Thus here she represents wisdom, while the other two respectively represent compassion and power. The *Trowo Zhi*, or "Four Wrathfuls," are visualized as standing in the four directions, although our tangka shows them along the front base of the stupa. These respectively represent the four mindfulnesses, four miracle powers, five strengths and five powers.

To complete the nine deities of the mandala, two *devaputra* are seen in the space above Ushnisha Vijaya. The Sanskrit term *devaputra* literally means "Son of God." They are here representing Bhrama the Creator, who requested the Ushnisha Vijaya transmission from the Buddha. They hold offering vases filled with the nectars of immortality. The symbolism is that the practice of the Ushnisha Vijaya Tantric methods brings the help and assistance of all worldly gods.

Every feature of these nine deities has its own spiritual symbolism. The three heads symbolize the ability of the Tantric system to heal all diseases and obstacles found in the three worlds: above, below and in-between. The nine eyes see the nine levels of the enlightenment methods, indicating that the system has the ability to cure all spiritual afflictions and limitations.

As for the eight hands, the first right hand holds a crossed vajra, symbol of complete harmony with all things inner and outer; the second holds a white lotus with Amitabha seated in it, symbolizing the power to transform from worldly existence into buddhahood; the third holds an arrow, which is the wisdom able to penetrate to the heart of ultimate reality; and the fourth is in the mudra of supreme generosity, indicating that the practice brings all worldly and spiritual fulfillment.

The first left hand holds a vajra lasso, which is the meditative concentration able to rope in the wandering mind; the second holds a bow, which is the samadhi that throws the arrow of wisdom to its target; the third is in the mudra of giving refuge; and the fourth, which is in the mudra of meditation, holds a vase filled with healing nectars.

Our artist has presented this set of the nine deities of the Ushnisha Vijaya mandala like a golden vase in a garden of flowers. The nine deities of the Ushnisha Vijaya mandala are all arranged in the vase-like stupa, while various buddha figures and other Tantric deities are arranged like flowers above and on both sides. This is a map to the various Tantric and devotional practices that were popular in the monastery to which this tangka originally belonged.

It is interesting to note that the first of the two Tantric systems in the Healing Trinity—White Tara and Amitayus—are largely practiced in one of two forms in the Tibetan world. The first of these is the *tsewang*, or "life enhancement empowerment ceremony," which was discussed earlier, wherein a high lama leads a gathering in guided meditation and mantra. Ceremonies of this nature usually last a few hours. The other form of the practice is the *tsey drup*, or "life enhancement practice," wherein the initiate practices meditation and mantra recitation privately on a daily basis. Alternatively, the *tsey drup* can be done as a retreat practice. Here the initiate enters solitary confinement and engages intensely in the Tantric methods of the system. This usually involves four or six sessions a day, each two to three hours in duration, and continues for weeks, months or even years.

In contrast, the healing method of Ushnisha Vijaya is not generally seen as a tsewang. Instead, it is usually commissioned as a healing ceremony, with professional ritualists

performing the ritual. Every Tibetan monastery and nunnery has numerous initiates who are highly trained in Tantric shamanism and spend much of their time performing various types of rituals at the request of patrons. Most monasteries and nunneries in Tibet supported themselves largely by means of their squad of professional ritualists.

The most popular ritual in the Ushnisha Vijaya system is known as "The Thousandfold Healing Rite." Here a large stupa is placed at the center of the altar, with six circles of offerings around it, one thousand in each circle. The inner circle is made of a thousand *tormas*, or ritual effigies. The next five rows have the offerings of the five senses, such as light, flowers, incense, and so forth. The final "thousand" is comprised of a thousand recitations of the long dharani of Ushnisha Vijaya (approximately two pages in length). The entire rite is performed as part of a lengthy liturgy, with chanting, horns, drums and so forth. A medium size monastery can complete the ritual in a day.

On the left we see Ushnisha Vijaya seated inside her stupa. None of the other deities of the mandala is shown . On the bottom right we see a man and his wife riding on a carriage drawn by two horses, making the sign of respect to Ushnisha Vijaya. Manjushri, the Buddha of Wisdom, is seated to the left, his wisdom sword raised on high.

In the personal practice of the sadhana, one visualizes oneself as Ushnisha, with the remaining eight deities as described above, all within the Victorious Stupa. A crossed vajra appears at Ushnisha Vijaya's heart, the syllable *BHRUM* at its center. This transforms, and reappears as oneself in ordinary form, with one's personal teachers above, parents in front, students to the right, friends and relative to the left, and finally servants and assistants behind. This entire assembly is seen inside the core of the crossed vajra at the center of Ushnisha Vijaya's heart. Lights then emanate forth from the mantric syllables, perform the two purposes, and bring back all healing and transforming energies. These dissolve into one's heart and spread to the visualized assembly, causing everyone's life force, creative energy and wisdom to increase.

The above meditation is also used as the highlight of the Thousandfold Ushnisha Vijaya Healing Rite, when one contracts professionals to do the healing ceremony on one's behalf. In fact, very few Tibetans hold the Ushnisha Vijaya initiation, which is a prerequisite to engaging in the personal practice. For most Tibetans, the Ushnisha Vijaya connection is made with professional shamans.

Because of the manner in which the Ushnisha Vijaya simultaneously performs healing on oneself and one's teachers, family, relatives, friends, and dependents, the

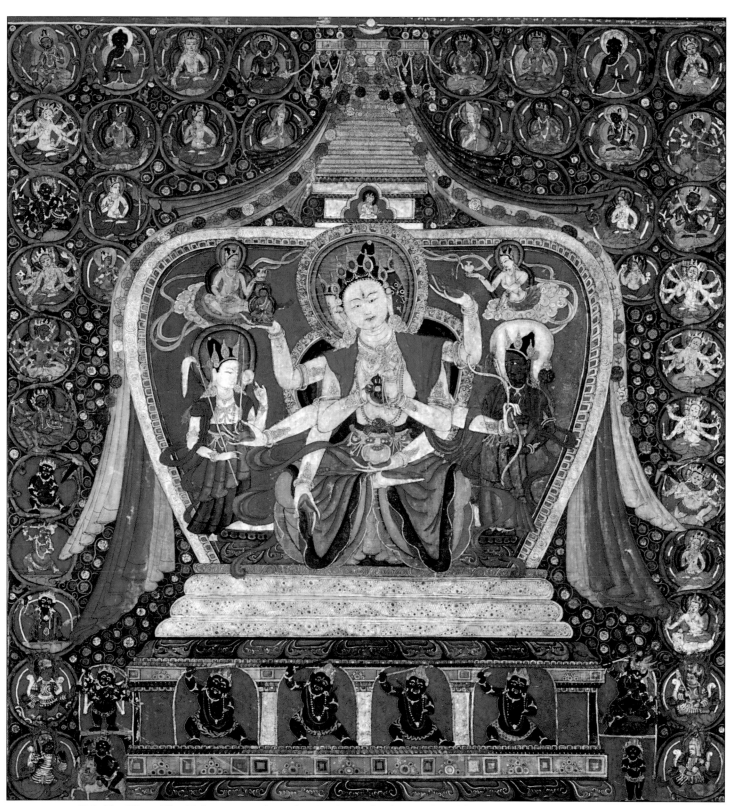

Ushnisha Vijaya; Tib., *Tsuktor Namgyalma*; *The Victorious Ushnisha Female Buddha*. Fifteenth century, 20 x 19.2 inches.

Thousandfold Ushnisha Vijaya Healing Rite is most popular with large and wealthy families.

It is one of the most common rituals performed for the long life of high lamas. For example, the Dalai Lama's private monastery is called Namgyal Dratsang, and derives that name from Ushnisha Vijaya. The Sanskrit name "Vijaya" translates into Tibetan as "Namgyalma." The tradition comes from the time of the Third Dalai Lama, who was based in the Ganden Potrang of Drepung Monastery. At one point the Third's health seemed fragile, so a section of Ganden Potrang monkhood was commissioned to take up the practice of the Thousandfold Ushnisha Vijaya Healing Rite on his behalf. The ritual, known in Tibetan as *Namgyalma Tong Cho*, was completely successful, and the section of the Ganden Potrang that performed it for the Third Dalai Lama became known as the Namgyal Enclave. A hundred years later the Fifth Dalai Lama moved his home base from Drepung to the Potala. He took his favorite monks from the Ganden Potrang with him, as well as the name "Namgyal Dratsang."

From that time in the mid-seventeenth century until the Chinese Communist invasion of Tibet over three hundred years later, the Namgyal Dratsang Monastery was based in the Potala with the subsequent Dalai Lama incarnations, and was charged with the task of performing all of the important rituals and ceremonies associated with his lineage. The performance of the Thousandfold Ushnisha Vijaya Healing Rite always held an important rank among these rituals.

Today the Namgyal Dratsang Monastery is rebuilt in Dharamsala, India, a few hundred yards from the Dalai Lama's home, where it continues to carry out its duties. The original Namgyal Dratsang in the Potala, Tibet, was re-opened in Tibet in the 1980s. Both maintain the tradition of the Thousandfold Rite.

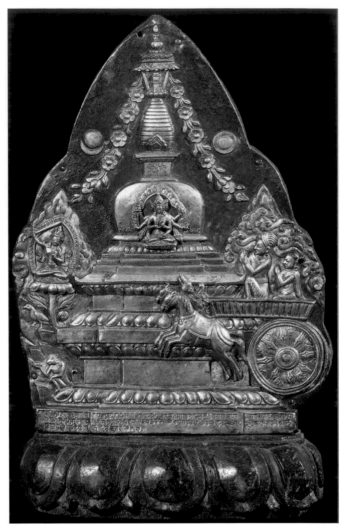

Ushnisha Vijaya Stupa from Nepal, nineteenth century, 18 inches, wood and copper.

CHAPTER 15

Female Buddhas with an Agenda

Marichi, detail from tangka on page 119.

All of the mandala deities in Tantric Buddhism can be said to have some kind of agenda, in the sense that they all represent and embody a particular quality of the enlightenment experience. As ambassadors of that particular quality, they promote it through their presence. Tantric meditation in connection with them utilizes their characteristic quality as the handle through which we grip the enlightenment package.

Arya Tara, for example, whom we encountered in chapter 1 of this section, symbolizes buddha karma, or enlightenment activity. All meditation on Arya Tara uses buddha karma as the driving force to success, and as the key with which the enlightenment experience is unlocked. It taps into buddha karma and directs it yogicly in particular ways, as outlined by the specific lineage of practice.

Similarly, all three buddha forms in the Healing Trinity have healing and rejuvenation as their principal agenda. In that sense they could easily have been placed in this chapter as "buddhas with an agenda." We set them in a chapter by themselves, simply because of their exalted stature.

Meditation upon a buddha form that symbolizes or embodies a unique quality, and recitation of his or her mantra, causes that particular quality to increase within the mind stream of the practitioner and become more active within his or her life. If we were to state the case in Jungian terms, these buddha forms are mental archetypes. Meditation upon them causes those archetypes to become more active and dominant.

In this chapter we present six female buddhas with specific agendas. They are known to most Tibetans and practiced by them either as objects of meditation and mantra recitation, or as commissioned shamanic ritual.

The Tibetan refugees in India not only survived but also thrived. Although displaced from their homeland, they quickly became very successful in the communities where they were transplanted. The present Dalai Lama once commented that a reason for this was the Tibetan tradition of invoking buddha forms such as these.

Ushnisha Sita Tapatra

For a baby to be born, its head must first reshape itself in order for it to be able to pass through the birth canal of its mother. For this reason the skull of a fetus is in three portions. During the birth process, these three portions rearrange themselves from the pressure of the mother's contractions, causing the head to become long and cone-like

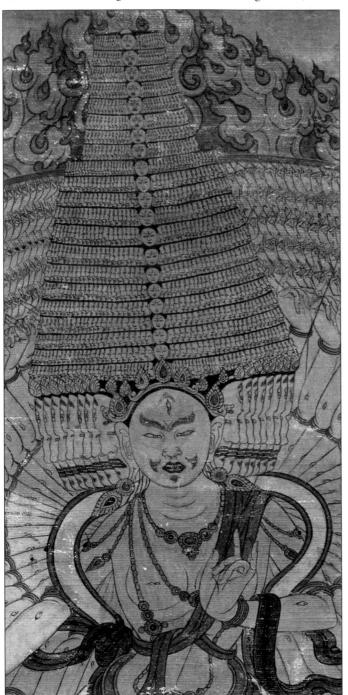

Ushnisha Sita Tapatra, detail from tangka on opposite page.

rather than round and ball-like. This reduces it in circumference and makes it small enough to travel through the birth canal. Once out of the womb, the plates slowly rearrange themselves and the head reassumes its proper shape.

The place where the three plates meet (at the top of the head) is soft to the touch for the first weeks after the child's birth and is a special and magical site. It remains special throughout the person's life, and a Tantric yogi or yogini will utilize it in meditation.

It is similarly magical at the time of buddhahood. When a person achieves enlightenment, this place on the skull stretches upward and forms into what is known in Sanskrit as the *ushnisha*, or "crown protrusion." In reality it is made of pure radiance and is infinite in height, although the perception of its size is determined by the spiritual merit of the perceiver. Those of low merit cannot see it at all. In Tibetan Buddhist art a buddha's ushnisha is usually depicted as resembling a knot of hair tied on top of the head. In fact, some Western books on Buddhist art erroneously describe it as being a hair knot.

The female buddha Ushnisha Sita Tapatra gains her name from this point on a buddha's crown. According to legend, when Buddha Shakyamuni invited his disciple Ananda to leave behind the worldly life, become a monk, and travel with him as his personal attendant, Ananda agreed on the grounds that Buddha would only give teachings when he was present to hear them. This was Ananda's way of ensuring that he would be able to receive every teaching the Buddha ever gave.

However, the Indian expression at the time for "give teachings" was "speak Dharma from the mouth." As a consequence, whenever the Buddha wanted to deliver a transmission for which Ananda was not sufficiently mature, he had to resort to numerous imaginative methods in order not to "speak Dharma from the mouth." The transmission of the *Ushnisha Sita Tapatra Tantra* was just such an occasion. When the Buddha transmitted this profound method, he spoke it from his ushnisha, and not from his mouth, so as not to break his pledge to Ananda.

Sita Tapatra literally means "White Parasol." Just as a parasol protects a person from the hot rays of the noonday sun, this Tantric tradition sets forth methods for establishing protection against all natural disasters. She holds a white parasol to symbolize this power.

There are a number of forms of Ushnisha Sita Tapatra. The most common one for personal practice somewhat resembles White Tara, having one face and two arms, and being seated in the posture of meditation. The Ushnisha Sita

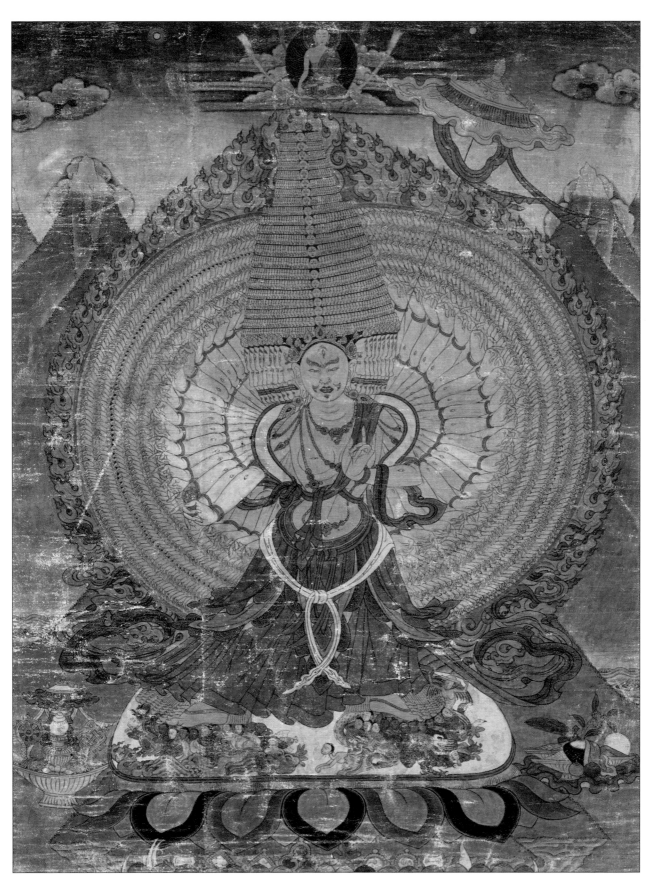

Ushnisha Sita Tapatra; Tib., *Tsuktor Karmo; White Ushnisha Parasol.* Nineteenth century, 22 x 16 inches.

Tapatra in our tangka here is the more complex aspect generally used when large groups of monks, nuns or lay shamans perform the extensive protection ritual on behalf of a patron or community.

The site of the future ushnisha on the human head is central to the application. Here the ritualists generate themselves in the form of the female buddha Ushnisha Sita Tapatra and draw all protecting energies of the buddhas and bodhisattvas into their hearts. They then project these energies up to their crown chakras and out through their ushnishas, where the energies form a parasol-like force field able to guard against all harms. The size of the force field determines the area covered by the protective meditation. Thus the technique is a kind of mental radionics for projecting a protective force field.

The Ushnisha Sita Tapatra in our tangka is known in Tibetan as "White Parasol Force Field with a Thousand Arms and A Hundred Million Eyes." Although here she is coated in pure gold as an offering, in fact she is actually white in color. White is the source of all form; the implication is that the rituals associated with her have the power to influence everything in the mundane world. To further symbolize this, she has 1,000 legs, of which the 500 on the left press down on a host of worldly gods, etc., while the 500 on the right press down on demons, etc. This signifies that all gods, spirits and other occult forces are subdued through the yogas of her Tantric system.

She has 1000 faces, to show that she watches over all places and at all times. Of these, 200 are white, 200 yellow, 200 red, 200 green and 200 are blue. These are the colors of the five buddha families and imply that she embodies the qualities and powers of all the buddhas. Each face has three eyes: one for wisdom, another for compassion, and the third for power.

Generally it is said that she has 1,000 hands and 100,000,000 eyes. These are metaphoric numbers, with the sense of "uncountable." The implication is that she is always working in 1,000 ways to uplift the world, and constantly watching for ways in which to help and bring benefit throughout the 100,000,000 world systems.

Of her two main hands, the first on the right holds the handle of a parasol as well as an arrow, respectively symbolizing her ability to protect from natural calamities, and her ability to eliminate harmful forces through the power of penetrative wisdom. Her left hand holds an eight-spoked Dharma wheel, a symbol of how meditation upon her mandala brings full realization of the eight qualities of enlightenment.

Behind these is a row of ninety-nine pairs of arms. Those on the right hold an eight-spoked Dharma Wheel, a symbol of how the practice of this Tantric system brings the full realization of enlightenment. Those on the left hold an arrow, again a symbol of the penetrative wisdom of her yogic system.

The remaining 400 hands on the right, in four sets of one hundred, hold a vajra, jewel, crossed vajra, and lotus. The remaining 400 hands on the left hold a bow, flame-tipped sword, lasso and hook, again in sets of a hundred each. The vajra represents the indestructible wisdom; the jewel shows how meditation fulfills all wishes; the lotus with a crossed vajra symbolizes how this Tantric system uses natural phenomena to produce enlightenment; the bow is the power of meditative concentration; the sword is the ability of wisdom to cut off the head of delusion; the lasso is the power to control the inner demons such as distorted emotions and outer demons such as malignant spirits; and finally the iron hook is the power of meditation to control the mad elephant of all inner and outer distractions and forces of harm.

Buddha Shakyamuni sits at the top center of the painting, his right hand in the mudra of calling the earth as witness and his left in the mudra of the utter stillness of meditation. The former of these two mudras has the sense of demonstrating the fact that the enlightenment experience, here represented by Ushnisha Sita Tapatra, is completely in harmony with the laws of the natural world, i.e., is not a mere belief system or cultural tradition.

Even the most modern and international of Tantric Buddhists accept the principle that the Buddhist tantras have unique powers such as those attributed to Ushnisha Sita Tapatra. For example, a decade or so ago the Dalai Lama and his monastery were requested to perform the ritual of this system in one of the Himalayan valley kingdoms to the south of Ladakh. The valley had suffered from earthquakes for several years in a row, and Indian scientists proclaimed that more were on the way. The Dalai Lama and his ritual assistants traveled to the valley and performed the Sita Tapatra rituals for averting earthquakes. According to friends from the region, the rites were successful.

Parnashavari

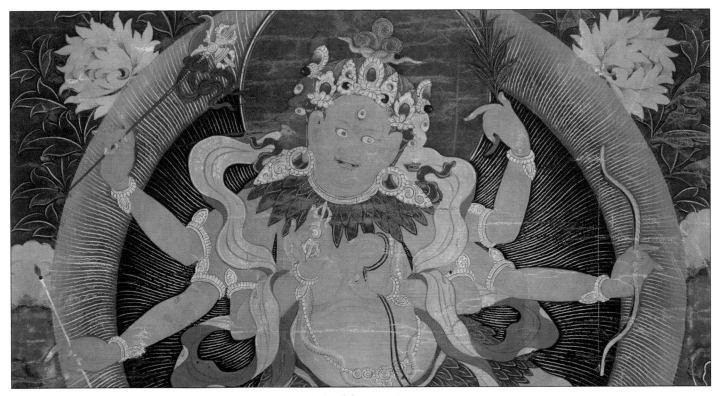

Parnashavari, detail from tangka on page 117.

Panchen Sonam Drakpa, the principal guru to the Third Dalai Lama, wrote a treatise in which he lists all the different Tantric systems practiced in Tibet, as well as their placement within the overall Buddhist Tantric tradition. As with all the Sarma schools, he divides the tantras into four classes: Kriya, Charya, Yoga, and Highest Yoga. All of the buddha forms that we have so far encountered in this book belong primarily to the first of these four divisions. Many of these also have modes of practice connected with the latter three classes, probably as a consequence of cross-fertilization with the passing centuries.

He states that the Kriya Tantras are of three distinctive types or "families": Padma (i.e., Lotus), Vajra (i.e., Diamond) and Tathagata (i.e., Gone to Suchness). Each of these Kriya divisions has a half-dozen or so subdivisions, with one or more Tantric systems within each. For example, in the Padma division of the Kriya Tantras, Amitayus is the lord of the family of tantras, Avalokiteshvara is the principal tantra in the division, and Arya Tara is the "mother" or principal female buddha of the division. In the Vajra division, Akshobya is the lord of the family, Vajrapani is the principal, and so forth. Finally, in the Tathagata division, Manjushri is the principal lord of the family, and Marichi (whom we will

see later in this chapter) is the "mother" or principal female buddha. The Tathagata division has a further five subdivisions, thus making seven types of Tantric systems in the Kriya class. The Ushnisha Kriyas are fourth in the list of seven, with both Ushnisha Vijaya and Ushnisha Sita Tapatra, as well as several others, being listed here.

Parnashavari is in the sixth division of the Tathagata Kriya family of tantras, which is simply called "The Male and Female Messengers." From the perspective of popularity in Tibetan practice, she is the most important of the Messengers.

Her agenda in general is healing, and in particular is protection against infectious diseases, such as plagues and so forth. Meditation on her mandala techniques and recitation of her mantra are said to strengthen the immunity system and make the practitioner invincible to such afflictions.

The Tibetans translated "Parnashavari" as "Loma Gyunma," meaning "The Leaf-Clad Lady." In our tangka she wears a garland of fresh leaves around her neck, and a skirt made from fresh leaves over her hips. These leaves are medicinal in nature and symbolize the healing and rejuvenating powers that the practice of her meditations entails.

She also wears a poisonous snake as a necklace. Snake poison is an important ingredient in a number of medicines

found in the Indian and Tibetan healing systems. The killing power of the poison is used in a controlled manner, in order to eliminate the causes of the disease.

Moreover, the snake symbolizes the nagas, a class of nature spirits that can cause disease when irritated by unthinking humans. Boils, for example, are often caused by cutting down trees without first seeking the permission and forgiveness of the nagas who live in them. Certain types of madness are caused by irritating the nagas. The nagas also send infectious diseases, such as plagues and so forth, to punish those who pollute the air, water and/or earth, for certain types of nagas also reside in these elements. Meditation in accordance with the Parnashavari Tantric system is one method of making and keeping peace with these nature spirits. To further emphasize the point, her hair is tied on top of her head in a topknot, using a snake as a hair band.

Parnashavari is whitish-yellowish to show the first two buddha karmas, those of pacification and increase. That is to say, she heals and protects by pacifying negative conditions and also by increasing the power of the good. Of her three faces, the central one shows an expression that is simultaneously slightly peaceful and slightly wrathful. This indicates how harmony with nature brings peace and happiness, whereas disharmony with it leads to difficulties. The red face on the left reflects desire and the white face on the right is peaceful; natural sexual desire as channeled through Tantric practice is one of the great healing and rejuvenating forces; and white, the color of peace, pacifies the negative conditions causing illness.

She has six arms. The first right hand holds a golden vajra, symbolizing indestructible wisdom; the first left holds a vajra lasso, symbol of control over the inner and outer elements. In the second pair she holds a vajra axe and a fan made of fresh leaves, respectively symbolizing the power to cut off disease from its root, and the cooling power of medicinal herbs. The third pair holds an arrow and bow, which we have seen in earlier tangkas, and represent the wisdom able to penetrate to ultimate reality, together with the throwing force of meditation able to project the wisdom arrow to that target. In Tantric Buddhism, the wisdom of infinity/emptiness is considered to be the greatest healing agent.

A red Parnashavari sits at the lower left of the tangka, and a black Parnashavari at the lower right. They are in the same appearance as the central figure and hold the same objects in their hands. Here the central figure embodies the first two of the buddha karmas needed for healing: pacification and increase. The red Parnashavari embodies healing and protection by means of the buddha karma of power, while the black Parnashavari represents the buddha karma of wrath or force.

A lama sits at the top center of our tangka. In all probability he was either the root or principal lineage master of the person who originally commissioned the painting. The shape and color of his hat identifies him as belonging to the Gelukpa School. Finally, a form of Mahakala, the embodiment of wrathful compassion, stands at the bottom center, completely surrounded by the raging fires of pristine wisdom awareness.

Although the Parnashavari Tantric system is practiced by all schools of Tibetan Buddhism, it is especially favored in the Drikung Kargyu. In fact, it is one of the highlights of the great ten-day Dharma Teaching Festival of the Snake Year, which traditionally was held once every twelve years at Drikung. People of all sects of Tibetan Buddhism would travel from near and far in order to participate and receive the ten days of teachings and initiations given by the presiding head of Drikung Monastery. As with all such religious festivals in Tibet, the teachings would be given from mid-morning until late afternoon, thus leaving early mornings free for the crowd to visit the power sites in the area (of which Drikung has many) and, perhaps more importantly, leaving the evenings free for partying with family and friends.

Tibetans worked hard to keep the atmosphere of their spiritual festivals one of joy and celebration, and to avoid the somber religiosity that would dissuade peoples from attending. Anyone who has been to a Kalachakra Festival led by the Dalai Lama in India will have experienced this. The atmosphere stands in sharp contrast to the mood at the Kalachakra Festivals he has performed here in the West, where lamas and Western scholars take turns speaking on the various precepts and disciplines associated with the tradition, such as not drinking alcohol, and so forth. At these festivals in India, the Tibetans set up taverns, restaurants and pleasure houses, while the locals bring in ferris wheels and merry-go-rounds. In the evening everyone eats and drinks considerably, and both moonshine and beer flow freely. Soon the crowd breaks out in traditional song and dance, usually forming into groups of thirty or forty people in large circles, and celebrating late into the night. At a similar festival the Dalai Lama once led with Drikung Chetsang Rinpochey in Tso Pema, India, the drunken crowd formed an enormous circle around the block of the house in which the Dalai Lama was staying and as an offering to him sang and danced until well past midnight.

This is the atmosphere within which the Parnashavari empowerments were traditionally given in Tibet, and especially so at the Drikung Dharma Teaching Festival of the Snake Year. The dominant mood was one of joy and celebration.

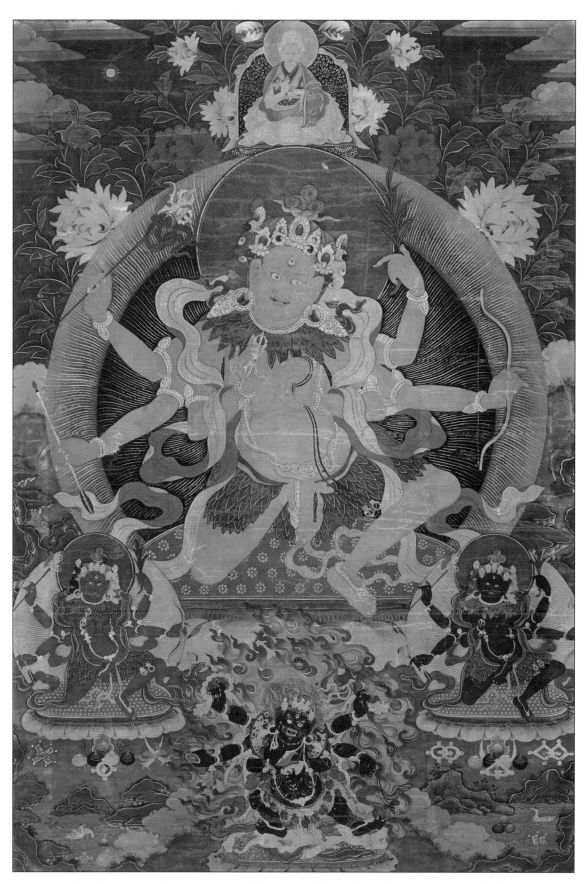

Parnashavari; Tib., *Loma Gyunma; The Leaf-Clad Lady.* Eighteenth century, 19.5 x 13.5 inches.

Marichi

Sharro sharro. Pal sharro.
Lha sha ro.
Kyi kyi nyima sharro.
Lhamo Odzer Chenma sharro
Arise, arise. Glory, arise.
Sacred being, arise.
Happy happy sun, arise.
Sacredness having the Rays of the Sun, arise.
Om marichi ye mam svaha.

Tangka paintings of Marichi often show her with the rising sun as her backdrop, because she most often is invoked at the crack of dawn. For this reason Western art scholars sometimes term her "the Goddess of Dawn," possibly because of their Greco-Roman perspective.

Marichi, however, is no mere goddess. Rather, she is a full-fledged female buddha and in that sense is equal to every other buddha. This is clear from the writings of the Third Dalai Lama's guru Panchen Sonam Drakpa, which were referred to earlier in our treatment of Paranashvari, the subject of the previous tangka. As Panchen Sonam Drakpa points out, Marichi is the "mother" or principal female buddha in the Tathagata division of the Kriya tantras.

The tradition surrounding her practice is perhaps another reason she is occasionally referred to in Western literature as the Goddess of the Dawn, for the meditations upon her are best performed in the early morning and culminate with the sunrise.

Here the initiate performing the meditation rises early and takes a bath. Meditative bathing and ritualistic cleansing are an important factor in all Kriya Tantra systems. He or she then sits facing the east in the direction of the rising sun and performs the usual generation of the visualization of the supporting and supported mandalas, the empowerment of the visualized assembly, and so forth.

When the sun begins to rise, the ritualist recites the dharani (in Tibetan) in a melodic manner: "*Sharro sharro. Pal sharro. Lha sharro. Kyi kyi nyima sharro. Lhamo Odzer Chenma sharro.*" This literally translates as follows: "Arise, arise. Glory, arise. Sacred being, arise. Happy happy sun, arise. Sacredness having the Rays of the Sun, arise." This is followed by recitation of the mantra (in Sanskrit): *Om marichi ye mam svaha.* The syllable *ye*, as those familiar with mantras will know, is not pronounced, but instead indicates a pause in the sound for emphasis.

Marichi's main agenda is to protect the practitioner from natural misfortunes. In particular, she protects against dangers from other living beings, such as wild animals, thieves and evil spirits. Meditation on her mandala, together with recitation of her dharani and mantra, is the principal means linked to her for accomplishing this.

Being in the Tathagata family, and also being the female counterpart of Manjushri, the Buddha of Wisdom, her quintessential nature is wisdom. The sun always represents wisdom in Tantric Buddhism, and the moon great compassion. The meditation is performed at sunrise, when the mind is most vibrant and open to a quantum leap in a wisdom breakthrough. Wisdom here is twofold: awareness of the conventional, transformative nature of all things; and awareness of their infinity/emptiness nature. The sun is the perfect teacher of these two wisdoms.

The dharani refers to Marichi as "Sacredness having the Rays of the Sun." Just as the rising of the sun heralds the end of the long, dark night, meditation on the Marichi mandala heralds the end of the long sleep of ignorance and the fears born from it.

Our tangka of Marichi is at once fascinating and mysterious. The centerpiece is the sun itself, with Marichi shown in below. She rides a chariot drawn by seven sows. This is a play on ancient Indian cosmology—and a favorite subject in Indian classical poetry—of how the sun is drawn across the sky by seven cosmic energies. Alternatively, Marichi is often depicted (in other paintings) as being seated on an enormous sow, with six little piglets running around her in play. The sow is a sacred image in Tantric Buddhism, as we will see later in the section on the Vajra Dakinis.

Here these seven sows also represent the seven principal heavenly bodies after which the days of the week are named: the sun, the moon, Mars, Mercury, Jupiter, Venus, and Saturn. The order is common to India and Tibet and probably moved along the Silk and Spice Roads thousands of years ago, eventually becoming an international standard. In our tangka all seven are equal; however, when as described above Marichi is seated on a large sow and six piglets play

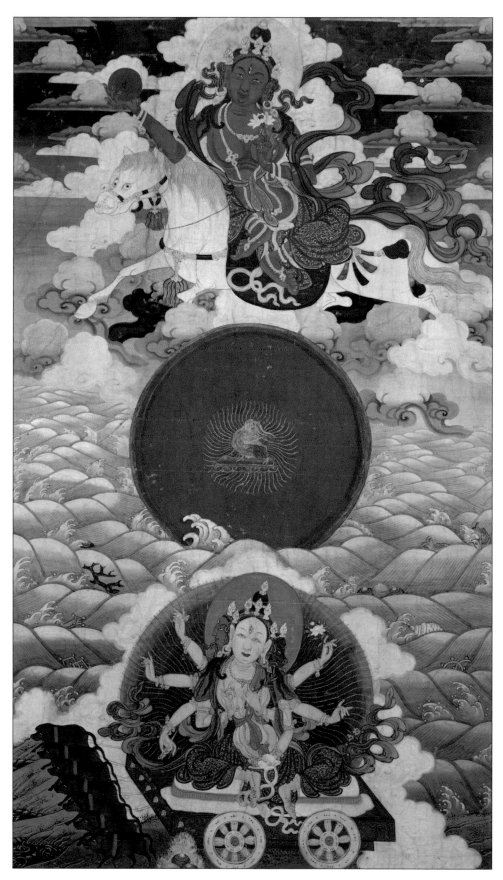

Marichi; Tib., *Ozer Chenma; She with the Rays of the Sun.* Nineteenth century, 34 x 19 inches.

around her, the large sow represents the sun and Sunday; the six piglets represent the remaining heavenly bodies and days of the week.

Look closely at the painting of the sun. A rooster with three legs and three tails is performing a dance within it. Inquiries to a dozen lamas in all the schools of Tibetan Buddhism failed to produce a confident explanation of its significance. Perhaps this rooster identifies the tangka as being from the Dayab area of Kham in Eastern Tibet; the Dayab artists were famous for always placing a rooster somewhere in their creations.

Alternatively, the rooster may be a residue from the ancient Dravidian myth from India, possibly of African origins, of a cosmic rooster who danced and scratched long before time began and who, through his dancing and scratching, created the known universe. Thirdly, the significance might be something completely mundane; the rooster always calls out with the sunrise and thus is associated with the sun. The three legs and three tails are another mystery. Suggestions and educated guesses will be welcomed.

We were unable to identify the female deity pictured in the sky above the sun. In fact, her actual placement is behind and below, but painting her there would have hidden her behind the sun. She holds a mirror that is the color of the setting sun and is located in the far west. In that Marichi is associated with the east and the sunrise, we can presume that she represents the west and sunset. Several Tibetan informants tentatively suggested that perhaps she is one of ancient Tibet's Tenma Chunyi, or "Twelve Female Revealors." Each of these holds a mirror, for from the most ancient of times all twelve were channeled by oracles in times of need. The mirror in ancient Tibetan culture was an important tool in the oracular arts; anyone channeling a deity would hang a mirror over his or her chest, much like an amulet on a necklace, with the mirror suspended in front of the heart. The deity would be called into the mirror and then accessed or channeled from there. We have included a tangka of the most popular of these twelve in chapter 8, "The Female Dharma Protectors."

Three-legged, three-tailed dancing rooster, detail from tangka on page 119.

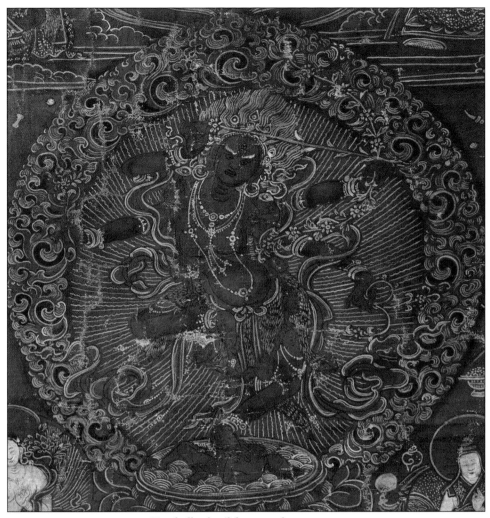

Kurukulle, detail from tangka on p. 123.

Kurukulle

Om svabhava shuddha sarva dharmah svabhava shuddhoh ham. All becomes emptiness. From emptiness arise the eight cremation grounds, and in their midst, from *PAM*, a red lotus, the syllable *RAM* at its center. This becomes a sun disk, on which arises the red syllable *HRIM*, which emanates rays of light. The lights dissolve back into *HRIM*. There is a complete transformation, and from which I emerge as glorious Kurukulle, body red in color, the mere thought of whom brings all in the three worlds under one's power.

The Kurukulle mandala is a popular cycle of Tantric meditation in all schools of Tibetan Buddhism. Consequently Kurukulle is also a popular subject in Tibetan mystical art.

Our painting of her is in the style known as *sertang,* or "golden painting." This technique is also (and more descriptively) known as *sertig,* or "golden lines." In it the artist paints outlines of his images with bonded gold dust on a canvas that has been made red with vermilion. This style of painting was originally popularized by the Sakya School sometime after the great Sakya master Chogyal Pakpa (whom Marco Polo met on his travels in the Far East) became the guru of the Mongolian emperor Kublai Khan in the thirteenth century. Tibetan artists gained wide exposure to a vast range of techniques in Kublai's court, and as a consequence the Tibetan arts underwent something of a renaissance. Kublai was a great patron of the arts and brought the best artists and craftsmen to his capital from the many civilizations under the rule of his vast empire.

Tibetans fell in love with the "gold on vermilion" effect, and within a few generations it had become incorporated by art schools throughout Central Asia. As we will see in several paintings later, they went on to develop this into *nagtang*, or "black painting," a technique in which the artist paints with gold lines on a black background.

Sertang paintings generally were commissioned in Tibet exclusively by high reincarnate lamas. The amount of gold used in the process placed them outside the means of ordinary Tibetan monks, nuns and laypeople. High lamas, on the other hand, had plenty of gold, as it was a common offering from visiting pilgrims and students. Gold in old Tibet was not widely used as a currency, and in fact the Tibetans did not produce their own money until the early twentieth century. Prior to that, everyone operated on the barter system. "You give me a yak skin filled with butter, and I'll give you a bag of salt from the Changtang Flats." Currency from foreign neighbors was accepted in the mix, with Mongolian "silver horse-hoof coins," as they were called, being the most popular. Gold for the Tibetans was generally reserved for use in their temple art. It was also used by laypeople as settings for personal jewelry, with coral and turquoise being the two favored stones used with gold.

It was not uncommon for a temple statue to have several hundred, or even one or two thousand pounds of gold in it. The Maitreya statue created by the First Dalai Lama at Tashi Lhunpo Monastery in the 1450s is one such example. The golden Maitreya image created by the Second Dalai Lama at Chokhor Gyal Monastery some fifty years later is another.

As we have seen in previous tangkas in this book, gold was also frequently used to color the buddhas and bodhisattvas, even if in the formal iconography that particular buddha or bodhisattva was associated with an altogether different color. When this was the case, the gold was seen as an offering. However, the use of gold found its most sublime expression in the *sertang* form.

Our tangka here is associated with the Sakya School, as indicated by the lineage lamas along the top. Kurukulle is especially important in the Sakya tradition, where she is counted among the famed "Red Trinity." She is also listed in the Thirteen Golden Dharmas, a collection of Tantric lineages unique and central to the Sakya School.

Kurukulle, who dances at the center of the painting, is also known in Tibetan as *Wanggi Lhamo*, or "The Female Buddha of Power." This is because her special agenda is the taming of the spirit world and protection against malicious demons. Numerous lineages of her practice from the four classes of tantras are maintained within the Sakya tradition, arranged according to five levels of profundity of application. This particular form belongs to the fourth and fifth of the higher classifications, which respectively are associated with the Hevajra and Vajrapanjara Tantric systems. Her body is red, which indicates the enlightenment activity of power, in the sense of forcefully subduing all forces of evil. Her hair flows upward, for her energy lifts practitioners to the state of enlightenment. She bears a slightly wrathful expression, for she embodies the activity of power. She holds a bow and arrow in the first pair of hands, and a hook and lasso in the second pair. We have seen these before with previous female buddhas. As inner symbols the bow is meditative concentration and the arrow the wisdom that penetrates to the heart of reality; as secret symbols they represent the ability to subdue the various elements of the occult world. Similarly, as inner symbols the lasso and hook represent the ability to rope in the wandering mind and to jump-start the elephant of the lethargic mind; as secret symbols these two implements snare and control occult elements such as ghosts and malicious spirits. All of these implements are made out of red utpala flowers, to symbolize the utilization of natural processes for purposes of subduing the forces of negativity. She wears a tiger skin as her lower skirt, to indicate the fearlessness expected of a practitioner of the system. She dances amidst the circular flames of the fire of pristine awareness on a platform made of a human corpse, a sun disc and a lotus blossom, indicating her wisdom of impermanence, infinity/emptiness, and transformative processes.

The Indian mahasiddha Virupa, source of many of the fundamental Sakya lineages, sits in the top left corner of our tangka, his hands in the teaching mudra. An unidentified Sakya lama sits in the top right, his hands in the mudra of presenting the universe as a mandala offering. Buddha Amitabha sits at the top center. A Green Tara is seated at the bottom left, indicating that Kurukulle is in reality a wrathful emanation of Arya Tara. A Sakya lama sits at the bottom right, a vase of immortality nectars in his extended right hand and the stem of a lotus in his left, a sword and wisdom sutra in its blossom. The sword and wisdom book suggest that he was regarded as being an emanation of Manjushri. Perhaps this is the great Sakya Pandita, a contemporary of Genghis Khan and the most famed Sakya lama linked to Manjushri. The wrathful Magzor Gyalmo, an important Sakyapa protectoress, appears at the bottom center.

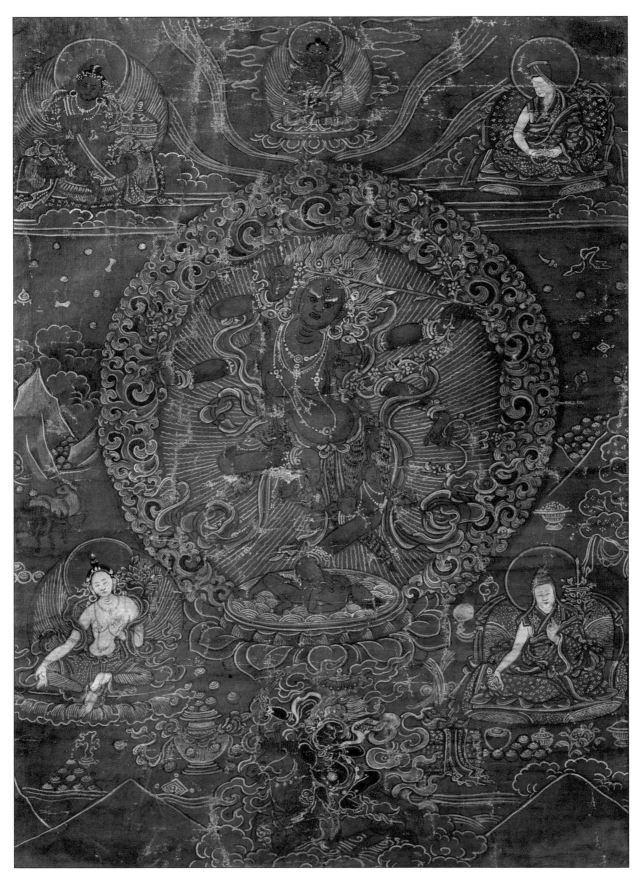

Kurukulle; Tib., *Rigchema; She of the Action Family.* Eighteenth century, 21 x 11 inches.

Simhamukha

Hail Simhamukha, mother of all buddhas,
The queen of dakinis who manifests from the ultimate sphere
And with magical buddha karmas smashes to dust
Outer, inner and secret hindrances and foes.

Although all schools of Tibetan Buddhism carry the initiations, teachings and lineage of practice of the Simhamukha Tantric system, it is especially popular within the Nyingma, or Old Schools. One reason for this is the belief that Simhamukha is a wrathful form of Guhyajnana Dakini, "the Secret Wisdom Dakini," who is said to have been the principal female teacher of Padma Sambhava, the most important early master in Nyingma history, when he lived in Uddiyana.

Another lineage of Simhamukha is similarly popular within the Geluk School, although here there are two reasons. First, the eleventh century master Atisha Dipamkara Shrijnana, who founded the Kadam School on which the later Geluk is based, is also said to have studied in his youth with Guhyajnana Dakini in Oddiyana, and consequently the lineage brought to Tibet by him is cherished. Second, the Dalai Lama incarnations in their pre-Dalai Lama life as Ratnadas, also went to Oddiyana and received training under Guhyajnana Dakini, adding to the myth and mystery.

Samantabhadra and Samantabhadri sit in sexual union at the top center of our painting. This feature identifies the tangka as belonging to the Nyingma School. He is blue in color, and she white. Both are completely naked, to symbolize the naked and unveiled nature of ultimate reality. If the tangka had belonged to any of the Sarma schools, this top-center position would be held by Buddha Vajradhara rather than Samantabhadra.

The central figure, Simhamukha, has the face of a lion. This symbolizes that her practice brings the fearlessness of enlightenment and the transformation of fierce emotions into constructive activity. Her body is maroon, which is a combination of red and blue, here representing the enlightenment activities of power and wrath. Her special agenda is the fearless confrontation of forces of evil and, when need be, their immediate and unhesitating destruction. In particular, her yogas empower the yogi or yogini with the ability to reverse any negative energy sent in his or her direction by other beings, and to direct it back to its sender.

She has three round eyes, a gaping mouth, and yellow hair that flows upward. The three eyes, as in so many Tantric paintings, indicate clairvoyant vision of all in the subtle world; her gaping mouth indicates that she devours evil beings as nourishment, without any detrimental effects to herself; and the hair streaming upward indicates that her practice leads to complete enlightenment. She dwells in the midst of a blazing fire of pristine awareness, to show that her wisdom consumes all negativity. Numerous lion-faced male dakas and female dakinis dance in the flames around her, the female being recognizable by their enormous, drooping breasts. Some are white, others yellow, others red, others blue, and still others green, to indicate the four buddha karmas (the green being all four in one). In the practice of the Simhamukha mandala, one can use whichever of the four one wishes as the central figure, depending on which buddha karma one wants to activate.

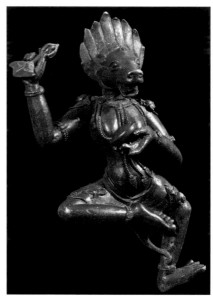

Simhamukha, eighteenth century, 12 inches, bronze.

As with many of the dakinis in Tibetan Tantric art, she holds a curved knife in her right hand and a skull cup filled with blood in her left. The curved knife indicates the wisdom that cuts out the guts of ignorance; the skull cup of blood is transcendental bliss. The khatvanga staff that is held in the bend of her elbow signifies that she is a full-fledged buddha in possession of the Three Kayas of enlightenment.

Various lineage masters are seated above and to the sides of the central image. The important Dharma Protectors of the Nyingma School are depicted below. Three of these are of divinities included in a later section of this book.

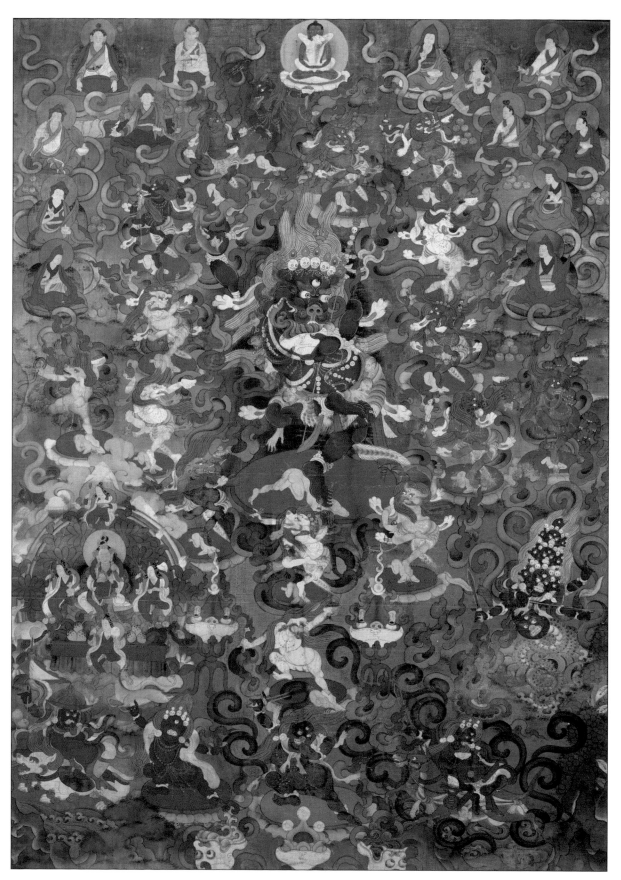

Simhamukha; Tib., *Sengdongma; The Lion-Faced Dakini.* Nineteenth century, 21 x 11.5 inches.

Sherab Chamma

The Bonpo lamas of Tibet generally do not use Sanskrit names for their mandala deities. They do, however, use the Tibetan equivalents of the words *buddha, bodhisattva,* and so forth; and much of the Bon linguistic is a close parallel to the Buddhist. For example, *Sherab Chamma* easily becomes *Maitri Prajna* in Sanskrit.

The Bonpos are often referred to in Western literature as "Tibet's indigenous pre-Buddhist tradition." In fact it is probably neither indigenous nor pre-Buddhist, at least not in its entirety. Instead, it is the pre-Songtsen Gampo era (i.e., pre-seventh century) Tibetan spirituality. Although it does hold some elements of pre-Buddhism in it, it is more probable, as the British Tibetologist David Snellgrove points out, that it comes from the region that today is Western Afghanistan/Pakistan, and that at the time was Buddhist. The Bonpos themselves describe their founder Tonpa Shenrab as coming from the land of Tazig to the west. In all probability he brought an early form of Tantric Buddhism with him. This later became downplayed by King Songtsen Gampo, when the latter established his empire in the mid-seventh century and declared the newly imported Buddhism of Northern India as the national religion of the country. In addition, he declared the written script devised in Central Tibet at the time to be the only official script of his empire. His purpose here was to establish a unified language, culture and spiritual basis for the many lands he had united, in order to ensure a lasting stability. Prior to this Bon had used the scripts of the neighbors to whom it was most close. The great kingdom of Zhang Zhung in the west, for example, would have used a form of Arabic. The kingdoms of Kham and Amdo probably used variants of the Chinese script. Songtsen Gampo hoped to establish a national standard.

Sherab Chamma is depicted as youthful and white in color. She holds a golden swastika in her right hand, a symbol of the eternal harmony of ultimate and conventional realities. The swastika is a pan-Asian symbol thousands of years old; in fact, Native North Americans carried it with them on their migrations over ten thousand years ago, and we find it in ancient Hopi cave and rock paintings in New Mexico.

She holds a golden vase filled with the nectar of loving wisdom in her left hand, indicating that those who meditate on her mandala will grow in this quality. The stem of a white lotus blossom can be seen between her fingers, with the flower opening above her left shoulder. This would indicate that she is the equivalent of Tara or Avalokiteshvara in the post-Songtsen Gampo Buddhist tradition. Moreover, in China the vase is an important symbol of Kuan Yin, who is Avalokiteshvara in female form.

Her right leg is extended and the left is drawn in, similar to the posture of Arya Tara. The extended leg indicates that she is active in the world for the benefit of living beings; her right folded underneath indicates that she never leaves her inner posture of meditation, no matter how active she seems to be. She sits on a throne with lotus and moon cushions, similar to the seat of Avalokiteshvara; and her throne is upheld by eight antelopes, again an animal associated with Avalokiteshvara in the formally recognized Buddhist schools.

Four attendants sit in the four corners, each with four arms. Their four arms represent compassion, love, joy and equanimity. Each of them holds unique implements, indicating that they have their unique ways of expressing these four sublime attitudes. They are red, green, white and blue, indicating that they are expressions of the four enlightenment activities.

At the bottom center of the flat brown landscape we see a large red bowl filled with precious jewels, red coral, ivory tusks and gold ornaments, all of which are topped with blazing jewels. These are the artist's offerings to Sherab Chamma, "She of Loving Wisdom."

Sherab Chamma is an alternate name for the female buddha Satrig Ersang when the latter is not included in the group of the Four Transcendent Ones, of which she is the first of the four. In her most wrathful form the latter manifests as the protector Sipai Gyalmo, the principal Dharma Protector in the Bon tradition.

Of note, in most of the later Buddhist schools Sipai Gyalmo is one of the twenty-one forms of Palden Lhamo, whom we shall meet later in chapter 8, "The Female Dharma Protectors."

Offering basket, detail from tangka on opposite page.

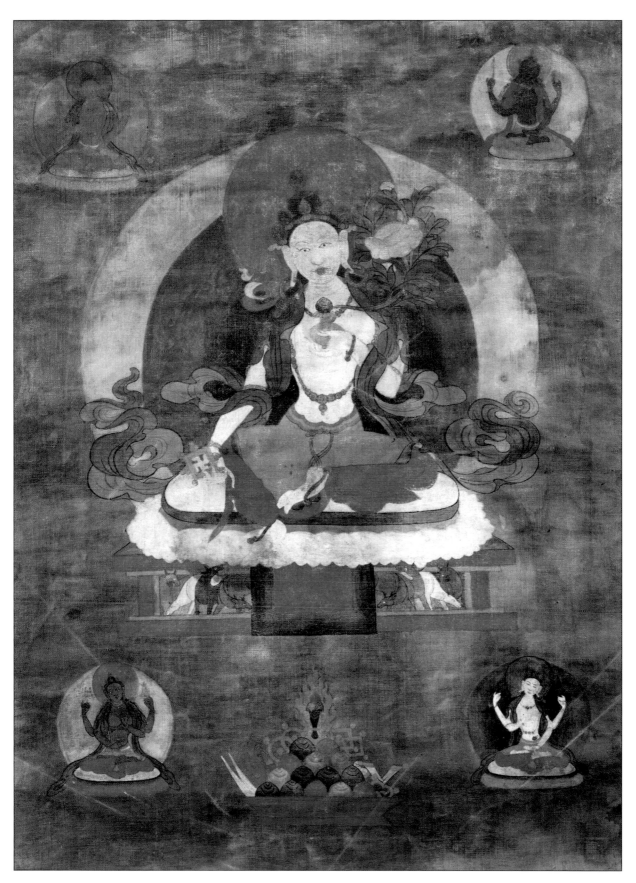

Sherab Chamma, She of Loving Wisdom, Nineteenth century, 19 x 10.5 inches.

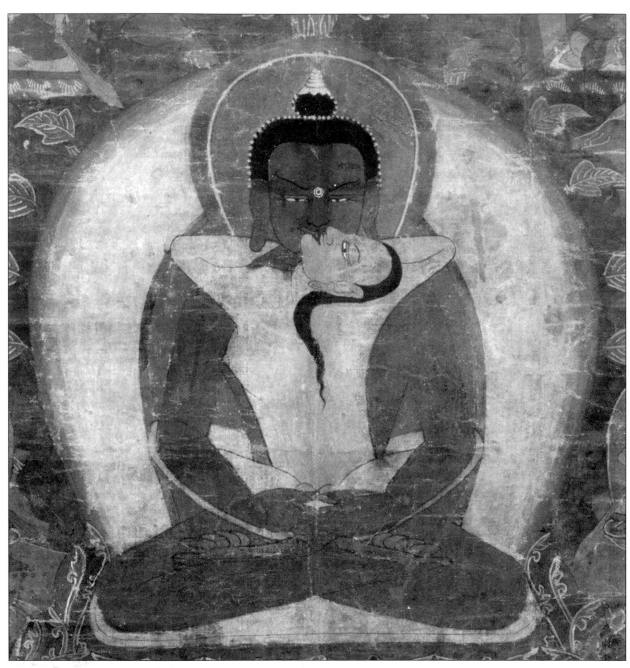

Samantabhadra and Samantabhadri, detail from tangka on page 133.

The Yum *in* Yab Yum

Hevajra and Nairatmya, detail from tangka on page 143.

The Tibetan word *yab* appears in colloquial Tibetan as an honorific for "father," and *yum* as an honorific for "mother." These are used in polite conversation for the parents of any high incarnate lama or aristocrat. We also saw *Yum* used earlier as "Mother," in the expression *Gyalwai Yum,* or "Mother of the Buddhas." However, *yum* as mother in the first of these cases is simple social convention, and in the second case is a metaphor used in both the Sutra Way and any of the first two levels of Tantra, Kriya and Charya.

In the third and fourth levels of the Tantras, however, or Yoga and Highest Yoga Tantra, both *Yab* and *Yum* take on a different meaning altogether. Here the sense is *Yab Yum Nyamjor,* or "male/female in sexual union," i.e., as Tantric consorts. Tibetan art is rich in erotic images of this nature. These images—and every Tibetan temple contains many of them—usually depict male and female buddhas in sometimes rather difficult-to-achieve physical positions of copulation. The Tantric texts and meditational manuals related to these mandala deities also refer to them as Yab Yum.

When the terms "yab" and "yum" are transported out of the fields of Tantric art, literature and meditation, we see them used in conjunction with the prefix syllable *Sang,* or "Secret." For example, the female Tantric partner of a male practitioner is referred to as *Sang Yum,* or "Secret Consort." The word "secret" here, however, does not imply that their sexual relationship is being kept a secret, but rather "that it is *rang sang,* or "self secret." The secret is not in the fact of the relationship, but in the manner in which this is understood. Ordinary people experience and understand the sexual encounter in an entirely different manner than does the Tantric adept. The sexual encounter is an act of conventional romance and pleasure for an untrained person, whereas for the Tantric practitioner it is the best ground for inner core transformation. The orgasmic state is considered by Tantric Buddhism to be the best occasion for meditation.

The tradition of Tantric sex has its roots in ancient India, the source of the Tantric legacy in Tibet. Here the

methods of meditating during love-making were primarily taught to Indian aristocrats, who were non-monogamous in lifestyle. Consequently they spent a lot of time making love with their various partners. Many of them led busy lifestyles, and the love-making periods of the day were their most quiet times. Given the strong spiritual mood of the ancient Indians, it was natural that they would want to maximize the spiritual value of these occasions.

The early Tantric yogis and yoginis did not think of Tantric sex as anything wild, titillating or indulgent, but simply as a means of making the best possible use of that particular time of their day. Nor did they think that introducing meditative techniques into the process would lessen the romantic atmosphere. Theirs was a simple situation: They made love several times a day and were happy to learn of techniques for elevating and transforming the experience.

The basic underlying principle behind Tantric sex is best explained by the eleventh-century Indian mahasiddha Naropa in his great work entitled *A Treatise on Empowerment*. As he puts it, "The sexual encounter is the best occasion for Tantric meditation because of three qualities of consciousness that arise during orgasm. The first of these is a sense of great pleasure or bliss. The second is an utter radiance or lucidity. Thirdly, an all-pervasive sense of non-duality or non-separateness arises. Tantric meditators utilize these three factors for their quick liberation and enlightenment."

Almost all of the Highest Yoga Tantras, with their mandalas of Yab Yum deities and associated practices, were originally taught to and for laypeople. However, the high number of men and women who achieved full enlightenment by means of them soon attracted a strong interest from the monastic community. As a consequence, the sexual element of Tantric Buddhism gradually became metaphoric for particular processes, and the living practice of esoteric love-making became rare. The *yab* in Yab Yum came to represent male energies, and the *yum* to represent female equivalents. In the language of Classical Buddhist India, *yab* represented *upaya*, or method, and *yum* represented *prajna*, or wisdom. "Method" here refers to the bliss that is experienced when one attunes to the primordial energies of the body and mind by means of opening the chakras; and "wisdom" refers to the clear light consciousness that is aroused by that bliss.

Two terms were introduced to mark the difference between real and imaginary Tantric sexual practice: *karmamudra*, or "action mudra," which refers to an actual sexual partner in Tantric meditation; and *jnanamudra*, or "wisdom mudra," which refers to meditation itself as being the lover.

The Tibetans seem to have shown great interest in karmamudra and the tradition of Tantric love-making during the early days of Buddhism in Tibet. However, an amazing enthusiasm for monasticism and celibacy swept across Central Asia from the eleventh century onward, and karmamudra was gradually replaced by jnanamudra. As a consequence, most lamas today of all schools of Tibetan Buddhism generally have only practiced jnanamudra. They will have heard about karmamudra, but will never have practiced it. This is equally true of married lamas; although they may enjoy sex as part of their normal married life, this is for ordinary romantic purposes, with the added biological function of producing children to act as their spiritual heirs.

How is *Yab Yum Nyamjor* practiced as jnanamudra? On the first level of Tantric meditation, or *Kye-rim*, the male aspect is the bliss that arises in the mind through meditating on the mandala of supported and supporting deities, reciting the mantra, and so forth; the female aspect is the mental radiance that arises from that bliss. The meditative technique ensures that these two operate in union. Put another way, the male element is the bliss that arises from the appearance of the mandala in the mind during meditation; the female aspect is the radiance that arises from the awareness that the subject and object of the meditation are of one nature. Sometimes it is also said that the bliss aroused by the meditation technique is the Yab; the mental radiance that is experienced from it is the Yum.

On the second level of Tantra, or *Dzog-rim*, the jnanamudra practitioner mainly engages in breathing exercises as a means of redirecting the subtle bodily energies in order to untie the knots of the chakras, which in turn allows out-of-body meditation (known as *gyu-lu* in Tibetan) and the accessing of the primordial clear light mind. Here the bliss experienced by drawing the energies into the central channel at the heart chakra is the Yab; the primordial clear light mind experienced after the fourth and highest level of bliss is the Yum.

One of the many features of Tantric sex that set it apart from its mundane equivalent is the fact that the male forgoes ejaculation and the release of fluids, the cause of the orgasmic state being so brief in the male sexual experience. Instead, he imitates the nature of the female orgasm, wherein energies and fluids are naturally internalized, and as a consequence multiple orgasms are experienced. To accomplish this he slows down the process when the drop begins to move downward and brings it to a standstill when it arrives at the tip. Here the three qualities of orgasmic consciousness naturally arise—bliss, radiance and

non-duality—but rather than arise as a momentary flash, as in ordinary sex, their experience is sustained by means of meditation and energy control. He retains the drop at the tip of the jewel in this way for as long as possible, thus sustaining the threefold quality of the orgasmic state, and looks for the signs of the primordial mind. When this arises he holds firmly to it, and gazes from within it directly into the infinity/emptiness nature of ultimate reality. Finally, he draws the drop back up the jewel passage, again by the powers of meditation and energy control. The process is repeated over and over, for as long as the love-making session continues. As suggested above, the practice for the female is much easier, because her orgasmic pattern is naturally more sustained and thus more conducive to Tantric meditation.

The Tantric control over ordinary ejaculation is illustrated by an anecdote related to the Sixth Dalai Lama, who was the only Dalai Lama incarnation not to remain a monk. To the contrary, he became a great Casanova and poet. He nonetheless is one of the most beloved of all Dalai Lamas by the Tibetans, and they believe his many romantic escapades to have been of a Tantric nature. He himself once said, "Not a night has passed without me bringing a different beauty to my bed. But I never once spilled a drop of sperm."

According to the anecdote, once when he was returning from one of his many nocturnal adventures he was confronted by some aristocrats and chided by them for his ostensible indulgences. He laughed, pulled out his penis, and said, "You can have sex, and I can have sex, but we shouldn't pretend that it is the same thing." His penis then immediately became hard, and a drop of sperm shot to its jewel tip. He exerted Tantric meditation, and the drop immediately reversed its direction and disappeared back up the jewel.

Most lamas today are celibate monks, and therefore see Yab Yum Nyamjor as a metaphor of enlightenment processes rather than as a symbol of enlightenment through Tantric sex. They practice jnanamudra rather than karmamudra. The same holds true for married lamas, for whom marriage is primarily a means of continuing the family line. Moreover, almost all teachers and students alike of married lamas are monastics, so the latters' attitudes are naturally aligned with the monastic perspective.

In brief, we can regard the Yab Yum figures in Tibet's mystical art as illustrations of a yogic tradition that incorporated Tantric sex as its highlight, as was the case before the Highest Yoga Tantras were absorbed into monasticism. Alternatively, we can regard these figures as artistic metaphors of the enlightenment experience, as became the case with the monastic reinterpretation of the tantras. In either situation we are left with an exquisite art form that transcends the limitations of ordinary convention.

In terms of female buddhas and women of enlightenment, it should be pointed out that as spiritual metaphors the Yab Yum mandala deities are indivisible and inseparable. That is to say, when one meditates on the mandala and transforms one's self-image from the mundane "I" into that of the mandala deity, it is in the sense of oneself becoming the two, male and female in union. One does not become the male embracing his consort, or the female embracing hers. Rather, one simultaneously becomes both, with the Yab being one's male qualities and the Yum one's female aspect. The "union" meditated upon is one of harmony between all things male and female. This is true on outer, inner, secret and most secret levels. The aim is to achieve bliss, radiance and the harmony of non-duality on all four dimensions.

Samantabhadra & Samantabhadri

Hail Samantabhadra, male and female in union,
Ocean of wisdom and pristine awareness,
Primordial embodiment of unchanging light,
Principal origin of all mandala forms.

Yab Yum images of Samantabhadra and Samtabhadri are seen in almost every temple, monastery and hermitage of the Nyingma School in Central Asia. Sometimes they appear as a single image in a fresco or tangka, and at other times are placed in the top center of a group of images to indicate their supreme importance. For example, we saw them in our previous chapter in the Simhamukha tangka, where they were given the seat of honor at the top center of the painting. Here they are the central images of the painting.

Samantabhadra and Samantrabhadri are regarded as primordial buddha figures in the Nyingma School and the source of almost all the Nyingma tantras. The two sit naked and in sexual union. Their nakedness indicates that they are Dharmakaya aspects, which in reality are formless and thus unclothed by finite limitations. The Dharmakaya is the sphere from which all enlightenment forms and activities manifest. All the other figures in the painting can therefore be regarded as their emanations. He is blue in color, indicating the vastness of space; she is white, the source of all forms. This is a purposeful reversal of the usual male/female symbolism with space and form, indicating that in enlightenment both aspects of one's sexuality achieve the full realization and resolution of conventional opposites. Their sexual union indicates that they have the full experience of bliss, radiance and non-duality awareness described earlier.

Six buddha figures stand along the two sides of the painting. These are the ambassador buddhas to the six realms of existence: the realms of the gods, demi-god, humans, animals, ghosts and hell beings. The buddhas emanate throughout all six of these realms in order to bring benefit, liberation and enlightenment to the living beings who have been reborn there. After death an unenlightened person is reborn into a particular realm depending upon which of his or her six delusions predominates: pride, jealousy, egoism, ignorance, attachment and aversion. Each of the six is transformed by an according wisdom, symbolized by one of the six colors of the six buddhas. All six buddhas are Nirmanakaya emanations of Samantabhadra and Samantabhadri.

Padma Sambhava, one of the founders of the Nyingma School, sits at the top center of the painting. Directly below him is a yogi with long black hair tied up on the crown of his head. This probably is Nyang Tingzin Zangpo, an important eighth-century Nyingma master whose work ensured the success and proliferation of Padma Sambhava's lineages. Nyang is said to have been able to sit for seven years at a time without rising even to eat, drink or go to the bathroom.

This painting is rich in female buddhas in the form of dakinis. For example, the lion-faced dakini Simhamukha can be seen to Padma Sambhava's right (the viewer's left), and the five principal dakinis can be seen in the upper left corner. We have included a Nyingma tangka with these five in a later section, "The Vajra Dakinis."

The eleventh-century yogi Milarepa sits to the right of the shoulders of the central figures. Although technically a forefather of the Kargyu School, he was posthumously adopted by all sects of Tibetan Buddhism because of the tremendous mythology that built up around him within a century of his passing. He wears the white robes of a yogi and has a red meditation belt over his shoulder because of the eighteen years he spent meditating in caves. His right hand is cupped beside his ear in the mudra of song; he is most famous in the Tibetan world for the collection of songs that he spontaneously composed. He never wrote any of these down, and so we have several versions of them compiled by disciples and spiritual successors over the generations to follow. The most famous is the *Mila Gur Boom*, or *Hundred Thousand Songs of Milarepa*.

The other figures in the painting are important meditational deities (Yidam) or Dharma Protectors (Chokyong) in the Nyingma School.

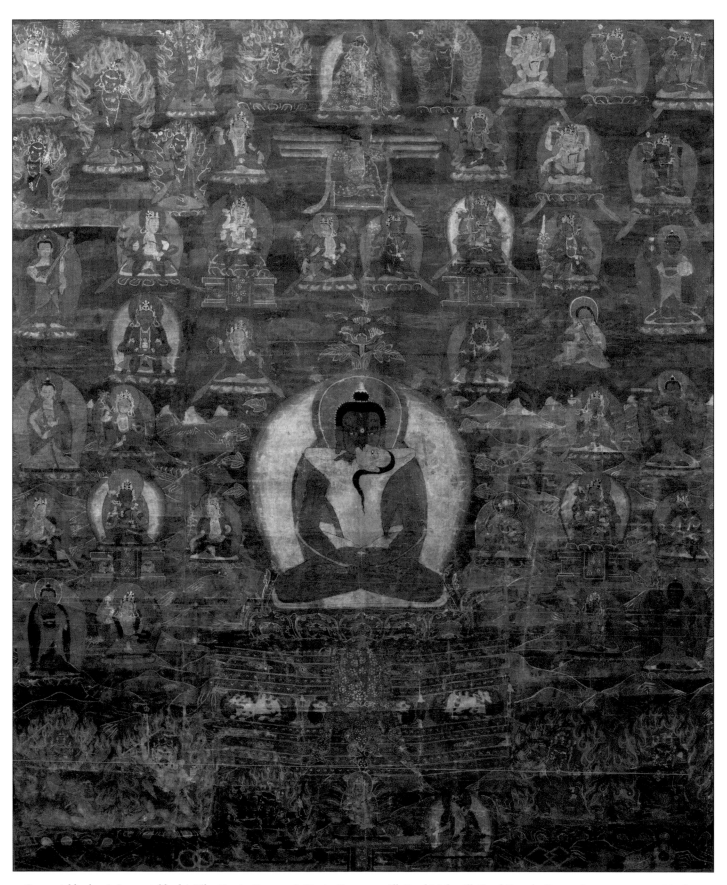

Samantabhadra & Samantabhadri; Tib., Kuntu Zangpo & Kuntu Zangmo; *All-Good Male, All-Good Female.* Sixteenth century, 34 x 28 inches.

Guhyasamaja & Sparshavajri

In general the Highest Yoga Tantras are divided into three types: male, female, and neither/both. Of these three, the Highest Yoga Tantras in the male category are again of three types: those which utilize sexual desire and sensuality as the path to enlightenment; those which utilize anger; and those which utilize lethargy, or "ignorance."

Guhyasamaja is the principal Highest Yoga Tantra in the first of these divisions. Popularly referred to as *Gyugi Gyalpo*, or "King of All Tantras," it is studied and practiced (in monasticized form) in all major Sarma or New Schools of Tibetan Buddhism. The Gelukpas use it as the main subject of study in their two main Tantric colleges, Gyumey and Gyuto.

"Guhyasamaja" literally means "The Secret Gathering." There are a number of explanations of the source of this name. One of these states that the system was originally taught at the request of King Indrabhuti. Indrabhuti explained to the Buddha that he required a special technique, because his job as king kept him extremely busy running the affairs of the state, and as a consequence the only time he had left over for meditation was when he was making love with his wives. Buddha laughed, manifested as Vajradhara, and transmitted the Guhyasamaja to him. Because Ananda was not sufficiently mature to listen to the teaching, Buddha and retinue, as well as Indrabhuti and the other recipients, all performed shape-shifting and gathered inside the sexual organ of the main female buddha in the Guhyasamaja Mandala. The teaching was called a "Secret Gathering" because of the place at which it was given.

In his *A Guide to the Buddhist Tantras,* the Thirteenth Dalai Lama points out that two commentarial traditions existed in India: those of Nagarjuna and Jnanapada. The iconography of the tangka shown here is from the Nagarjuna lineage.

The Great Thirteenth goes on to state that three principal lineages of this transmission came to Tibet. One was brought in by Atisha Dipamkara and formed the basis of the Kadam School. A second lineage was imported by the translator Goe Lotsawa and transmitted through the Sakya and Zhalu Schools. The third lineage was brought to Tibet by the translator Marpa Lotsawa and passed on through the order of Kargyu masters. The Thirteenth concluded by saying, "Lama Tsongkhapa collected together these various lines of transmission and united them into one stream." As most readers will know, Lama Tsongkhapa was the founder of the Geluk School.

The principal Yab Yum image in the Guhyasamaja mandala is that of Akshobhyavajra and Sparshavajri. The former name translates as "The Unmoving Diamond," and the latter as "Diamond Touch." The male is referred to as "unmoving" because the wisdom generated by this Tantric method gives rise to the awareness that cannot be displaced from the enlightenment experience. The female is referred to as "Diamond Touch," because her passionate embrace arouses the diamond wisdom. She represents the utilization of all the objects of touch as objects of Tantric meditation. However, the caress of the male and female sexual organs is the most sublime of all touch sensations, and therefore she is especially symbolic of this.

Both Akshobyavajra and Sparshavajri have six arms and hold a Dharma Wheel, indicating complete enlightenment; a lotus, indicating the transformation of sexual lust into enlightenment; a vajra, symbolizing the five pristine awarenesses; a sword, which is the wisdom that cuts off grasping at duality; the Three Jewels, indicating that the practice brings ultimate safety and salvation; and a bell, symbol of the wisdom of infinity/emptiness.

Four other Yab Yum figures are seated in the four corners. If shown in a mandala, these four would be in the four cardinal directions. They are similar to the central image, with the exception that their bodily colors and also the implements that they hold vary. In our tangka all five are painted in gold as an offering; in reality each of the five Yab Yums has its own color, to indicate the five buddha families. The implements that they hold also vary, again to indicate the buddha family to which they belong. While the central female buddha represents diamond touch, the four remaining females represent diamond taste, fragrance, sound and sight.

In other words, the five female buddhas are embodiments of the wisdoms for utilizing the objects of the five senses as fuel for the enlightenment experience. Moreover, just as the best touch is the lover's embrace, similarly the best taste is the lover's kiss, best fragrance the lover's breath, best sound the lover's passionate sighs, and best sight the ecstasy in the lover's eyes.

As said in the introductory section to this chapter, in ancient times most practitioners of this system would have been non-monastic, and the practice would have been undertaken in the context of love-making. By the ninth or tenth century, however, the system had largely been absorbed by the celibate monastic tradition and transformed into monastic liturgy.

It has almost exclusively been practiced as liturgy for the past five or six centuries. Any monk or nun receiving the initiation is usually given the practice commitment of chanting a standard meditation text once a day for the rest of his or her life. Texts of this nature vary in length, but usually are a hundred pages or more, and require upwards of an hour to chant.

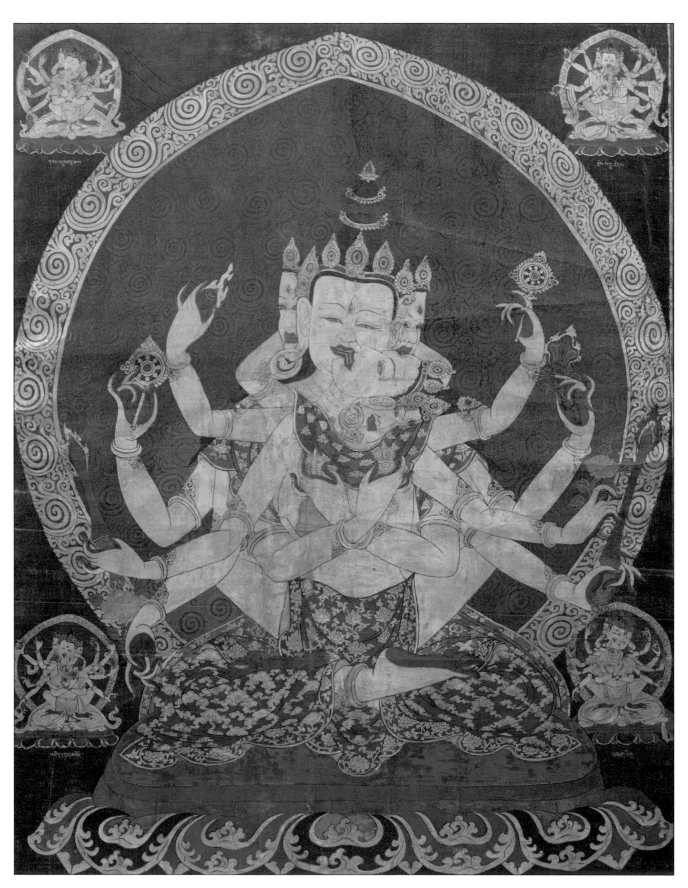

Guhyasamaja & Sparshavajri; Tib., Sangwai Dupa; *The Secret Gathering.* Sixteenth century, 30.2 x 23 inches.

Vajrabhairava & Vajra Vetali

As was pointed out with the tangka of Guhyasamaja, the male category of Highest Yoga Tantras are of three types, depending on which of the three psychic poisons they utilize as the path: sensual desire, anger, or lethargy/ignorance. Guhyasamaja uses sensual desire, whereas Vajrabhairava uses anger. They are called "The Diamond Terror Male/ Female" because they strike fear into all the forces of evil.

Vajrabhairava's alternate name is Yamantaka, meaning "The Destroyer of Death." This is given from the three perspectives: the practice removes obstacles that cause premature death; it eliminates the inner death, which is the afflicted emotions and mental distortions; and it cures the secret death of blockages in the subtle energy channels and chakras of the body.

The consort's name, Vajra Vetali, means "Diamond Zombie," or perhaps "Resurrected Diamond." Both Yamantaka and Vajra Vetali are wrathful emanations of Manjushri, the Buddha of Wisdom. The implication is that wisdom as a male force wrathfully destroys the three kinds of death; as a female force it heals and resurrects.

Vajrabhairava in solitary form, i.e., without the consort, is perhaps the most common Tantric meditational deity in the Gelukpa School. When depicted in solitary form he stands in a striking posture with a huge erect penis, symbolizing that the practice quickly brings the great bliss of Tantric enlightenment. When depicted with his consort, the penis is still erect and has the same symbolism, although obviously it is not visible to the viewer, just to the meditator as an object of visualization.

As with all the Tantric mandala deities, every bodily feature has its symbolism. Vajrabhairava's two horns indicate that the system incorporates the illusory body and clear light yogas with equal emphasis. The thirty-four hands, together with body, speech and mind, are the thirty-seven wings of enlightenment. The sixteen legs are the sixteen aspects of infinity/emptiness. The figures being trampled under the right legs show that the practice brings the eight magical abilities, such as clairvoyance; the eight under the left indicate that the practice brings the eight aspects of the supreme siddhi, which is enlightenment itself. All the objects in the thirty-four hands similarly have their meanings. The man on a skewer, for example, indicates that the practice brings enlightenment in one lifetime. The fire pot indicates that the system has the full instruction on the inner heat practice.

The primordial buddha Vajradhara can be seen at the top center of the painting, with Lama Tsongkhapa in the upper left corner and White Tara in the upper right. Two Dharma protectors stand to the side: Mahakala and Yama Dharmaraja. This latter figure dances on a buffalo, his penis erect, while his consort Chamundi dances beside and attempts to mount him. Yama Dharmaraja and Chamundi as a pair are the special protectors of those who practice the Vajrabhairava Tantra.

At the bottom center we can see a small image of Magzor Gyalmo with Vaishravana to the left and Setrap Chen to the right. These and the other peripheral figures in the tangka will have been set where they are at the request of the original patron who commissioned the painting, and because they were important in his or her training.

The practice of Vajrabhairava is common to all three Sarma Schools—Sakya, Kagyu and Gelug—but is most popular within the Geluk.

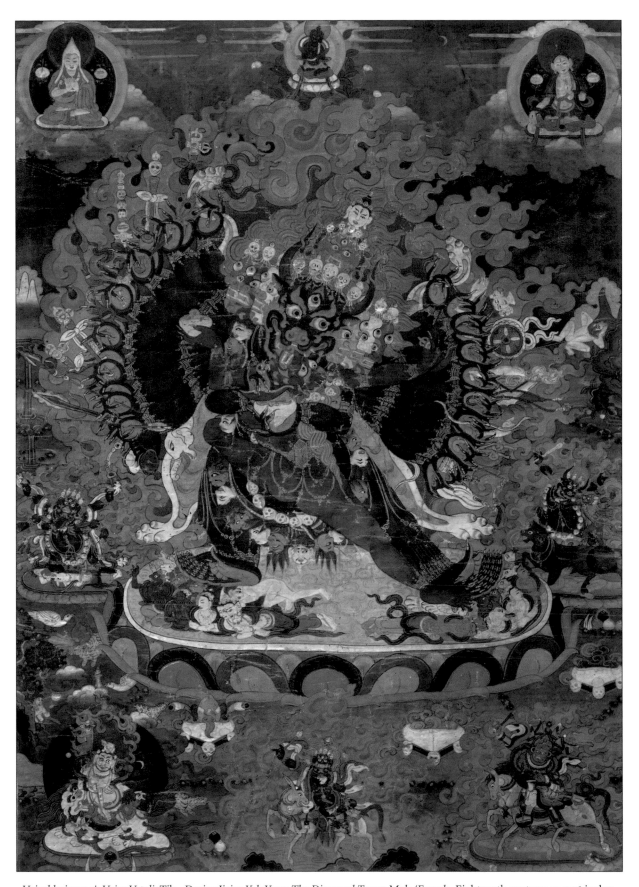

Vajrabhairava & Vajra Vetali; Tib., *Dorjey Jigjey Yab Yum; The Diamond Terror Male/Female*. Eighteenth century, 22 x 16 inches.

Kalachakra & Visvamata

The system of classifying the Highest Yoga Tantras into male, female and neither/both, and then further breaking down the male tantras into three—those working with sensual desire, those working with anger, and those working with lethargy—was a later development in Tantric Buddhism and did not emerge until the eighth or ninth centuries A.D. Prior to this all Tantric systems were taken at face value as complete paths in and of themselves. Perhaps this is because the Tantras were transmitted in extreme secrecy for many centuries and confined only to the most promising students. Most practitioners would only know of their own system and never even hear of the others.

Gradually, however, as the Tantras became absorbed by monasticism, it was no longer possible to keep things secret. Monasteries after all are usually communities of several hundred monks and/or nuns. Everyone started learning of the many different Tantric systems, and the need to classify and structure them arose.

However, there was no clearly defined criterion that could be applied. As a result, different structures appeared. Moreover, often there would be considerable debate over the particular category in which a given Tantra should be placed, even within a single classification system.

The Kalachakra Tantra is just such a case. Some schools of Tibetan Buddhism speak of it as being a female Tantra, and others as a neither/both Tantra. Still others call it a male Tantra and place it in the third category of male tantras, namely, those that work with lethargy/ignorance as the path to enlightenment.

Kalachakra is said to be one of the first Tantric systems taught by the Buddha, for he delivered the transmission at the same time as teaching the *Prajna Paramita Sutras.* However, the historical texts claim that shortly thereafter it was carried out of India, to a kingdom in the north known as Shambala. It remained in Shambala for many centuries, and was not brought back to India until the tenth century. It came to Tibet shortly thereafter. Because of its late appearance, it was not known to the Nyingma, and became an exclusive doctrine of the Sarma Schools. However, its vast popularity eventually prompted the Nyingmapa to acquire their own lineage of it, and so now it is an important tradition in all sects of Tibetan Buddhism.

There are a number of reasons for the pervasiveness of the Kalachakra doctrine in Central Asian culture. First, it is the most important source of the Tantric Buddhist sciences of astronomy, cosmology and astrology. As a consequence, all educated Tibetans touch upon it to some degree during the course of their studies. Second, there is a tremendous mythology surrounding Shambala, a legendary Shangri-la-type kingdom located somewhere along the Silk Road; receiving the Kalachakra initiation can produce a rebirth there. Third, the Kalachakra scriptures are a main source of the Buddhist prophecies, and prophecy always draws attention. Finally, the precise time for collecting particular medicinal herbs is set by means of astronomy, one of the Kalachakra sciences; hence all Tibetan doctors and healers must have at least a basic training in it.

The Kalachakra texts speak of three Kalachakras, or "Time Wheels": Outer Kalachakra, which is the system of astronomy, astrology and cosmology; Inner Kalachakra, which addresses the human situation and includes subjects such as neurology, psycho-immunology, and so forth, as well as subjects directly related to human culture, such as environmentalism; and Alternative Kalachakra, which is the yogic system for using the outer and inner Kalachakras as a path to enlightenment.

Our tangka depicts the standard form of Kalachakra in Yab Yum mode. This lineage passed through the Zhalu School, a sub-sect of the Sakya, and later came into the Gelukpa from there. The Dalai Lama publically gives the initiation into this Tantric mandala every couple of years, and has done so in the West on more than a half-dozen occasions. When he gives the initiation in India, hundreds of thousands of Tibetans and Himalayan Indians attend.

The female in the union is Visvamata, whose name means "The Variegated Mother." She stands in sexual union with the male, and is naked except for her jewelry, for the primordial awareness that she personifies is unveiled and shines with great beauty in the world. She embodies the wisdom of *tong-zuk,* or "empty form," a term refering to a Tantric application that allows the practitioner to dissolve the atomic structure of the physical body altogether. By means of the tong-zuk application the Kalachakra practitioner can go beyond the simple rainbow body yogas of the ordinary Highest Yoga Tantras and transform the body into an utter vacuity that only appears as present due to a projected mental image, somewhat like a hologram. This unique doctrine and yoga of *tong-zuk* are exclusive to the Kalachakra sustem. "The Variegated Mother" Vishvamata symbolizes this ability. As the First Dalai Lama explains in his *Notes on the Two Yogic Stages of Glorious Kalachakra,* "When one realizes the wisdom produced by the path of the Kalachakra yogas, one's body transcends ordinary substantiality altogether, and becomes as clear and lucent as the sky

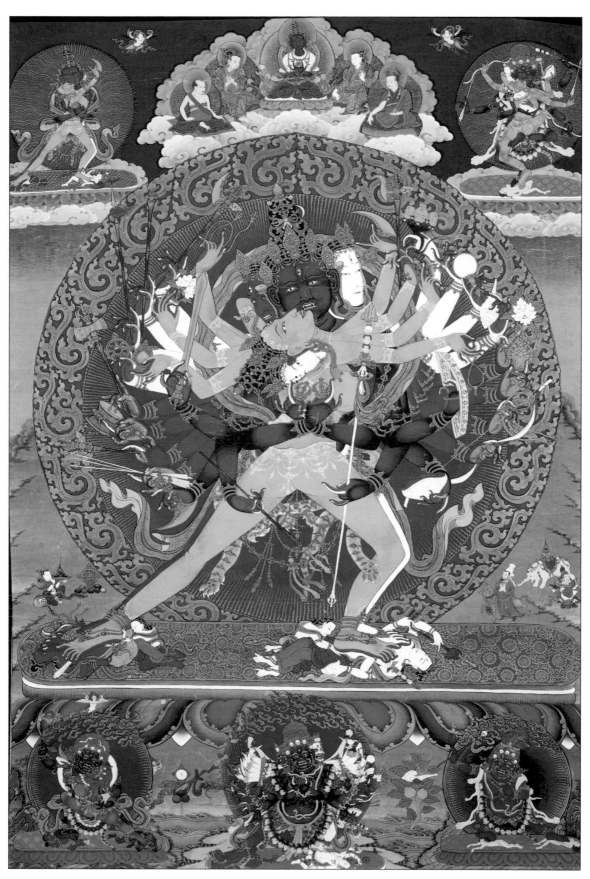

Kalachakra & Visvamata; Tib., *Dukhor Yab Yum; The Time Wheel, Male/Female.* Seventeenth century, 34.5 x 24.5 inches.

itself....One's mind fills with great bliss, and one enters into an eternal embrace with the innately unmoving wisdom. This is the Great Variegated Mother Vishvamata."

The primordial buddha Vajradhara sits at the top center of the painting, with a Shambala lineage master/king on either side. The wisdom sword in the lotus of the one to the left of Vajradhara identifies him as Manjushrikirti, author of *The Abbreviated Kalachakra Tantra*, a text regarded as the basis of the Kalachakra tradition. Presumably the one on the right is Pundarika, another important early Kalachakra writer and Shambala king. We are unable to identify the two monks sitting below them.

A simple two-armed form of Kalachakra in sexual union stands is in the upper left corner. Mahamaya, "The Grand Illusion," stands in sexual union in the upper right. This latter Tantric system, a close relative of the Chakrasamvara and Hevajra systems, was a very popular mandala practice for many centuries in Tibet, but for some reason faded to obscurity some two hundred years ago.

Vajra Vega, the special protector for the Kalachakra cycle of Tantras, stands at the bottom center. A form of Vajrapani stands to his left, and a form of Hayagriva to his right.

Chakrasamvara & Vajravarahi

The Tantric system based on the mandala of Chakrasamvara and Vajravarahi in union is perhaps the single most widespread of all the Highest Yoga Tantras in all the Sarma Schools of Tibetan Buddhism. One reason for this is that this practice was very popular in tenth- and eleventh-century India, when Tibetan Buddhism was undergoing its renaissance and the new schools began to emerge. Three different Indian lineages—those of Luipada, Krishnacharya and Ghantapada—came to Tibet in various lines of transmission at this time. Our tangka depicts the Luipada transmission.

Another reason for the popularity of the Chakrasamvara/ Vajravarahi system is the Tibetan love of geomancy and sacred power sites. This Yab Yum pair is linked to many of the great pilgrimage sites of the Himalayas, including Mt. Kailash itself, the source of the Indus, Ganges, Brahmaputra and Sublej Rivers (or, from a Western geographical point of view, of tributaries leading into them). In fact, all twenty-four dakini sites are linked to the Chakrasamvara/Vajravarahi Tantras, with Mt. Kailash being at the center of them.

The name "Chakrasamvara" literally means "Wheel of Bliss." Its epistemological explanation is that the meditations and yogas of the system arouse the wisdom that is able to draw every object of knowledge (i.e., every possible type of experience) into the sphere of the great bliss of non-duality. Of the three types of Highest Yoga Tantras—male, female, and neither/both—it is the principal Tantra in the female division.

Chakrasamvara's body is dark blue, indicating space and the primordial wisdom. Vajravarahi's body is red, representing fire and sexual passion. He has four heads, each of a different color, symbolizing the four buddha karmas of peace, increase, power and wrath. His three eyes see everything in the past, present and future. His twelve arms indicate the twelve links in the chain of dependent origination, thus symbolizing that his mandala contains the complete instruction for liberation and enlightenment.

His right foot presses down on the breast of the Hindu goddess Kalaratri, symbolizing that his practice eliminates ordinary birth and life. The left foot presses on the head of the black Hindu god Yama, Lord of Death, meaning that Chakrasamvara's practice eliminates ordinary death and transmigration.

The term "Heruka" or "Blood Drinker" is often prefixed to Chakrasamvara's name. Just as Christians drink the blood of Christ, Heruka Chakrasamvara drinks the blood that is the wisdom of bliss and void combined.

Buddha Akshobhya, "the Unshakable One," is seated at the top center of the tangka, for Chakrasamvara is associated with the vajra family of buddhas.

As for the consort Vajravarahi, we will see more on her in the next two chapters, "The Vajra Dakinis" and "The Female Buddhas & Their Mandalas."

As enthusiasts of Tibetan mystical art will know, the equivalent of Chakrasamvara Yab Yum in the Nyingma School is the renowned Chemchog Heruka, of the eight Herukas.

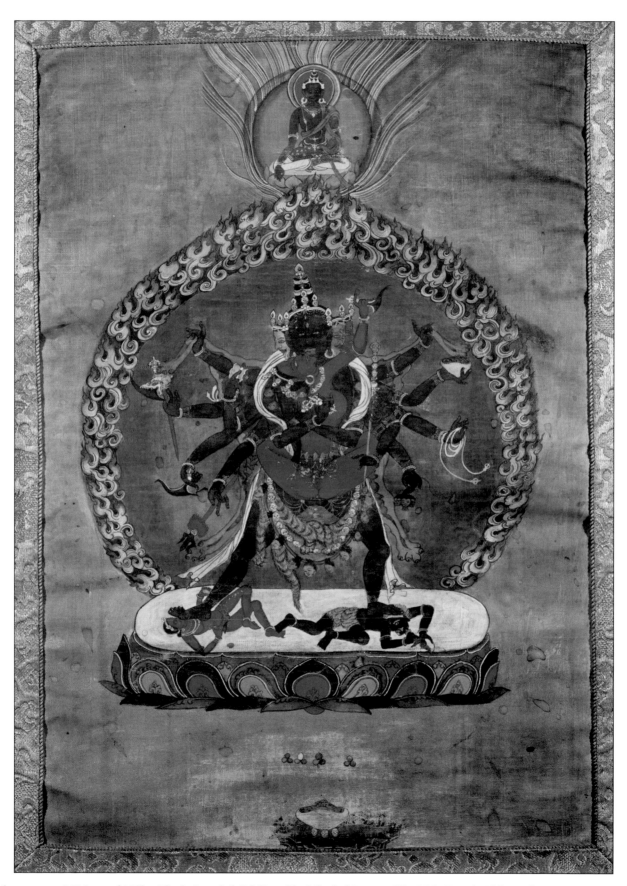

Chakrasamvara & Vajravarahi, Tib., *Khorlo Demchok Yab Yum; The Wheel of Supreme Bliss Male/Female.* Eighteenth century, 31 x 9 inches.

Hevajra & Nairatmya

The Hevajra Tantra, like the Heruka Chakrasamvara Tantra, belongs to the female division of Highest Yoga Tantras. Like Chakrasamvara, it is maintained within all the Sarma or New Schools of Tibetan Buddhism. It is in fact very close in nature to the Heruka Chakrasamvara Tantra, and numerous Indian texts are shared in common by the two.

However, even though Hevajra Male/Female was the principal meditation deity of Marpa Lotsawa, the founder of the Kargyu School (and therefore the forefather of all twelve Kargyu sects), the Kargyupas no longer maintain it as a practice lineage, but only as an empowerment for blessings. It was similarly very important within the Gelukpa in earlier centuries, but in recent generations has been replaced by Heruka Chakrasamvara. Like the Kargyupas, the Gelukpas today only maintain it as an empowerment for blessings.

Fortunately it remains the central practice within the Sakya Order and therefore is fully preserved as both an empowerment and as a practice tradition. Our tangka here is an exquisite example of the commitment to artistic excellence that the Sakya School brought to Tibetan culture.

The principal image—Hevajra and Nairatmya in union—is actually three images in one, although laid out for visual presentation as though one above the other. Here we see three different forms of this Yab Yum pair, each of which stands on a red triangle, a symbol of the female sex organ.

The central image is the Mind Vajra. Here Hevajra stands in sexual union with the female buddha Nairatmya, "The Selfless One." Both are blue in color, representing mind and space. His eight faces see the eight facets of enlightenment, and sixteen hands touch the essence of the sixteen aspects of infinity/emptinesses. Each hand holds a skull cup filled with blood, indicating the bliss that is the nutrient giving the power to arouse the sixteen wisdoms. Both male and female are adorned with bone ornaments, because the Hevajra Tantra is the primary source of the Buddhist yoga of inner heat. Eight female figures of various colors dance on the lotus petals surrounding the central image, representing the eight blissful wisdoms that are awakened when knots in the eight energy channels at the heart chakra are released.

Above this cluster we see the Body Vajra, white in color, in sexual union with a white Nairatmya. They are surrounded by the eight great Hindu gods, symbolizing how the Hevajra practice brings the eight common siddhis.

On the lower red triangle we see a red Hevajra and consort. This is the speech/emotion Vajra. They are surrounded by the eight great nagas, symbolizing how the practice brings the eight natural powers.

The primordial buddha Vajradhara sits at the top center of the painting. This is the Buddha in his Tantric form, who originally taught this Tantric system. To the left stands Vajrayogini (whom we will see in the following chapter) and to the right the stands Vajrabhairava (whom we have already encountered in this chapter).

Virupa, the eleventh-century Indian mahasiddha from whom the early Sakya lamas received most of their lineages, is seated to the left. His body is dark brown, he wears a red meditation belt, and his left hand is held up in the wrathful gesture. Sakya Pandita is seated on the right. Two other Sakyapa lineage masters sit below them.

Two forms of the Dharma Protector Mahakala stand at the bottom right and left of the painting: Brahmarupa Mahakala on the left and Panjarnatha Mahakala on the right.

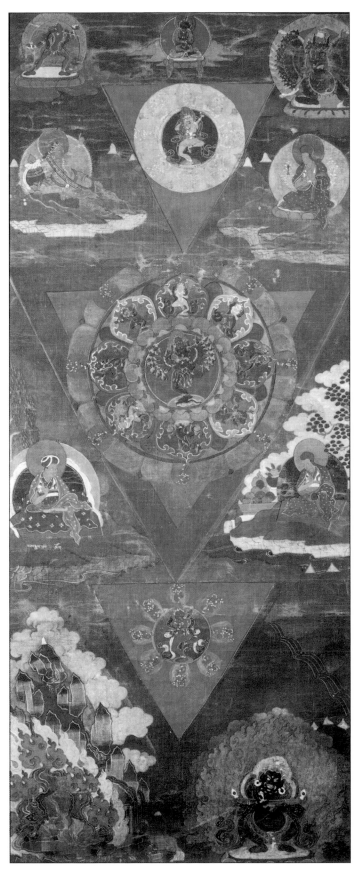

Hevajra & Nairatmya; Tib., *Kyedor Yab Yum*; *The Ultimate Diamond Male/Female.* Seventeenth century, 30 x 12 inches.

Vajrakila & Triptachakra

Vajrakila in his Yab Yum form is one of the most important Tantric traditions to survive from the most ancient of times. Because it is a common practice to Bon and the Buddhist Schools, it also serves as evidence, as David Snellgrove suggests, that Bon had strong links to Buddhist India in the pre-Songtsen Gampo era (mid-seventh century).

All schools of Tibetan Buddhism maintain their own lineages of Vajrakila. For example, it is not uncommon to see Sakya Trizin, the present head of the Sakya School, brandishing his Vajrakila dagger and touching it to the head of a visiting pilgrim as a healing blessing. Most Gelukpa monasteries perform a Vajrakila dance and ritual on the last day of the year, to exorcise the negative energies of the year gone by. Similarly, images of Vajrakila are frequently seen in Kargyu monasteries, and the practice is especially strong in the Drukpa Kargyu.

The real enthusiasts of the Vajrakila tradition, however, are the Nyingmapas, the lamas of the Old Schools. All the Sarma Schools have other systems as their mainstream Tantric practice, whereas within the Nyingma it is a central doctrine.

Our tangka here depicts Vajrakila in his form of Vajra Kumara, the activity buddha from the set of Eight Herukas of the Mahayoga Tantras in the Nyingmapa School. It is presented in the form of a wrathful painting, with gold and minimalist color on a black background.

The female buddha in the equation is the wrathful dakini Triptachakra. The standard Nyingma hymn to her, which is part of the sadhana liturgy in the Vajrakila daily practice, reads as follows,

> Hum! *Fearful queen Triptachakra,*
> *In nature Samantabhadri, source of all*
> *mandalas:*
> *You manifest as a fierce rakshasi to subdue*
> *noxious beings,*
> *And stamp the wheel of existence with the*
> *seal of your wisdom.*
> *Rapturously embracing your consort*
> *signifying non-duality,*

> *Your right hand holds a khatvanga to*
> *destroy Evil;*
> *And with skull cup of blood held in your left*
> *You bring samsara and nirvana under your*
> *power.*

> *Queen of all dakinis, your terrific roar*
> *shakes the whole world*
> *As you grind to dust the host of noxious*
> *beings in the triple world,*
> *And with compassion release the five*
> *families of beings*
> *Into the sphere of dharmadhatu itself.*

Various wrathful figures appear in the flames above and below. Some ride the auspicious animals, such as dragon, lion, and so forth, and wield instruments of exorcism, such as mystic daggers and iron hooks. Others fly through the sky with their mystical powers. Most of these are female and appear in the form of wrathful dakinis with large sagging breasts.

For the past four or five centuries the Nyingma lamas have mainly relied upon *terma* or "revealed treasure" lineages of Vajrakila. In fact, it is possible that the only *kama* or "direct instruction" lineage from Padma Sambhava to survive as a living practice into modern times is the Khon lineage in the Sakya tradition. This *Khon-lug* version of Vajrakila has remained one of the central pillars of the Khon branch of the Sakya transmissions since the earliest of times, when the Khon patriarchs received it directly from Padma Sambhava himself in the eighth century. This is one reason that it was of such interest to Jamgon Kongtrul the Great, the eighteenth-century Rimey master, when he was compiling all the terma traditions of Vajrakila. Incidently, the eighth-century Khon recipient and lineage holder of this Kama transmission of Vajrakila was Khon Luwang Sungwa, who also was one of the seven first monks at Samya, Tibet's first fully operative monastery.

Vajrakila & Triptachakra; Tib., *Dorjey Purpa Yab Yum; The Vajra Dagger Male/Female.* Seventeenth century, 78 x 23.50 inches.

Walchen Gekho & Lokbar Tsamey

This tangka, from the Bon School (pre-Songtsen Gampo era), depicts one of the principal Bon mandala deities in Yab Yum form. Also known as Sangwa Dragchen, or "The Great Secret Wrathful One," he stands in sexual union with the consort Lokbar Tsamey.

Walchen Gekho has nine heads, symbolizing the "Nine Ways of Bon." These are in three sets of three, arranged one above the other. The center face in each set is blue, while the right one is white and the left red. The central face of the consort is yellow, completing the four colors of the four buddha karmas or activities. A pair of Garuda wings is unfurled behind, representing his Phoenix-like ability to devour the snakes of ignorance, hatred and greed, and to transform these poisons into healthy nutrition. He has eighteen hands, showing that the mandala contains and embraces all of the Nine Ways of Bon with both method and wisdom.

Buddha Samantabhadra sits in meditation at the top center of the painting, his body naked to represent the unobscured Dharmakaya. He is the common adibuddha to both the Bon and Nyingma traditions. Various Bonpo lineage lamas are seated around him. The lama in the front center is probably Tonpa Shenrab, the traveling teacher from Tazig (east Persia or western Pakistan/Afghanistan), who originally brought the Bon doctrines to Tibet.

Although the female buddha and consort Lokbar Tsamey has a body that is red in color, symbolizing sexual passion, her central face is yellow, while the remaining two faces are white and red. Just as Walchen Gekho must borrow her (central) yellow face to complete his four buddha activities, so too she must borrow his (central) blue face to complete her four.

Both figures stand on two *lhu* demons, symbolizing how the practice of their mandala gives power over and protection from the occult world. Unlike standard Tibetan Buddhist thrones, which usually are upheld by eight lions or eight elephants, theirs is held up by the five auspicious animals. Above the throne is the standard threefold seat of lotus, sun and moon, just as in the Nyingma and Sarma schools. Abiding in the completeness of sexual union, they stand enmeshed in the flames of the fire of wisdom.

Various wrathful retinue figures surround the Yab Yum Walchen Gekho and Lokbar Tsamey. The most important of these is the enlightened protector Sipai Gyalmo, here depicted at the bottom center. She eventually came to be regarded as one of the twenty-one forms of Palden Lhamo, the Oracle of the Lake Lhamo Latso. She is surrounded by various worldly protectors, all of whom work for the safety and success of those who practice the mandala meditations and mantra recitations of Walchen Gekho and Lokbar Tsamey, male/female in union.

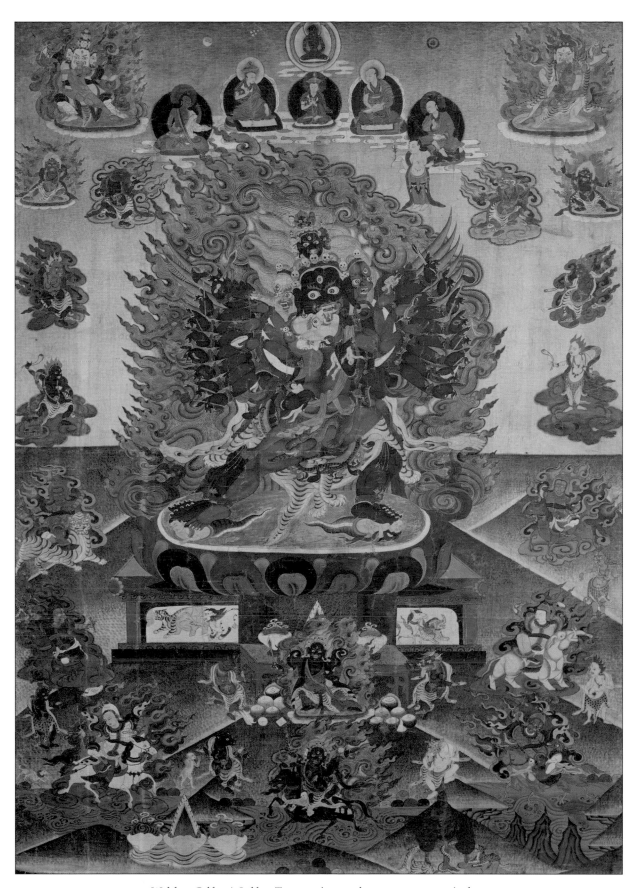

Walchen Gekho & Lokbar Tsamey, nineteenth century, 35.5 x 26 inches.

The Vajra Dakinis

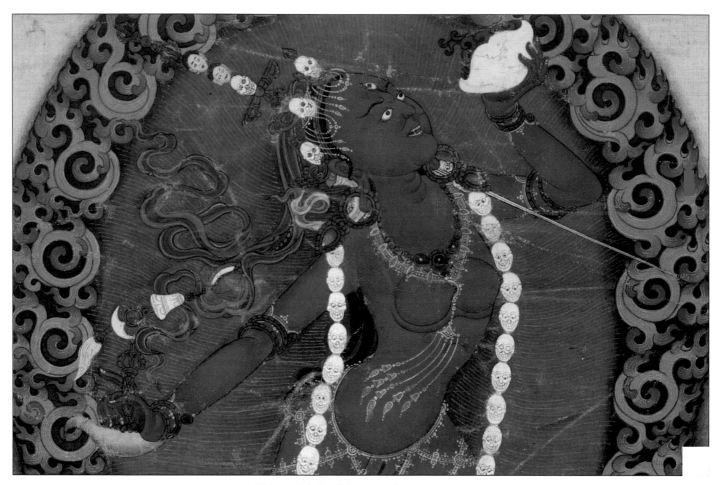

Vajrayogini, detail from tangka on page 155.

We touched briefly upon the subject of the dakini in chapter 9, "Three Jewels, Three Roots and Three Female Buddhas." We dealt with the epistemology of the term there. As was pointed out in that chapter, some dakinis are worldly Dharma protectors, and as such belong to the third of the Three Roots. We will see some of these later, in chapter 20. Others, however, are regarded as full-fledged buddhas and serve in the capacity of yidams, or mandala meditational deities. These are the vajra dakinis, also known as the *jnana*

dakinis, or "wisdom dakinis," and are the subject of the present chapter.

All the principal female mandala deities seen in sexual union with a consort can be called dakinis. Often, however, they are used as meditational objects in mandalas of their own, without the overt presence of their male partner. It could also be pointed out that several of the paintings in chapter 3, "Female Buddhas with an Agenda," could just as easily be placed here. Simhamukha certainly fits in this category from a

technical point of view, in that she is a yidam in the Highest Yoga Tantra division. Kurukulle could also be placed here, because even though her main form is classified as a Kriya Tantra, most Tibetans use her in a Highest Yoga Tantra context. However, we chose to keep these two in chapter 3 because they generally are practiced in specific contexts, whereas those of this chapter are used as objects of meditation in a more general way.

As was said earlier, the Highest Yoga Tantras are divided into three classes: male, female, and neither/both; and in turn the male tantras into three: those dealing with anger, those with desire/lust, and those with apathy/ignorance. Although it is not a hard and fast rule, in general the vajra dakinis in the female tantras are sexier and better looking, with measurements probably something like 35-25-36. Those in the male tantras tend to look a bit like escaped lady wrestlers from the WWF (see Vajrakila's consort), perhaps 48-38-50. Again, within the male tantras, those in the category that works with desire/lust (see Guhyasamaja's consort) tend to be better looking than those in the category working with anger (see Vajrabhairava's consort). In brief, the female tantras take a more conventional approach to beauty, whereas the male tantras tend to go in for a tough-to-the-point-of-ugly type of look. But then, beauty is in the eye of the perceiver.

The Tantric tradition likes to speak of things in three ways: outer, inner and secret. Sometimes a fourth, "most secret," is added. When the term "vajra dakini" is addressed in this way, the outer is defined as the wisdom of bliss and void as manifested in the form of a particular female mandala deity, such as Vajravarahi, Nairatmya, and so forth. These dakinis can appear to those of good fortune at any time, and often come in dreams, meditational visions, and even in the form of human or other living beings that encourage one's life to unfold in enlightenment directions.

On the inner lever, the vajra dakini is one's own sensitivity to the wisdom of bliss and void. This is the omnipresent factor of primordial blissful awareness that is always at hand and only needs to be accessed in order for our lives to become completely transformed.

On the secret level the vajra dakini is the blissful dance of radiance and subtle energies that occurs within the vajra body, causing the chakras to open and the mind to experience ever higher states of a spiritual liberation and ecstasy.

Something should perhaps also be said on the history of the term "dakini." In our discussion of the Chakrasamvara Tantra we mentioned the twenty-four power places of Himalayan India and Tibet. Tibetans call these the *Khadro Sangwa Nechen Nyerzhi*, or "Twenty-four Secret Great Dakini Sites." Vajravarahi is connected with Mt. Kailash, the central of the twenty-four.

The tradition of regarding these twenty-four as power sites far predates Budhhism. It also predates Hinduism. The very word "dakini" is of Dravidian and not Sanskrit origins, indicating that it belonged to the Dravidian peoples who inhabited India long before the Aryans invaded from the north and overran the subcontinent somewhere around 4,000 B.C. The Dravidians were strongly into worship of the feminine and regarded these twenty-four sites as residences for the type of goddesses they called "dakini."

The Aryans adopted these places as their own and designated them as special to Ishvara, the "Destroyer" in their their trinity of God the Creater (i.e., Brahma), God the Sustainer (i.e., Vishnu), and God the Destroyer (i.e., Ishvara, who later became Shiva). They then went on to link the Dravidian dakinis of the twenty-four places to Ishvara.

Tantric Buddhists claim that the Buddha was concerned with certain negative aspects of the Ishvara dakini cults, and with the manner in which they had become reinterpreted by the Aryan tradition. In particular, the Ishvara cult encouraged the practice of human and animal sacrifice. The original name "Heruka," or "Blood-Drinker," comes from that ancient Hindu tradition of blood sacrifice.

Furthermore, in ancient Dravidian India, the dakinis in each of the twenty-four places had a human body but the head of an animal or bird. Thus there were eagle-headed dakinis, crow-headed dakinis, lion-headed dakinis, tiger-headed dakinis, buffalo-headed dakinis, and so forth. Often the high shaman officiating over a particular ritual would wear the mask of the bird or animal associated with the particular practice. It is possible that our own North American Natives brought this tradition with them when they migrated here from Central Asia some ten to twenty thousand years ago, for we still see it with them. Our Native Americans would have been part of the tradition from early Dravidian days, and thus far predate the advent of Aryan Hindism and the later Buddhism.

To counteract the Ishvara dakini tradition of blood sacrifice and other anti-enlightenment activities, the Buddha manifested the Heruka Chakrasamvara mandala and pressed down with it upon each of the twenty-four places. In this way he subdued Ishvara and his dakinis, forced them to renounce the practice of living sacrifices, and swore them in as subjugated Dharma protectors.

Moreover, to subdue the blood-drinking dakinis he emanated the vajra dakinis in the same forms as those of the individual power sites, with human bodies and the heads of animals and birds. Here, however, they did not drink human

and animal blood in sacrificial offerings, but rather drank the blood of the transcendental great bliss of enlightenment. In other words, they were full-fledged female buddhas manifest in the form and appearance of power site dakinis.

We can read this ancient myth in various ways. One would be that the Buddha took the dakini traditions of ancient India and integrated them into his Tantric legacy, absorbing the best that was in them and eliminating the worst, and in general restructuring them to meet the criteria of his enlightenment tradition.

Another interpretation, and one given by the Tantric Buddhists themselves, is that the dakini tradition is part of a much earlier pan-Asian tradition, one dating from the teachings of a buddha who lived in the distant past. These lineages had become diluted and corrupted over the centuries. Buddha Shakyamuni in his forms as Samantabhadra and Vajradhara collected them together, restored them to their original purity, and updated them for the new world era.

Perhaps something should be said of the tradition of depicting the dakas and dakinis as having human bodies with an animal or bird head. Like many ancient mystical traditions, Buddhist Tantricism regards all living things as embodiments of particular qualities. A lion is not just a big soulless cat walking the face of the earth, but is an embodiment of a particular type of sacred energy. The same can be said for the elephant, tiger, bear, monkey, wolf, crow, eagle, and so forth. As embodiments of particular energies, these animals and birds symbolize aspects of our own physical, emotional and spiritual worlds. The dakas and dakinis represent the yogic means for accessing these dimensions of energy and consciousness. Tantric Buddhists speak about them as being expressions of the primordial mind, which is the key whereby enlightenment is attained. A Darwinian might say that they are means for accessing aspects of our deep, ancestral nature that have been lost and forgotten through the spiraling circles of evolution. Jung perhaps would say that they are dimensions of the subconscious mind.

Finally, it should be pointed out that the dakas and dakinis are celebrations of both life and death. They are life, in that they embody the sexual forces that create and perpetuate joyful being; this is symbolized by the Tantric feast, often known as "the dakini feast," held on the tenth and twenty-fifth days of the month by those initiated into the dakini tantras, a feast at which alcohol and meat must be consumed to represent the explosively blissful power that results from the intermingling of the male and female sexual fluids. And they are death, in that they represent the levels of consciousness that prevail after the body has deceased. At that time they are aspects of wisdom that arise and guide the yogi or yogini through the perilous road of the *bardo*.

As the Seventh Dalai Lama put it in a prayer,

> *And when this life one day ends,*
> *May the spiritual masters manifest as Heruka*
> *Surrounded by the host of dakas and dakinis,*
> *And lead me to Khechara, the Vajrayogini*
> *Pure Land.*

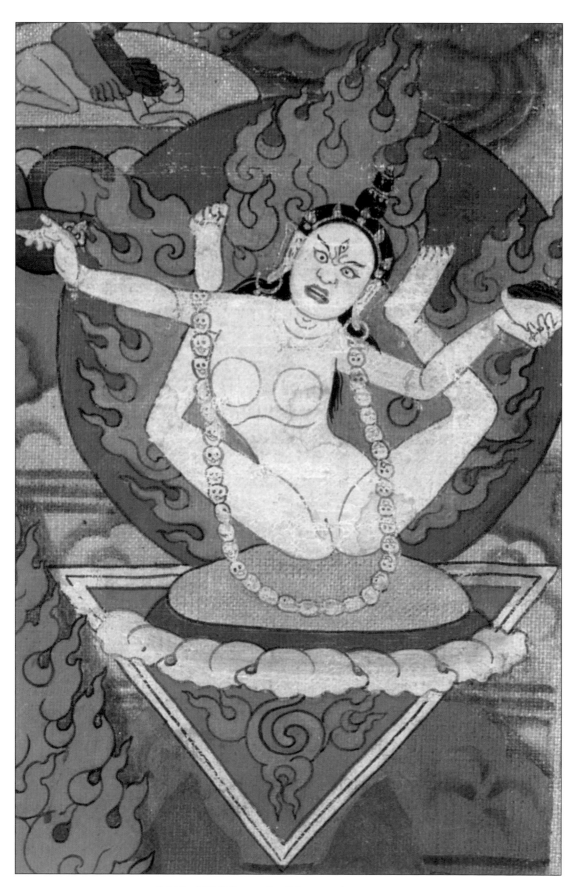

Sukkhasiddhi Lhamo, detail from tangka on page 207.

Vajravarahi

Vajravarahi is the principal female buddha in the Heruka Chakrasamvara Tantra, and we encountered her in that context in the previous chapter. This Tantric system produced a number of spin-off practices, based on the personal visions of particular masters. Several of Tibet's most important Vajra Dakini practices have their roots in these visions.

Three visionary lineages of the Heruka Chakrasamvara Tantra —those of the Indian mahasiddhas Luipa, Krishnacharya and Ghantapa—came to Tibet in the eleventh century as part of the spiritual renaissance from which the Sarma Schools were born. The third of these is known in Tibetan as *Tilbu Lha Ngayi Khilkhor*, or "Ghantapa's Five Deity Chakrasamvara Mandala." The form of Vajravarahi depicted in our painting, with the five dancing dakinis, is sourced in this tradition, as transformed by the visionary experiences of a later Indian master, Tilopa. Tilopa gave the lineage to Naropa, who transmitted it to his Tibetan disciple Marpa Lotsawa.

Ghantapada's Five Deity Chakrasamvara Mandala is the principal *khyil-khor lha-drup*, or "mandala deity practice," used in the Karma Kargyu School, as well as in most of the other eleven Kargyu sub-sects, during the second six-month phase of the traditional three-year retreat. When this is done, Chakrasamvara stands in union with red Vajravarahi at the center of the mandala, with the four other dakinis in the cardinal directions. This practice is reduced to a simplified dakini meditation by dropping out Chakrasamvara, leaving Vajravarahi and the other four dakinis.

The central figure, Vajravarahi, is red, symbolizing sexual passion and the all-distinguishing wisdom. She has an intense expression that is simultaneously slightly peaceful and slightly wrathful, for she executes all four buddha karmas with ease. Her three eyes see all things in the three worlds, and her dark yellow hair flows upward to indicate that her practice brings transcendence.

Her right hand holds aloft a curved knife with a gold vajra handle, representing the wisdom that severs the ego, and her left holds a white skull cup, representing the great bliss of nonduality. She supports an upright katvanga staff in the bend of her left elbow, to indicate that she is in nature all three Buddha Kayas. She is adorned with five white skulls as crown jewels, indicating that the practice of *tummo*, or inner heat, is a central element of her instruction.

All five dakinis are in a similar dancing posture and hold the same implements. They are all of different colors, indicating the five buddha families or five races, as well as the five wisdoms, five elements, and so forth. However, the yellow dakini is replaced by a second red, to indicate the emphasis on the sacred sexual energies of the female tantras associated with the Chakrasamvara systems.

The figure at the top center of the painting is the Thirteenth Karmapa (1733-1797). This identifies the painting as having belonged to a practitioner in the Karma Kargyu School of Tibetan Buddhism. He wears the robes of a monk, and his lower body is wrapped in a yellow meditation cloak. The shape of his throne suggests that the painting was made during his lifetime.

He is depicted with the famous *Zha-nag*, or "Black Hat." This hat has its origins with the First Karmapa and the Ming Emperor of China. Once when this lama was giving a Tantric empowerment to the Ming emperor, the latter had a vision in which he saw Karmapa wearing a hat woven from the black hair of the dakinis. He later had a replica made of the hat he had seen in his vision and offered it to the lama. Since that time the hat has been a symbol of the spiritual authority of all subsequent Karmapa lamas. As the generations passed, the Karma Kargyu School, of which the Karmapa incarnations are the head, even became known by the name "Black Hat Sect." The highlight of the enthronement ceremony of a young Karmapa reincarnation is the presentation of this hat. Throughout a Karmapa's life he will perform many "Black Hat Ceremonies," in which the hat is taken out of its case and placed on his head. People sit and witness the ceremony as a blessing.

The symbolic power of this hat remains in effect today. In fact, this has led to a problem in the present generation. After the previous Karmapa passed away (the Sixteenth), the Tai Situ Lama recognized a boy in Tibet as the reincarnation and managed to get the Dalai Lama to endorse him. Later another important Karma Kargyu lama, the Sharmapa, put forth another candidate and enthroned him. As a consequence we have two Karmapas, but only one hat. Presently the former lives in India and the latter in a Karma Kargyu center in the south of France.

The parties behind each have attempted to gain possession of the Black Hat, as this would give their candidate an upper hand in the quest for uncontested recognition, much in the sense of possession being nine-tenths of the law. Whoever has the hat has ninety percent of the Karmapa's hereditary spiritual authority, at least in the minds of ordinary Tibetans.

In fact the actual black hat given to the First Karmapa by the Ming emperor was enshrined inside a stupa in a chapel of the Potala sometime during the mid-seventeenth century and has been preserved ever since that time in this way. The ceremonial hat used by the Karmapa incarnations since then has been a replica of that original.

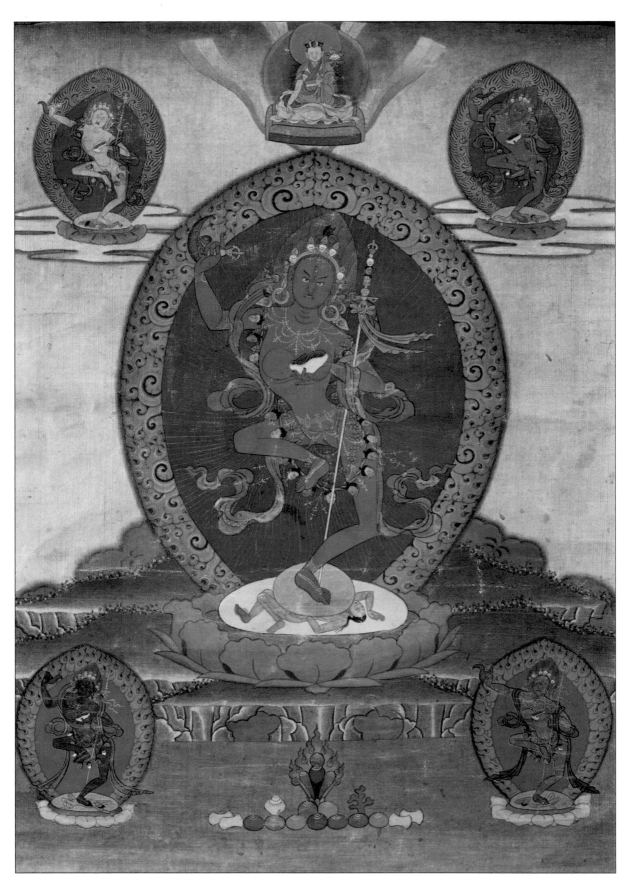

Vajravarahi; Tib., *Dorjey Pakmo; The Diamond Sow.* Eighteenth century, 14.75 x 10.75 inches.

Vajrayogini

The tenth-century Indian mahasiddha Tilopa had many disciples, but Naropa was the greatest amongst them. He is especially important to Tibetan Buddhism, because all the Sarma, or New Schools, of Tibetan Buddhism have numerous lineages from him. He was one of the two principal teachers of Marpa Lotsawa, forefather of the Kargyu and its subsequent evolution into twelve sub-sects (four "Older" and eight "Newer"). In addition, he was a teacher of Atisha, founder of the Kadam School. Also, some of his lineages made their way into the Sakya School via Nepal. Finally, most of these lineages from Naropa later came to Tsongkhapa and his eclectic work in the late fourteenth and early fifteenth century, wherein he fused all of the principal Sarma transmissions into the Geluk School.

The form of Vajrayogini in this tangka is popularly known to Tibetans as *Naro Khachoma*, or "Naropa's Space Lady." This is one of the few lineages that Naropa did not give to Marpa. Instead, it went to the Pamtingpa brothers from Nepal, who, after studying extensively with Naropa, carried it back to their homeland. They did most of their retreats and teachings at Parping, a small mountain village in Nepal that until today remains an important Vajrayogini power site and pilgrimage place, as well as home to several dozen temples, monasteries and meditation hermitages.

This Pamtingpa lineage eventually came to Tibet with the early Sakya lamas and remained an exclusive Sakya doctrine for almost three centuries. After that it spread into the Geluk School. Today it is the most important dakini yidam practice in both of these traditions. It is listed as one of the five principal Tantric systems in the Sakya School, whereas in the Gelukpa it is often used as the yidam practice by those who undertake the traditional three-year retreat on the Six Yogas of Naropa.

Although the standing position of Vajrayogini differs from that of Vajravarahi, many of the other details are the same. The main difference is that the Vajravarahi practice (and iconography) is based on a vision of Tilopa, whereas Vajrayogini is based on a vision of Tilopa's disciple Naropa. This gave rise to the alternate name of Naro Khechari.

As with Vajravarahi, Vajrayogini is red, to symbolize sexual passion. She also holds a curved knife, a skull cup, and a katvanga staff, all having the same symbolism as with Varahi.

Vajradharma sits at the top center of the painting. He is an alternate form of the primordial buddha Vajradhara and is unique to the Vajrayogini system. Red in color, he holds a damaru drum in his right hand to symbolize the inner heat yoga and a skull cup in his left to symbolize the blissful wisdom of non-duality. A katvanga staff leans against his left shoulder.

Two Sakya lamas sit in the upper corners of the tangka. They wear monastic robes and the dark red pandita hats typical of Sakyapa masters. Both are seated on cushion thrones, possibly indicating that the painting was created during the lifetime of the two lamas. The lama on the left displays the iconographic signature of the great eclectic master Jamyang Khyentsey Wangpo (1820–1892), who wrote twenty-two texts on the practice of Vajrayogini.

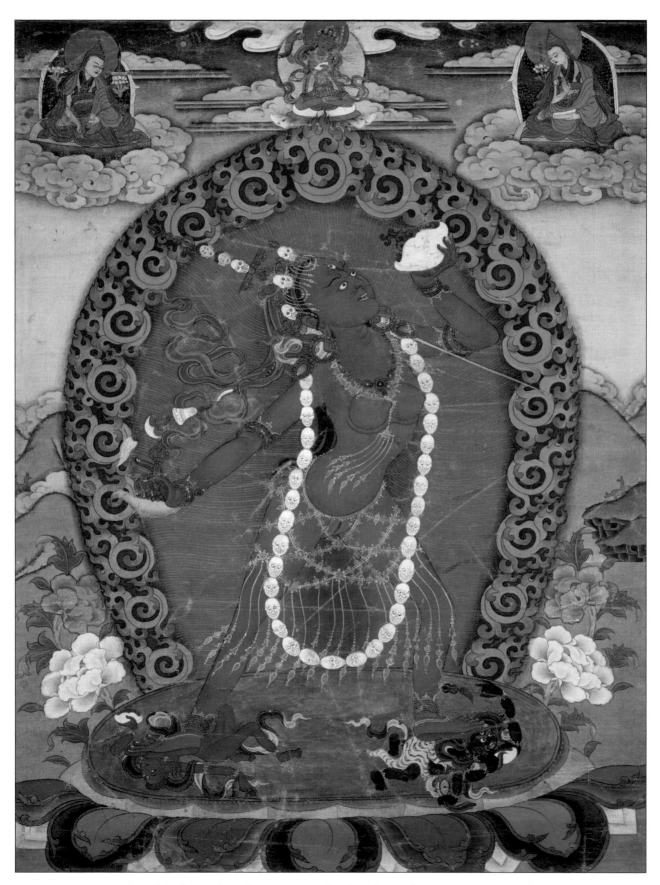

Vajrayogini; Tib., *Dorjey Naljorma; Diamond Yogini*. Nineteenth century, 20 x 14.50 inches.

Vajra Nairatmya

Nairatmya, the female element in the Hevajra equation, is another very important dakini practice in Tibet. As we saw earlier, the Hevajra Tantra is strongly linked to the Heruka Chakrasamvara Tantra, and in fact the two share a number of fundamental canonical texts from the ancient Indian tradition. Marpa Lotsawa, who received the bulk of the Heruka Chakrasamvara transmissions from Naropa, also received the Hevajra Tantra from him, together with the associated dakini practices. In fact, Hevajra in union with Vajra Nairatmya was Marpa Lotsawa's principal mandala practice. He was so devoted to this dakini practice that he even named his wife (Dakmeyma) after her. Surprisingly enough, even though Marpa is the founder of the Kargyu Schools, neither Hevajra nor Vajra Nairatmya is given much attention today in the Kargyu, and they have become an almost exclusive practice tradition within the Sakyapas.

Our painting depicts the eleventh century mahasiddha Virupa, the principal Indian source of many of the Sakyapa lineages. This indicates that the piece once belonged to a Sakya monastery. Here Virupa is seen experiencing three visions of Vajra Nairatmya. These three visions are a central part of his spiritual biography, as in them he received the instructions and transmissions that became the hallmark of his legacy. He is better known today for the teachings received in these visionary states than from anything he received from his more ordinary teachers.

In the central image Vajra Nairatmya is shown as naked from the waist up, although her hands, which hold a cutting knife and skull cup, are painted discreetly in front of her breasts to downplay the sexuality of the piece. Presumably the tangka was commissioned by a monastic community for whom modesty was considered a virtue. The nakedness symbolizes the authentic and uncontrived nature of her wisdom and teachings. She wears a tiger skin as a skirt, to show that she embodies the fearless practice of meditation in jungles and other remote places. The second Vajra Nairatmya is shown above her, dancing on one leg with the other leg drawn in as though in meditation. Finally, the third visionary form is seated in meditation.

The story of Virupa's encounters with the dakini Vajra Nairatmya is a favorite with Tibetans. According to it,

Virupa was living as a monk in Nalanda and in fact was its abbot. He lived an ordinary monk's life during the day, teaching the Sutra traditions to the young monks, and so forth, but at night secretly practiced Tantric meditation on the Heruka Chakrasamvara mandala. However, after considerable time had passed he did not receive any signs of success, and only had bad dreams. He decided that Vajrayana was not for him in this lifetime and therefore quit the practice and threw his mantra mala into the latrine.

Suddenly Vajra Nairatmya appeared to him in the form of an ordinary woman and instructed him to fetch and clean his mala. The following night she appeared again, this time in the form of the dakini Vajra Nairatmya in the fifteen-dakini mandala, and proceeded to give him initiations and teachings. The pithy instructions that he received at this time became the basis for the transmission famed in Tibet as the *Lam Drey*, or "Path and Fruit" legacy, which is the most treasured instruction of the Sakya School.

At the time of his early visions Virupa was a celibate monk in the great Nalanda Monastery, but soon thereafter he left the monastery, disrobed, and wandered the Indian jungle. Stories of his miraculous powers are a popular subject in Tibetan literature.

As for his "bad dreams" mentioned above, according to the story he had received the Heruka Chakrasamvara initiations but not the oral instructions on dream interpretation. The dreams seemed bad but in reality were only indications that his karmic connection was not with the Heruka Chakrasamvara practice, but rather to the sister mandala Hevajra, with the dakini Nairatmya.

Various Indian masters in the lineage of transmission of the Hevajra Tantra are shown along the top of the painting. Virupa is again included here, placed third from the right. One of his main students, Dombi Heruka, sits on a tiger beside him.

Another group of mahasiddhas not directly related to the main Hevajra lineage are shown in a line at the bottom. The Sakyapas are famous for their set of eighty-four Indian mahasiddhas. It is possible that this painting once belonged to a set in which all eighty-four and their lineages were celebrated.

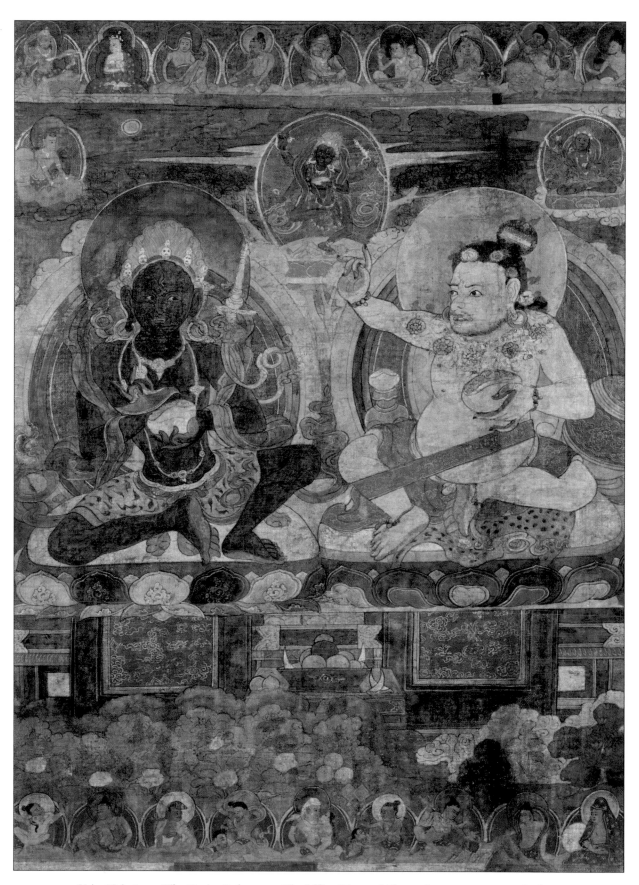

Vajra Nairatmya; Tib., *Dorjey Dakmeyma; The Selfless Diamond.* Sixteenth century, 23.75 x 31 inches.

Sita Yogini

Our tangka depicts the White Yogini from the lineage of Machik Labdon (1055–1153), the great female mystic from the Lab region of Tibet (near Mt. Everest). Here she appears as a wisdom dakini, her body in the posture of mystical dance, and is naked except for her jewelry and the scarf over her arms and shoulders. She holds a hand drum representing Dharma activities in her right hand, and a bell symbolizing the wisdom of infinity/emptiness in her left.

This dakini form from Machik Labdon eventually found its way into all schools of Tibetan Buddhism. The Second Dalai Lama, for example, wrote a meditation manual on the practice. His disciple Panchen Sonam Drakpa later wrote an extensive commentary to this, and these form the basis of the practice in the Gelukpa School.

This particular tangka depicts a Karma Kargyu lineage of transmission. This is evidenced by the presence of one of the Sharmapa Lamas in the top left corner of the painting. The early Sharmapa *tulkus* were second in line under the Karmapas in the Karma Kargyu School, until official recognition of his reincarnation was banned in the late eighteenth century.

Machik's principal guru, the Indian teacher Padampa Sangyey, sits at the middle left of the painting (i.e., to Machik's right), his body dark brown in color. He is in the guise of a mahasiddha, with bone ornaments, a skull crown and a red meditation belt. He holds a damaru in his right hand and a thigbone horn in his left.

The mandala dakini Vajravarahi, body red, dances in the right center (i.e., Machik's left). This is the principal Karma Kargyu dakini practice, and we will encounter her in the following chapter, "Female Buddhas & Their Mandalas."

Directly below the central figure is Troma Nagmo, the wrathful Black Yogini in the Machik lineage. We have a wonderful tangka of her later in this chapter.

The female buddha Prajna Paramita, the personification of wisdom, is at the top center of the painting, with Buddha Shakyamuni seated below her. The presence of Prajna Paramita in Tibetan art often indicates that the image is linked to Machik Labdon. Although Prajna Paramita is known in all schools of Tibetan Buddhism, she is given extensive coverage only in the lineages from Machik. Various Dharma protectors adorn the bottom of the painting.

The yogic method symbolized by the White Yogini descending from Machik Labdon is most often used in conjunction with a practice known in Tibetan as *Metok Chulen*, or "Living on the Essence of Flowers." Here the practitioner gives up ordinary food and instead each day eats only a half-dozen pills made from flower petals. The Second Dalai Lama also composed a commentary to this method, in which he outlines the standard recipe from Machik for creating the flower essence pills that are used as the basis of a twenty-one-day fasting retreat, and the meditations, disciplines and activities to be pursued during the retreat.

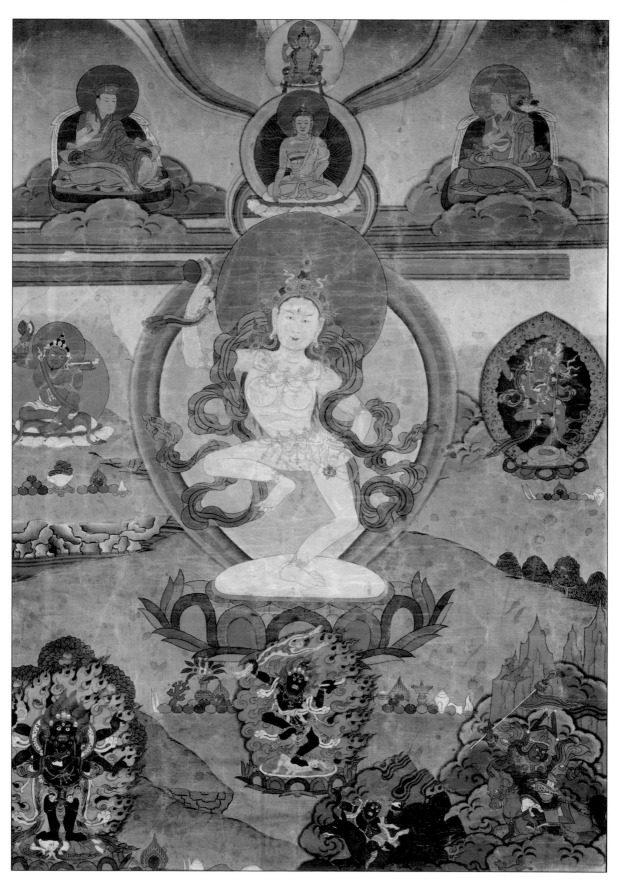

Sita Yogini; Tib., *Naljorma Karmo; The White Yogini*. Nineteenth century, 23 x 16.75 inches.

Krisna Krodha Dakini

A second important dakini practice descending from the great female mystic Machik Labdon is that of Khadroma Troma Nakmo, "The Black Fierce One." Again, as with the White Yogini, this transmission was an exclusive tradition of the Zhichey Chod School for several generations, but eventually was absorbed to some extent by all schools of Tibetan Buddhism. For example, the interest of the Eighth Karmapa in the practice caused it to spread widely within the Kargyu. Moreover, the Jetsun Dampa Lamas of Mongolia spread it widely throughout the Gelukpa monasteries and hermitages of Amdo and Mongolia. Moreover, the Second Dalai Lama composed a brief manual on the practice. For a more detailed account of his teachings on the subject, though, we have to look to the writings of his main disciples, several of whom took notes on the Second's various oral discourses on the Machik lineages.

However, without a doubt the Nyingma School has shown the most enthusiasm for the lineage over the centuries, and many Nyingmapa lamas today rely upon it as their principal dakini practice. This dedication is reflected in the visionary texts of the previous-to-previous Dujom Rinpochey (1835–1904), whose *terma* writings are regarded as the most authoritative and complete on the subject. He is the predecessor to the previous Dujom, who served as head of the Nyingma from 1963 until his death in 1987.

Our tangka here represents the Nyingma lineage, as indicated by the image at the top center. This is Padma Sambhava, an early forefather in the Nyingma School. He is wearing the robes of the Three Vehicles—Hinayana, Mahayana and Vajrayana—indicating that he is a master of all three Ways. To his left is the Indian master Padampa Sangyey, the principal guru of Machik Labdon and the Indian source of the Black Dakini lineage in Tibet. The other three lama figures (unidentified) in this area of the painting are lineage masters in the Black Dakini transmission.

The face of the Black Dakini is wrathful in appearance, symbolizing the wisdom of the conventional, relative level of reality. The head of a sow can be seen above it, symbolizing the wisdom of infinity/emptiness, the ultimate level of reality. She gazes upward, indicating that the practice brings quick enlightenment. Her hand implements are similar to those of Vajravarahi and have the same symbolic meanings. She wears an elephant hide as an upper shawl, for her meditation techniques bring easy control over the wandering mind; and she wears a tiger skin as a lower garment, indicating fearlessness in meditation. The skirt is tied in front in a manner that leaves the lips of her vagina exposed, to symbolize that the meditational practice induces the great bliss that is the basis of Tantric meditation on emptiness. She is adorned with snakes, for all the nature spirits come to the assistance of those who do her practice.

Four other dakinis dance in the four directions, each in her unique color: red Padma Dakini (lotus); yellow Ratna Dakini (jewel); green Karma Dakini (activity); and white Chakra Dakini (wheel).

The five dakinis each dance on the heart of a naked man. We'll leave the symbolism behind this feature of the image up to the imaginations of our readers.

Three wrathful female Dharma Protectors protector figures can be seen at the bottom center of the painting. Each holds a curved knife in the right hand and a skull cup filled with blood in the left. The central one sits on a wolf, which is standing inside a triangle filled with blood. The triangle symbolizes the female sex organ, and the blood is from the menstrual cycle. The two lower figures are mounted on a tiger and leopard. Each also holds a lasso tied to a naked man, whom they drag along behind them. Again, we leave the symbolism of this detail to the reader.

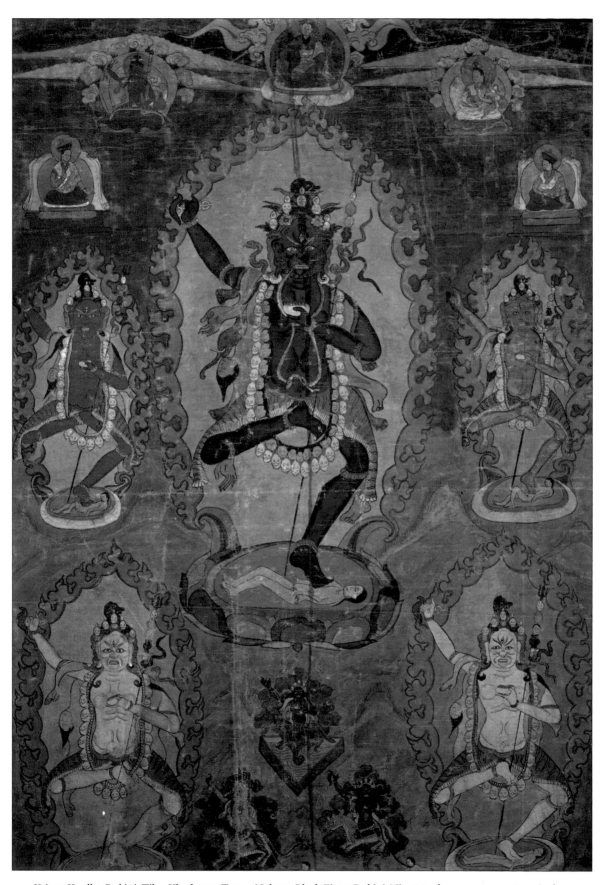

Krisna Krodha Dakini; Tib., *Khadroma Troma Nakmo; Black Fierce Dakini.* Nineteenth century, 27 x 18.50 inches.

Samaya Tara Yogini

This somewhat rare and unusual painting depicts Samaya Tara Yogini, known in Tibetan as Damtsig Dolma Naljorma. She is dark green, is semi-peaceful/semi-wrathful, and is accompanied by four attendant yoginis, one in each of the four directions. Thus this is a Highest Yoga Tantra form of Tara, born from cross-fertilization with the Vajrayogini Tantric systems of India.

The central figure is dark green, to indicate that she is the essence of primordial energy flow. Her face has three eyes: the right eye sees all conventional reality; the left sees all transcendental reality; and the third sees all occult truth.

She has eight hands, of which three on the right hold an arrow tipped with a pink utpala flower, a damaru hand-drum, and curved knife. The arrow tipped with the flower symbolizes the wisdom of Samaya Tara's yogic system, that is able to transform all negativity into creative energy by means of awareness of infinity/emptiness. The hand-drum symbolizes the power of yogic control of the subtle bodily energies. The curved knife is the primordial awareness that severs the ego-grasping syndrome. The fourth right hand shows the mudra of supreme generosity, indicating that the practice fulfills both mundane and spiritual needs.

Her four left hands hold a blue lotus blossom with the stem held to the heart, a bow constructed of utpala flowers, a trident, and a skull cup filled with blood. The lotus represents her ability to transform worldly situations into transformative spiritual experiences; the bow constructed of utpala flowers symbolizes her powers of meditation and is able to throw the arrow of wisdom to its target; the trident shows that she simultaneously rests within the Three Kayas; and the skull cup filled with blood shows that the practitioner of the Samaya Tara system drinks deeply of the transcendental great bliss. An ornate katvanga staff rests against her left shoulder, to indicate that her system of yoga carries the complete authority of the Mother Tantra systems.

She is adorned with a tiara of five skulls, for she is master of the five wisdoms. A necklace of fifty-one freshly severed human heads adorns her neck, for she has severed all ordinary activity of the fifty-one secondary mental archetypes.

The primordial buddha Vajradhara sits in the sky above her, indicating that her yogic system belongs to Highest Yoga Tantra. The Indian master Buddhagupta sits on the left, his appearance that of a Tantric mahasiddha. He is attired in a loincloth and meditation belt, his hair long, with some tied on the crown of the head.

Taranatha, the Tibetan disciple of the sixteenth century Indian master Buddhagupta, sits to the right. He wears the pandita hat of the Jonangpa lineage, and is dressed in the robes of a monk. His presence in the painting, as well as that of his teacher Buddhagupta, identifies the piece as belonging to the Jonangpa School.

A wrathful blue yogini holding a sword and riding a blue buffalo appears in the top left corner of the painting. A semi-wrathful red yogini holding a hook and riding a red deer appears in the top right. A peaceful white yogini holds a lotus blossom and riding a yellow goose appears in the bottom left corner. Finally, a peaceful yellow yogini riding a white elephant appears in the bottom right. These are the four main retinue figures from the mandala of twenty-five deities belonging to the Wisdom/Mother Highest Yoga Tantra. Together the five symbolize the transformation of the five human psychophysical aggregates into the five buddha aspects of full enlightenment. The promise of the five together is the attainment of enlightenment by means of that transformation.

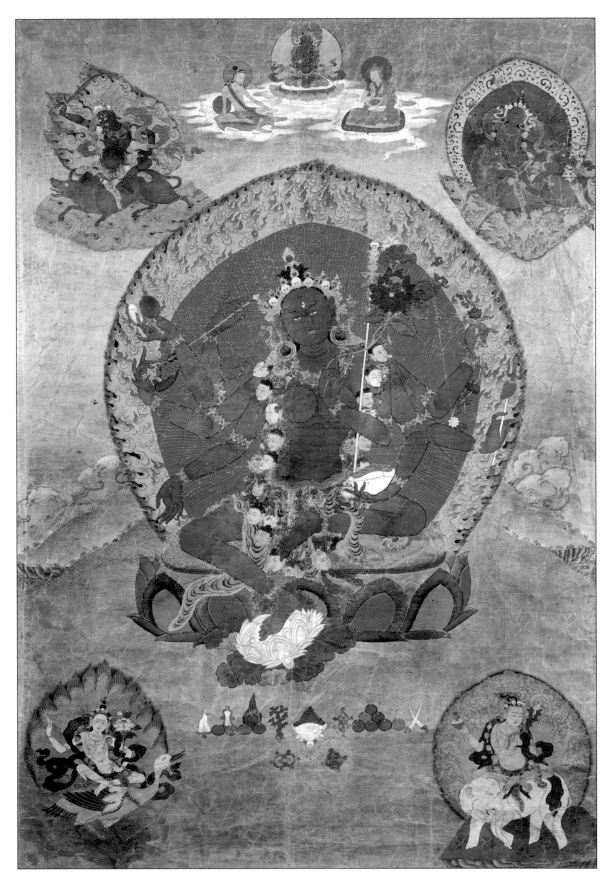

Samaya Tara Yogini; Tib, *Damtsig Dolma Naljorma; The Sworn Liberator Yogini.* Eighteenth century, 35.7 x 26 inches.

Female Buddhas & Their Mandalas

As was said in Part One, the Tibetans translated the Sanskrit term "mandala" as *kyilkhor*, with *kyil* having the sense of "essence" and *khor* the sense of "to extract." In other words, a mandala is an object of meditation that is used to extract the essence of life, which is wisdom and enlightenment.

We also spoke of both supported and supporting mandalas, with the latter term referring to the mandala deities as meditational objects, and the former term referring to the cosmogram or residence supporting those deities. A Tantric deity such as Arya Tara, for example, is a "supported mandala" because meditation upon Arya Tara extracts the essence of buddha karma or enlightenment energy. The cosmogram or mandala palace within which Arya Tara is envisioned is also a mandala, because meditation upon it extracts the essence that supports the deity mind.

In fact both supported and supporting mandalas are of one nature, for both are but emanations of the wisdom consciousness of the central deity. In this sense the mandala (in its two aspects of supported and supporting) is a pictograph of the enlightenment experience itself. This was said by the great Seventh Dalai Lama in his commentary to the Guhyasamaja self-initiation rite: "The wisdom aspect of the principal deity appears as supported and supporting mandalas, including all deities and the residence. Nothing is outside of this. Everything about the mandala is exclusively in the nature of the Tantric wisdom of bliss and void."

The manner in which mandalas are used in meditation is often misunderstood. Many people seem to think that they are visualized in front of oneself and then their meaning contemplated, somewhat as one would visualize and contemplate the meaning of, say, a snowflake.

However, as we saw in the later chapters of Part One, the authentic tradition involves a process of reinventing the sense of self. One's mind becomes the mind of the mandala deity (or deities), one's body becomes the deity's body, and one's speech becomes the deity's vajra mantras and songs. In addition, the entire external world transforms into the supporting mandala. Finally, although appearing in aspects of body, speech, mind and external world, all aspects are in the one nature of the primordial wisdom of non-duality.

When painted on canvas, this external mandala takes on the appearance of a small two-dimensional design, the size being set by the size of the canvas. However, the actual visualized mandala is three dimensional, and as large as the cosmos itself, trillions of miles across and also from top to bottom. The painted design is really a "seen from above" blueprint, although it is not proportionally correct. For example, Vajrayogini in her mandala appears as though inside a double triangle that resembles a Star of David, with the star generally being depicted as two or three times her body size. In fact the star is as big as the cosmos, with Vajrayogini being perhaps the size of a sesame seed at its center. It is impossible to convey this sense of proportion on a canvas.

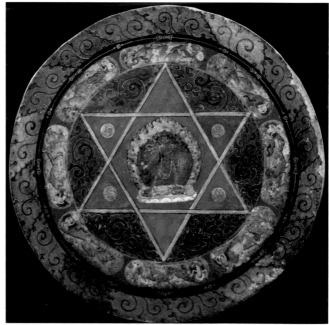

Mandala of Vajrayogini (Naropa Lineage). A simplified mandala, painted on wood, used for giving initiation. Also see pages 154–155.

Every aspect of this supporting mandala symbolizes an aspect of consciousness that is a prerequisite to becoming the mandala deity. Therefore an understanding of it is a prerequisite to understanding the Tantric process. Every mandala has its own unique features, but there are also a number of common features about them. We can look at these by beginning on the outside and working in.

Usually a four-colored ring of fire is shown on the outside. Although resembling a ring, this is in fact a globe, trillions of miles in diameter, and encompasses the entire cosmic structure. The symbolism is that the mandala wisdom encompasses all spheres of experience and pervades everything in the universe. It is of four colors, because this wisdom, driven by great compassion, fills the universe with the four buddha karmas or enlightenment activities.

Inside of this is a ring or chain of vajras. Again, although it is painted as a two-dimensional ring, in fact it is a globe that completely encases the mandala. The vajra represents indestructibility, and the symbolism is that nothing can destroy or reverse this wisdom, and no temptation or negativity can shake it. Those who attain it become eternally wise and enlightened, regardless of what circumstances they encounter.

Two thin circles, white and red, are inside of the ring of vajras. These may not be visible on smaller paintings, but are clearly seen on larger ones. They represent the *dharmadayo*, or "reality source," which is visualized as an inverted triangular pyramid, white outside for the wisdom of infinity and red inside for orgasmic bliss. Sometimes instead of two circles this dharmadayo is represented by an actual triangle; or, as in the case of the Yogini mandala, a double triangle resembling a Star of David. The triangle has a point at the bottom and spreads infinitely wide at the top, for meditation on the mandala causes all of one's spiritual qualities to expand to infinity. The entire mandala residence and deities are inside of this triangle (or double triangle), indicating that the supported and supporting mandalas arise from the joyful play of bliss and wisdom.

A circle of white lotus flowers is often seen inside of these various rings. This symbolizes the power of the Tantric tradition to transform the ugliness and misery of ordinary existence into beauty and blissful wisdom. Alternatively, in Highest Yoga Tantra, the white lotuses symbolize the ability to use sexual passion, a force that so often binds and confuses ordinary beings, as a dynamic tool for enlightenment.

A large crossed vajra stands at the center of all this, with its four wings or "horns" reaching into the four directions. Each of the horns has the standard five points, representing the five wisdoms. In most paintings the presence of these vajra horns can be seen at each of the four gateways to the celestial mansion that is the supporting residence of the mandala deities; for practical reasons usually only two or three of them are depicted in the painting. The implication is that only those with the five wisdoms can enter through the gateways and become the deity.

If we add together the five vajra horns at each of the four gateways we have a total of twenty vajra horns in all. These represent the transformation of the twenty misconceptions of the nature of the self into the twenty authentic wisdoms. (Of these twenty misunderstandings, there are four with each of the five *skandhas*, or psychophysical aspects of a person. For example, the four with the skandha of form are as follows: thinking that the self is form; thinking that form is self; thinking that the self possesses form; and thinking that form possesses a self.)

The mansion itself, as with everything in the supporting mandala, is made of blissful light and energy. Nothing is solid in the sense of the conventional appearances of things. The walls are made of five layers of lights: white, yellow, red, green and blue. The symbolism is that the mandala deity resides in a house made of the five primordial wisdoms.

The four entranceways in general represent the four levels of *dhyana*, or higher meditation. Only those with higher meditation can enter, or alternatively all residing therein are in possession of higher meditation. Specifically, the eastern gate is the four mindfulnesses, the southern gate the four miracle legs, the western gate the five strengths, and the northern gate the five powers. One enters the mandala residence by acquiring these qualities.

The four sides of the mansion are rimmed with a supporting ledge. This represents the four *samadhis*, such as the samadhi of warrior presence, and so forth. Four groups of offering goddesses stand on this ledge; they represent the four *dharanis*, such as the dharani of mantra power and so forth.

The entire complex is adorned with jewels, pearl necklaces and other decorations. The jewels represent the various ways in which the Tantric wisdom fulfills the needs and wishes of the world. The pearl necklaces represent the innate purity of the Tantric path. The complex is also adorned by jewel spouts, resembling upturned bottles. These represent how the blissful wisdom of enlightenment constantly rains down nutrient and elixir that inspires living beings to grow and transform. Finally, the circle at the center of the mansion represents the infinity aspect of all things, the sphere within which all phenomena are made equal in non-duality.

Every mandala has hundreds of smaller details, each of which has its own symbolism. However, what is said above represents the principal ideas behind the process of "entering into the mandala."

The Mandala of Heruka Chakrasamvara

We encountered a simple form of Heruka Chakrasamvara in chapter 16, "The Yum in Yab Yum." As was said there, three different Indian lineages of this Tantric system came to Tibet in various lines of transmission during the renaissance of the eleventh century, when the Sarma or New Schools of Tibetan Buddhism were emerging.

The principal image in our tangka is that of the Luipa transmission of Heruka Chakrasamvara. This is the most complex of the three lineages and contains sixty-two mandala deities. This is the principal form of Chakrasamvara in both the Sakya and Gelukpa schools. Here the central deity is shown standing in sexual union with Vajravarahi, surrounded by five circles of retinue figures.

When we look closely at the outer rings of the mandala we can see a ring containing the eight great charnel grounds. This element is not found in certain mandalas, such as Guhyasamaja, but is always emphasized in the Chakrasamvara cycle. Many of the Indian practitioners of the Chakrasamvara Tantra made retreats in the charnel grounds in order to intensify their sense of the dangerous nature of human life. Dead bodies would be left as offerings to wild animals, and carnivorous animals are always more dangerous when feeding. The Chakrasamvara practitioner would sit in meditation in the midst of the dramatic scene of decomposing corpses, tigers and jackals feeding on the dead, and so forth. Usually each charnel ground is shown with eight features, such as a fire, a tree, a cloud, and so forth.

Each of these eight features symbolizes an aspect of the main yogic training in the Chakrasamvara cycle. The fire, for example, symbolizes the yoga of inner heat.

The primordial buddha Vajradhara sits at the top of the painting, with a red Vajrayogini to the left. Various Indian and Tibetan lineage masters sit to either side of him.

Two other simplified mandalas are also depicted in our tangka: those of Hevajra, in the upper left, and of Rakta Yamari, in the upper right. Various other Tantric deities fill the remaining space above and below.

The large figure at the lower right is Solitary Vajrabhairava, whom we saw (in Yab Yum form) in chapter 16. His particular form here is from the vision of Lama Tsongkhapa, suggesting that the painting belonged to one of the early Gelukpa monasteries. The small, seated figure at the bottom left, dressed in the attire of a monk, is probably the person who originally commissioned the painting.

The various figures along the bottom are Dharma Protectors. These include Chaturbhuja Mahakala (bottom right), the special protector of the Chakrasamvara Tantras.

The painting style is typical of fourteenth and fifteenth century Tsang, southwestern Tibet. This style can be seen in the temples and monasteries of towns like Gyangtsey, Shigatsey and Sakya, all of which were on the Lhasa-Katmandu trade route and therefore showed strong Nepali influences.

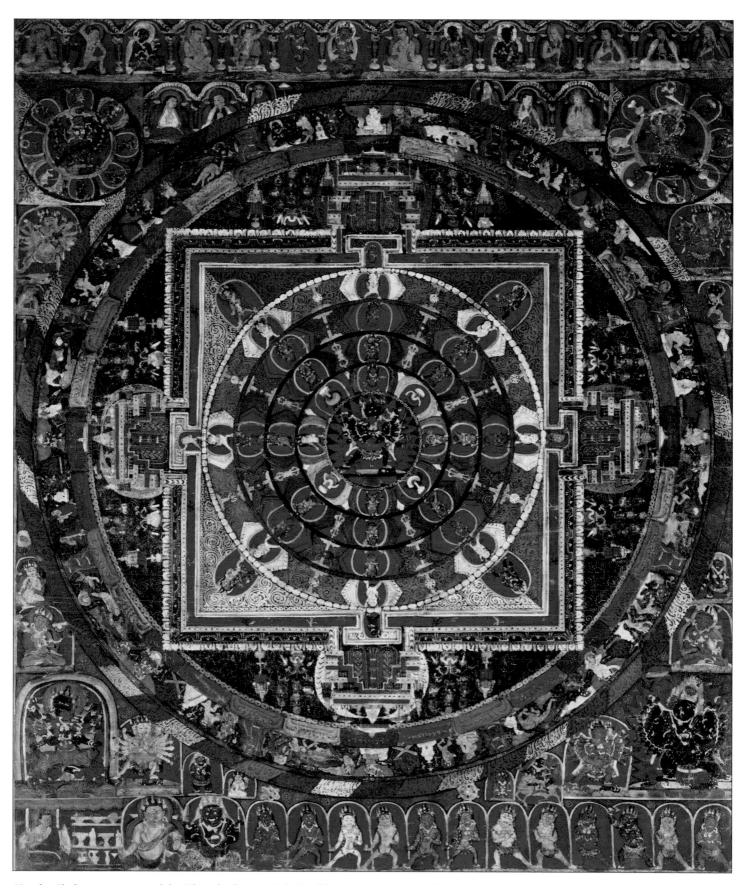

Heruka Chakrasamvara Mandala; Tib., *Khorlo Demchok Khyilkhor; Mandala of the Wheel of Supreme Bliss.* Fourteenth century, 32 x 26.50 inches.

Mandala of Vajravarahi

We encountered a painting of Vajravarahi and her five-deity mandala in a previous chapter, "The Vajra Dakinis." There she was depicted dancing naked in a field, with her four emanations in the four directions. Here we have the five in their mandala setting, at the center of a "Star of David" double tetrahedral triangle. Vajravarahi is in the center, while red Khandaroha dances above, green Lama to the right, dark blue Dakini below, and yellow Rupini to the left. A swastika sits in each of the six points of the "star," representing the intersection of bliss and wisdom that results from the practice.

In addition to this principal mandala, each corner of our painting is decorated with its own simplified mandala of other Tantric transmissions. All four are predominantly female. Presumably all of these were central practices in the life of the person who commissioned the tangka some five hundred years ago. A mandala with Heruka Chakrasamvara, in sexual union with Vajrayogini and surrounded by four dancing dakinis, is shown in the upper left corner. A mandala with Hevajra, in sexual union with Vajra Nairatmya and surrounded by four dancing dakinis, is in the upper right. A Kurukulle mandala, with four accompanying dakinis, is in the bottom left corner. Finally, a mandala of Arya Tara with four other Tara emanations is depicted at the bottom right.

The top of the painting has the traditional depiction of Indian and Tibetan lineage masters. The lamas with the black hats are various incarnations of the Karmapa Lama, the hereditary head of the Karma Kargyu School. His presence identifies the piece as having once belonged to a practitioner from that sect. The lama with a similarly shaped hat, although red in color, is an incarnation of the Sharmapa Lama, another important Karma Kargyu tulku (seated on the far right of the second row).

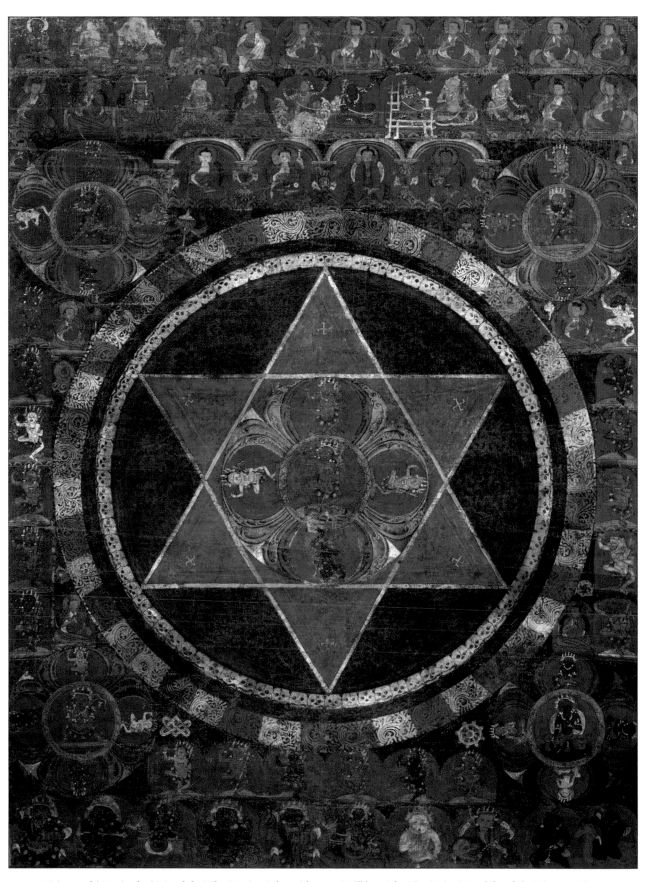

Vajravarahi Panja-devi Mandala; Tib., *Dorjey Pakmo Lha-nga Kyilkhor; The Five Deity Mandala of the Diamond Sow.*
Fifteenth century, 19.5 x 14.5 inches.

Vajrayogini (Naro Khechari)

Tantric texts state that it is best to achieve full enlightenment in one lifetime. However, if one cannot manage to accomplish this, then the next best thing is to take a rebirth in a pure land and continue the enlightenment path from there. Buddhist scriptures speak of many different pure lands of this nature, such as Tushita, which is the paradise of Maitreya Buddha, and Sukkhavati, the pure land of Amitabha Buddha.

However, Khechara, the pure land of Vajrayogini, is special amongst these, for the rainbow body yogas associated with the Vajrayogini Tantra empower a practitioner with the ability to take along his or her physical body at the time of death. With the other pure lands, such as the two mentioned above, only the soul transmigrates at death. The body must be left behind.

The myth of Khechara Pure Land and the rainbow body yogas is a popular subject in Tibetan art and literature. Tibetans love to tell stories of masters who, at the time of death, dissolved their body into rainbow light and flew off to Khechara, leaving behind only hair and nails. This is the theme behind our painting.

Here Vajrayogini in her form of Naro Khachoma, or "Naropa's Space Lady," is seen on the first floor of the palace symbolizing Khechara Pure Land. The place seems to erupt from the center of the mandala with a perspective almost Picasso-esque in style. The viewer should remember that, if the painting were drawn to scale, the palace would be smaller than a sesame seed at the center of the double triangle.

The second floor depicts a simple form of Heruka Chakrasamvara in sexual union with Vajrayogini, surrounded by a group of early Sakya lineage masters. The suggestion is that these lamas transmigrated to Khechara, and are there still, guiding those reborn there in the Tantric path and sending out emanations to benefit the world.

On the third floor of the Tantric path we see Vajradharma, the Vajrayogini form of the primordial buddha Vajradhara. He holds a vajra and bell at his heart, to symbolize his state of enlightenment.

The sky to the right and left of the palace/pure land is filled with flying dakinis. They are leading various Vajrayogini practitioners who have attained the rainbow body stage to the mystical land of Khechara.

Various Dharma Protectors are depicted along the bottom of the painting.

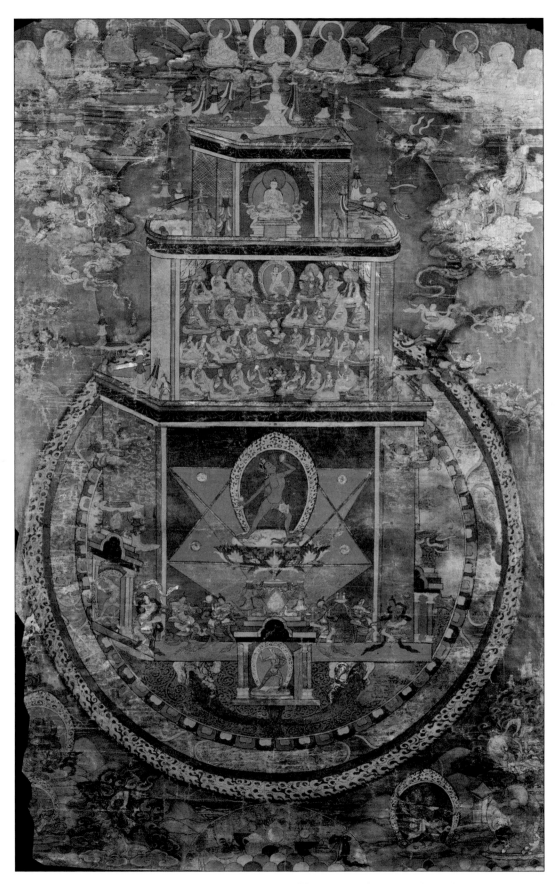

Vajrayogini (Naro Khechari) Mandala; Tib., *Dorjey Naljorma Kyilkhor; Diamond Yogini*. Eighteenth century, 36 x 23 inches.

Mandala of Prajna Paramita as "The Healing Buddha"

The traditional Tibetan system of natural healing is based on the *Gyuzhi*, or "Four Medical Tantras." All graduates of the Mentsikhang, or Central Medical University in Lhasa that was established by the Fifth Dalai Lama in the mid-seventeenth century, were trained and tested rigorously in these four fundamental texts, together with many commentaries to them. The traditional medical training required a minimum of seven years of coursework followed by a five-year internship. Only after this would the graduate doctor be allowed to set up his or her own practice.

Tibetans believe that the Four Medical Tantras were taught by Buddha Shakyamuni himself in his form as Bhaishajyaguru, or "The Master Healer." This form of the Buddha is a popular subject in Tibetan art.

The first of the four texts is known as *The Root Medical Tantra: The Essence of Ambrosia*, and is presented as a healing theater. Here the Master Healer (i.e., Buddha Shakyamuni in the form of the Master Healer) appears at the center of the mandala and explains how each of the various directions of the mandala is associated with physical, emotional and mental states, as well as with herbs, minerals, diets, exercises, meditations, yogic techniques, and behavioral therapies that establish and maintain health and balance of body, mind and spirit in any given situation. He also introduces the idea of eight basic types of illnesses and eight Medicine Buddhas that symbolize the medicinal arts used to cure them.

Because the Medical Tantras were taught by the Buddha and are based on the universal wisdom of enlightenment, their mandala is often presented with the female buddha Prajna Paramita, "The Mother of All Buddhas," seated at the center. Here Prajna Paramita represents the healing wisdom of all enlightened beings of the past, present and future. Occasionally, this central seat will not be given to Prajna Paramita, but to *The Root Medical Tantra* itself. When the latter is the case, the book usually sits on a flower taken from the legendary healing tree. This tree has medicinal properties in every part, from root, bark and trunk, to leaves, flowers and fruit.

In our mandala the female buddha Prajna Paramita is depicted as orange, to symbolize the transcendental wisdom that is the source of all enlightenment. She has four hands for the four immeasurable qualities: love, compassion, joy, and equanimity. These four qualities are prerequisites for any healer. Her two inner hands are in the mudra of teaching, for a healer should share his or her knowledge. The two outer hands hold a vajra and a book, representing method and wisdom combined.

The Eight Medicine Buddhas sit in a circle around Prajna Paramita, and outside of them are various rings of bodhisattvas. Rows of lineage teachers can be seen at the top and bottom of the painting, with Buddha Shakyamuni at the top left.

Of interest, the thirty-five Buddhas of Purification sit in groups crammed into the corners of the painting. All illness is related to negative karma, and the recitation of the names of these thirty-five buddhas is one of the traditional methods of purifying negative karma. Medicines, diet, exercise (behavioral therapy) and spiritual application are considered to be the four principal means of healing. The recitation of the sutra containing the names of these thirty-five buddhas is one of the many methods recommended in the fourth category, that of healing through spiritual application.

While a doctor will study the Medicine Buddha mandala as a map to the body, emotions and mind, as well as to the causes of diseases in any of these three spheres, and the cures for those diseases, he or she might also practice daily meditation upon the mandala. When this is done, the same dynamics come into play as with all mandala meditation. For example, one begins by dissolving the entire universe into light, and then re-emerging as the buddha figure at the center of the mandala, with the other mandala deities, as well as the supporting mandala environment, as an extension of one's wisdom.

In chapter 14, "The Healing Trinity," we encountered the yogic healing traditions associated with White Tara, Amitayus and Ushnisha Vijaya. These also are included in the fourth of the above healing methods. Moreover, just as healing initiations with these three are popular public events, similarly one often encounters the public healing initiation of the Eight Medicine Buddhas. In this ritual the master invokes the mandala, and then calls the transforming energies and healing powers symbolized by the Eight Healing Buddhas. These eight come into the room and sit in a row one above another in the space above the initiates. They then dissolve into light and healing energies, from the top downward, which flow into the initiate, filling his or her body, and healing on physical, emotional and spiritual levels. In this way the initiate absorbs and acquires the powers and blessings of all Eight Healing Buddhas.

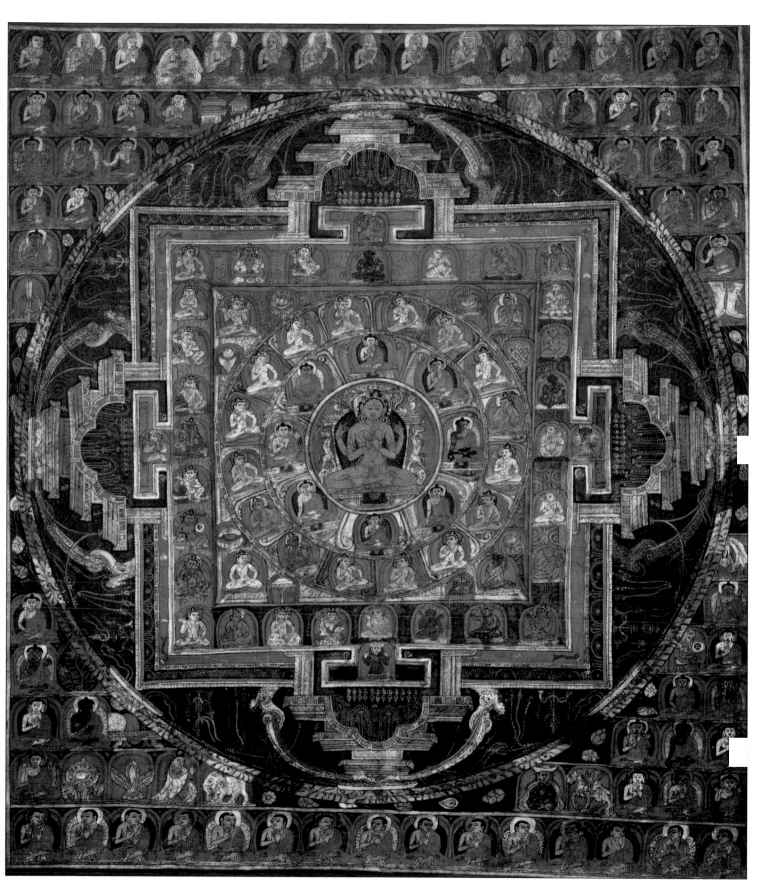

Baishajvaguru Mandala; Tib., *Sanggyey Menla Kyilkhor; Mandala of the Master Healer (symbolized by Prajna Paramita).* Fifteenth century, 21.50 x 18 inches.

A Highest Yoga Tantra Tara Mandala

We explored the spiritual and artistic traditions of Arya Tara to some extent in chapter 13. However, even though in India the Tara Tantra and its applications were usually limited to the Kriya Tantra division, in Tibet it became amplified by the visionary experiences of the lineage masters. In particular, because the Tibetans began their romance with Tantric Buddhism with the Highest Yoga Tantras, and also because of the widespread popularity of the meditations associated with Arya Tara, it was only a matter of time before some cross-fertilization would occur.

Our present tangka depicts Arya Tara in just such a situation. No longer is she a virginal Kriya Tantra mandala deity. Instead, here we see her in the throes of a passionate sexual embrace with her Tantric consort. This particular Tara mandala practice comes down through the centuries from the early Sakyapa lamas. One of the first great Tibetan commentaries on Tara was written by the great Sachen Kunga Nyingpo (1092–1158).

Even more unusual, whereas most Tantric deities in the Yab Yum sexual embrace are seen from a perspective as though we were standing behind the female and facing the male, the perspective in this painting is reversed. Instead, we the viewers are as though behind the male and see the female face directly, with the male face turned to the side to reveal the kiss. The official name for this posture in Tibetan Tantric terminology is *cho-lokpa*, or "practicing in reverse," which is also used in the literature on Tantric love-making to mean "lady on top." The reason for the more standard perspective, of course, is that generally men are bigger than women, so placing the male at the back (facing forward) and the woman in front (facing upward) allows for both to be seen clearly in a painting. Here, to compensate, the female is depicted as being larger than the male.

The central figure is Arya Tara in Yab Yum sexual union with Buddha Amoghasiddhi. As we saw in chapter 13, Arya Tara in general represents buddha activity and also air/energy. Amoghasiddhi represents the same qualities. Hence both are green, the color of air/energy.

In addition to the stem of a lotus flower, which is the usual symbol held in Tara's right hand, she also holds a curved knife, the standard implement of a vajra dakini in the Highest Yoga Tantras. Her left hand holds a white skull cup, again a standard vajra dakini symbol. Her two arms embrace her consort, and she straddles him with her legs. He is depicted as being a lighter green than she, which is done solely for artistic purposes. In fact his color is identical to hers, for he represents the male equivalent of her enlightenment activities. They kiss with great passion and are seated in the vajra posture, to indicate that although they are both deeply moved by great sexual bliss they remain unmoving in the awareness of ultimate reality. In this way they sit in a sphere of red swirling light, symbolizing the ecstatic sexual passion of the enlightenment experience.

Buddha Amitabha sits directly above the couple, body red in color. At his right is the consort white Pandara Vashini. At the right is Buddha Akshobhya, holding a vajra and bell. Below is the consort Mamaki. Below is Buddha Vairocana, holding a wheel and a bell. At the left is the consort Vajradhatvishvari, holding a wheel-handled curved knife and a skull cup. At the left is Buddha Ratnasambhava, holding a jewel and bell. Above is the consort Lochani.

Outside of the circle, within the square enclosure, are four female attendant deities. Four female guardian deities stand at the four doors

Buddha Shakyamuni is depicted at the top left of the painting, together with Tara and the lineage masters. Heruka Chakrasamvara is depicted in the upper left of the painting, suggesting that the mandala is a cross-fertilization of the Arya Tara Tantra with the Heruka Chakrasamvara Tantra. At the upper right is Amitayus, the Buddha of Boundless Life, in sexual union with his consort. At the lower right is Vajravarahi, and at the lower left Rakta Yamari. Each of these Tantric deities is accompanied by two monks.

A solitary monk sits in the bottom right corner of the painting. He is probably the person who originally commissioned the painting.

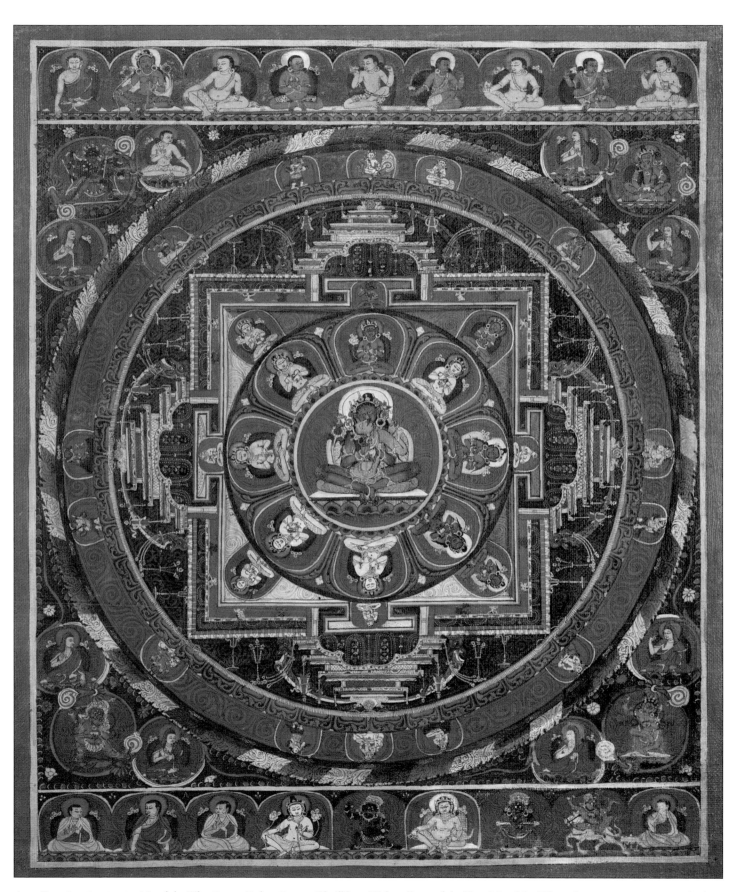

Arya Tara Anuttaratantra Mandala; Tib., *Jetsun Dolma Lamey Khyilkhor*; *Highest Form of the Tara Mandala*. Fifteenth century, 14.50 x 11.50 inches.

Mandala of Rakta Yamari and Vajra Vetali

The Tibetans received three different forms of the Vajrabhairava Tantric system, together with the associated mandala practices. In a previous chapter ("The Yum in Yab Yum") we saw the form known as *Shintu Drakpo*, or "Extremely Fierce." The present mandala is less fierce and depicts the red emanation known as Rakta Yamari, together with the consort Yamari. It is based on the Indian Tantric text known simply as the *Rakta Yamari Tantra*, which in nineteen chapters sets forth the basic principles of the practice.

The central figure depicts Rakta Yamari in sexual union with the consort Vajra Vetali. The symbolism is much the same as with Vajrabhairava, where the male represents the force that fends off death in its three forms of outer (i.e., premature death), inner (i.e., emotional and cognitive distor-

tions) and secret (i.e., a blockage in the subtle energy circuitry of the body). The female, Vajra Vetali or "The Diamond Zombie," represents the rebirth or rejuvenation that follows when these three negative conditions have been eliminated.

A line of Indian and Tibetan lineage masters sits in lines at the top and bottom of the painting. Their names are written below them, making their identification obvious. Chogyal Pakpa, who was the guru to Kublai Khan, the Mongolian ruler of China in the thirteenth century, sits fourth from the right in the line at the top. His presence identifies the piece as belonging to the Sakya School of Tibetan Buddhism.

The piece is painted in the old Gyangtsey style, with the characteristic predominance of red.

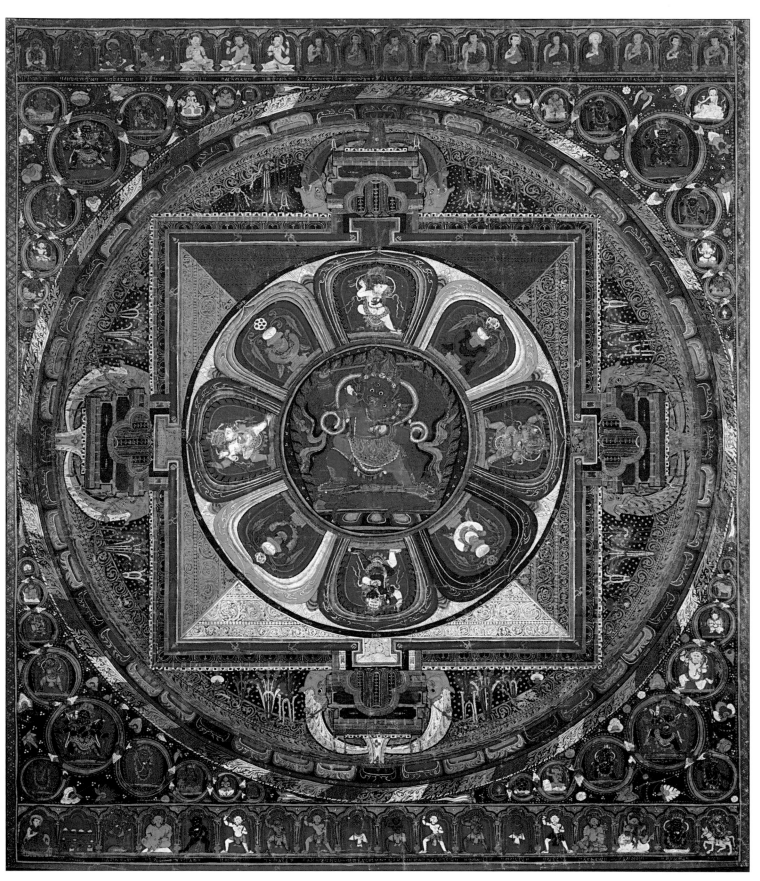

Rakta Yamari Mandala; Tib., *Shinjey Shemar Yab Yum Kyilkhor; The Mandala of the Red Enemy of Death, with Consort.*
Sixteenth century, 35 x 30.25 inches.

CHAPTER 19

Female Dharma Protectors

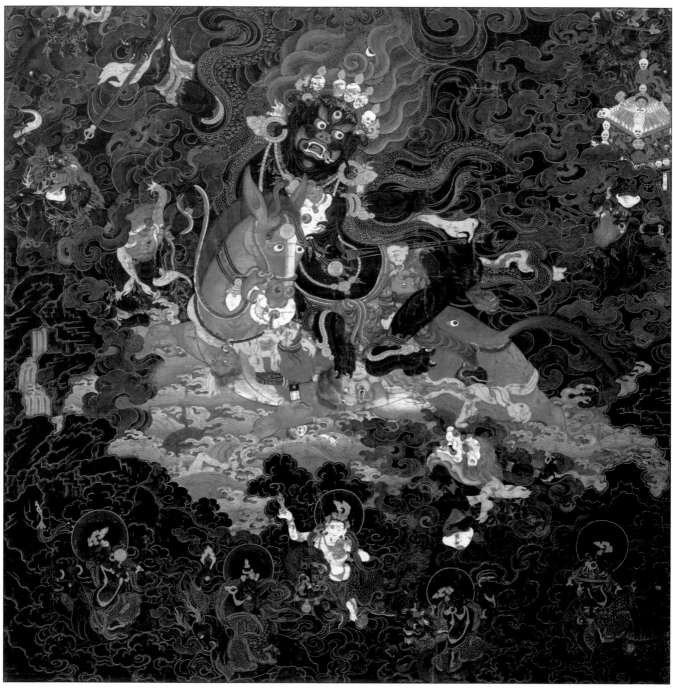

Detail from tangka on page 185.

We briefly discussed dharmapalas (i.e., Dharma protectors) in chapter 9, "Three Jewels, Three Roots, & Three Types of Female Buddhas." As was said there, in the Sutra Way the Buddha, Dharma and Sangha are the Three Jewels of spiritual inspiration, guidance and encouragement, whereas in the Tantra Way the Three Roots—the guru, the mandala Yidams, and the assembly of dharmapalas, dakas and dakinis—perform this function. The dakinis in the context of this third Root are not the vajra dakinis discussed in an earlier chapter ("The Vajra Dakinis"), but rather are themselves special types of Dharma protectors.

The nature of the Dharma protectors can be discussed from three perspectives: outer, inner, and secret.

From the outer perspective it can be said that they are spiritual forces—gods, goddesses, and various types of spirit beings—that are committed to assisting those who propitiate them. This is the conventional understanding of the average Tibetan nomad or villager who makes a daily smoke offering to the local dharmapalas.

From the inner perspective the Dharma protectors represent psychological states or archetypes of the Tantric practitioner, and the ability of those mental states to perform particular functions in the individual's spiritual life. For example, the standard liturgy to the Dharma protectress Palden Lhamo, which has a passage for each of the four enlightenment activities, speaks of Palden Lhamo and the activity of wrathful protection as follows:

> *The qualities of the four activities emanate*
> *from mind itself,*
> *Even though there is no mind or mind*
> *essence.*
> *In deeper truth there is no color and no*
> *form,*
> *Only one's own mind manifest as a magical*
> *illusion.*
>
> *It is in this sense that glorious Palden*
> *Lhamo*
> *Manifests the pacifying ways of a Dharma*
> *protector,*
> *Makes peace, becomes peace, shows peace-*
> *keeping ways,*
> *Is surrounded by a retinue of peace-keeping*
> *helpers,*
> *And has an intensely white body as a sign*
> *of peace.*
> *Protectress who performs all pacifying deeds,*
> *Pacify my illnesses, hindrances and ghosts.*

The same text then goes on to repeat the verse in three other ways, once each for the enlightenment activities of increase, power and wrath, replacing the color "white" respectively with yellow, red and black, and rephrasing the final line of the request accordingly.

An understanding of the Buddhist doctrine of karma is fundamental to an appreciation of how and why the dharmapala principle works in real life. Here it is said that we all carry within our mindstreams an infinite number of karmic seeds from past lives and therefore have the potential of an infinite number of ways in which our lives can unfold. Why do some people so easily meet with health, success, fame, wealth, love, happiness, family, and so forth, while others struggle intensely without seeing any of these positive results? The answer is that the former people have few blockages to the rivers of their karmic seeds, whereas the latter have many blockages. From the perspective of the inner interpretation, the dharmapalas represent the mystical technology for opening the dams that hold back the rivers of our positive karmic flows, and shutting down the rivers of the negative karmic flows. Doing this is not an end in itself, but rather is an expedient means that affords the possibility of creating environments that are more conducive to spiritual practice and the attainment of final enlightenment, wherein all ordinary karma is left behind, and in its place one operates solely on the basis of great compassion and the four buddha karmas.

The secret interpretation of the dharmapalas is that they are mysterious manifestations of the blissful mandala energies in an illusory theater of the four enlightenment activities. Like all things associated with the mandala, these four activities are but manifestations of the blissful wisdom of the non-duality of mind and the objects of perception, and are but reflections of the playful nature of the mandala deity.

In another interpretation of the secret aspect of the Three Roots, the first root (the Guru) represents the realization of the enlightenment experience. The second root (the Yidam or mandala deity) represents this enlightenment experience in the context of being in the world and the relation between self, others and ostensibly outer phenomena. Finally, the third root (the dharmapalas, etc.) represents activity in the world. In this sense, the Guru is one's own mind/spirit, the Yidam one's emotions/speech, and the dharmapalas, etc., one's body as an instrument of impacting the world through the four buddha karmas. These four are by definition based on the great compassion that is the heart of the Tantric path. They manifest in one of four ways, these four being the four buddha karmas or enlightenment activities listed above.

This said, Tibetans nonetheless classify all the different types of Dharmapalas into one of two categories. As was said in chapter 9, these two are called *Jigten Chokyong*, or "worldly dharmapalas"; and *Jigten Leydeypai Chokyong*, or "dharmapalas beyond-the-world." The former are generally thought of as beings that are unenlightened and thus are still within the six realms of *samsara*, whereas the latter are beings who are fully enlightened and thus are actually emanations of particular buddhas.

Every Tantric system has its own principal protectors. These come from India and were associated with the particular Tantric system from the beginning. Usually they are thought of as being emanations of the principal mandala deity and are classified as beyond-the-world (or enlightened) dharmapalas. In other words, they are manifestations of the Yidam in the form of a wrathful protector. The Vajrabhairava Tantra, for example, presents Dharmaraja with consort in this role, and the Heruka Chakrasamvara Tantra presents Mahakala.

As for the practice of incorporating Jigten Chokyong, or the worldly, unenlightened protectors, this tradition goes back to India and the Buddha himself. In fact, it has its roots in the Sutra interpretation of refuge in the Three Jewels. Here one becomes a Buddhist by taking refuge in Buddha, Dharma and Sangha, and accepting two precepts for each in terms of practice (i.e., what to do) and two precepts for each in terms of discipline (i.e., what not to do). One of the "what to do" precepts of refuge in the buddhas is to regard enlightenment as the supreme sanctuary. In terms of what *not* to do, one should not continue with the practice of invoking and praying to the worldly gods as an ultimate practice. However, one may do so for conventional, basic purposes, such as to pray for one's daily bread, or to be forgiven for one's trespasses. As a result of this attitude, wherever Buddhism went in its 2,500-year history, it not only allowed but even encouraged people to maintain their old religious practices. These, however, were (and are) to be given a back seat to the greater purpose of enlightenment.

The early Indian teachers who came to Tibet brought some religious practices of this nature with them and passed these on to their disciples. For example, in ancient India many early Buddhists took up the propitiation of Ganapati (i.e., Ganesha), the elephant-headed son of Shiva, as a wealth and prosperity practice. We have included a tangka of Ganapati later in this chapter, to illustrate how the practice was transformed by the Tantric Buddhists. Several dozen dharmapalas came to Tibet in this way, many from India, but others from other countries. For example Pehar Gyalpo, the deity propitiated as the State Oracle of Tibet and channeled

in the process for finding the reincarnations of the Dalai Lamas, is probably a minor deity from eastern Persia, brought in by Padma Sambhava as a result of his birth in Oddiyana, a trading center on the Old Silk Road. The Tibetans have gotten good mileage out of this worldly import, for he has been the primary source of counsel to the Tibetan government ever since the Fifth Dalai Lama assumed national dominance in 1642. This deity is channeled by its medium and asked for advice in every national crisis great and small. The word "gyalpo" in the name Pehar Gyalpo does not mean "king" or "kingly," as most Tibetans today seem to think, but rather is the name of a type of ferocious spirit referred to in early Tibetan diction as a "gyalpo spirit."

Other worldly Dharma protectors in Tibetan Buddhism were indigenous to shamanic Tibet long before Buddhism was imported from India. The early masters chose to incorporate the best of the old traditions rather than to contest them. For example, the twelve pre-Buddhist goddesses known as the *Tenma Chunyi*, or "Twelve Revealers," were almost immediately adopted by Buddhism in Tibet. Many of these twelve continue to be invoked today on a regular basis. Similarly, the "Five Healing Sisters," who are associated with the five great mountains of the Everest region, were also incorporated.

Sometimes these worldly dharmapalas become controversial, and different factions of Tibetans argue over the validity of incorporating a particular deity. In the late nineteenth century, for example, a handful of Nyingma and Karma Kargyu lamas in Kham took exception to the Gelugpa protector Dorjey Shugden. Not much came of their grumblings, until Dilgo Khyentsey Rinpochey, a lineage descendent of this anti-Shugden group, became a tutor to the present Dalai Lama. As a consequence the Dalai Lama pressed those Gelukpas who had received the Shugden initiation to drop the practice, thinking that his spiritual popularity with the Tibetans would carry the issue. The opposite happened. Rather than drop the practice, those committed to the Dorjey Shugden practice dropped their loyalty to the Dalai Lama. The incident developed into a conflict that has achieved widespread attention, even finding its way onto the pages of *Time Magazine*. Tibetans may like their lamas, but they like their gods even more.

They especially like the worldly protectors. Buddhas and bodhisattvas help in general ways, the Yidams serve as great objects of mandala meditation, and the beyond-the-world protectors do a great job in keeping one's practice effective and on track. The worldly protectors, however, have an immediate impact on the physical reality of daily life that none of the above, for all their transcendent spirituality, can match.

It is important to point out that the Tantric practices associated with the dharmapalas always remain a secondary and not a primary endeavor. This is evident in the way they are invoked. One must first do the *dak-kyey*, or meditation of oneself becoming one's principal Yidam, together with all aspects of the supporting and supported mandalas. Only after this is effected does one invoke the dharmapala. Moreover, these dharmapalas are not invoked as *dak-kyey* meditations, but rather as *dun-kyey*, or "a visualization in front." In other words, one does not become the dharmapala, but rather becomes the Yidam. One then summons the dharmapala to come into one's presence and commands him or her to fulfill the ancient pledge to protect and serve. This is true in regards to both the worldly (unenlightened) and the beyond-the-world (enlightened) dharmapalas.

Although almost all Tibetans, from simple farmers to sophisticated lamas, are very dedicated to the practices associated with their dharmapalas, nobody seems to know much about the histories of their origins or the mythologies surrounding them. If one asks ten different lamas about any given dharmapala one will probably come up with ten different accounts. Everyone knows a few common stories about each dharmapala, but beyond that there is little consensus.

There are, of course, texts that address the topic of the histories of the individual dharmapalas, but these are never critical studies of history and myth as such, but rather are more in the line of collected stories of the famous masters in the past who did the practice, together with a list of the miraculous results that were produced.

One can know which dharmapalas are considered "worldly" and which "beyond-the-world" by examining the type of tangka known as *tsok-zhing*, or "field of accumulation." In this type of tangka, all of the most important lineage masters, mandala Yidams, and dharmapalas/dakas/dakinis of a particular sect are arranged in the form of layered decorations on a tree. Usually the founder of the school sits at the center/top of the tree, with the various classes of mandala deities, buddhas and bodhisattvas in rows below, and various groups of lineage masters in the sky above in each of the four directions. We will see a tangka of this nature associated with the Zhichey Chod lineage and White Yogini in the chapter 20, "Great Female Lineage Masters." Often the bottom row on the tree is filled with the enlightened, beyond-the-world dharmapalas, whereas the unenlightened, worldly dharmapalas are kept off the tree altogether and instead are shown standing nearby on the ground.

In this chapter we have used the Sanskrit names of only those dharmapalas whose origins in India are clear, such as Chitipati, Ekajati, and Ganapati. We have left the names of those of Tibetan origins in Tibetan, and also those whose claims to Indian origin are questionable. Since the eleventh and twelfth centuries Tibetan writers have tried to link everything to India, ostensibly in order to bring an added credibility to the particular subject. India is the *arya desha* or "holy land" to these writers, so the temptation to do this has always been strong. A second tendency of the Tibetans is to link everything to the eighth century master Padma Sambhava in some revelatory way. Again, this is often just the creative imagination at play.

Palden Lhamo Magzor Gyalmo

Tibetans make their tangkas in various mediums. The simplest is the *shing par*, or woodblock print. The next up the ladder is a *tsun shing par*, or woodblock print that has been painted in, sort of like a paint-by-numbers creation. After this comes the watercolor on canvas, the category to which most of the tangkas in this book belong. These are in various forms, such as the *tsun-tang*, or tangka painted in full color on a white canvas; the *ser-tang*, which is gold lifework on a canvas that has been stained red with vermilion; and the *nak-tang*, which is gold lifework on a canvas stained completely black. Then there is the *tsim-tang*, or the embroidered tangka, which is made by embroidering with colored thread on a cotton canvas. Finally, at the very top of the ladder, there is the *gu-tang*, or appliqué tangka, which is made by carefully cutting and stitching pieces of brocade into a desired image.

This last form, the appliqué tangka, was the most highly prized of all in Tibet, and tangkas of this nature would often be adorned with pearls and precious gems as a sign of the respect in which they were held. Appliqué tangkas were rarely owned by individuals other than high reincarnate lamas with wealthy labrangs, because a single appliqué tangka could easily cost as much as ten or twenty painted ones. The present tangka belongs to this most treasured of categories.

The subject of the piece is the female protectress Magzor Gyalmo, "Queen of Wrathful Rituals." She is one of the main forms of the twenty-one emanations of Palden Lhamo, the protectress associated with Tibet's famous Lhamo Latso Oracle Lake. Magzor Gyalmo is more commonly known simply as Magzorma. *Mak* means war or battle, and *zor* is a type of wrathful ritual. The meaning is that Magzor Gyalmo is invoked as a means of establishing peace through Tantric ritual. She is strongly linked to the Dalai Lama incarnations, because the First adopted her as his personal dharmapala, and the Second built his main monastery, Chokhor Gyal, at Metoktang just below the waters of her lake. In fact, the Second Dalai Lama held her in such high regard that he recited ten thousand of her mantras every day of his adult life. He took up this practice at the age of sixteen after completing a meditation retreat in which he experienced life-transforming visions and realizations and continued it until his death almost fifty years later.

Makzorma is depicted as being extremely wrathful in appearance and holds aloft a vajra club in her right hand and a skull cup filled with blood in her left. The vajra club symbolizes her role as peacemaker, or "wrathful ritual," for with it she pounds the causes of war to dust. The skull cup identifies her as a wrathful dakini, with transcendental bliss as her primary nutrition. She rides a mule on top of the waters of a river of blood, symbolizing how she protects practitioners from the bloody catastrophes and miseries of life. She is clothed in tiger skins, showing the fearlessness that she bestows, and she wears human skins as her scarves and shawls, to indicate how she saves those who rely on her.

At the bottom of the tangka are her two principal attendants. The one on the left, a naked blue dakini with the face of a mythical creature resembling a sea dragon, holds the reins of her mule. The one on the right, a dark red dakini with the face of a snow lion, follows behind the mount. Both are adorned with human skins and bone ornaments. The former symbolizes Magzorma's connections with all things to do with rivers and seas, whereas the latter symbolizes her power over all things on land and in mountains. Both appear in the forms of dakinis, indicating that both also have power over all things in space. Thus the three worlds—below, between, and above—are covered by their presence and activities.

Because of the connection of Palden Lhamo with the Oracle Lake, she is often used for divination. Her particular divination method utilizes dice, and we can see these in the tangka, where they are dangling from the straps of a cloth in which a *mo-pey* or divination manual is wrapped (just under the mule's nose). Traditional Tibetan books are loose leaf, either hand-copied or printed from woodblocks, and generally wrapped in a cloth.

Anyone wanting to become a divination master in the Palden Lhamo Magzorma method is instructed on how to undertake the retreat. During this retreat the dice that will later be used as the divination instruments are placed on the altar. The trainee pursues the mantra recitation and meditation for some months, until the dice turn over on the altar by themselves. This indicates that they are now empowered by Magzorma and can be used effectively in divination.

The divination method itself is rather simple. The person wanting advice poses a number of alternatives to a particular problem. The lama throws dice on each alternative, using either one die three times or three dice once, and gets a number between three and eighteen. He or she then looks in the divination manual and comes up with a positive, negative or neutral reply to the particular inquiry. When the reply is negative, a list of rituals might well be recommended as a remedy, and hence the name Magzor Gyalmo, "Queen of Wrathful Rituals." In fact, the Magzorma divination manual is a veritable database of Tantric rituals, with hundreds being listed as recommendations for various situations that might arise. Most Tibetans ask for a confirmation divination on every important issue in their lives: whom to marry, when to have a baby, what school to attend, where and when to do business, and so forth.

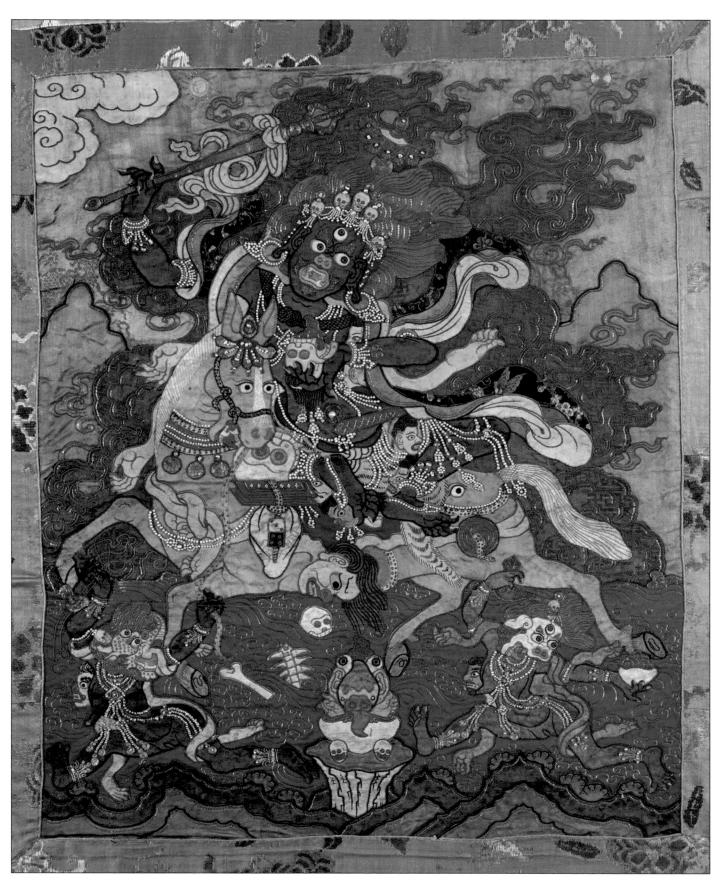

Palden Lhamo Magzor Gyalmo, Glorious Divine Queen of Wrathful Rituals. Eighteenth century, 53 x 32 inches.

Magzor Gyalmo with Tseringma Chey Nga

Although Magzorma herself is a beyond-the-world dharmapala, her connection with the Oracle Lake gives her a special standing with the dharmapalas that were adopted from Tibet's pre-Buddhist shamanic traditions, especially those that were connected with sacred sites. Perhaps the foremost of these are the Tseringma Chey Nga, or "Five Healing Sisters." These five—Lhamo Tashi Tseringma, Tinggi Zhalzangma, Miyo Lobzangma, Chopan Tingzangma, and Tekar Drozangma—are linked to the greatest of Southern Tibet's sacred mountains, all of which lie in the Mt. Everest region. Milarepa, the eleventh century yogi and poet, made these five mountains and their Five Healing Sisters especially cherished by all Tibetans through the songs to them that he composed during the years of his retreat on and near Everest.

Our tangka here depicts Magzorma with the Five Healing Sisters. Magzorma can be seen riding on her mule through a sea of blood, together with her two standard attendants, one holding the reins and the other following behind. The Five Healing Sisters are depicted along the bottom, each riding her own animal: a mule, a horned horse, a lion, a dragon, and a tiger.

Tibetans make pilgrimage to the five holy mountains associated with the Five Healing Sisters, including Mt. Everest, not in order to hike around or to scale the peaks there, but rather in order to strengthen, heal and rejuvenate their life-force by practicing meditation and merit-gathering there. Performing the invocations of the Five Healing Sisters at any of these five sacred mountains is an especially powerful merit-gathering act. Mt. Everest itself is known to Tibetans as Jomo Langma, an epithet of the first of the Five Healing Sisters, who is the central white figure in the group. Everest is the most important of the five, with Mt. Zhizhi Pangma a close second.

These Five Sisters and the great mountains that they represent are important to the old medical tradition of Tibet and traditionally were primary regions where medicinal herbs were collected. Often the healing power of a particular herb is affected by the altitude at which it grows, and Tibetan doctors collect many of their herbal medicines at fifteen to twenty thousand feet and higher. Herbs from these five great mountains are especially cherished; not only are they med-

ically excellent, but in addition they contain special blessings from the Five Healing Sisters. The five mountains sit on the border of Nepal and Tibet and have completely different climates and growing conditions on their northern and southern slopes. As a result, they are veritable paradises for the high-altitude herbologist.

The Five Healing Sisters are also associated with the five principal chakra sites or energy and chemical centers of the body—brain, thyroid, heart/lungs, abdominal region (including liver, stomach, pancreas, spleen, etc) and sexual region. For this reason they are often shown in five colors and hold symbols representing the five buddha families.

A group of five lineage masters can be seen in the sky above the dharmapala figures. These five were very important in the spiritual renaissance of the seventeenth century. The most important of them is the illustrious Fifth Dalai Lama (seated to the right of the central figure), who became spiritual and temporal head of a newly unified Tibet in 1642. The figure to his right is Panchen Lobzang Yeshey, the Great Fifth's main spiritual heir. This is the Second Panchen Lama (listed as the Fifth Panchen by the Chinese), who became the tutor to the short-lived Sixth Dalai Lama, and then also tutor to the Seventh Dalai Lama.

Both the First Panchen Lama and his disciple the Fifth Dalai Lama wrote brief manuals for meditation on the Five Healing Sisters. In addition, Panchen Lobzang Yeshey practiced meditation in the caves of the Mt. Everest region and later sent many of his disciples to these same places for their long retreats. The spiritual tradition of the Five Healing Sisters, which is very popular with the educated peoples of that area, came into the Gelukpa with considerable force at that time. Panchen Lobzang Yeshey also placed one of his disciples, Khachen Yeshey Gyaltsen, in a twelve-year retreat on Mt. Everest. This disciple achieved enlightenment and became the greatest Gelukpa master of the late eighteenth century.

The practice of the Five Healing Sisters achieved something of a national status during the lifetime of the Fifth Dalai Lama and became incorporated in the list of annual rituals sponsored by the Lhasa government. This has continued to the present day, and the tradition is maintained by the Tibetan government in exile.

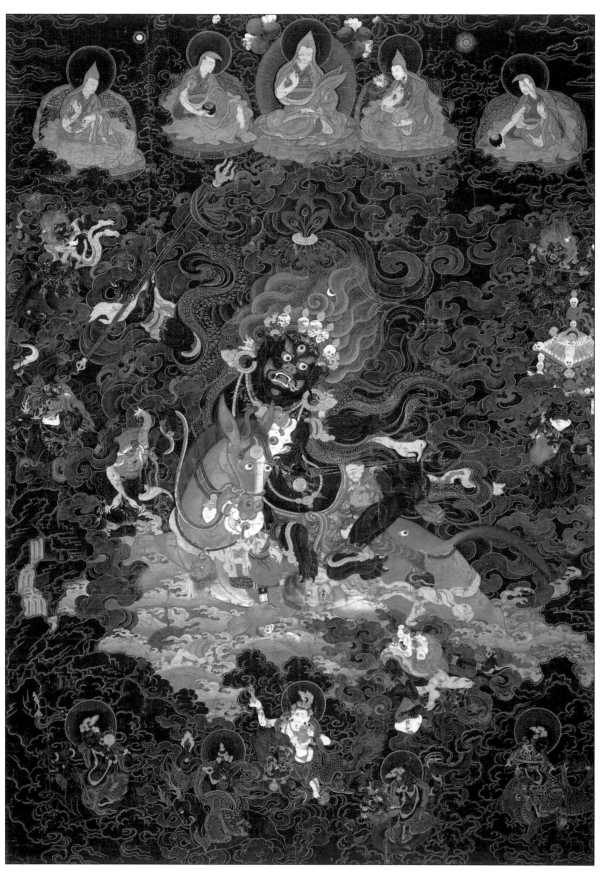

Magzor Gyalmo with Tseringma Chey Nga, The Queen of Wrathful Rituals with the Five Longevity Sisters.
Seventeenth century, 33 x 23 inches.

Dorjey Rabtenma

Dorjey Rabtenma is another of the twenty-one emanations of Palden Lhamo. She resembles Magzurma in many ways and has the same two attendants. In fact, all twenty-one Palden Lhamo emanations share many common features. They differ in hand implements, to symbolize that each has her own special function. They also vary in color, for each emphasizes a different application of the four enlightenment activities.

Dorjey Rabtenma is maroon, indicating that she is on the upside of the Palden Lhamo emanations in the category of the enlightened activity of power. In other words, she is power mixed with wrath. She holds a flaming sword in her right hand, indicating that she is a wisdom emanation, for her sword cuts off the head of ego-grasping and the duality syndrome. She cradles a mongoose in her left hand, which is spitting out variously colored jewels. This symbolizes that she has a special function of ensuring prosperity and wealth.

A radiant sun shines at her navel, again a symbol that she is primarily connected with the wisdom (as opposed to the method/universal love) aspect of the spiritual path.

However, she does not overlook method, and a moon can be seen as a jewel in her hair.

These two symbols also indicate her special function as a dharmapala for those practicing the high Tantric yogas. The sun at the navel is ovum/female energies, and the moon above the crown is sperm/male energies. The union of these two in meditation is the primary aim of the yogic path.

Dorjey Rabtenma was the principal dharmapala utilized by Zhalu Monastery and the great twelfth-century master Buton Rinchen Drubpa (1290–1364), compiler of the Tibetan Tengyur canon. Because Buton's work was so important to all schools of Tibetan Buddhism, this increased its popularity with everyone. We can see Buton in the upper left hand corner of this tangka, wearing his characteristic yellow hat. Probably the figure at the top center is Guru Padma Sambhava in the form of a monk scholar. Padma Sambhava is said to have consecrated most of the power places associated with Palden Lhamo, including Lhamo Latso, the Oracle Lake.

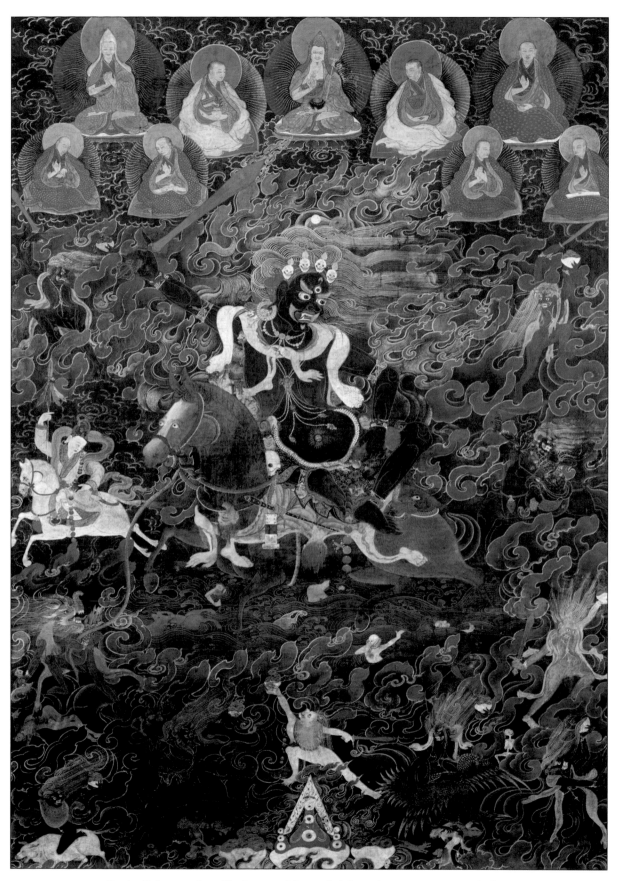

Dorjey Rabtenma, Superbly Constant Diamond, eighteenth century, 35.25 x 25 inches.

Shri Chitipati

The Yab Yum pair known to Tibetans as Durdak, or "The Lord and Lady of the Charnel Grounds," are the principal dharmapalas associated with the Vajrayogini Tantric systems. They are especially popular in the Vajrayogini lineage of Naro Khachoma, or "Naropa's Space Lady." In fact, they appear at the foot of one of the Vajrayogini tangka included in an earlier chapter of this book.

As we saw in our discussion of the Heruka Chakrasamvara mandala (in the chapter "Female Buddhas & Their Mandalas"), meditation in charnel grounds was a common practice with the Indian mahasiddhas in the Chakrasamvara/Yogini lineage of transmission. This exotic dharmapala couple have their origins in that tradition.

However, the popularity of the Lord and Lady of the Charnel Grounds goes beyond their appearance in tangkas and as statues. They are also a common feature of the mystical performing arts and are a major part of many of the annual *cham* lama dances that are held by the monasteries of Central Asia. These cham dances are generally daylong affairs, sometimes even four or five days of dawn-to-dusk participation. The appearance of two dancers dressed in skeleton outfits always livens up the crowd. The dance is not a freeform production but an exact choreography based on the visionary experiences of the great Vajrayogini masters of the past.

Our tangka depicts the Skeleton Lord and Lady dancing under a pavilion made of human bones. Both skeletons look the same, so it is difficult to know which is male and which female. The only sure sign is that sometimes the male is depicted as though dancing on a conch shell, and the female as though dancing on a cowrie shell. The right hand of each holds a club that is topped with a human skull, to indicate that all hindrances will be pounded to dust. The left of each holds a skull cup filled with blood, symbolizing that they provide the nutrient of blissful wisdom. The right and left corners at the bottom of the tangka contain framed scenes from the charnel grounds, with tigers and vultures devouring corpses, and so forth.

The rainbow-colored silk fans beside the ears of the two dancing figures are significant and symbolize the rainbow body yogas for which the Vajrayogini Tantra is famed, and through which the practitioner learns the art of dissolving the five elements of the coarse physical body into rainbow energies. The Tibetan art of levitation is largely based upon this yoga.

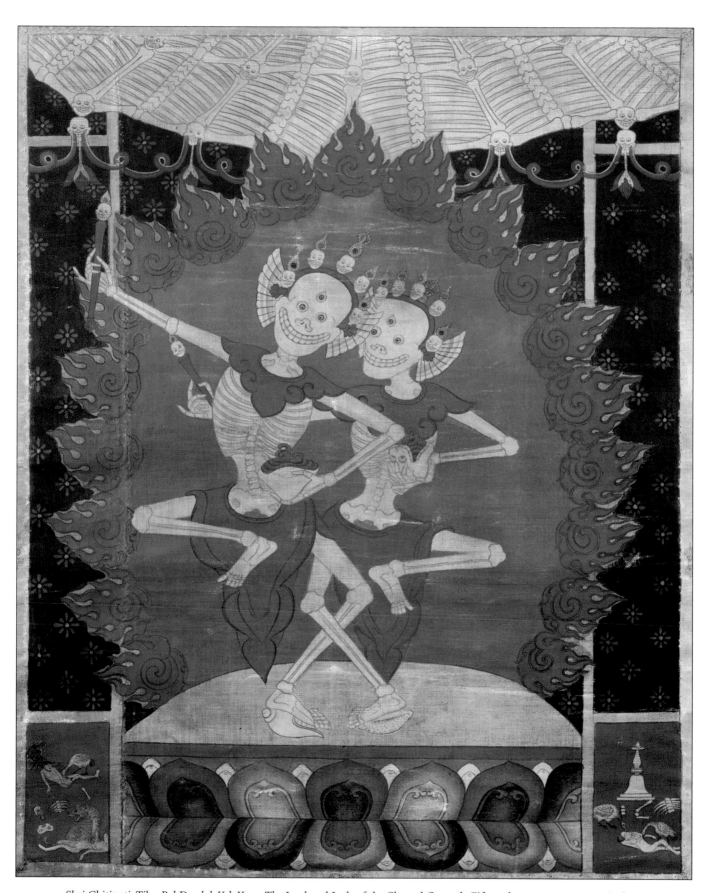

Shri Chitipati; Tib., Pal Durdak Yab Yum; *The Lord and Lady of the Charnel Grounds.* Fifteenth century, 18 x 14.50 inches.

Ekajati

Ekajati was a popular Kriya Tantra deity in India and often appeared as part of the trinity of Arya Tara, Marichi and Ekajati. In fact we saw her in this trinity arrangement at the bottom of the White Tara tantka in chapter 14, "The Healing Trinity," and we quoted a famous verse to the three from the First Dalai Lama's hymn to Arya Tara, *The Lektrima*. This manner of forming trilogies of Kriya Tantra deities—one from each of the three families of tantras in the Kriya division—spilled over into Tibet and became a common feature of Tibetan art.

When linked to Arya Tara and Marichi in the above way, Marichi represents the daytime Tantric experience, whereas Ekajati represents the nighttime experience. Arya Tara represents the expression of buddha karma that pervades both.

In Tibet, however, Ekajati became much more popular as a dharmapala than as a Yidam of the Kriya Tantras. She became paired with the male dharmapala Rahula, with Rahula representing an eclipse of the sun during the day and Ekajati representing a lunar eclipse at night. Tantric practitioners see all natural experiences as external symbols of particular experiences, and the spiritual significance of these two forms of eclipse became embodied in this way. The eclipse is regarded as a moment of special magic and power.

In our tangka Ekajati is depicted as black, with one central eye, one breast, and one long white tooth biting down over her lower lip. Her yellow hair flows upward like the flames of a fire and is twisted into a single braid. Her right arm is held upward in the threatening mudra, with the index finger pointing outward and emanating a wolf; for just as the wolf's howl symbolizes the night, so do the energies of the lunar eclipse that she symbolizes. She brandishes a stick adorned with an impaled corpse, for those who know how to correctly utilize the energies of a lunar eclipse can easily achieve enlightenment in one lifetime. Her left hand is upraised to her mouth and holds a dark red human heart, symbolizing how she extracts nutrition from the forces that frighten ordinary mortals. In this painting, the position of the hand and heart conceals her solitary breast.

Although Ekajati is practiced by all schools of Tibetan Buddhism, she is the chief protector of the Revealed Treasure traditions in the Nyingma School and thus receives special attention from Nyingmapa lamas.

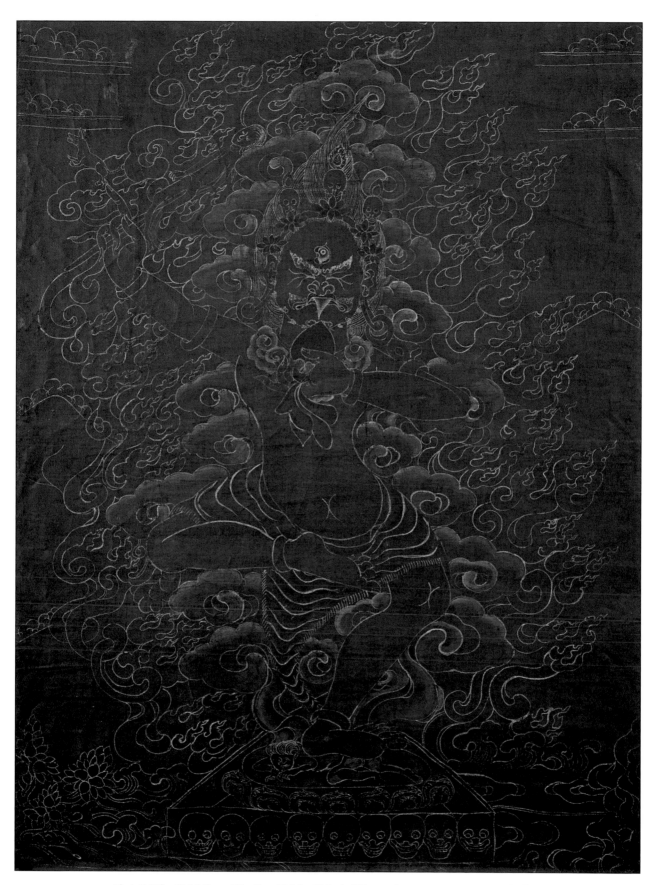

Ekajati; Tib., *Ralchikma; The One Hairbraid Lady.* Ninteenth century, 23.50 x 18.50 inches.

Rakta Ganapati & His Five Dakinis

One of the most unusual iconographic images in the pantheon of Tibetan Buddhism has to be that of Rakta Ganapati with his five dakinis. Here Ganapati (an epithet of Ganesha) is shown being held on high by a black, naked, monkey-headed dakini, who simultaneously performs oral sex on him while passing menstrual blood into a cup made from a human skull. Meanwhile, four naked red dakinis dance in the four directions, also passing menstrual blood into skull cups.

The Buddhist Tantric systems associated with Heruka Chakrasamvara are somewhat parallel to the Hindu Tantric traditions associated with the *Shiva Puranas*. The elephant-headed Ganesha, or Ganapati, who is mythologically presented as the son of Shiva, became the spokesperson for the *Puranas*. He also became an important protector of the Chakrasamvara Tantras in the Tantric Buddhism of classical India. Later he became popular in the the various schools of Tibetan Buddhism as a dharmapala giving protection and support to those who rely upon the Chakrasamvara mandala.

From the thirteenth century or so the phenomena of *terma*, or "treasure revelations," began to manifest in the Nyingma. Many of these revelations were reworkings of traditional Nyingma lineages. These eventually gave rise to what is now known as "the distant lineages" and "the close lineages," with the former being the original transmissions imported from India between the seventh and eleventh centuries, and the latter being a reworked revelation format of the transmission. However, not all terma were adaptations of early Nyingma lineages. Many were adaptations of traditions from the Sarma Schools, and thus of teachings that previously did not exist in the Nyingma. The terma tradition of the Six Yogas of Naropa, for example, is just such a case.

Similarly, the "Ganapati with menstruating dakinis" is most probably a Nyingma terma revelation that is an adaptation of the lineages of Ganapati descending from the Kadam School. However, whereas the Kadam iconographic forms of Ganapati were of a somewhat more modest sexuality, the Nyingma terma revelation bumped the whole thing up a notch.

The symbolism of the exotic painting, interpreted in accordance with standard Tantric imagery, is that the female, who is wisdom, drinks the male essence, which is blissful energy. These two substances—bliss and wisdom, represented by sperm and ovum—are then transmuted in the body of transcendental awareness, the female womb, and pass out as the blood of orgasmic consciousness into the human skull.

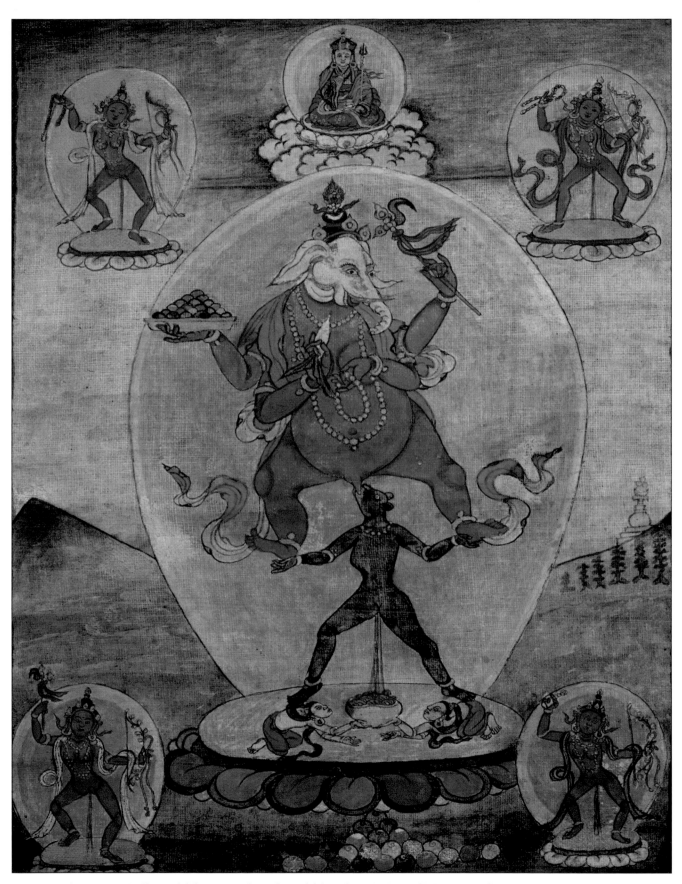

Rakta Ganapati; Tib., *Tsokdak Marpo; The Red Wrathful Lord & His Five Dakinis.* Ninteenth century, 11.25 x 8.50 inches.

Khadroma Tsomo Chechang Marmo

This dakini dharmapala is one of eight attendant figures in the retinue of Gonpo Shanglon, a worldly dharmapala connected with Tibetan medicine. Her wolf face and red tongue symbolize the process used by early Tibetan doctors in collecting medicinal herbs in remote places. The Tibetan medical system talks about eight categories of disease and eight types of flavors. Whenever someone becomes sick, the tongue sends a signal to indicate what flavors are required for a cure. These flavors indicate the presence of particular nutrients with healing properties. A natural medicine that tastes terrible to a healthy person will taste good to a person with the according illness.

According to this theory, all medicine originated with peoples who had sensitive tongues, and could put together the link between the eight types of illness, the eight types of taste, and the tens of thousands of possible sources of those tastes. By a system of trial and error they categorized all the various illnesses and the various sources of the flavors that effect the required cures, such as herbs, flowers, roots, trees, minerals, and so forth.

This ability to heal oneself by following one's tongue is symbolized by the she-wolf, who does just that. A sick wolf wanders alone in the high mountains, seeking out the substances that have the healing ingredients signaled by the sense of need for a particular flavor. She wanders alone in remote places, chewing on the appropriate substances as she encounters them.

Here this natural healing instinct takes the embodiment of a worldly dakini with the face of a wolf and a huge red tongue. She rides a white nine-headed bird, to symbolize the nine branches of knowledge.

The Medicine Buddha sits at the top center of the painting. We saw his mandala in an earlier chapter, "Female Buddhas & Their Mandalas," although there the central position in the mandala was taken by the female buddha Prajna Paramita, Mother of all Buddhas. Here the Medicine Buddha holds the branch of the legendary Myroblyan healing tree in his right hand and holds a bowl filled with fruit from the same tree in his left.

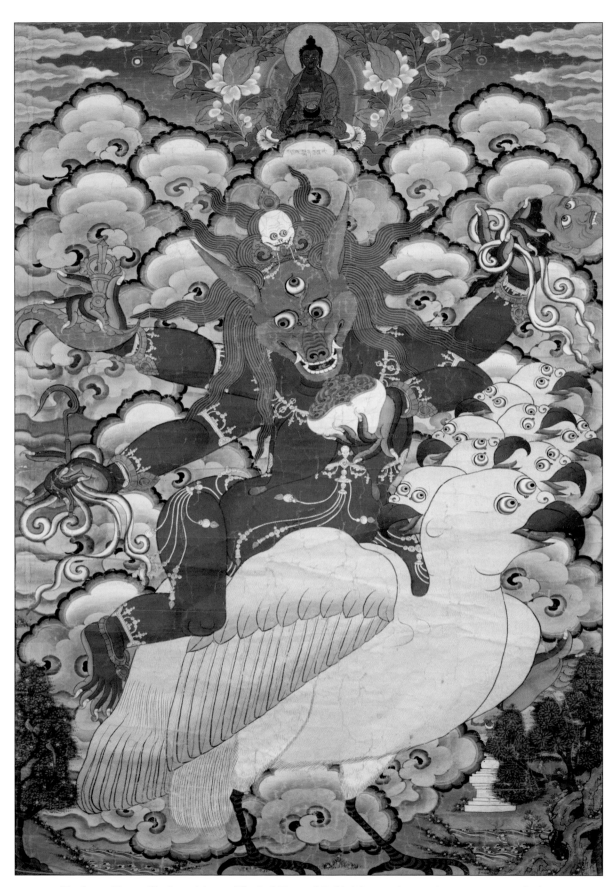

Khadroma Tsomo Chechang Marmo, The Red-Tongued Dakini Queen, nineteenth century, 36 x 56 inches.

Sinpoi Tsomo Jigjey Marmo

As with the previous painting, the subject of this piece is also one of eight attendant figures in the retinue of Gonpo Shanglon, the dharmapala associated with traditional Tibetan medicine. In this painting our Queen of Dakinis takes the form of a wrathful spirit queen, a *Sinmo*, and mounts a male zombie with nine heads, again symbolizing the nine branches of knowledge. We thought that our female readers might especially enjoy the image. The wolf face that we saw in our previous tangka is here placed as a small head protruding from above our heroine's crown.

However, whereas the previous painting expressed the idea of the art of healing as a natural extension of the harmony with the senses and the elements of the world in which we live, this painting brings us to another important aspect of Tibetan medicine, which is the training in the wisdom tradition. This is symbolized by the wisdom sword in the right hand of our heroine, and also by the trident in her left hand. (The trident symbolizes the unified wisdoms of the Three Buddha Kayas.)

The wisdom tradition in the Tibetan medical system involves cosmology and astronomy. Every herb, root and other organic healing agent is most effective when harvested at the precise moment of its natural perfection. These times are not set by a solar calendar, but rather by the exact timing as read by the positions of particular stars, planets and other heavenly bodies.

The figure seated at the top center of the painting is Desi Sangyey Gyatso (1653–1705), one of Tibet's main writers on the Tibetan Buddhist sciences of cosmology and astronomy. He was one of the great renaissance men of the late seventeenth century and also served as regent to the Fifth Dalai Lama in the latter's old age. In fact, he also oversaw the search for and enthronement of the young Sixth Dalai Lama.

Desi Sangyey Gyatso also wrote extensively on Tibetan medicine. His books on the subject are still used today as required reading in the training of young Tibetan doctors.

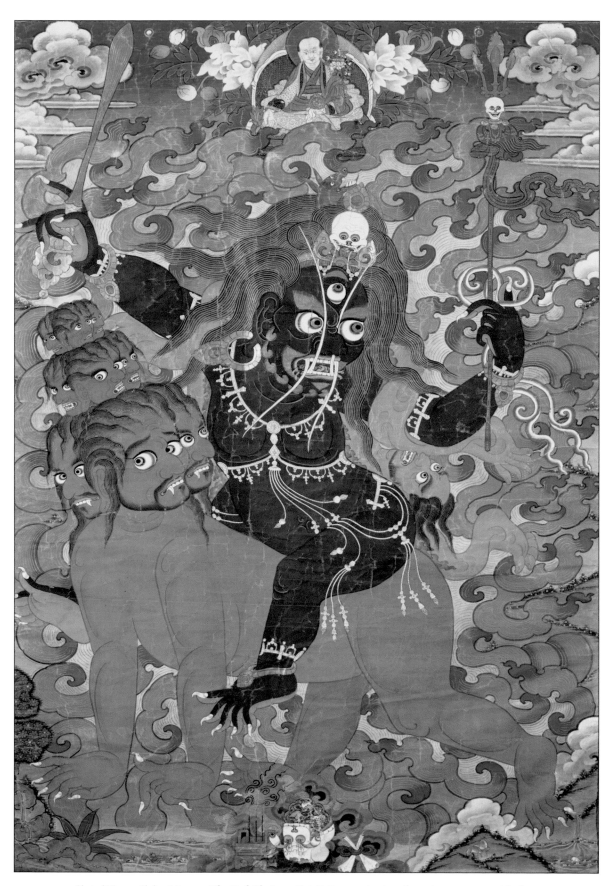

Sinpoi Tsomo Jigjey Marmo, The Red Bhairava Spirit Queen, nineteenth century, 35.50 x 56 inches.

Lhamo Dorjey Yudonma

As was stated in the introductory section of this chapter, wherever Buddhism has gone in its 2,500 year-history it has usually incorporated the best of what was there at the time of its arrival. Perhaps the best of Old Tibet was the shamanic tradition of channeling various deities.

Channelling in ancient Tibet was often a spiritual art passed from mother to daughter. Those who were good at it were held in high regard and were consulted by everyone from simple villagers to the highest of lamas. Generally at the time of a séance the medium would dress in the costume of the deity to be channeled, with mirror through which the deity is to enter her body being suspended directly in front of her heart. Monks or shamans connected to the family would chant verses of invocation, and after a few minutes the medium would suddenly jump from her seat in a state of deep trance, usually chanting wildly in spontaneous verse.

In our introduction to this chapter we also mentioned twelve pre-Buddhist female deities known as the Tenma Chunyi, or "Twelve Revealers," who are associated with twelve sacred power places across Tibet. The twelve are thought of as a set and were quickly incorporated by the early Buddhist masters. Legend has it that Padma Sambhava himself subjugated them and swore them to the protection of the Dharma.

Although all twelve are equal in status, Dorjey Yudonma is special among equals and was incorporated as special protector of the Gyuto Tantric Monastery sometime in the fifteenth century. In that this became one of the two monasteries from which all Ganden Tripa or official Throne Holders (i.e., heads) of the Gelukpa School are chosen, this brought her to a position of national importance. However, the actual mediums continued as mother-daughter transmissions. One of the main mediums alive today resides in Dharamsala, India, the town where the Dalai Lama and his government in exile are based. Usually two or three monks from the local branch of the Gyuto Tantric Monastery are called to her house to perform the invocation prayers whenever a session is arranged.

Dorjey Yudonma is depicted as white in color, with a peaceful and youthful appearance. Her right hand holds a long-life arrow decorated with a mirror and a streamer in five colors. The arrow symbolizes the healing power of wisdom, and the five colored streamer represents the balance or harmony of the five elements of the body. Her left hand holds a mirror, which represents her function as an oracle who is easily channeled by means of the mirror method.

She rides atop a deer, while her four attendants, who stand at the four corners, ride horses. The wrathful bodhisattva Vajrapani is depicted at the top center of the tangka, presumably to indicate her pledge to protect and assist Dharma practitioners, and thus began her new career as a Buddhist dharmapala, in the presence of Vajrapani, the wrathful bodhisattva symbolizing power.

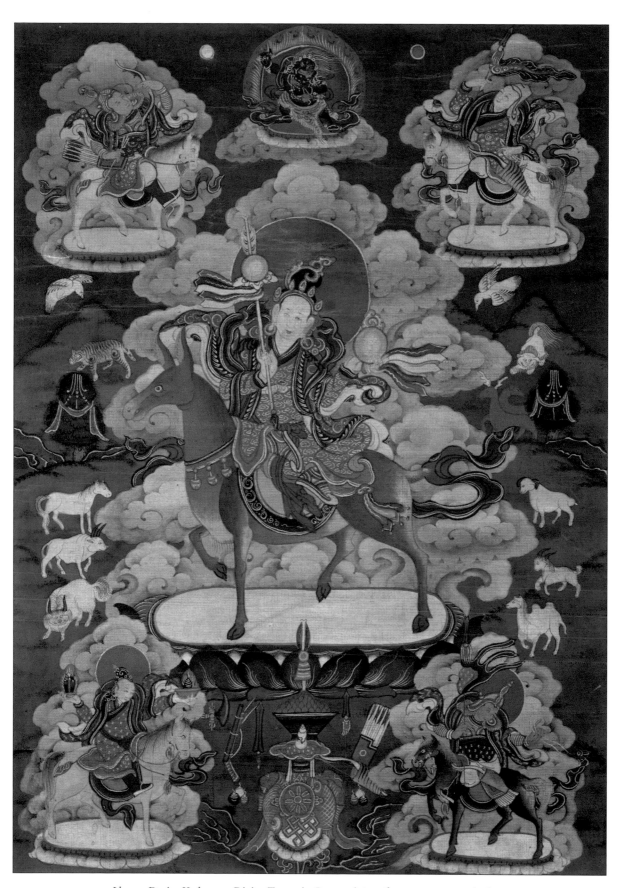

Lhamo Dorjey Yudonma, Divine Turquoise Lamp, ninteenth century, 14 x 10 inches.

Lhamo Tashi Tseringma

In an earlier tangka in this chapter we encountered Palden Lhamo in her form as Magzorma, with the Five Healing Sisters in a row at the bottom of the painting. There they appeared as secondary figures in a larger painting dedicated to Magzorma, and also as outlines in gold against a dark black background, with only a hint of color. The gold-on-black type of tangka is generally reserved for wrathful deities, a category to which Magzorma clearly belongs.

The Five Healing Sisters, however, are peaceful dharmapalas. For that reason they usually do not appear on *naktang*, or "black tangkas," but in radiant color, and with the beauty and splendor of their youth in full display.

Here we have the five in the latter style. Lhamo Tseringma is the chief of the five, so is depicted at the center of our painting, with the other four in the four corners. She is white and holds a golden vajra in her right hand and a golden vase filled with healing nectars in her left. Youthful in appearance, she is adorned with gold ornaments and beautiful garments and rides a white snow lion.

The remaining four healing sisters are depicted in the four corners: Tinggyi Zhalzangma in the upper left, riding n a wild ass; Miyo Lozangma in the upper right, riding a young tiger; Tekar Drozangma at the bottom left, riding a blue dragon; and Chopan Drinzangma in the bottom right, riding a deer. The direction guardian Vaisravana sits in the bottom center of the painting, holding a victory banner in his right hand and a mongoose of wealth in his left.

Earlier we mentioned the connection between these Five Healing Sisters and five great mountains in the Mt. Everest region on the Tibet-Nepal border. According to legend, Padma Sambhava first entered Tibet via the Everest route. After crossing the high pass on the eastern slope of Everest he came down along the northern ridge and discovered a magnificent cave. He stopped here in meditation for some days, and since that time his cave has remained an important landmark for pilgrims to Everest. There was no readily accessible drinking water near his cave, so Padma Sambhava kicked the side of the mountain and a spring instantly appeared. All pilgrims to Everest's northern slope still drink from this spring for blessings. Eventually the Five Healing Sisters, mischievous by nature, began appearing to him in order to distract him from his meditations. He instantly manifested in wrathful form, made them pledge to protect and serve the Dharma forever, and thus transformed them into Buddhist dharmapalas.

Four hundred years later Milarepa took up meditation in the region. The five noticed him and decided to test his resolve. To this end they manifested as various kinds of apparitions and attempted to distract him. However, no matter how hard they tried they could not succeed. Humbled, they manifested in their ordinary forms and requested his blessings. Later they returned again and requested his teachings on the inner-heat yoga, which he gave to them. They also returned a third time, to request the teachings on karmamudra and the sexual yoga techniques.

Because Milarepa is an important forefather of all twelve Kargyu sects, these three encounters of his with the Five Healing Sisters ensured them a special place in Kargyu history and practice. The devotional connection with them eventually spread to all schools of Tibetan Buddhism.

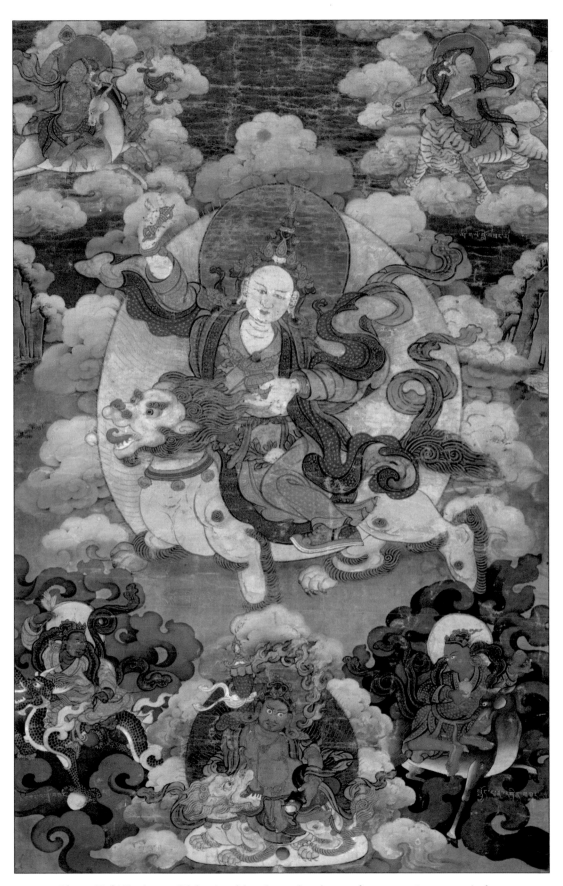

Lhamo Tashi Tseringma, Divine Auspicious Longevity, nineteenth century, 18.50 x 11.50 inches.

CHAPTER 7

Mantra & Mandala

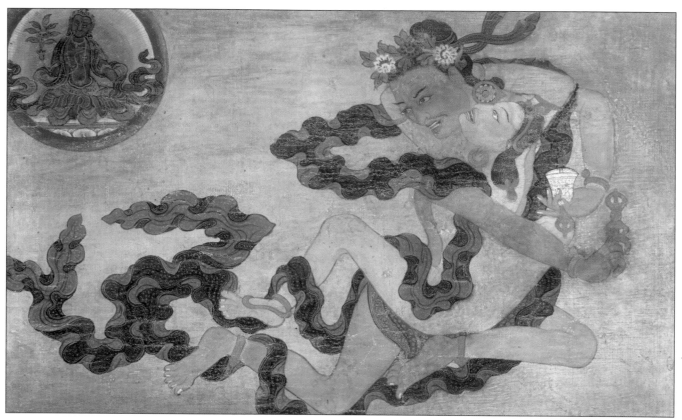

Detail from tangka on page 211.

As we pointed out in chapter 9, "Three Jewels, Three Roots & Three Types of Female Buddhas," the mystical arts of Tibet glorify three types of females: the lineage masters of the past and present; the Yidams, or mandala meditation deities; and the Dharmapalas, or "Protectors of Truth." The first of these three "Roots" is considered most important in the sense that without it there would be no lineages of transmission of the second and third Roots. The second is most important in the sense that it is the actual essence of the Tantric practice, and therefore is the ultimate refuge. The third is most important in the sense that it provides the supportive environment within which one can access the first two.

Men might be credited with a superior position in the Sutra Way, whereas women have an advantage in the Tantra Way. Nowhere is this reflected more strongly than in the early days of Tantric Buddhism in India. Many of the Tantric systems, such as the *Vajrabhairava Tantra*, were taught by the Buddha at the specific request of females. Moreover, many of the lineages of the classical period—the eighth to twelfth centuries A.D.—were based on visions of female yidams and dakinis. For example, in a previous chapter, "The Vajra Dakinis," we encountered Virupa's visions of Nairatmya. Similarly, in that same chapter our tangka of Vajrayogini in the form of "Naropa's Space Lady" is based on a female vision; and the mandala of Vajravarahi in the chapter

"Female Buddhas in their Mandalas" is a Karma Kargyu transmission based on a vision of Vajravarahi experienced by the Indian master Ghantapada and later transformed by a similar vision of Tilopa.

Finally, many of the lineages of transmission that came to Tibet are rooted in the visions and teachings of great Indian women. We highlight a number of these here. The first of these is Bhikshuni Lakshmi, who lived somewhere between the eighth and eleventh centuries A.D. Her lineage of the annual sixteen-day-fasting practice became something of a national event from the time of the Seventh Dalai Lama onward. Then there is the famous eleventh century yogini Niguna, whose "Six Yogas" are maintained in all schools of Tibetan Buddhism in some form or other. We have also included three tangkas that depict great Indian mahasiddhas with their female disciples, all of whom are popular figures in Tibetan art and literature.

As for female mystics from Tibet, here we have limited ourselves to the two most famous of these—the eighth century Yeshey Tsogyal, often said to be the first Tibetan woman to achieve enlightenment in one lifetime, and the twelfth century yogini Machik Labdon, whom we encounterd in the chapter "The Vajra Dakinis," where she was presented as the White Yogini. For space reasons, we have to limit ourselves to this handful of lineage masters.

Western knowledge of Tibetan art, culture, and history is still at something of a pioneering stage. Very little was known until after the Chinese Communist invasion of the 1950s caused the Tibetan diaspora and scattered tens of thousands of Tibetan refugees around the world. Since then, however, we have made up for lost time. There are now over a thousand Tibetan Buddhist meditation centers in the United States alone, and at least as many in Europe. Several universities now offer doctorate programs in Tibetan studies, and numerous Tibet-related subjects are offered on the undergraduate level by most major schools. In short, our knowledge of all things Tibetan has grown by leaps and bounds over the last generation.

It would be fun sometime down the road to do something more thorough on the great females of Tibet. Thousands of them are mentioned in Tibetan literature. The Sakya School, for example, has several dozen women who became female counterparts of the Sakya Trizin. These exceptional ladies carried the title "Sakya Jetsunma," with the term Jetsunma being the equivalent of the male Jetsun, which generally is applied only to highly accomplished mystics. The Sakya Jetsunmas were spiritually trained from childhood in all aspects of the Buddhist tradition as held by the Sakya School. The modern-day Jetsunma Kushok Chimey Luding, sister of the present Sakya Trizin lama, is an example and holds all the lineages of transmission held by Sakya Trizin himself. Unfortunately no in-depth study has yet been made of this unique legacy.

Similarly, the Nyingma School has produced a large number of female mystics generally known by the name Jetsunma Khadrola, or "Highly Accomplished Dakini." Dakini here simply means female Tantric adept or saint. There are presently three yoginis of this nature living in the refugee communities of India and Nepal. No doubt there are also many of them behind the Bamboo Curtain in Chinese-occupied Tibet. The Kargyu and Geluk lineages of Zhichey Chod (from Machik Labdon) also produced numerous accomplished yoginis of this nature. For example, a famous Jetsunma Khadrola of the Gelukpa School passed away in Tibet just a few years ago in her mid-eighties. (This one was also a little bit infamous for her mischievous nature, because during her lifetime she seduced and defrocked thirteen different reincarnate monk-lamas.) Again, no in-depth study has been made of this class of extraordinary women.

Tibet also sustained a number of female tulku lineages. The Gelukpa reincarnate Jetsunma Dorjey Pakmo Tulku was perhaps the most famous of these and was ranked as one of the four highest lamas in the country, the other three being the Dalai Lama, the Panchen Lama, and the Sakya Trizin. Many of the larger nunneries had a tulku, as did many of the lay hermitages.

For example, the mother of the Second Dalai Lama was just such a reincarnate. In his autobiography (written in roughly 1528) he states: "When my father in his forty-fifth year he married my mother, Kunga Palmo by name. She was a recognized reincarnate who in an earlier life had been a female disciple of the great Gyalwa Gotsang, when she was the famous yogini Khadroma Drowai Zangmo." He continues, "From childhood my mother could remember many of her previous incarnations. Then as a young woman she became profoundly accomplished in the three principal Highest Yoga Tantra systems: Guhyasamaja, Vajrabhairava, and Heruka Chakrasamvara. She was also adept in the Kalachakra Tantra system, as well as the Medicine Buddha mandala practice....I had the great honor of entering this world through the womb of this highly accomplished being."

Once again, no in-depth western study of the female reincarnates of Tibet has been made.

Bhikshuni Lakshmi

Most of the great female mystics of Tantric Buddhism were lay yoginis and not celibate monastics. Bhikshuni Lakshmi stands out in contrast. "Bhikshuni" is the formal title of a fully ordained Buddhist nun. Of interest, the lineage of bhikshuni died out in Tibet after the civil wars of the tenth century and were never restored. All Tibetan nuns from that time onward were *shramanera*, or "novice nuns." The only difference in the two levels of ordination is that the former has more secondary precepts and can only be taken by an adult. The latter can be taken younger in life. Both have the same four basic vows: to abstain from killing; to abstain from stealing; to abstain from drinking alcohol; and to abstain from sexual intercourse.

Bhikshuni Lakshmi, detail from tangka at right.

According to the Tibetan biographies, Bhikshuni Lakshmi was born into a royal family in tenth-century India. She requested monastic ordination when still in her youth, and her parents gave their blessings. Thus from an early age she was able to enter into study of the Sutra and Tantra traditions.

When she was in her early twenties she came down with leprosy and decided to leave communal living in order to prevent others from contracting her disease. She built a meditation hut in a nearby forest for her meditations for her new life. One night she dreamed of the great mahasiddha Indrabhuti, who advised her to take up the practice of Avalokiteshvara in connection with fasting. Consequently she moved her residence to a nearby power site associated with Avalokiteshvara and began the practice. Within a year she had healed herself of the leprosy, and some five years later achieved enlightenment.

She dedicated the remainder of her life to teaching and performing other enlightenment activities.

Stories of her magical deeds abound. For example, one day she walked to the center of a town and began performing a wrathful Vajrayogini dance in order to transform the minds of those to be trained. During the dance she pulled out a dakini knife and cut off her own head, and continued to dance headless. At the conclusion of the dance she picked up her head, placed it back on her body, and calmly walked away.

The lineage of Avalokiteshvara meditation and fasting descending from her is practiced in all schools of Tibetan Buddhism. It is especially popular with Tibetan laypeople, many of whom undertake it for the first sixteen days of the holy Fourth Month, known in Tibetan as *Saka Dawa*. The fasting retreat is undertaken in *cha*, or "pairs." Each set is comprised of two days. During the first day the practitioner abstains from all food and drink, not even swallowing his or her own mouth waters. This is done in conjunction with mantra recitation, meditation, and many full length prostrations. During the second day a midday meal is allowed, and the person also restocks the body with fluids. The practitioner decides on how many of these "pairs" to undertake, the full Saka Dawa retreat being made up of eight pairs, or sixteen days. Some Tibetans also undertake the practice on a monthly basis, doing one "pair" each month during the full moon period.

Our tangka depicts Avalokiteshvara in the form used in the fasting practice. It is a *Tsok-zhing*, or "Field of Accumulation" painting, in which the principal masters in the lineage of transmission are portrayed. Bhikshuni Lakshmi can be seen at the top of the cluster of masters in the upper right corner, for the oral transmission lineage descends from her. The cluster in the top left corner has Avalokiteshvara in simplified form at the top, representing the earlier Tantric tradition from which Bhikshuni Lakshmi received the Avalokiteshvara Tantra that inspired her visions upon which her oral transmissions are based. The bodhisattvas Manjushri and Vajrapani stand below Avalokiteshvara respectively to his right and left. As we saw before, these constitute the trio that symbolizes the three essential qualities of enlightenment: compassion, wisdom and spiritual power. The implication is that the practice of the fasting yogas descending from Bhikshuni Lakshmi induces enlightenment characterized by these three virtues.

Tibetans say that while Bhikshuni Laksmi's outer appearance was that of a Buddhist nun, her inner nature was Arya Tara, and her secret essence was Vajravarahi.

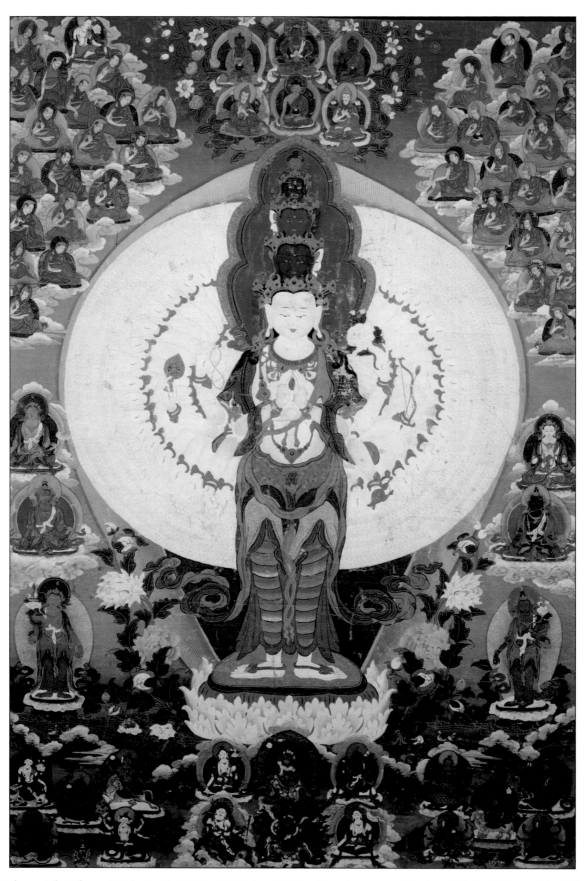

Avalokiteshvara; Tib., *Chenrezig; The Gently Gazing Bodhisattva.* Eighteenth century, 53.5 x 36 inches. This is the form of Avalokiteshvara used in the fasting practice from Bhikshuni Lakshmi. She sits at the top of the cluster of lineage masters in the upper right corner.

Niguma

The eleventh century Indian mahasiddha Naropa had a dramatic impact upon Tibetan Buddhism because of the various ways in which his lineages made their way to the Land of Snows. We saw earlier how Marpa Lotsawa used Naropa's lineages as the basis of his newly founded Kargyu School, and also how Naropa's Vajrayogini teachings found their way into the Sakya School via the Pamtingpa brothers of Nepal. Other of Naropa's transmissions, such as his lineages of the Kalachakra, entered Tibet through other avenues.

One of Naropa's greatest disciples, however, an Indian woman who is known to Tibetans as Niguma, "The Sister," studied with Naropa, practiced intensely in the jungles of north India under his guidance, and eventually achieved enlightenment. Tibetans know her best through a special transmission of the Six Tantric Yogas from one of her Tibetan disciples, the yogi Khyungpo Naljor. Originally a small school known as the Shangpa Kargyu, emerged from this movement, although it became absorbed by the other schools within a few generations and disappeared as a separate entity.

Niguma as a dancing Vajrayogini,
detail from tangka on opposite page.

The lineages from Niguma, however, have remained popular throughout the centuries. The Second Dalai Lama wrote two commentaries to them, combining the transmissions that he received from his father, who was the head of a branch of the Shangpa Kargyu, with the oral explanations coming down through the Gelukpa School.

In his commentary the Second tells of how Kyungpo Naljor traveled to India in search of enlightenment, and how merely on hearing the name Niguma he knew she would be his guru. He asked how to find her and was told, "If one's mind is pure one can meet her anywhere, whereas if one's mind is impure she cannot be seen, for she dwells on the pure stages and has achieved the rainbow body. However, often she appears at the gathering of dakinis in the great charnel ground to celebrate the Tantric feast."

Consequently Khyungpo Naljor went to the charnel ground and waited for her. Then suddenly she appeared, dressed only in bone ornaments, and began to dance wildly in all directions. He prostrated, requested to be received as a disciple, and offered her 500 measures of gold dust. She accepted the offering, but continued dancing, scattering the gold dust in the forest as she moved. Eventually she gave him the initiations and instructions of the Six Yogas and guided him in the practice until he achieved realization.

Once when asked for the essence of her teachings she replied

All things in worldly existence
That are colored by attachment and
 aversion
Are in reality devoid of any real existence.
When this is seen, everything is seen as
 golden.
When we meditate upon the illusion-like
 nature
Of all the illusion-like phenomena,
We attain illusion-like enlightenment.

Our tangka depicts all the principal Tantric deities that were central to the Shangpa Kargyu School, as transmitted from Niguma to Khyungpo Naljor. These include the five great Shanpa mandala deities: Heruka Chakrasamvara at the center, in sexual union with Vajravarahi; Hevajra in sexual union with Nairatmya in the upper left corner; Mahamaya in sexual union with Vajra Dakini in the top right; Guhyasamaja in union with Sparshavajri at the bottom left; and Vajrabhairava in sexual union with Vajra Vetali at the bottom right. Red and white yoginis are seen in the upper sides, the former being Vajrayogini as embodied in Niguma and the latter Sitayogini as embodied in Sukkhasiddhi. The principal Shangpa Kargyu dharmapalas can be seen along the bottom.

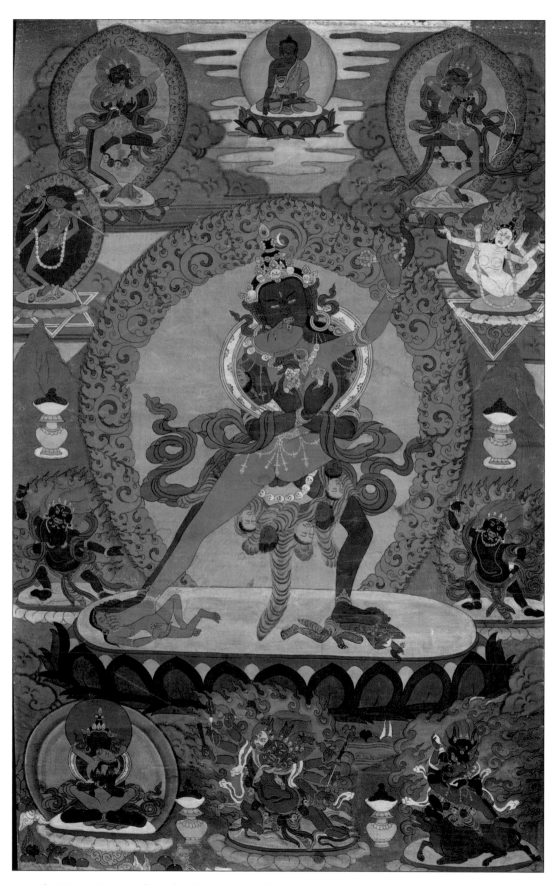

The Niguma Lineage of Heruka Chakrasamvara (See page 166.), nineteenth century, 22.25 x 14 inches.

Saraha & His Female Guru

The Indian mahasiddha is perhaps the most important figure in the history of Tantric Buddhism. In fact, the Tibetan historian Taranatha puts him forth as the original compiler of the Highest Yoga Tantras.

What is less well known is that his principal guru was a woman. In our painting she is represented by the arrow that he holds in his hands. His very name, "Saraha," is taken from the caste to which she belonged: Arrowsmith.

According to the story, Saraha was originally given the name Rahula. He studied Hinduism as a young man, but then became a Buddhist monk. One day some young women convinced him to drink with them. His drunkenness threw him into a visionary state of ecstasy, and in his vision he was instructed to seek out a particular female arrow-maker and ask her for her teachings. He went to the market-place, where he saw her sitting engaged in her craft. He instantly knew that she was his guru and asked to be her disciple. The two lived, traveled and practiced together from that time onward, and under her guidance he achieved enlightenment. Sometimes in Tibetan art she is depicted as an arrow in Saraha's hands and sometimes as a bare-breasted yogini in the space above his head, with the arrow in her hands.

The man and woman to either side of Saraha are probably two of his close disciples, for whom he wrote two of his most important *doha*, or verses of mystical instruction, known as the *Royal Songs of Sahara*. These are still used today as the basis of the mahamudra tradition of Tantric Buddhism. In one of them Saraha states,

> *One can light many lamps in a house,*
> *But a blind person will remain in darkness;*
> *Similarly, the innate nature of reality is*
> * everywhere around us,*
> *Right under our noses, but foolish people*
> * still remain blind.*

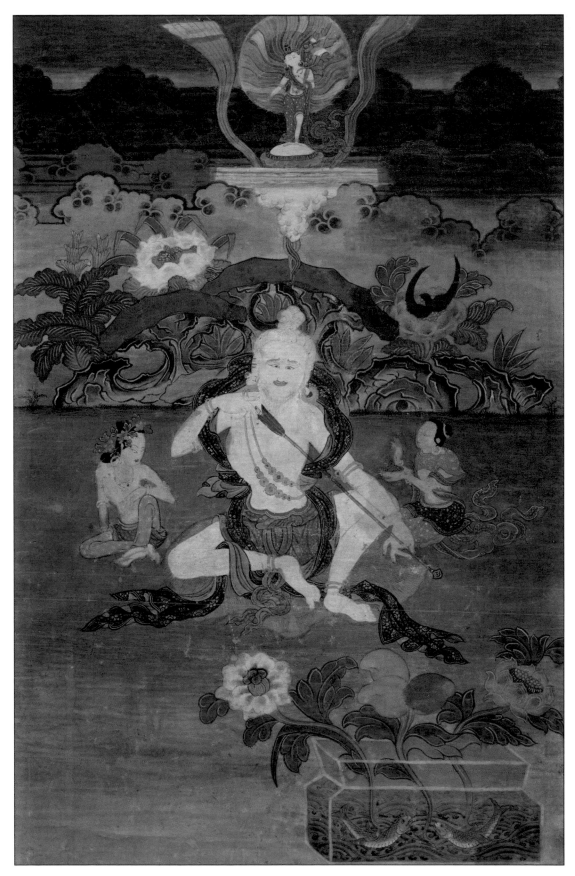

Saraha & His Female Guru, nineteenth century, 18 x 12 inches.

Ghantapada & Consort

We encountered the Indian mahasiddha Ghantapada on several occasions in earlier chapters, for he is an important figure in the Heruka Chakrasamvara transmission known as "Ghantapada's Five Deity Mandala," as well as in the Vajravarahi mandala derived from it, "The Five Deity Vajravarahi Transmission."

Ghantapada studied with numerous masters, but the most important of them all was the female mystic Chinta Yogini, a low-caste woman who earned her living by herding pigs. It was through the instructions and guidance that he received from her that he achieved his enlightenment.

Our painting tells the story of a famous legend associated with Ghantapada's life. After establishing him in practice, Chinta Yogini sent him into retreat. Ghantapada lived in a forest for many years and eventually was joined in his meditation hut by the daughter of a local prostitute. The two became infamous for heavy drinking and wild love-making.

The local king, who sponsored many celibate meditators in their retreats, took offense at Ghantapada's behavior, and felt he had been deceived. He went to the forest with the intent to punish him. When the king arrived and began reciting his list of charges, Ghantapada and his lady sat in sexual union in his presence, and levitated into the sky. The king became filled with anger, causing Ghantapada's flask of alcohol to overturn. So much alcohol spilled out that the kingdom was flooded. The king and his minister can be seen standing in the floodwaters as houses float by. The white figure is Avalokiteshvara, the Bodhisattva of Compassion, who manifested and turned back the flood alcohol/waters.

Ghantapada's very name is adopted from his consort. In the above story, she turns into a tantric bell, a symbol of female energy and the wisdom of infinity/emptiness. The word "Ghanta" literally means "bell."

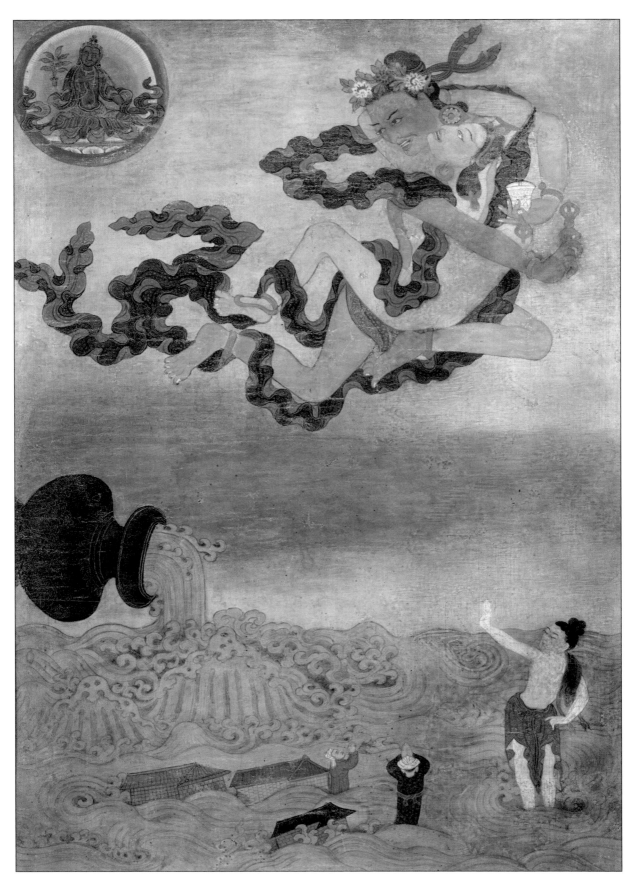

Ghantapada & Consort, nineteenth century, 21 x 15.25 inches.

Dombi Heruka & Consort

The Indian mahasiddha Dombi Heruka is listed in Tibetan literature as one of the two principal disciples of Virupa, whom we encountered several times in earlier chapters as the source of the principal Sakyapa lineages. Virupa's encounters with and visionary experiences of the female buddha Nairatmya are depicted in a tangka in chapter 17, "The Vajra Dakinis." Virupa's other main disciple was Krishnacharya, whom we mentioned as the source of one of the three principal lineages of Heruka Chakrasamvara in Tibet.

Virupa placed both Dombi Heruka and Krishnacharya in forest retreats with female consorts, and both achieved enlightenment. Both of them also became important writers on the sexual practices of Tantric Buddhism.

Dombi Heruka, however, is less important as a lineage master than his spiritual brother Krishnacharya, but is more important as a subject of Tibetan mystical art. He and his yogini partner tamed a wild tiger and often rode around naked on it when they went collecting alms.

In our painting the couple is shown on their tiger. He holds a poisonous snake in his right hand, to indicate his power over the natural world. She holds up a skull cup filled with blissful nectars, in fact probably alcohol. Their eyes are interlocked in an amorous glance as they ride without concern through an idyllic forest setting of mating birds in the foreground and waterfowl sporting in the lake behind them.

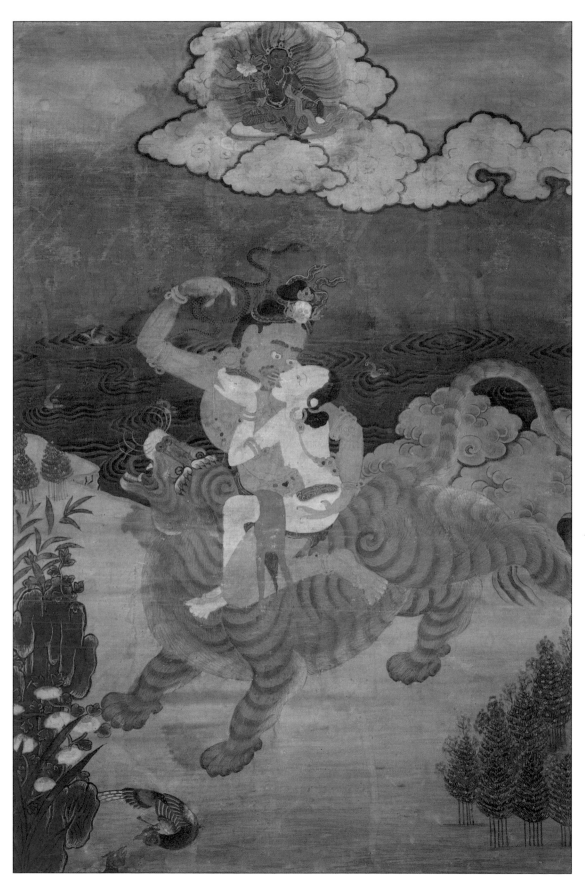

Dombi Heruka & Consort, nineteenth century, 18 x 12 inches.

Yeshey Tsogyal

The eighth-century female mystic Yeshey Tsogyal is perhaps the most famous woman in Tibetan history. It would seem that she is as relevant in modern times as she was thirteen hundred years ago, because an Internet search on her name (spelled Yeshe Tsogyal) produces several thousand hits.

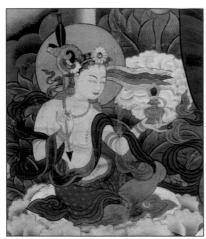

Yeshey Tsogyal, detail from tangka on opposite page.

Yeshey Tsogyal was the principal disciple of the great Indian master Padma Sambhava, who was brought to Tibet by King Trisong Deutsen in order to teach Tantric Buddhism and also to help establish Tibet's first official monastery. We saw him on several earlier tangkas, for he is often placed at the top center of paintings belonging to the Nyingma School, being regarded as their most important forefather.

However, the success that Padma Sambhava achieved in Tibet can largely be attributed to Yeshey Tsogyal, for after he left the Land of Snows his work was carried on by her. Not only did she write his biography, thus immortalizing him in the Tibetan mind, she was instrumental in many of the translation and building projects that his visit had inspired. She also wrote down many of his esoteric teachings for which the Tibetans were not yet prepared, and hid them in secret places, where they would be found by future generations when the times were ripe. Others she buried in the mindstreams of her disciples, who would remember them in future lives.

When Padma Sambhava first arrived in Tibet, Yeshey Tsogyal was in fact one of the wives of King Trisong Deutsen. According to legend, her beauty was so great that numerous petty kings and chieftains had threatened to go to war over her hand in marriage. King Trisong Deutsen saw no peaceful solution, other than to remover her from the playing field altogether by announcing that she would marry him, knowing that none would dare challenge his authority.

Padma Sambhava and Yeshey Tsogyal instantly fell in love with one another when he arrived in Tibet, and the king consented to her leaving his palace to accompany him on his teaching travels. The two remained together throughout his stay in Tibet. When he left he recommended that she go to Nepal and buy a white male slave, with whom she had karmic connections from many past lives, to assist her in her Tantric sexual practices. Yeshey Tsogyal did this, and achieved enlightenment in retreat with him.

Yeshey Tsogyal is a principal source of devotional practice with the lamas of the Nyingma School, which believes that she achieved the immortality of the vajra body and that she continues to come in visions to those of pure aspiration. She is also a favorite subject in Tibetan art.

Our tangka depicts Padma Sambhava in the center, with Yeshey Tsogyal below him and to his right. The figure below him and to his left is the yogini Mandarava, his principal female disciple in India. Although Yeshey Tsogyal is more important to Tibetan Buddhism from the point of view of the many lineages of transmission that descend from her, Mandarava is almost as important a figure in Tibetan art and literature. These two yoginis are sometimes called "Padma Sambhava's two wives," and sometimes his "two consorts." In fact both were important female disciples who achieved enlightenment under his guidance. He certainly practiced Tantric sex with both of them, but the relationship was primarily guru-disciple.

He had met Mandarava while teaching in Zahor, a Himalayan kingdom in present-day Himachal Pradesh, India. She was a nun when he arrived, but he soon seduced her and brought an end to her celibate life. He met Yeshey Tsogyal many years later, when he came to Tibet. He remained in mystical contact with both of them long after he rode off into the sunset to teach in other lands, appearing in their dreams and meditational visions to teach, guide and inspire them.

The primordial buddha Samantabhadra sits at the top center, with Buddha Amitabha to the left and Padmapani Avalokiteshvara to the right. At the bottom left is the Indian monk Shantirakshita, who had pressed King Trisong Deutsen to invite Padma Sambhava to Tibet. King Trisong Deutsen sits in the lower right corner, his hands in the mudra of teaching Dharma, the stems of two lotus blossoms held in his fingers. These lotuses support a wisdom sword and *Prajna Paramita Sutra* scripture, indicating that he is regarded as an emanation of Manjushri, the Bodhisattva of Wisdom.

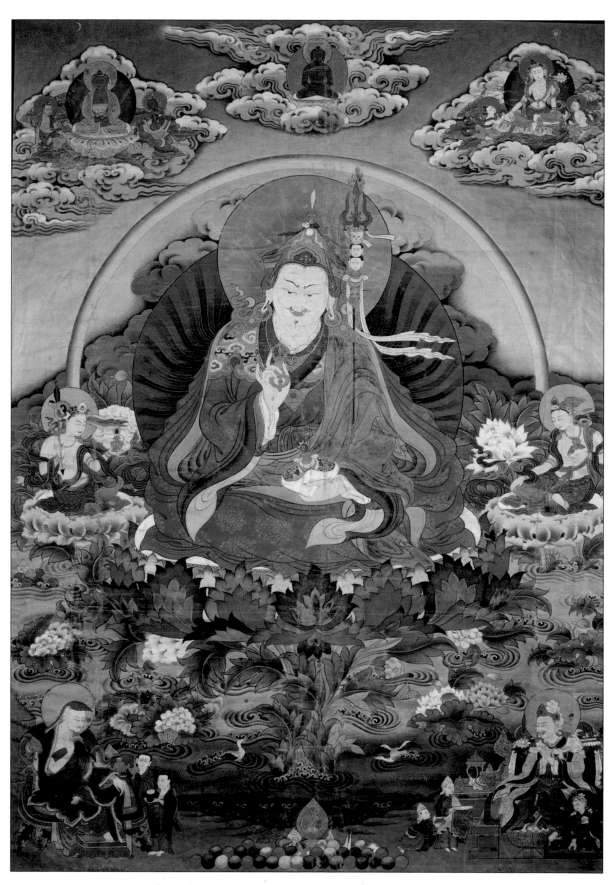

Padma Sambhava, with his chief Tibetan female disciple Yeshey Tsogyal seated below to his right and his chief Indian female disciple below to his left. Nineteenth century, 27.5 x 19.13 inches.

Machik Labdon

The famed Tibetan female mystic Machik Labdon (1055–1153), whose name means "The Solitary Mother, Lamp of Lab," here appears in the form of the White Yogini, naked and dancing on one leg, playing a *chomdar* hand drum in one hand and a bell in the other. Lab is an ancient kingdom in the southwest region of Tibet, not far from the Everest region.

The tangka is in a category known in Tibetan as *Tsok-zhing*, meaning "Field of Accumulation." It is a "field" which, when meditated upon as an object of devotion, produces the "accumulation" of both merit and wisdom. Paintings of this nature generally show the lineage masters and Tantric deities that are central to a particular school or sect.

Here the school is the *Zhichey Chod*, or "Pacifying and Cutting." The lineages descending from Machik come down in these two streams. One could count both lineages as individual schools, although most people holding the one lineage also hold the other. In later Tibetan literature the "Zhichey" part of the name is dropped, leaving "The Chod School."

Technically Machik Labdon and the school of Tibetan Buddhism descending from her appeared in the Sarma, or New School, period. However, her lineage uses much of the technical terminology of the Nyingma, or Old Schools. As a consequence, the Zhichey Chod does not fit neatly into either category.

Machik's lineage existed as a school of its own for several centuries but was eventually absorbed into the bigger sects. Today all four mainstream schools of Tibetan Buddhism, as well as Bon, have their own lineages of Zhichey Chod from Machik Labdon.

Machik is usually depicted in the form of the White Yogini, because she propagated the practice of meditation on this dakini so widely that she came to be identified with it. The *chomdar* drum in her hand is a type of *damaru*, although much larger than the ordinary variety carried by the mainstream Indian mandala deities. This drum is used in the *Chod* practice, in which one visualizes cutting one's body into pieces and offering it to the hungry ghosts and other entities as a form of meditation on the void nature of the body. During the meditation the drum is played slowly, while the practitioner sings melodic verses from the visions of Machik or the later Zhichey Chod lineage masters. The music from this tradition is among the most hauntingly beautiful of anything ever written in Tibetan history. Most masters of the *ja-tor* ("gift to the birds") tradition in Tibet, in which the body of a deceased person is ritually cut into small pieces and fed to the vultures, were Chod practitioners. They would sing the melodic Chod songs as part of the ritual.

Machik's two sons are seated beside her: Tonyon Samdrup is on her left, while Gyalwa Dondup is on her right. The former is dressed in monastic robes, while the latter has the long dark hair, white robes and red meditation belt of a lay yogi. Both were instrumental in preserving and transmitting her lineages. The great female mystic Dorjey Donma, a blood descendent of Gyalwa Dondup and a reincarnation of Machik herself, is seated below him. This mystic is of particular interest, because the principal female reincarnation lineage is sourced in her.

Above at the top center are five figures of Vajrasattva and consort, each in a different color to represent the five buddha families. They are surrounded by the eight principal bodhisattvas. Prajna Paramita, the female buddha known as "The Great Mother," gold in color, is seated below them. Below her are the buddhas of the three times, surrounded by shravakas and pratyekabuddhas. The buddha Shakyamuni is in the center, with the buddha of the previous age (Kashyapa) on the left and the future buddha (Maitreya) on the right. This symbolizes how the teachings of Machik and the White Yogini embody the essence of all buddhas past, present and future, and are the heart of the wisdom legacy symbolized by Prajna Paramita.

On a bank of clouds at the left side of the painting (White Yogini's right) are the main gurus and lineage teachers of the Zhichey Chod lineage. The Indian master Padampa Sangyey sits at the center, his body brown in color, holding a damaru and a trumpet made from human bone. This illustrious being, who was Machik's principal spiritual teacher, is said to have lived for 978 years by means of "living on the essence of flower pills." Various other masters are depicted around him, some from India, including Tilopa and Naropa, and others from Tibet, including Padma Sambhava and the Eighth Karmapa. Many of these are not in the mainstream Zhichey Chod lineage of transmission, but rather are important in the particular lineage that had been held by whoever originally commissioned the painting. The presence of the Eighth Karmapa suggests that the patron of the tangka was a Karma Kargyupa.

On the cloud bank at the right side (Yogini's left) is a group of mandala deities. The composition of these reinforces the theory that the painting was originally created for a Karma Kargyupa. Here red Vajravarahi is the centerpiece, which is a standard in all twelve Kargyu Schools. Above her is Simhamukha, the wrathful activity dakini, whom we saw

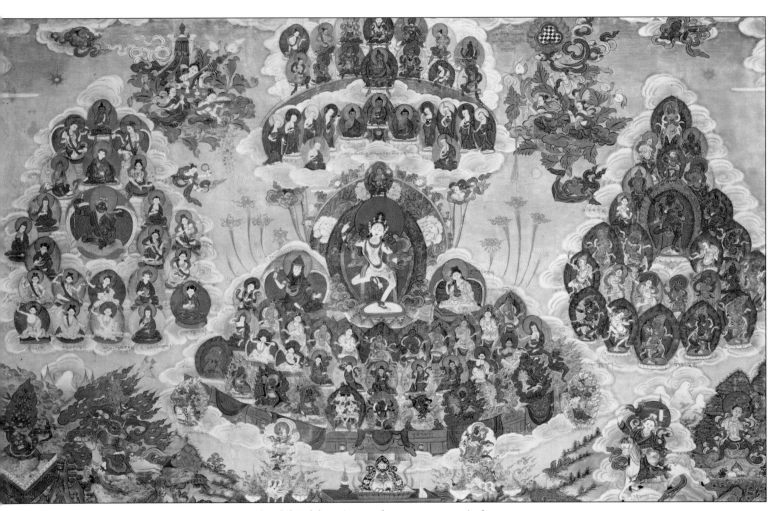

Machik Labdon, nineteenth century, 25 x 15 inches.

in chapter 15, "Female Buddhas with an Agenda." At the top of the cluster is Sahaja Chakrasamvara, also popular in the Karma Kargyu.

Below the central White Yogini is a horizontal row of ten dakinis, and below that a row of eleven lineage gurus. The bottom row is comprised of the Dharma Protectors of the Zhichey Chod tradition.

The Second Dalai Lama's grandmother, and also his father, were major lineage holders of the Machik transmissions during the fifteenth century. His grandmother spent forty-four years of her life in a bricked-in retreat, dedicating her days and nights to intense practice of the tradition. The Second Dalai Lama wrote numerous texts elucidating the meditation techniques that he had received from them. The high level of popularity that he achieved throughout the length and breadth of Central Asia, and the emphasis that he placed on the lineages from Machik Labdon in his own life and teachings. This stimulated a renewed interest in Machik Labdon and her mystical legacy and contributed significantly to the survival of her lineages to the present day.

Machik Labdon, detail from tangka on previous page.

Part Three

EPILOGUE

A Dakini Song from the Seventh Dalai Lama

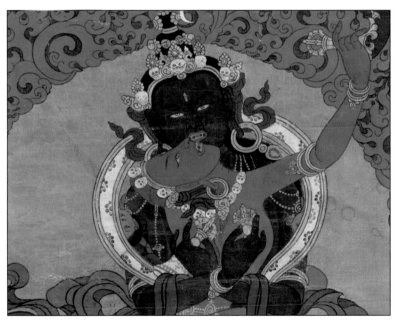

Detail of tangka on page 207.

This dakini song by the great Seventh Dalai Lama (1708–1757)
summarizes the wisdom embodied by the female buddhas and beautifully presents
the quintessential points of the Buddhist path to enlightenment as transmitted from the
dakinis and embodied in the Ghantapada Lineage of the Heruka Chakravamsara Tantric
tradition. This text summarizes all the teachings of the Highest Yoga Tantras and is
the very heart essence of the dakinis.

This song was originally translated by Glenn H. Mullin with Lobsang Norbu Tsonawa in
The Seventh Dalai Lama, Songs of Spiritual Change (Snow Lion Publications, Ithaca, N.Y., 1980) and
republished as *Meditations to Transform the Mind* (Snow Lion Publications, Ithaca, N.Y., 1999).

Homage to the feet of my all-kind spiritual masters,
Who are in nature inseparably one
With Heruka Chakrasamvara, Male/Female
 in sexual union,
The wheel composed of all objects of knowledge,
Whose essence is great bliss clear as the autumn sky.

Fortunate are they who meet with the doctrine
Of the all-beneficial wisdom tradition,
That shows as precepts all sutras and tantras.
Fortunate indeed; an opportunity obtained but once.

Yet breath, like mist, is delicate;
And life, seemingly strong, is ever near to passing.
Quickly pluck the essence of Dharma,
For definite it is you will die at the hands
 of the great enemy Death.

Have not the three doors stood open to negativity?
Then the inconceivable misery of the lower realms
Certainly will fall upon you;
And, if still weak, you will not be able to bear them.

Some look, and see; in the innermost way
 they turn
To a guru-deva, an embodiment of Buddha,
Dharma and Sangha.
With attentive concentration they focus
On cultivating the white and dispersing the black.

Reveling in objects of greed and attachment
Is drinking poison mistaken for nectar.
The luxuries, securities and comforts of the world
Are like dramas enjoyed in a dream.

No lasting happiness can be found
In any samsaric position,
And how foolish to sit complacent
In a hole filled with misery.

Turn the horse of the mind upward,
Rein him with the three higher trainings,
Strike him with the iron whip of fierce effort,
And cut unto the open road of liberation.

All beings, mothers who lovingly have nurtured us,
Are floundering in the seas of confusion.
The child who cares not for their anguish,
Are the waters of their hearts not bitter?

Wholly discarding selfish thoughts,
Hold close the ways which better the world
And strive to live the six perfections,
That yield buddhahood, ultimate benefit for all.

Sever the mind from chaotic wandering;
Fix it firmly on its object with mindfulness,
Without falling prey to agitation or dullness:
Train in meditation blissful and clear.

The manifold things we perceive
Are deceptive projections of deluded thought.
When we search for their ultimate essence,
Emptiness free of an essence appears.

The things that manifest also fade
And only footprints of names remain;
The other side of this is called dependent arising.
What else need be known?

Having first trained in these foundations practices,
Seek out a tantric master, embodiment
 of Buddha Vajradhara,
Lord of the Paradise Beneath None;
Gain the four ripening initiations
And enter into the mystic circle.

The body transforms into a great vajra-mandala,
And, in the inconceivable mansion of joyful repose,
The real deity—the subtle mind held between the
Kiss of the male and female drops—
Manifests as the blood-drinking Male/Female
 in Union.

The dakas and dakinis dance a blissful dance
In the mystic channels and secret drops;
Mundane perception is severed from consciousness
And all emanations become ultimately pure.

Visualize yourself as Heruka with consort,
Luminous yet void, body empty,
Energy channels of three qualities vibrating within;
At your heart a Dharma wheel with eight petals

Bears the indestructible drop in the form of HUM
Between the sun of method and the moon of wisdom.
Mind firm on this, tremulous misconceptions are cut,
And the clear light, sheer as the autumn sky, arises.

The outer consort, in nature fire,
Melts the life-drops that course
Through the 72,000 channels,
Bringing them into the central channel,
Giving rise to the four ineffable joys.

Outside, all sensory movement of mind
 and energy ceases;
Inside, mundane views, ignorance
 and darkness disperse.
Thus by yoga even sleep is transformed
Into the nature of dharmakaya's clear light.

By cultivating these yogic methods,
We can in general see through
 all distorted appearances
And in particular know the body as dream-like,
Thus building the dancing form of an endowed deity
And maintaining the according emanations.

By mentally reciting the secret mantras
 of the vajra dharmas
Of entering, resting and dispersing energy
 at the heart
While controlling the life-drop made
 of five clear essences,
The knots of ignorance are easily untied.

The tip of the vajra is placed firmly in the lotus
And mind as the syllable HUM is brought
 into the central channel;
One drinks and drinks the essence of nectars
And goes mad with innate joy unmoving.

By thus settling the mind in the subtle vajra letter
And bringing the drop to the four chakras
 and sensory gates,
One directly sees all aesthetic objects
Found throughout the three worlds.

Thus one opens the windows
 of the six miraculous powers,
Sees the faces of innumerable deities,
Masters the meanings of the words of the teachings
And gains the delightful company
 of an immortal lover.

In the tip of the vajra between the eyebrows,
The light of the sun, moon and stars swirls
 in the drop.
By bringing mind and energy to that point,
The white bodhimind is forever increased.

Then with the fine brush of samadhi paint
A masterpiece incorporating all beauties of life;
One gains the aid of a fully qualified consort
And one's experience of the blisses blazes
 higher and higher.

Mind fixed on the bliss and mudra of the consort,
A rain of innate joy pours down.
Again and again seducing the beautiful one,
Symbol of the mind embracing reality itself,
One melts into the sphere of spontaneous bliss.

From the center of the navel chakra where meet
 the three energy channels,
Shine lights from white and red pyramids.
Looking through the nucleus of five drops therein,
The mind's nature is seen as five buddhas.

White and yellow energies shape into a vase
And the all-destroying fire rages.
The letters AH and HAM flare, fall and vibrate,
Transporting one to the end of the primordial
 path of great bliss and wisdom combined.

Lights from the mystic fire flash
 into the hundred directions,
Summoning the blessings of buddhas
 boundless as space.
Once again the five natures of mind arise as sounds,
Releasing a rain of ambrosial knowledge.

The apparitions of people and things
Dissolve into light, and the waves
Of misconception are stilled.
No longer is the radiance of clear light obscured.
Even post-meditation mind maintains
 immaculate view.

In the sphere of semblant and innate mahamudra,
Empty images appear as rainbows.
Flawless method emanates phantom circles,
Erecting the perfect mandala of deities and abodes.

The illusory body merges with clear light
Like clouds dissolving into space.
The fires of innate wisdom arise
And consume the seed of grasping for self.

This great union of the radiant vajra body
With the vast clear light of mind
Is called "the samadhi moving magnificently,"
A stage not touched by the ordinary intellect.

This consciousness, purified of all transient stains,
Gazes clearly and directly at the sphere of truth.
Like a magic gem it manifests the Beatific Body
Of Heruka Chakrasamvara for the sake of others
And sends out countless emanations,
Each in accord with the needs of the world.

Thus in this age of short lifespan,
Buddhahood is swiftly and easily attained
By turning lust for sensual objects
Towards the friend who instills great bliss.

Think: By studying, contemplating and meditating
Upon the flawless Vajrayana teachings,
The highest path, the esoteric way of all
 tantric Adepts of the past,
May I in this very lifetime attain with ease
That point most peerless and supreme.

And if in this life ultimate power is not found,
At my death may the dakas and dakinis protect me
And lead to the rainbow palace of Vajrayogini
In the pure land Kajou Shing, there
 to enjoy clouds of transcendent offerings.

May I and all practitioners of this tantra
Soon complete the esoteric path of secrets
And, within ourselves ever perfecting the practices
Of the sutras and tantras taught by the Buddha,
May we master this mysterious way.

Until then, may the mighty dakas and dakinis
Who dwell in the twenty-four Heruka grounds
Care for us in every time and situation
As a mother watches over her only child.

Bibliography

Recommended Works on Tibetan Mystical Art

Beer, Robert. *The Encyclopedia of Tibetan Symbols and Motifs*. Boston: Shambhala, 1999.

Chandra, Lokesh. *Buddhist Iconography: Compact Edition*. Second reprint. New Delhi: Lokesh Chandra. International Academy of Indian Culture and Aditya Prakashan, 1999.

Dagyab, Loden Sherab. *Tibetan Religious Art*. 2 vols. Wiesbaden: Otto Harrassowitz, 1977.

Jackson, David. *A History of Tibetan Painting: The Great Tibetan Painters and their Traditions*. Wien: Verlag der Osterreichischen Akademie der Wissenschaften, 1996.

Jackson, David and Janice. *Tibetan Thangka Painting*. Illustrated by Robert Beer. London: Serindia, 1984.

Kvaerne, Per. *The Bon Religion of Tibet: Iconography of a Living Tradition*. London: Serindia Publications, 1995.

Landaw, Jonathan, and Andy Weber. *Images of Enlightenment: Tibetan Art in Practice*. Ithaca, N.Y.: Snow Lion Publications, 1997.

Leidy, Denise Patry, and Robert A. F. Thurman. *Mandala: The Architecture of Enlightenment*. New York: Asia Society Galleries, Shambhala Publications, 1998.

Mullin, Glenn H., and Andy Weber. *The Mystical Arts of Tibet*. Atlanta: Longstreet Press, 1996.

Rhie, Marylin M., and Robert A. F. Thurman. *Wisdom and Compassion: The Sacred Art of Tibet*. Expanded ed. New York: Tibet House, in association with Harry N. Abrams Inc., 1996.

Singer, Jane Casey, and Philip Denwood. *Tibetan Art: Toward a Definition of Style*. Trumbull, Conn.: Weatherhill Press. 1997.

Thurman, Robert A. F., Marylin M. Rhie, and David Jackson. *Worlds of Transformation*. New York: Tibet House, 1999.

Wilson, Martin, and Martin Brauen. *Deities of Tibetan Buddhism: The Zurich Paintings of the Icons Worthwhile to See*. Bris sku mthon ba don ldan. Boston: Wisdom Publications, 2000.

Recommended Books on the Feminine in Tibetan Buddhism

Allione, Tsultrim. *Women of Wisdom*. London: Routledge and Kegan Paul, 1984. Reprint. Ithaca, N.Y.: Snow Lion Publications, 2000.

Beyer, Stephan. *The Cult of Tara, Magic and Ritual in Tibet*. Berkeley: University of California Press, 1978.

Changchub, Gyalwa, and Namkhai Nyingpo. *Lady of the Lotus-Born: The Life and Enlightenment of Yeshe Tsogyal*. Boston: Shambhala Publications, 2002.

Chonam, Lama, and Sangye Khandro. *The Lives and Liberation of Princess Mandarava*. Boston: Wisdom Publications, 2001.

Dowman, Keith. *Sky Dancer: The Secret Life and Songs of the Lady Yeshe Tsogyel*. London: Routledge and Kegan Paul, 1984. Reprint. Ithaca, N.Y.: Snow Lion Publications, 1996.

Edou, Jerome. *Machig Labdron and the Foundations of Chod*. Ithaca, N.Y.: Snow Lion Publications, 1996.

English, Elizabeth. *Vajrayogini: Her Visualization, Rituals, and Forms*. Cambridge, Mass.: Wisdom Publications, 2002.

Mullin, Glenn H. *Selected Works of the Dalai Lama I: Bridging the Sutras and Tantras*. Writings of the First Dalai Lama on Arya Tara and other Buddhist subjects. Ithaca, N.Y.: Snow Lion Publications, 1985.

Mullin, Glenn H. *Selected Works of the Dalai Lama II: The Tantric Yogas of Sister Niguma*. Writings of the Second Dalai Lama on the Six Yogas of Niguma and other Buddhist subjects. Ithaca, N.Y.: Snow Lion Publications, 1985.

Rinpoche, Bokar. *Tara: The Feminine Divine*. San Francisco: Clear Point Press, 1999.

Shaw, Miranda. *Passionate Enlightenment*. Princeton, N.J.: Princeton University Press, 1995.

Wilson, Martin. *In Praise of Tara: Songs to the Saviouress*. Cambridge, Mass.: Wisdom Publications, 1996.

Female Buddhas on the Web

Female buddhas included in this volume can all be visited at the Himalayan Art Project (HAP), www.himalayanart.org. These tangkas and other items have been photographed and catalogued, making it possible for visitors to refer to the iconographic descriptions and view the images in greater detail. To do this, open your browser and type in the following address:

<http://www.himalayanart.org/image.cfm/[item number].html>

In place of [item number], type in the number of the item you wish to view. For example, if you wished to learn more about the White Tara, from the Atisha Lineage of Twenty-One Taras on page 69, you would type in the following:

<http://www.himalayanart.org/image.cfm/337.html>.

If you click directly on the image the details will be enlarged. You can also visit HAP by typing www.himalayanart.org and going to the "Collections" page, where you can hit the search button to look for an item by Himalayan Art Project number. Following is a list of the art, divided by collection, with each one's page number and HAP numbe.

Shelley and Donald Rubin Collection

page	name	HAP number
56	*Prajna Paramita Sutra* book cover	700105
60	*Arya Tara*	14
65	*The Twenty-One Taras: The Atisha Lineage*	672
67	*The Twenty-One Taras: A Sakya Interpretation*	1049
83	*The Centerpiece for the Taras Who Protect*	832
85	*Tara Who Protects from the Danger of Lions,*	831
87	*Tara Who Protects from the Danger of Elephants*	833
89	*Tara Who Protects from the Danger of Fire*	834
91	*Tara Who Protects from the Danger of Thieves*	828
93	*Tara Who Protects from the Danger of Imprisonment*	830
95	*Tara Who Protects from the Danger of Drowning*	829
97	*Tara Who Protects from the Danger of Ghosts*	827
105	*Amitayus*	112
110	*Ushnisha Vijaya Stupa* from Nepal	700095
119	*Marichi*	220
124	*Simhamukha,* bronze	700088
125	*Simhamukha*	784
133	*Samantabhadra and Samantabhadri*	36
137	*Vajrabhairava and Vajra Vetali*	311
143	*Hevajra and Nairatmya*	593
145	*Vajrakila and Triptachakra*	284
147	*Walchen Gekho and Lokbar Tsamey*	200046
153	*Vajravarahi*	839
157	*Vajra Nairatmya*	1
163	*Samaya Tara Yogini;*	657
164	*Mandala of Vajrayogini* (Naropa Lineage), wood	1008
167	*Heruka Chakrasamvara Mandala*	97
173	*Baishajvaguru Mandala*	902
175	*Arya Tara Anuttaratantra Mandala*	779

177	*Rakta Yamari Mandala*	1041
185	*Magzor Gyalmo with Tseringma Chey Nga*	105
191	*Ekajati*	263
195	*Khadroma Tsomo Chechang Marmo*	192
197	*Sinpoi Tsomo Jigjey Marmo*	193
209	*Saraha and His Female Guru*	227
213	*Dombi Heruka and Consort*	228
217	*Machik Labdon*	223

Rubin Cultural Trust

page	name	HAP number
139	*Kalachakra and Visvamata*	65001

Rubin Foundation

page	name	HAP number
59	*Arya Tara,* bronze	700035
69	*White Tara, from the Atisha Lineage of Twenty-One Taras*	337
71	*Yellow Tara, from the Atisha Lineage of Twenty-One Taras*	338
73	*Red Tara, from the Atisha Lineage of Twenty-One Taras*	340
75	*Dark Colored Tara, from the Atisha Lineage of Twenty-One Taras*	450
81	*The Eight Taras Who Protect from the Eight Dangers*	323
103	*Chintachakra Tara*	542
109	*Ushnisha Vijaya*	663
113	*Ushnisha Sita Tapatra*	429
117	*Parnashavari*	434
123	*Kurukulle*	422
127	*Sherab Chamma*	200009
135	*Guhyasamaja and Sparshavajri*	487
141	*Chakrasamvara and Vajravarahi*	69
155	*Vajrayogini*	290
159	*Sita Yogini*	619
161	*Krisna Krodha Dakini*	491
169	*Vajravarahi Panja-devi Mandala*	94
171	*Vajrayogini (Naro Khechari) Mandala*	334
183	*Palden Lhamo Magzor Gyalmo*	472
187	*Dorjey Rabtenma*	330
189	*Shri Chitipati*	462
193	*Rakta Ganapati*	207
199	*Lhamo Dorjey Yudonma*	435
201	*Lhamo Tashi Tseringma*	433
205	*Avalokiteshvara*	40
207	*The Niguma Lineage of Heruka Chakrasamvara*	624
211	*Ghantapada and Consort*	514
215	*Padma Sambhava*	188

Index

A

The Abbreviated Kalachakra Tantra (Manjushrikirti), 140
Abhidharma Pitaka, 23
agendas
 in general, 123
 Sherab Chamma, 126
 Simhamukha, 124
Akshobhya, 115, 140, 174
Akshobhyavajra, 134
Amitabha, 29, 61, 80, 108, 122, 170, 174, 214
Amitayus, 68, 98, 99, 101, 115, 172
 discussed, 104–106
Amoghasiddhi, 174
Ananda, 112
art
 discussed, 43–46, 99
 mystical art, 47–50
 nagtang, 122
 sertang, 121–122, 182
 sertig, 121
Arupakaya, 27
arya, 27
arya desha, 27
Arya Tara, 15, 32, 106, 115, 123, 164, 168, 174, 190. *See also* Tara
 Eight Taras Who Protect from Eight Dangers
 centerpiece, 82
 in general, 79, 80
 Tara Who Protects from Danger of Drowning, 94
 Tara Who Protects from Danger of Elephants, 86
 Tara Who Protects from Danger of Fire, 88
 Tara Who Protects from Danger of Ghosts, 96
 Tara Who Protects from Danger of Imprisonment, 92
 Tara Who Protects from Danger of Lions, 84
 Tara Who Protects from Danger of Thieves, 90
 Forms of Tara, 57–61
 Four Taras from Atisha lineage, 68
 Dark-Colored Tara, 74
 Red Tara, 72
 White Tara, 68
 Yellow Tara, 70
 in general, 54
 Mother of all Buddhas, 55–57
 Tibetan Romance with Arya Tara, 57–58
 Twenty-One Taras
 Atisha lineage, 64
 in general, 62
 Sakya interpretation, 66
 Twenty-One Verses in Praise of Tara, 73–78
Asanga, 27, 43, 56
Ashoka, King, 47, 104
Atisha, 15, 58, 104, 154
Atisha (Battacharya/Chinpa), 48n2
Atisha Dipamkara Shrijnana, 48, 62, 70, 134
Avalokiteshvara, 24, 29, 54, 58, 64, 102, 107, 126, 204, 210, 214

B

Basham, Prof. A.L., 51
Bhaishajyaguru, 172
Bhikshuni Lakshmi, 203
 discussed, 204
BHRUM, 108
Bikkshuni Lakshmi, 40
bindhu, 37
The Blue Annals (Goe Lotsawa), 47n1
bodhichitta, 19n3, 24
bodhisattva, 24, 180
Bodong Chokley Namgyal, 74
Bon, 47–50, 126, 144, 146
Brahma, 107
Brahmaputra River, 140
Buddha, 17
Buddhagupta, 162
Buddhism, 20, 21–22, 39, 138, 180, 198
Buton Rinchen Drup, 74, 78, 186

C

cha, 204
Chakra Dakini, 160
chakras, 37, 106
Chakrasamvara. See also Heruka Chakrasamvara
 Vajravarahi and, 140
Chakrasamvara Tantra, 149
cham, 188
Chamundi, 136
Charya tantra, 32
Chaturbhuja Mahakala, 166
Chemchog Heruka, 140
China, 47, 49, 51–52, 99, 126, 203
Chinta Yogini, 210
Chintachakra Tara, 59. *See also* Tara
 discussed, 101–103
Chitipati, 181
cho-lokpa, 174
Chogyal Pakpa, 49, 121, 176
Chokhor Gyal Monastery, 104, 122, 182
Chokyong Khadro Khadroma, 39
chomdar, 216
chopa, 22
Chopan Tingzangma, 184, 200
chulen, 106
Conze, Edward, 55
Crushing the Forces of Darkness (Dalai Lama I), 19
The Cult of Tara (Beyer), 54n1

D

dak-kyey, 36, 181
Dakas, 40–41
Dakinis, 40–41, 148–149, 179
Dalai Lama, generally, 29, 110, 123, 124, 152, 180, 182, 198, 203
Dalai Lama I, 49, 58, 59, 61, 76, 78, 101, 104, 106, 122
 Crushing the Forces of Darkness, 19
 Lek Trima, 15, 79, 84, 102, 190
 Notes on the Two Yogic Stages of Glorious Kalachakra, 138
Dalai Lama II, 36–37, 106, 203, 218
 A Raft to Cross the Ocean of Buddhist Tenets, 21
Dalai Lama V, 49, 99, 110, 180, 184
Dalai Lama VI, 131, 184
Dalai Lama VII, 32, 36, 106, 164, 220
Dalai Lama XIII, 28, 37, 39
 A Guide to Buddhist Tantras, 35, 134
damaru, 216
Damtsig Dolma Naljorma, 162
de Gaulle, Charles, 38
Desi Sangyey Gyatso, 196
devaputra, 107
dewa, 32
dharani, 76
dharanis, 165
The Dharani of Tara Who Protects from the Eight Dangers, 79
Dharma Dodey, 104
Dharma Protectors. *See also* Dharmapalas
 Dorjey Rabtenma, 186
 Ekajati, 190
 in general, 179–181
 Khadroma Tsomo Chechang Marmo, 194
 Lhamo Dorjey Yudonma, 198
 Lhamo Tashi Tseringma, 200

Dharma Protectors (*cont.*)
　Magzor Gyalmo and *Tseringma Chey Nga*, 184
　Palden Lhamo Magzor Gyalmo, 182
　Rakta Ganapati and *Five Dakinis*, 192
　Shri Chitipati, 188
　Sinpoi Tsomo Jigjey Marmo, 196
dharmadayo, 165
Dharmakaya, 27–30, 56
Dharmapalas, 40, 102, 148, 202. *See also* Dharma Protectors
dhyana, 165
Dilgo Khyentsey Rinpochey, 180
dogyi chulen, 106
doha, 208
Dolma Boom, 62, 68
Dolma Lkakhang, 15
Dolma Mandal Zhichok, 62, 68
Dombi Heruka, 156
　Consort and, 212
Dorjey Donma, 216
Dorjey Pakmo, 29
Dorjey Rabtenma, discussed, 186
Dorjey Shugden, 180
drang-don, 21, 22
Drepung Monastery, 110
Drikung Chetsang Rinpochey, 116
Drikung Kargyu, 116
Drubpai Gyalmo, 104
Dujom Rinpochey, 160
Durdak, 188
Dzog-rim, 130

E

Egypt, 47
Ekajati, 102, 181
　discussed, 190

F

The First Dalai Lama (Mullin), 54n1

G

Gampopa, 48
Ganapati, 180, 181. *See also Rakta Ganapati*
Ganden Potrang, 110
Gandhi, Mahatma, 100
Ganges River, 140
Gautama, 19
Genghis Khan, 122
Ghantapada, 152, 203
　Consort and, 210
Goe Lotsawa, 134
gompa, 22
Gonpo Shanglon, 194

Gorum Zimchi Karpo Temple, 48
Green Tara, 59, 64. *See also* Tara
gu-tang, 182
Guhyajnana Dakini, 124
Guhyamantra-yana, 32
Guhyasamaja, 166, 206
Guhyasamaja, discussed, 134
Guhyasamaja and Sparshavajri, 134–135
Guhyasamaja-tantra, 44n2
A Guide to Buddhist Tantras (Dalai Lama XIII), 35, 134
Guru, 179
gyalpo, 180
Gyalwa Dondup, 216
Gyalwa Gotsang, 203
Gyalwai Yum, 55, 129
Gyangtsey, 166
gyu-gyi-lam, 31
Gyugi Gyalpo, 134
Gyuto Monastery, 198
Gyuzhi, 172

H

Hayagriva mandala, 106
Healing Buddha. *See also* Medicine Buddha
　Prajna Paramita, 172
Healing Trinity, 123
　Amitayus, 104–106
　Chintachakra Tara, 101–103
　in general, 98–100
Heruka Chakrasamvara, 140, 149, 174, 188, 192, 206. *See also Chakrasamvara* mandala, 166, 167–177
Hevajra, 66, 166
　Nairatmya and, 129, 142, 206
Highest Yoga Tantra Tara Mandala, discussed, 174
Hinayana, 23–24
　bodhichitta, 24
hum, 101

I

Iabrang Karcha, 49
In Praise of the 108 Names of Arya Tara, 57
In Praise of Tara (Dalai Lama I), 54n1, 57n11, 62
In Praise of the Twenty-One Taras (Dalai Lama I), 57, 62
India, 47, 99
　Buddhism, 21–22, 144
　Dharamsala, 110, 123, 198
　Tso Pema, 116
Indrabhuti, King, 134, 204
Indus River, 140

J

Jamgon Kongtrul the Great, 144
Jamyang Khyentsey Wangpo, 154
jang-sem, 19n3
Jatakas, 24
jator, 216
Jetari, 104, 107
Jetsunma Dorjey Pakmo Tulku, 203
Jetsunma Khadrola, 203
Jetsunma Kushok Chimey Luding, 203
Jigten Chokyong, 40, 180
Jigten Leydeypai Chokyong, 40, 180
Jina, 55
jnana dakinis, 148. *See also* Vajra Dakinis
jnanamudra, 130
Jokhang, 16, 47
Jomo Langma, 184. *See also* Mt. Everest
Jung, Carl G., 150

K

Kalachakra, Visvamata and, 138–140
Kalachakra Tantra, 31
Kalachakras, 138
Kalaratri, 140
kama, 144
Kangyur, 23
Karma Dakini, 160
karmamudra, 37, 130
Khachen Yeshey Gyaltsen, 184
Khado Sangwa Nechen Nyerzhi, 149
khadro, 41
khadroma, 41
Khadroma Drowai Zangmo, 203
Khadroma Troma Nakmo, 160
Khadroma Tsomo Chechang Marmo, discussed, 194
Khandaroha, 168
Khechara, 170
Khon Konchog Gyalpo, 48
Khon Luwang Sungwa, 144
Khon-lug, 144
Khyungpo Naljor, 206
Konchok Sum, 39
Krisna Krodha Dakini, discussed, 160
Krisnacharya, 212
Kriya tantra, 32, 115, 118, 149
Kuan Yin, 126
Kublai Khan, 49, 121, 176
Kungpa Palmo, 203
Kurukulle, 66, 149, 168
　discussed, 121–123
Kye-rim, 130
kyil-khor, 32, 106, 164

L

labrang, 49
Lalivavistara Sutra, 19n2

Lam Drey, 156
Lama Chenngawa, 101
Lama Drom Donpa, 48
Lama Drom Tonpa, 58
Lama Tsongkhapa, 49, 134, 136
Lama Yunten Dorjey, 74
Lek Trima (Dalai Lama I), 15, 79, 84, 102
lha-yi nal-jor, 31
lha-yi nga-gyal, 36
Lhamo Dorjey Yudonma, discussed, 198
Lhamo Latso Oracle Lake, 104, 182, 184, 186
Lhamo Tashi Tseringma, 184
 discussed, 200
lhu, 146
Lineage Masters
 Bhikshuni Lakshmi, 204
 Dombi Heruka and *Consort,* 212
 in general, 202-203
 Ghantapada and *Consort,* 210
 Machik Labdon, 216-218
 Niguma, 206
 Saraha and *Two Disciples,* 208
 Yeshey Tsogyal, 214
Little Red Book (Mao Tse-tung), 99
Lobzang Chokyi Gyaltsen, 49
Lochani, 174
Lokbar Tsamey, 146
 Walchen Gekho and, 146
Lumbhini, 19n1

M

Machik Labdon, 40, 106, 158, 160, 203
 discussed, 216-218
Magzor Gyalmo, 122, 136, 186, 200
 Palden Lhamo Magzor Gyalmo, 182
 Tseringma Chey Nga and, 184
Magzurma. *See Magzor Gyalmo*
Maha-anuttara-yoga tantra, 32
Mahakala, 136, 142
Mahamaya, 140, 206
Mahayana, 24
Maitreya, 27, 49, 122, 170
Maitri Prajna, 126
mak, 182
Mamaki, 174
mandalas, 31-34
 in general, 106-107, 164-65
 Heruka Chakrasamvara, 166
 Highest Yoga Tantra Tara Mandala, 174
 Kurukulle, 121-123
 Marichi, 118-121
 Parnashavari, 115-117
 Prajna Paramita as "Healing Buddha", 172
 Rakta Yamari and *Vajra Vetali,* 176

Ushnisha Sita Tapatra, 112-114
Ushnisha Vijaya, 107-110
Vajravarahi, 168
Vajrayogini (*Naro Khechari*), 170
Mandarava, 214
Manjushri, 24, 29, 64, 72, 102, 108, 115, 122, 136, 214
Manjushrikirti, 140
mantra, 31-34
Mao Tse-tung, 99
Marco Polo, 48-49, 121
Marichi, 102, 115, 190
 discussed, 118-121
Marpa Lotsawa, 48, 104, 134, 142, 152, 154, 156, 206
Medicine Buddha, 194. *See also* Healing Buddha
Meditations to Transform the Mind (Mullin), 36n2
Mentsikhang, 172
metok chulen, 106, 158
Mila Gur Boom, 132
Milarepa, 48, 104, 132, 184, 200
Miyo Lobzangma, 184, 200
Mongolia, 48
Mt. Everest, 184, 200
Mt. Kailash, 140, 149
Mt. Zhizhi Pangma, 184
mudra, 45, 61
Mulatantra, 31
Mystical Verses of a Mad Dalai Lama (Mullin), 36n6

N

nadi, 37
nagas, 116
nagtang, 122
Nairatmya, 212
 Hevajra and, 142, 206
 Vajra Nairatmya, 156
nak-tang, 200
Namgyal Dratsang Monastery, 110
Namgyal Enclave, 110
Namgyalma Tong Cho, 110
nangwa, 32
Naro Khachoma, 154, 170, 188
Naro Khechari. See Vajrayogini
Naropa, 44n3, 104, 130, 152, 154, 156, 206
Native Americans, 47, 126, 149
Nepal, 104, 154
nges-don, 21, 22
Nick, Prof. Lloyd, 52
Niguma, discussed, 206
Niguna, 40
Nirmanakaya, 27-29
Norbu Lingka, 15

Notes on the Two Yogic Stages of Glorious Kalachakra (Dalai Lama I), 138
Nyang Tingzin Zangpo, 132
Nyatri Tsenpo, 47

O

Oddiyana, 124, 180
om (mantra), 101
om nama tare name hara hum hara svaha (mantra), 77
om svabhava shuddha sarva dharmah svabhava shuddoh ham (mantra), 35
om tare tuttare ture svaha (mantra), 77
An Ornament of Clear Comprehension (Maitreya), 27

P

Padampa Sangyey, 158, 160, 216
Padma Dakini, 160
Padma Sambhava, 101, 104, 132, 160, 180, 181, 186, 198, 200, 214, 216
Pakmo Drupa, 48
Palden Lhamo, 40, 126, 146, 179, 186, 200
Palden Lhamo Magzor Gyalmo, discussed, 182
Pamtingpa brothers, 154
Panchen Lama, 68, 99-100, 203
Panchen Lobzang Yeshey, 184
Panchen Sonam Drakpa, 115, 118, 158
Parnashavari, 84
 discussed, 115-117
Parping, 154
Path of the Bodhisattva Warrior (Mullin), 28n3, 35n1
The Peerless Stream (Maitreya), 43
Pehar Gyalpo, 180
Perfection of Wisdom Sutra, 31
Persia, 47, 180
Philistine, 47
Potala, 15
prajna, 130
Prajna Paramita, 15, 55, 158, 216
 as "Healing Buddha," 172
Prajna Paramita Devi, 56-57
Prajna Paramita Sutras, 55-56, 138, 214
prana, 57
Pundarika, 140

R

A Raft to Cross the Ocean of Buddhist Tenets (Dalai Lama II), 21
Rahula, 208
Rakta Ganapati. See also Ganapati
 Five Dakinis and, 192
Rakta Yamari, 74, 166, 174
 Vajra Vetali and, 176
Rakta Yamari Tantra, 176

Ramochey, 47
rang sang, 128
Rateng Monastery, 48
Ratna Dakini, 160
Ratnasambhava, 174
Rato Gompa, 15
Rato Monastery, 48
Rechung Nyen Gyu, 104
Rechungpa, 104
Red Tara, 72. *See also* Tara
Refuge Objects, 39
Rigsum Gonpo, 64, 102
rimpa nyi-gi-nal-jor, 36
Rinchen Zangpo, 48
Root Medical Tantra, 172
Root Tanta, 31, 59, 79
Rubin Museum, 52
Rupakaya, 27
Rupini, 168

S

Sachen Kungpa Nyingpo, 174
*Sacred Tibetan Chants from the Great
 Prayer Festival*, 15n1
sadhana, 35, 36
Sahaja Chakrasamvara, 218
Saka Dawa, 204
Sakya, 166, 203
Sakya Monastery, 48
Sakya Pandita, 122, 142
Sakya Trizin, 99, 144, 203
samadhis, 165
Samantabhadra, 28, 146, 150
 Samantabhadri and, 128, 132
Samantabhadri, 28
 Samantabhadra and, 132
Samaya Tara Yogini, 162–163
Samboghakaya, 27–30
samsara, 180
Sang, 129
Sang Yum, 129
sang-gyey, 17
sang-gyey kyi-trinley, 55
Sangwa Dragchen, 146
santana, 27
Saraha, Two Disciples and, 208
Sarasvati, 136
Satrig Ersang, 126
sel, 27
sel-nang, 36
Selected Works of the Dalai Lama I, 15n1,
 54n1, 57n12
Selected Works of the Dalai Lama II,
 21n2, 22n2
selwa, 32
ser-tang, 182
sertang, 121–122

sertig, 121
Setrap Chen, 136
Shakyamuni, 19–20, 21, 24, 31, 40, 158,
 172, 174, 216
 Jatakas, 24
Shambala, 138, 140
Shangpa Kargyu, 206
Shantideva, 84
Sharmapa Lama, 168
Sherab Chamma, discussed, 126
Shigatsey Monastery, 104, 166
shing par, 182
Shintu Drakpo, 176
Shiva Puranas, 192
shramanera, 204
Shri Chitipati, discussed, 188
Siddharani, 104–106
Siddhartha, 19
Silk Road, 47, 118, 138, 180
Simhamukha, 132, 148–149
 discussed, 124
Sinmo, 196
Sinpoi Tsomo Jigjey Marmo, discussed,
 196
Sipai Gyalmo, 126, 146
Sita Yogini, discussed, 158
Sitayogini, 206
skanda, 17
Snellgrove, David, 126, 144
Songtsen Gampo, King, 29, 40, 47, 58,
 104, 126
Sparshavajri, 134, 206
stupa, discussed, 28
Sublej River, 140
Sukhasiddhi, 151, 206
Sukhavati, 170
Sutra, 23
Sutra Pitaka, 23
Sutra Way, 17, 21, 22, 31, 202
 discussed, 23–26, 39–40
symbols, 43, 108, 186

T

Tai Situ Lama, 152
Tai Situpa, 99
Tantra, 23, 32
Tantra Way, 17, 21, 22, 44, 202
 discussed, 31–34, 35–38, 39
Tara, 15, 47, 126. *See also*
 Arya Tara
 Chintachakra Tara, 59, 101–103
 Dark-Colored Tara, 74
 Eight-Armed Tara as Vajra Dakini,
 162
 Green Tara, 59, 64, 68, 102
 Highest Yoga Tantra Tara Mandala,
 174

Red Tara, 72
White Tara, 45, 58, 98, 101–102, 136,
 172
 Atisha lineage, 68
 White Tara meditation, 16n2, 101
Yellow Tara, 70
Tara Temple, 48
Taranatha, 162
The Tara Root Tantra, 57, 62, 79
Tashi Lhunpo Monastery, 68, 122
tawa, 22
Tekar Drozangma, 184, 200
ten, 25
Tenma Chunyi, 120, 180, 198
terma, 99, 144, 192
Thirteenth Karmapa, 152
Three Kayas, 98
 discussed, 27–31
Three Roots, 39–42
Thurman, Prof. Robert, 49
Tilbu Lha Ngayi Khilkhor, 152
Tilopa, 154
Time magazine, 180
Tinggi Zhalzangma, 184, 200
Tipupa, 104
tong, 27
tong-zuk, 138
tongpa, 32
Tonpa Shenrab, 126, 146
Tonyon Samdrup, 216
tormas, 108
Treatise on Empowerment (Naropa), 130
Treatise on Initiations (Naropa), 44n3
Tri Ralpachen, King, 47
Trinleyma, 55
Tripitaka, 23
Triptachakra, 144
Trisong Deutsen, King, 40, 47, 214
Troma Nagmo, 158
Trowo Zhi, 107
trul-pa, 27
Tsa-gyu Lama, 39
Tsawa Sum, 39
Tse-ta Zung-trel, 106
tsedang yeshey gyi ngodrup, 106
Tsepagmey Shakdunma, 101
Tseringma Chey Nga, Magzor Gyalmo
 and, 184
tsewang, 59, 98, 104, 106, 108
tsey drup, 108
tsim-tang, 182
Tsok-zhing, 204, 216
Tsom, 21n1
Tsongkhapa, 154
tsun shing par, 182
tsun-tang, 182
tulku, 29, 158
tulpa, 29

tummo, 152
Tushita, 170
Twenty-One Taras
 Atisha lineage, 64
 in general, 62
 Sakya interpretation, 66

U
Uddiyana, 124
upaya, 130
ushnisha, 112
Ushnisha Sita Tapatra, discussed, 112–114
Ushnisha Vijaya, 15, 98, 101, 172
 discussed, 107–110

V
Vairocana, 174
Vaishravana, 136, 200
Vajra Dakinis, 37, 41, 168, 202, 203, 206
 Eight-Armed Tara as Vajra Dakini,
 162
 in general, 148–150
 Krisna Krodha Dakini, 160
 Sita Yogini, 158
 Vajra Nairatmya, 156
 Vajrayogini, 154
 Vajrvarahi, 152, 158
Vajra Kumara, 144
Vajra Nairatmya, 156, 168. *See also*
 Nairatmya
Vajra Vega, 140
Vajra Vetali
 Rakta Yamari and, 176
 Vajrabhairava and, 136, 206
Vajrabhairava, 72, 166, 176, 206
 Vajra Vetali and, 136, 206
Vajrabhairava Tantra, 202
Vajradhara, 70, 124, 134, 136, 140, 142,
 162, 166, 170

Vajrahatvishvari, 174
Vajrakila, discussed, 144
Vajrakila and Triptachakra, 144–145
Vajrapani, 24, 64, 102, 107, 115, 140,
 198
Vajrasattva, 216
Vajravarahi, 154, 158, 166, 206, 216
 Chakrasamvara and, 140
 mandala, 168
Vajra Vetali, 72
Vajrayogini, 15, 142, 164
 discussed, 154
 mandala, 170
Vajrvarahi, 174, 203, 204
 discussed, 152
Varahi, 154
vayu, 57
Vijaya, 110
Vinaya Pitaka, 23
Virupa, 66, 122, 142, 156, 212
Visvamata, Kalachakra and, 138–140

W
Walchen Gekho, Lokbar Tsamey and, 146
Wanggi Lhamo, 122
Watt, Jeff, 52
White Tara, 45, 58, 98, 101–102, 136, 172
White Tara meditation, 16n2, 101
White Yogini, 158, 216
The Wonder That Was India (Basham),
 51n1

Y
yab, 128, 129
Yab Yum
 Chakrasamvara and *Vajravarahi*, 140
 in general, 128–131
 Guhyasamaja, 134
 Hevajra and *Nairatmya*, 142

Kalachakra and *Visvamata*, 138–140
Samantabhadra and
 Samantabhadri, 132
Vajrabhairava and *Vajra Vetali*, 136
Vajrakila, 144
Walchen Gekho and *Lokbar Tsamey*,
 146
Yab Yum Nyam-jor, 33
Yab Yum Nyamjor, 129, 130
Yama, 140
Yama Dharmaraja, 136
Yamantaka, 66, 136
Yanas, 23
Yarlung Dynasty, 47
Yellow Tara, 70. *See also* Tara
Yeshey Tsogyal, discussed, 214
Yidam, 39, 40, 180, 181
Yoga tantra, 32
yugganada, 32

Z
Zahor, 214
Zha-nag, 152
Zhalu Monastery, 186
Zhang Zhung, 126
zor, 182
Zung Du, 79